Drawing

Drawing

Space, Form, & Expression

Second Edition

Wayne Enstice
Director, School of Art, University of Cincinnati

Melody Peters
The University of Arizona, Tucson

Prentice Hall, Englewood Cliffs, New Jersey 07632

Library of Congress Cataloging-in-Publication Data

Enstice, Wayne
 Drawing : space, form, and expression / Wayne Enstice, Melody
Peters.—2nd ed.
 p. cm.
 Includes index.
 ISBN 0-13-304643-5
 1. Drawing—Technique. I. Peters, Melody, II. Title.
NC730.E65 1995
741—dc20 94-48306
 CIP

Assistant Editor: Marion Gottlieb
Project Managers: Hilda Tauber/Andrew Roney
Cover design: Anthony Gemmellaro
Cover art: *Apple Bronzino*, 1993
 Mary Ann Currier.
 Courtesy, Tatistcheff Gallery, New York.
Manufacturing buyer: Bob Anderson

© 1996 by Prentice-Hall, Inc.
A Simon & Schuster Company
Englewood Cliffs, New Jersey 07632

Printed in the United States of America
10 9 8 7 6 5 4 3 2

ISBN 0-13-304643-5

Prentice-Hall International (UK) Limited, *London*
Prentice-Hall of Australia Pty. Limited, *Sydney*
Prentice-Hall Canada Inc., *Toronto*
Prentice-Hall Hispanoamericana, S.A., *Mexico*
Prentice-Hall of India Private Limited, *New Delhi*
Prentice-Hall of Japan, Inc., *Tokyo*
Simon & Schuster Asia Pte. Ltd., *Singapore*
Editora Prentice-Hall do Brasil, Ltda., *Rio de Janeiro*

In memory of Dr. Robert W. McMillan
For his encouragement
and professional insights.

Contents

2 *The Two-Dimensional Space of a Drawing* 47

3 *Shape, Proportion, and Layout* 59

4 *The Interaction of Drawing and Design* 76

5 *Linear Perspective* 94

6 *Form In Space* 116

Preface

We first developed our program of study for teaching drawing during the fifteen year period prior to the publication of the first edition of *Drawing: Space, Form, and Expression*. Though we believed at the time in the soundness of our approach for our own purposes, we were understandably daunted by the prospect of opening up our classroom methods for scrutiny in a national arena. In view of our initial doubts, we were, and remain, extremely gratified by the high level of approbation accorded the first edition.

We also appreciate the generous and constructive insights provided by our many colleagues who teach and coordinate foundation programs across the country. With their encouragement, we have enriched and expanded our coverage of those issues which are central to the art of drawing—and in so doing, we hope that our revisions for this second edition have deepened the inspirational values of our text.

In order to continue to provide student readers with a cross section of drawing precedents and, thereby, to demonstrate *visually* the tremendous flexibility of the medium, we have devoted much of our energy in this second edition to bringing a new freshness to the wide assortment of master drawings. In the case of student work, we have significantly enlarged the number of high quality images, and in contradistinction to the first edition, we have selected many of these student drawings from beyond the boundaries of our own university.

Nowhere is the motivational value of student works more apparent than in Chapter 12, *Portfolio of Student Drawings*, which is unique to our book. This new chapter showcases twenty-nine sustained drawings by students from sixteen different foundation programs in the United States. The accompanying discussion weaves a thematic fabric out of formal, conceptual, and expressive threads that appear throughout earlier chapters of the book.

Our original guiding principle remains the same in this second edition: to write a text which both addresses the needs of the absolute beginner in drawing and continues to serve students as they progress toward more sophisticated matters of technique, style, expression, and art-historical consciousness. To advance this goal and in response to the rapidly expanding area of color drawing in colleges and universities, we have added a chapter on color. With thirty full-color plates, this chapter begins with an overview of color drawing from its

emergence in the mid-nineteenth century to its proliferation in our own time; its middle sections provide the reader with a solid grounding in basic color theory; it then concludes with discussions on the synthesis of color with design and content in a work of art.

To help the student toward a fundamental understanding of art today, we have thoroughly updated our *Portfolio of Contemporary Drawings* chapter. Surveying the major streams of contemporary art entirely *through the medium of drawing*, this chapter aids the student in relating the complex attitudes of Modern and Postmodern theory directly to the drawing act itself.

Like its predecessor, the second edition places a premium on an organization that builds cumulatively from general to specific, but it does so without losing sight of the basics. Also featured are a sustained emphasis on the picture plane as the major unifying factor in pictorial art and a focus on the process of drawing itself, from how to orient a support to troubleshooting an image and overcoming artistic blocks.

The first seven chapters concentrate more fundamentally on the "facts of seeing"—the observation of space and form and their translation into the language of the plastic arts. But keeping in mind the needs of more advanced students who may want to explore personal sources of meaning and visual transformation, we have addressed more directly, and with more complexity, the origins of expression in chapters eight through thirteen (including the aforementioned color and "portfolio" chapters), integrating the discussion with formal analysis and couching it within the framework of history.

Acknowledgments

To paraphrase Thomas Wolfe, it was not any easier the second time. As a natural consequence, the demands on those people who constitute our support group have been as intense, and our appreciation for their efforts are as genuine, as they were during the preparation of the first edition. We are indebted most profoundly to our respective families for their forebearance and for their constancy in shoring up slumping energies and spirits. Marie Enstice deserves the full measure of our gratitude for countless hours spent at the keyboard of a word processor and for leveling at the most opportune moments criticism of a most unvarnished and, therefore, welcome kind. Our thanks also go to Posner's Art Store for help in assembling the Glossary of Media; to faculty colleagues Craig McDaniel and Mary Frisbee Johnson for their insights as readers of portions of the manuscript; to Jinpil Shin for his technical assistance; to Bud Therien, our acquisitions editor, and to assistant editor Marion Gottlieb, who worked assiduously to help us over several obstacles; and to our project managers, Hilda Tauber and Andrew Roney, for their expert guidance during the production of this book.

Our enthusiasm for developing this revised edition was stoked by the opportunity to review literally scores of student works sent us by colleagues around the country. We are grateful to all who participated, and we extend our appreciation to the instructors and former graduate teaching assistants from whom we have selected student examples to use as illustrations, including: Anthony Batchelor, Art Academy of Cincinnati; Nancy Hall Brooks; Gary Buhler; Jane Burgunder, Middle Tennessee State University; Charles Cajori, New York Studio School of Drawing, Painting, and Sculpture; Linda Caputo; Lynn Charron; Maureen Ciaccio; Allyson Comstock, Auburn University; David L. Deming, University of Texas at Austin; Robert Evans, Indiana State University; Stephen Fleming, Kansas City Art Institute; Sean Gallagher, Central Connecticut State University; John P. Gee, Ball State University; William Greider; Charlie Hacskaylo; Ann Hoff, University of Arizona; David James, University of Montana;

Mary Frisbee Johnson, Indiana State University; Carol Jokinen, Jarvis Collegiate Institute (Toronto); April Katz, Clarion College; Don Kimes, American University; Leonard Koenig, University of Missouri at Kansas City; Al Kogel, Cochise College; Dale Leys, Murray State University; Anne Lindberg, Kansas City Art Institute; Mercedes Matter, New York Studio School of Drawing, Painting, and Sculpture; Susan Messer, University of Wisconsin at Whitewater; Catherine Nash; Graham Nickson, New York Studio School of Drawing, Painting, and Sculpture; Sara Nott, University of Arizona; Sheila Pitt, University of Arizona; Janice Pittsley, Arizona State University; Matthew Radford, New York Studio School of Drawing, Painting, and Sculpture; Jan Reeves, University of Oregon; Carol Saarinen; Jim Sajovic, Kansas City Art Institute; William B. Sayler, Pratt Institute; Robert Stolzer, University of Wisconsin at Stevens Point; and D.P. Warner, Edinboro University.

We especially want to thank the following students whose drawings appear in this book: Fumiko Amaro, Jill Anderson, Christopher Arneson, Anne Bagby, Kirt Barr, Melissa Bartell, Tom Bennett, Greg Boas, Jennifer Bogard, Crystal Bray, Michael Breidenbach, Ann Carroll, Felix Chan, Chinban Chang, Neal Conley, James Conners, Georgeanne Cooper, Mark Bemen Darter, Jennifer Diorio, Andreas Efstathiou, Shan Eills, C. Brent Ferguson, Paul Fleming, Ron Fox, Noelle Fridrich, Carla Galuppo, Jamie Geiser, Tim Giblin, Bobbette Gilliland, John Gonzalez, M. Austin Gorum, DeAnn Gould, Bob Graham, Jan Gregory, Joanna Groh, Randall Hamm, Jim Hawks, Andrea Hernandez, Kim Holland, Taylor Hsiao, Sherilyn Hulme, Tim Joyner, Namiko Kanamaru, Christine Karkow, William Kesterson, Kristen Kiger, Nam Kim, Rena Allen Klingenberg, Mikal Korostyshevsky, Matthew Kruse, Alyce Kukinski, Karen Kurt, Chi-Hsing Lai, Jennifer Langston, David Larson, Mila Libman, Paul Lile, Sandy Lipsman, Cheryl Long, Christopher Lucas, Julie Malecha, Tamara Malkin-Stuart, Theresa Marshall, Christine McKay, Jennifer O'Donogue, Cochise College; Amy McLaughlin, Dawn Morgan, Denis Nakhtsen, Jeff Neugebauer, Kevin Ngai, Amy O'Neill, Jan Pagnini, Mitosh Patel, Kari Patterson, Will Pereira, Melissa Peterson, Paul Pittman, Jennifer Plourde, Robert H. Pranger, Lyne Raff, Laura Reuland, Christopher Riely, Ken Riley, Karen Roman, Christopher Ross, Christopher Sickels, Marcia Smartt, Toni Spaeth, Katherine Stinchcomb, Dennis Cheng-Yen Tan, Chereen Tanner, Angela Burch Tingle, Milly Tossberg, Tadd Trausch, Dacey VanderWal and Myrta Wold.

Finally, we would like to acknowledge the following colleagues for their helpful reviews of our manuscript: Harry Ally, Valdosta State College; Alain Gavin, Chicago State University; Edwin Pinkston, Louisiana Tech University; Ronald Michaud, University of Massachusetts; and Ed Shay, Southern Illinois University.

Wayne Enstice
Melody Peters

Introduction

So you have the urge to draw! This urge is something you share with millions of people, from prehistoric times (Fig. 0–1) to our own day. Young children, whose primary activity is making sense of the world, seem naturally inclined to draw. As they reach preteen years, however, many, if not most, stop drawing, due perhaps to self-consciousness, frustration, or simply a decreasing need. Adolescents and adults who resume the habit of drawing frequently become aware of their role as artists, and those of us who spend a large part of our waking hours in the pursuit of art feel that our compulsion to do so sets us apart

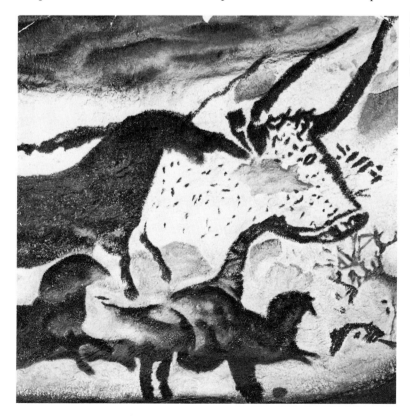

FIGURE 0–1
Prehistoric art
Cave painting of great black bull
and red horse at Lascaux, France
Courtesy, Art Resource

somewhat from the rest of society. Yet, we also know that making art puts us in touch not only with ourselves but also in a very special way with visible and even invisible realities. You will repeatedly experience this sense of communion while making art of any kind, but most frequently this will come as a result of drawing, the most intimate and spontaneous of all visual-art practices.

The professional artist and serious student alike use drawing for a multitude of purposes. We sometimes produce drawings for their own sake, but frequently we draw to record, explore, or consolidate visual ideas. In this respect, drawing is the visual counterpart of writing and like writing can be used to utilitarian or expressive ends.

In this chapter we introduce you to the drawing tradition and its practice. We begin by tracing the impact that Renaissance attitudes have had in shaping drawing's role within the visual arts. Included is a review of developments in drawing today, which will help you relate your daily pursuits in the medium to the larger historical mainstream of drawing activity.

The remainder of this chapter centers on advice we customarily give our beginners to smooth their entry into the world of drawing, which, for all its excitement, may at times seem a bit overwhelming. The benefits of much of this advice will become more apparent as you progress; in the meantime, the counsel you receive here will help you get an early start on developing good drawing habits.

The Legacy of Drawing

We think of drawing as the primary field of study for the aspiring artist since it is the most expedient way of training the eye to observe accurately. This is of enormous benefit to anyone who wants to be involved with representing perceived reality. Practice at drawing and close observation will also prepare you to visualize things that exist only in your imagination.

Our interest in making accurate representations of visual reality has its foundation in Renaissance art. Before that time, artists were more concerned with the symbolic import of their subject matter. And in most cases, conventions for representing common subjects eliminated the necessity for the artist to engage in firsthand observation of natural appearances.

In the Renaissance period, scholars began to redefine the relationship between the secular and spiritual worlds. For the first time artists began to feel justified in taking more interest in the material world around them. As a result, Renaissance artists disciplined themselves to look at and think about what they saw in a manner that would have been foreign to previous generations of artists. And for the first time, Western artists devoted a great deal of rational thought to the problems of form and space. They also had to work hard to sharpen their perceptual skills. This reliance on personal observation backed up by rational thought informed a new spirit of drawing, as seen in the Leonardo da Vinci (Fig. 0–2).

The increased availability of paper in Europe during the fifteenth century did much to encourage the practice of drawing. Before this time, the cost of drawing materials, such as parchment or prepared wooden panels, limited the practice of experimental drawing. With paper, however, the artist could afford to draw in an exploratory way, making many studies of one subject before settling on a final image (Fig. 0–3). Because of its new investigative role, drawing in the Renaissance gained the prestige of a science. This spirit of investigation has been with the study of drawing ever since and accounts for the existence of art programs in colleges and universities today.

In the two centuries following the time of Leonardo, the radical scrutiny of human anatomy as practiced by Renaissance artists became conventionalized.

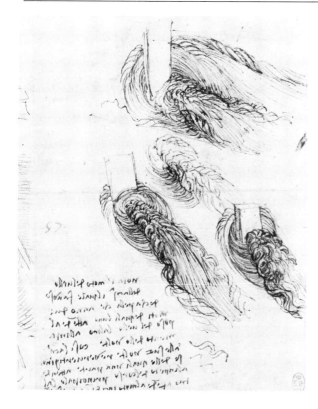

FIGURE 0–2
LEONARDO DA VINCI
Studies of Water
Portion of drawing, pen and ink
The Royal Collection © 1994 Her Majesty Queen Elizabeth II

As an example, let us look at a life drawing (or *academie* as it was called) by the eighteenth-century sculptor and academician, Bouchardon (Fig. 0–4). Note that in this drawing there is a very systematic way for representing the figure in its environment. The artist employs only three categories of marks. A pattern of lines is used to indicate the background; short, scarcely visible strokes are used for the surface of the body. The most varied stroke is reserved for the outside edges of the figure. This conventional use of line was common practice in life drawing of the period. To enhance the presence of the figure, artificial light was

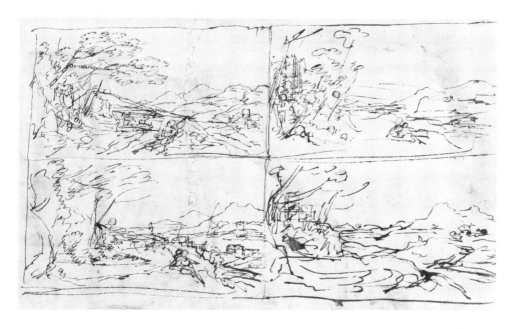

FIGURE 0–3
CLAUDE LORRAIN
Landscape Studies, 1630–1635
Red crayon on white laid paper, 184 × 272 mm (verso of *Wooded View*)
Teylers Museum, Haarlem, The Netherlands

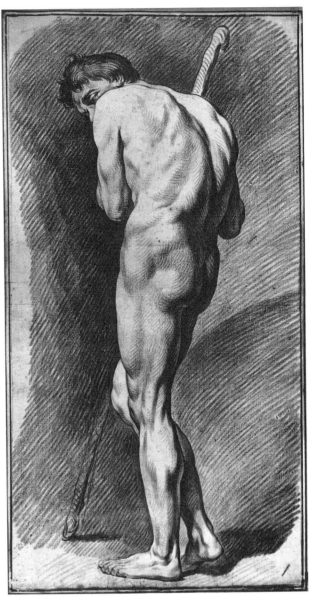

FIGURE 0–4
Edme Bouchardon
Standing Male Nude with Staff
Red crayon on paper, 22⅞″ × 11⅞″
Courtesy, Santa Barbara Museum of Art. Museum Purchase

used, which had the effect of throwing the anatomy into sharp relief while letting the background drop away.

It is instructive to compare the Bouchardon with a work made a generation later (Fig. 0–5). In this drawing, Ingres *does not* dramatically set the figure apart from the background. The same natural light that illuminates the lively features of the sitter also brightens the haze below and is a harbinger of the increased role that nature would play in French art during the rest of the nineteenth century.

How very different is the attitude toward light, form, and space in the self-portrait by Courbet (Fig. 0–6). Here light is not that flattering, all-pervasive entity that it is in the drawing of Ingres. Instead, it is harsh and reveals the forms of the artist's face roughly and imperfectly. The parts of the face obscured by shadow merge with the gloom that envelops the figure. As a realist, Courbet demonstrated that the natural tendency of strong light is not to separate the figure from the background but rather to break up form so that parts of it become indistinguishable from the space around it. By observing the impartiality of natural light, the artist effects a brutish realism. Once again, the investigative

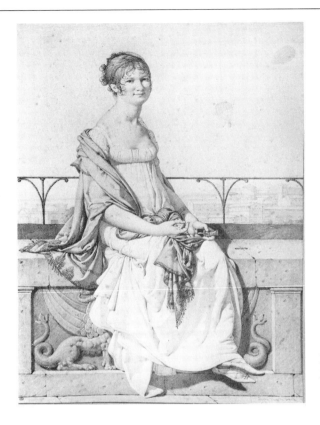

FIGURE 0–5
J.A.D. INGRES
Portrait of Barbara Bansi
Courtesy, The Louvre, Paris (RF31287)

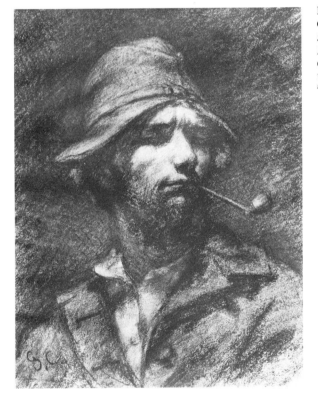

FIGURE 0–6
GUSTAVE COURBET
Self-Portrait (The Man with the Pipe), c. 1849
Charcoal, 11½ × 8¾″
Wadsworth Atheneum, Hartford. Purchased through the gift of James Junius Goodwin

potential of art is fully present, and objective observation is seen as an end in itself.

Later in the century, the Impressionists achieved a directness in their use of media that was unprecedented. In paintings and drawings, they asserted the actuality of their media to recreate the ephemeral aspects of constantly changing moments in the natural world. Look at the drawing by Monet (Fig. 0–7) and compare its inventive use of marks to the more convention-bound approach of Bouchardon (Fig. 0–4). Note how in the Monet, many of the marks achieve a physical presence that recalls our experience of actual objects. One kind of mark stands for the fishermen's rods, another for the twisted cable, and yet another for the wavering reflections of the cable. Also note the absence of outlines in the Monet. The Impressionists often did away with them, reasoning that no such lines may be observed in nature.

Impressionist artists were dedicated to expressing with immediacy their experiences of the natural world. But in contradistinction to earlier artistic traditions, the Impressionists, and many of the modern artists that followed, let the actual stuff of their media stand as a metaphor for the physical reality they described on paper and canvas. In works of this kind, every mark exerts a material presence of its own rather than imitating the surface appearance of natural things. This insistence on the physical nature of the artist's media is just one of the Impressionist traits that began to undermine the long-lived Renaissance tradition of illusionistic realism.

Looking again at the Monet, note that particular attention is paid to the design, or composition, of the drawing. The two boats in effect mirror each other along a diagonal, making us aware of the small space between them. Running counter to these large diagonal shapes is the series of vertical reflections on the water, which function to stabilize the image. These compositional devices make us aware of the play of two-dimensional forces within the rectangle of the picture. The emphasis on two-dimensional organization over the more traditional illusion of deep space marks the general trend toward a flattening of the picture image in the late nineteenth and early twentieth centuries. (Note, too, that a sense of depth is restricted by the elimination of the horizon line.)

The modern artist's emancipation from the illusionistic tradition can be seen as emblematic of a wider-ranging movement toward greater artistic freedom. In the early years of the twentieth century, artists offered increasingly daring interpretations of the visible world, sometimes refashioning appearances beyond easy recognition. Drawing in the later half of the twentieth century, as

FIGURE 0–7
CLAUDE MONET
Two Men Fishing, ca. 1880–1882
Black crayon and scratchwork on paper coated with gesso and incised with fine lines for reproduction by "guillotage," 256 × 344m

Courtesy of The Fogg Art Museum, Harvard University Art Museums. Bequest of Meta and Paul J. Sachs

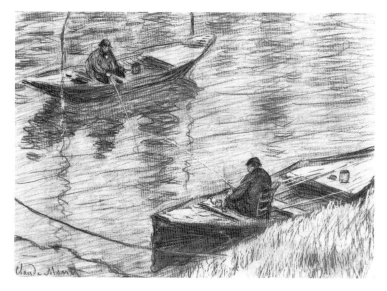

we shall see, has been characterized by a multitude of forms and styles of drawing, some traditional and some radically new, that have resulted from artists' attempts to extend or redefine the nature of the drawing medium.

Extending the Definition of Drawing

Drawing today is firmly established as a medium in its own right. Drawings now have an aesthetic and commercial value that gives them a stature equivalent to that of painting and sculpture. But this has not always been the case.

Renaissance concepts about the role of drawing within the visual arts were deeply influential for a long time. During the Renaissance, skill at drawing was highly valued and was in fact considered the most precious tool at the artist's command. Nevertheless, drawings themselves were not accorded the status of a legitimate art form, but were regarded merely as preparatory studies for painting and sculpture.

For centuries after the Renaissance, drawing had two functions. First, it was the customary means of training young artists. Second, it became a way for more established artists to try out ideas before embarking on their more ambitious work, as we may see by comparing the study and final painting by Tintoretto in Figures 0–8 and 0–9.

Today, drawing continues to fulfill both these functions. It remains the accepted foundation for aspiring artists, and the use of drawing to work out ideas persists unabated. In fact, the preparatory studies, or *working drawings*, that artists make are frequently held in high esteem by the art-viewing public. Let us examine why.

Among all visual-art forms, preparatory drawings put the viewer most in touch with what an artist thinks and feels. This opportunity for an intimate look at the origins of a work has a special attraction for viewers and has given rise to numerous exhibitions of artists' working drawings. Compare, for example,

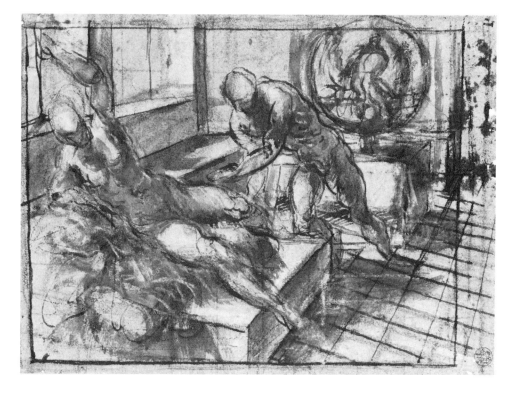

FIGURE 0–8
TINTORETTO
Venus and Vulcan, c. 1550
Pen and brush, black ink and wash, heightened with white on blue paper
Kupferstichkabinett Berlin; Staatliche Museen preussischer Kulturbesitz

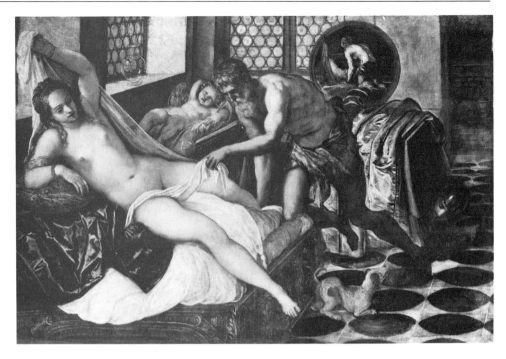

FIGURE 0–9
TINTORETTO
Venus, Vulcan and Mars
Oil on canvas
Courtesy, Alte Pinakothek, Munich

the drawing by Barry Le Va (Fig. 0–10) with one of his works as it appeared installed in a gallery (Fig. 0–11). The representation of space in the graphic work is surprisingly different from the effect of the installation. The drawing has a sense of interior, psychological space and as such lends an unexpected romantic slant to what otherwise appears to be a matter-of-fact assembly of objects on a floor.

In addition to the popularity of working drawings, a finished drawing by an artist is today regarded as a complete and independent art form. Accompanying this loosening of the Renaissance concept of drawing has been a profusion of interpretations as to what defines drawing in the twentieth century.

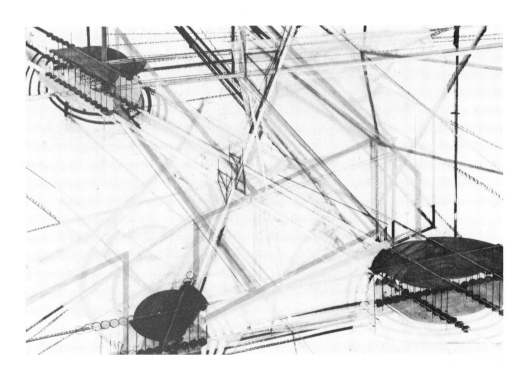

FIGURE 0–10
BARRY LE VA
Drawing Interruptions: Blocked Structures #4
Mixed media, 48 × 72"
Courtesy, Sonnabend Gallery

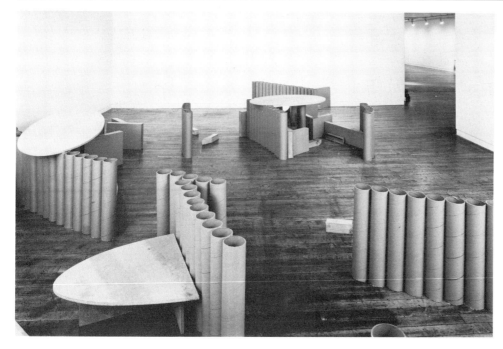

FIGURE 0–11
BARRY LE VA
Twisted Chain (of Events): Sketching a Possibility
Particle board, homosote, wood, cardboard tubing. Dimensions variable. Installation at Sonnabend Gallery, New York City, 1981
Courtesy, Sonnabend Gallery

Particularly today, in an age marked by aesthetic "pluralism," the diversity of drawing styles seems unlimited (Figs. 0–12 and 0–13).*

In the midst of this unprecedented wealth of drawing styles, two tendencies prevail in contemporary drawing. On the one hand, the Renaissance concerns for representing forms in space continue to thrive (Fig. 0–14). Simultaneously, a more modern bias toward the actuality of media has emerged as a viable alternative (Fig. 0–15). Less predictable is the genre of works that challenge conventional beliefs about drawing, such as Walter De Maria's *Mile-Long Drawing* (Fig. 0–16), which consists of two parallel mile-long lines of chalk drawn twelve feet apart in the Mohave Desert.

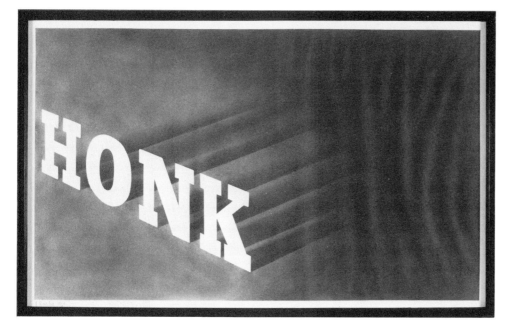

FIGURE 0–12
ED RUSCHA
Honk, 1964
Gunpowder on paper, 14½ × 23"
© Ed Ruscha, courtesy Leo Castelli Gallery, New York City. Photo: Dorothy Zeidman

*For further examples and a discussion of contemporary drawing styles, see Chapter 13.

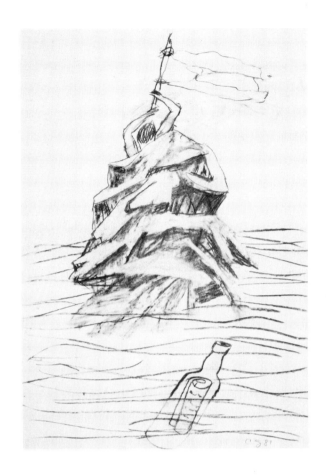

FIGURE 0–13
CHARLES GARABEDIAN
Farewell to H.C. Westerman, 1982
Charcoal on paper, 25 × 15⅛″
Courtesy, L.A. Louver Gallery, Venice, CA.

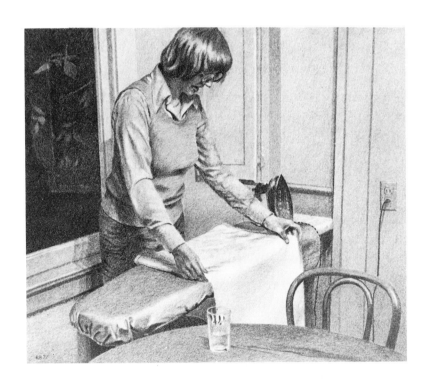

FIGURE 0–14
ROBERT BECHTLE
Nancy Ironing, 1977
Pencil on paper, 12⅞ × 15″
San Diego Museum of Art. Museum Purchase

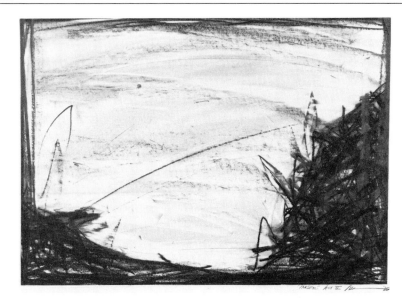

FIGURE 0–15
ROBERT WILSON
Parsifal, Act II, 1985
Graphite on paper, 22¼ × 30″
Courtesy, Paula Cooper Gallery, New York. Photo: James Dee (RW458)

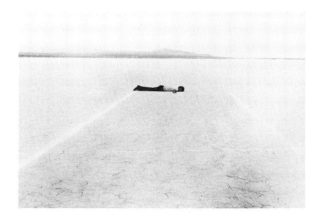

FIGURE 0–16
WALTER DE MARIA
Mile Long Drawing, 1968
Two parallel chalk lines on desert dry lake. One mile long, lines 12 feet apart and 3 inches wide, artist lying on the desert floor
Copyright © 1969 Walter De Maria

The Student and Master Drawings

Presumably, we all look at master drawings for enjoyment. That enjoyment might include anything from the simple wonder that an artist could achieve so realistic a likeness of a particular thing to the more sophisticated appreciation of an inventive use of composition and imagery.

To increase your skills as an artist, you will also be studying master drawings to find out what gives them so much expressive power. While seeking this information, you will become more familiar with the basic principles of drawing and gain a sense of how and why those principles have been manipulated to meet specific ends. Moreover, spending time with drawings from various phases of art history will help you to see the relationship between past and present drawings. You also will find countless instances when new forms of expression coexisted with older drawing practices. Indeed, even the most startlingly reshaped concepts have never invalidated drawing in traditional terms.

The Issue of Talent

When you look at works by esteemed masters, you may find yourself in awe of their virtuosity. Your admiration for these works may lead you to wonder if you have sufficient talent to undertake a serious study of drawing. This question is frequently expressed by beginners and usually results from a misunderstanding about what it takes to learn to draw.

Learning to draw is an acquired skill. The fundamentals of drawing form a body of knowledge well within the reach of the college student. This body of knowledge is imparted through concepts that are often easy to grasp but require repeated application to fully comprehend. Through consistent application, you will obtain a set of measurable skills that you will use as if by second nature.

Learning to draw is also based on desire. Talent, viewed in this way, is more a matter of inclination than anything else. Someone with the ambition to draw well can learn to excel. But the person possessing sound basic skills and a personal need to express ideas visually will be equipped to do work of a more serious and personal nature.

The Public Side of Drawing

The bulk of your learning will take place while you are drawing. In this respect, learning to draw is like learning to ride a bicycle. The theory of what to do can only be imperfectly explained. Actual understanding must be gained from the experience of getting onto the bike or applying marks to paper.

At first, many students are uncomfortable when drawing in the presence of others. After all, drawing is an intimate activity, and what you make is always to some extent autobiographical. Ironically then, the most common setting for learning to draw is the *public arena* of the classroom.

If you are self-conscious about revealing your lack of skill to your classmates, remember a couple of things. First, with the exception of one or two students who may have had more experience, you and your classmates are pretty much in the same boat; you are all beginners. Second, learning to draw is a process of accumulating knowledge and experience. Focusing on the concept presented in a particular exercise or assignment will relieve you of the obligation to make a drawing that looks "really real."

Fortunately, your participation in the drawing process will ease all such anxieties. You will find that the challenge of drawing requires such concentration that you will become oblivious to the presence of other people in the classroom. And attaining this level of concentration will make it easier for you to draw, unhampered by the insecurities of working in a relatively public setting. Later, when you notice the very rapid development of your drawing skills, you will probably appreciate the energy and support of the classroom situation.

Seeing Versus Naming

Achieving feelings of privacy while drawing in a crowded classroom is the result in large part of switching your thinking from the usual verbal mode to a nonverbal mode. Whenever you concentrate on a nonverbal task, such as drawing, you will be inclined to block out verbal distractions, such as a conversation taking place in the same room. This nonverbal state of mind has another, and even more important, role to play in your drawing practice, however, since it encourages you to focus on the *visual* character of your subjects rather than relating to your subjects only on the basis of their *names* and *uses* in the everyday world.

Since our main form of daily communication is verbal, or symbolic, we

tend to deal with the world on the basis of objects we can name: telephone, car, dog biscuits. In drawing, this situation is almost reversed since we attribute meaning to our subjects more fully on a visual basis. Correspondingly, their worldly associations are de-emphasized—or at least, they should be.*

But beginners often feel more secure if a subject is loaded with meaning, in the verbal sense, or has an abundance of nameable parts. The more nameable parts, they feel, the more likely the drawing will succeed as a recognizable image. For example, let us say a beginner were asked to draw a still life containing an old boot and some draped cloth. Attracted to the boot because of its more specific cultural identity, the beginner will record individual details much as an itemized grocery list is compiled: two broken laces, twelve hooks and eyelets, one stiffened tongue, and so on. Less scrutiny will be given to the general form and structure of the boot, and far less information given about the draped fabric. This tendency to draw each unit of the subject separately arises from the habit of naming and usually results in a drawing that looks fragmented and superficial in its treatment of the subject matter.

On the other hand, beginners who emphasize a subject's visual character are able to see its wholeness and the way each part is integral to that whole. In a visually oriented state of mind, the beginner might, for instance, decide to exaggerate the robust volume of the boot as opposed to the linear twisting of the piece of cloth (Fig. 0–17).

So, seeing means to stress a *visual* interpretation of the subject to be drawn. Your ability to overcome the tendency to name what you see (three pencils on a tabletop) and depend instead on visual insight (three diagonals on a flat surface) may take some practice to develop. But a visual approach yields far more satisfactory drawings than one that accentuates a subject's everyday identity and symbolic connotations.

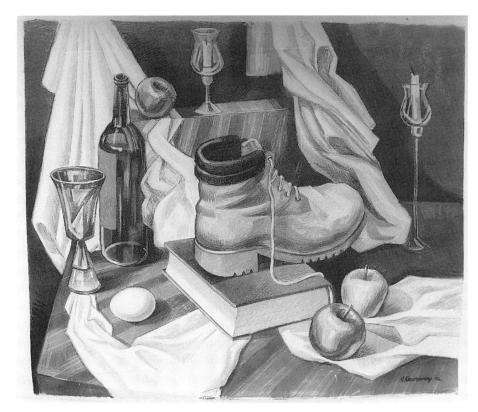

FIGURE 0–17
Mikal Korostyshevsky, Pratt Institute
Student drawing: still life with visual character of subject emphasized
4 × 5'
Courtesy, the artist

*This is not to deny the cultural content in subject matter. At this stage, however, the *visual* content of what we draw cannot be overemphasized. For further discussion of content that is culturally based, see Chapters 8 and 13.

Drawing as a Process

Making a drawing is like participating firsthand in the development of an organism. This development is a natural process, from the drawing's genesis to its completion.

In this regard, consider that making a drawing is a process of *forming* something; it is a way for the artist to materialize responses to things that are real or imagined. Although process is integral to the realization of any artwork, its visual traces are usually obliterated by the time a work is completed. However, we are afforded insights into the developmental process of a work of art when different states are preserved, as in Figures 0–18 and 0–19, two successive impressions of the Rembrandt print *Christ Presented to the People* that show, among other changes, the crowd in front of the podium replaced by two rusticated arches. Serial images may also provide evidence of an artist's process, as in Figures 0–20 through 0–22, which showcase Picasso's mastery of form improvisation.

So, like any organic thing, a drawing must be permitted to grow and change. And the process of making a drawing is most successful when the artist is alert and responsive to this potential for change as the drawing is being formed.

In practical terms, this means that your drawing method should not be limited to only up-close, detailed work. Working up close does have its benefits, since you can concentrate on detail and enjoy the sensuality of applying drawing media to paper. But working at arm's length or less may make it difficult to see how all the parts of a drawing fit together.

To fully gather in the whole effect of a drawing, it is necessary to "shift your perception" away from the representation of subject matter detail. One means for doing this is to physically move back—several paces from your drawing—to gain an overview of its progress. Another way is to turn the drawing upside down or view it in a mirror to reverse the image. These simple strategies

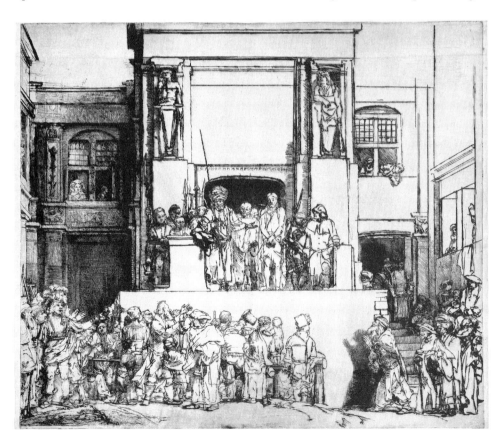

FIGURE 0–18
REMBRANDT
Christ Presented to the People
Etching, first state
*The Metropolitan Museum of Art, Gift of Felix M.
Warburg and his family, 1941 (41.1.34)*

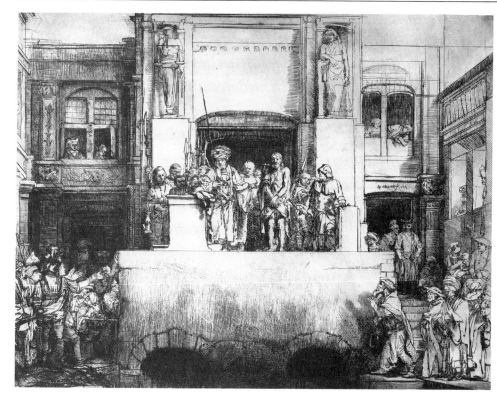

FIGURE 0–19
REMBRANDT
Christ Presented to the People
Etching, last state
The Metropolitan Museum of Art, Gift of Felix M. Warburg and his family, 1941

FIGURE 0–20
PABLO PICASSO
Bull, State III, December 18, 1945
Lithograph, printed in black, composition, 12⅜ × 18¹⁵⁄₁₆″
The Museum of Modern Art, New York. Mrs. Gilbert W. Chapman Fund. © 1996 Artists Rights Society (ARS), New York/SPADEM, Paris

will help you diagnose problems that might otherwise escape your notice. They also place you in a better position to see, and take advantage of, new possibilities emerging in a drawing.

Regularly taking stock of your work has the added value of helping you appreciate a drawing's identity as an independent, created object. You will become more accustomed to the fact that all drawings, even those filled with convincing descriptions of things, have their own logic quite apart from those properties of illusion or imitation of the natural world.*

*For more on the drawing process, see "Troubleshooting Your Drawings" in Chapter 9.

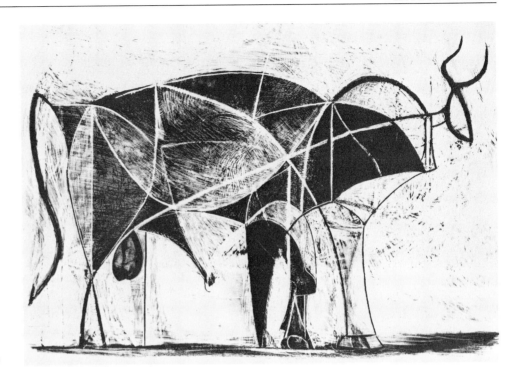

FIGURE 0–21
PABLO PICASSO
Bull, State VI, December 26, 1945
Lithograph, printed in black,
composition, 12 × 17⁷⁄₁₆″
The Museum of Modern Art, New York.
Mrs. Gilbert W. Chapman Fund. © 1996 Artists
Rights Society (ARS), New York/SPADEM, Paris

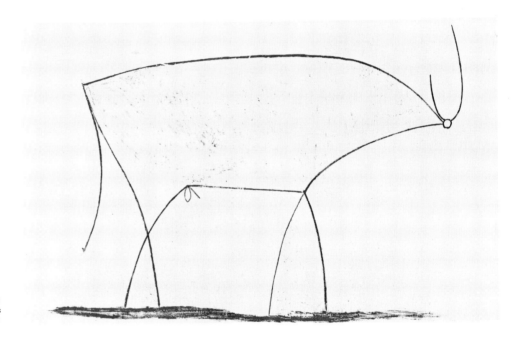

FIGURE 0–22
PABLO PICASSO
Bull, State XI, January 17, 1946
Lithograph, printed in black,
composition, 11³⁄₈ × 16¹⁄₈″
The Museum of Modern Art, New York. Acquired
through the Lillie P. Bliss Bequest. © 1996 Artists
Rights Society (ARS), New York/SPADEM, Paris

The Merits of a Sketchbook

A sketchbook is a handy means for accelerating your progress in drawing. Bound sketchbooks may be purchased at any art supply store, although some artists prefer to bind their own so that they can insert papers of different weights, surfaces, and colors. Media of all kinds are suitable for a sketchbook; indeed, part of the pleasure of keeping a sketchbook is experimenting with media not commonly used in the classroom, such as ballpoint pen, felt-tip markers, or collages made with available materials like leaves and matchbooks.

For many artists, the act of filling a book has almost magical significance, as we sense when looking at the Wolffli sketchbook page (Fig. 0–23), which is

FIGURE 0–23
ADOLF WOLFFLI
Bschutti, Pümpser-Polka
Pencil, 14½ × 28¼"
Courtesy, the Phyllis Kind Gallery, Chicago and New York. Photo: Wm. H. Bengtson.

clearly obsessive in character. For others, keeping a sketchbook is simply a practical alternative to recording ideas on random scraps of paper, which tend to get lost or discarded.

Often considered an artist's personal diary, the sketchbook is an excellent context for recording a whole range of ideas, verbal as well as visual. There are times when you are flooded with ideas, some of them related to a particular endeavor, and others coming seemingly from out of the blue and distracting you from your major purpose. In your sketchbook you are free to jot down all these ideas without the pressure of making them relate to each other (Fig. 0–24); at least you will know where to find this information at a later date should you need it.

There will be times when you will use your sketchbook in a more directed fashion. You might use your sketchbook as a vehicle for sharpening your perceptual skills, filling it with literally hundreds of drawings of things encountered in daily life. In addition to the benefits bestowed by such constant application

FIGURE 0–24
JAMES ENSOR
Head in Profile and Other Studies,
n.d.
Black crayon
©1994 Estate of James Ensor/Licensed by VAGA, New York. Photograph © 1994, The Art Institute of Chicago (1955.1010 recto), Print and Drawing Fund. All Rights Reserved.

to drawing, leafing through an entire book of sketches will assure you of your growing skill.

The itinerant artist of the past used the sketchbook to record natural phenomena in distant lands (Fig. 0–25), a practice that is continued today by the contemporary artist who uses the sketchbook to extend the processes of search and discovery beyond the confines of the studio (Fig. 0–26).

Make a habit of carrying a sketchbook with you on your daily rounds, and pull it out when anything in the visual world about you catches your interest. Sketching is less instantaneous than photography, but it is a much better way to record the visual ideas that form your unique vision of the world. In the Cézanne sketch, Figure 0–27, the artist's visual idea consists of the contrast between the complicated shapes bound by gnarled tree branches and the quiet horizontals and verticals elsewhere in the landscape. Can you imagine how

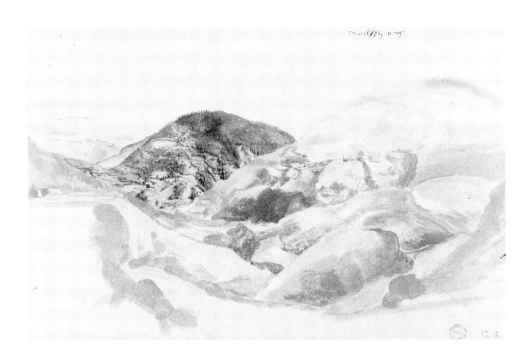

FIGURE 0–25
ALBRECHT DÜRER
Alpine Landscape
210 × 312 mm
Ashmolean Museum, Oxford

FIGURE 0–26
KEN O'CONNELL
Sketchbook page: *Eastern Oregon*
Charcoal, 24 × 30"
Courtesy, the artist

difficult it would have been to record this visual fact in a photograph without also recording a great deal of extraneous information?

The sketchbook also has its uses in a studio context. It is an appropriate place to try out ideas for more-prolonged works. You might also find the sketchbook a handy format in which to make analyses of masterworks (Fig. 0–28), where the information you glean from proven masters may be seen in the context of your own emerging artistic identity.

FIGURE 0–28
DENNIS CHENG-YEN TAN, Indiana State University
Student sketchbook drawing: analysis of masterwork
Courtesy, the artist

The Three-Dimensional Space of a Drawing

When was the last time you dragged your finger across the condensation on a car window? Or had the urge to make your mark on the surface of a building, an underpass, or a freshly leveled sidewalk?

As kids, most of us loved to make marks on available surfaces. As adults, some of us still do, using art as an outlet for these energies. If improperly directed, however, this drive may lead to the form of vandalism known as graffiti. Curiously, in the 1980s, radical street artists were adopted by the established art market, with the result that "spray-can graffiti art" became one of the recognized styles of that decade (Fig. 1–1).

This chapter invites *you* to explore mark making anew and with a refreshed purpose. You will observe how the marks you make suggest space in a drawing; and you will learn the organizational principles behind this phenomenon, principles that will be fundamental to your growth in descriptive drawing.

FIGURE 1–1
A-ONE
Ambush in the I
Spray paint on linen,
63¾ × 115½"
Courtesy, Sidney Janis Gallery, New York

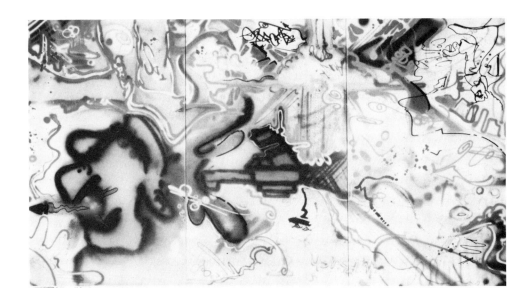

Making Your Mark

The word *mark* as we have been using it has three major ramifications in regard to artistic expression:

1. Its primary meaning is a trace or blemish left on a surface. As such, it may be a scratch, dent, hole, stain, or deposit. In shape it may range from that of the meaningless smudge, spot, tick, or line to the more meaning-laden forms of punctuation marks, letters of the alphabet, or corporation logos.

2. A mark also records the presence of the agent that made the mark. The graffiti artist who sprays a cryptic sign or tag on a subway train is in effect indicating a territorial claim to a piece of corporate property. Likewise, a manufacturer stamps a trademark on a product not only to indicate its origin but also to stake a claim on the public's consciousness.

3. Finally, a mark is often used as an indicator of spatial quantities: Spatial distance may be indicated by road markers; area by boundary markers; and volume by calibrations such as those found on a measuring cup.

A mark in a drawing may take into account all three meanings. First of all, artists are generally concerned about the quality and range of marks they make on the surface of their paper. Second, a mark is a record of the action taken by the artist who made it. Third, the artist, as one who is interested also in making visual representations of nature, uses marks to measure relative spatial quantities in the world (Fig. 1–2).

The Mark Versus the Line

The conception that most people have of a drawing is that of a picture made with line. The use of flowing line is particularly suited to the portrayal of subjects

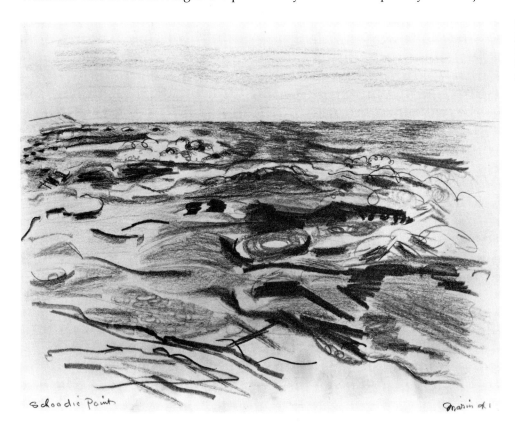

FIGURE 1–2
JOHN MARIN
Schoodic Point, 1941
Crayon on paper, 10½ × 13½"
Courtesy of Kennedy Galleries, Inc., New York

of great complexity, but a line is only one kind of mark, and for many artists, a much larger repertoire of marks is in order. Many other kinds of marks are the result of short, direct gestures. They are, therefore, relatively abrupt in appearance. Such marks are seldom used for full-blown representation; instead, they most often function as spatial indicators in a drawing, as in their verbal counterpart, "mark that spot." Look, for example, at the Jasper Johns drawing *Flag* (Fig. 1–3). Although apparently about a specific object, the real subject of the drawing is the profusion of marks that seem to move back and forth between the surface of the drawing and the sketchy image of the flag.

Figure–Ground

As soon as you put a mark on a surface, you set up a figure–ground relationship. To clarify this, place a blank sheet of drawing paper in front of you. Consider it carefully. It has a particular tone (in most cases white or off-white), a particular shape (usually rectangular), and a particular size and texture. This clean, flat surface is the *ground* of your drawing.

Make a single mark on this ground, and you have created a thing of visual interest, or what we call a *figure*. A figure in a drawing may represent a recognizable object or it may be a nonrepresentational shape, but in either case, it is something that may be readily distinguished from its visual context. The term *figure*, as used here, is not limited to the human body. A figure may be, for instance, the representation of a tree, an invented symbol (Fig. 1–4), or a letter of the alphabet.

This first mark (or figure) you make heightens your awareness of the area of your ground by making the vertical and horizontal dimension of the drawing paper more apparent (Fig. 1–5). It is as if a magnetic attraction exists between the mark and the edges of your paper.

Let us return to our example of a blank sheet of paper. Looking at this paper with a different intent, you can probably conceive within its emptiness the existence of an amorphous and relatively infinite space. Imagining this space will take an act of will on your part. Experiencing it will be somewhat akin to staring at a patch of clear blue sky—there is no beginning, middle, or end.

FIGURE 1–3
Jasper Johns
Flag, 1958
Pencil and graphite wash on paper,
7½ × 10⅜"

Private collection. © 1994 Jasper Johns/Licensed by VAGA, New York.

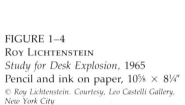

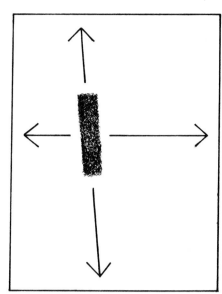

FIGURE 1–4
ROY LICHTENSTEIN
Study for Desk Explosion, 1965
Pencil and ink on paper, 10⅝ × 8¼″
© *Roy Lichtenstein. Courtesy, Leo Castelli Gallery,
New York City*

FIGURE 1–5

One mark dramatically alters this perception of space (Fig. 1–6). It is now as if a solitary bird has appeared in that blue sky, giving you a single point of spatial reference. This first mark on a page changes the formless character of the space into a more defined and tangible volume. In a sense, the mark creates the space in which it exists.

A second mark of a lighter or darker tone than the first increases the illusion of a specific spatial volume (Fig. 1–7). Appearing to be at a measured distance from the first, it provides a second point of reference in the space of the drawing. Each mark thereafter adds another station to the space, thereby increasing its structural definition.

So, the first two marks on your paper may be seen as figures against a ground, in which case they make the physical presence of the ground easier to grasp. They may also be seen as two spatial points in your drawing, thus opening up the ground illusionistically.

Artists frequently play one mark against another to create spatial tension.

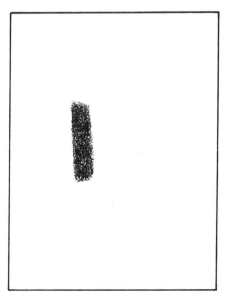

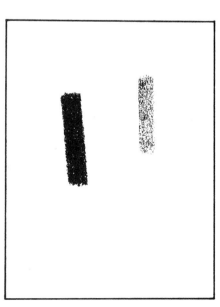

FIGURE 1–6 (left)

FIGURE 1–7 (right)

FIGURE 1–8
MICHAEL SINGER
Ritual Balance Study, 1974
Mixed media on paper (collage,
charcoal, chalk), 43⅝ × 83½"

Solomon R. Guggenheim Museum, New York.
Photograph by Robert E. Mates, © The Solomon R.
Guggenheim Foundation, New York (76.2216)

In this regard, let us look at the Michael Singer drawing pictured in Figure 1–8. You will note that, in general, the marks are different in some way from one another. It is that difference, what we might call the distinguishing character of a mark, that influences how we read a mark's position in space. And by extension, it is the range of differences in the accumulated marks that expresses the kind of space in total that is portrayed.

The Picture Plane

The space represented in a drawing is a semi-enclosed volume. Except for the potential of unlimited depth, the illusion of three-dimensional space in your drawing is bounded on all four sides by the edges of your paper and in front by the transparent "wall" we call the *picture plane*.

Common usage has given the term *picture plane* two meanings. First, it refers to the actual flat surface, or opaque plane, on which you draw. Second, it is often regarded as an imaginary, transparent "window on nature" that represents the format of your drawing mentally superimposed over the subject you wish to draw (Fig. 1–9).

The act of drawing links the two meanings of the term *picture plane*. When drawing, you look through the imaginary picture plane to gather information about the space and form of your subject, and you transfer this information to the actual picture plane of your drawing surface. As a result of this process, your drawing paper is virtually equivalent to the window on nature that you have imagined.

Of course, the imaginary picture plane does not actually exist except as an abstract concept to assist the artist in depicting things as they appear. Looking through this artificial plane can be compared to sizing up a subject through the viewfinder of a camera: you are framing, or selecting that portion of the subject you wish to draw from the visual field before you. In so doing, you have taken the first step in organizing the three-dimensional space of your drawing.

This concept was developed (actually rediscovered) in the early Renaissance, at which time artists were becoming increasingly involved in duplicating natural appearances. Not only did they develop the idea of the picture plane as

FIGURE 1–9

FIGURE 1–10
ALBRECHT DÜRER
The Artists' Treatise on Geometry,
1525
Woodcut
*The Metropolitan Museum of Art, Harris Brisbane
Dick Fund, 1941 (41.48.3)*

a mental device, but they also experimented with mechanical means for transferring points located on actual objects in space onto the flat surface of the picture plane (Fig. 1–10).

The Picture Plane Begins Your Space

To reinforce your understanding of the concept of the picture plane, we offer the following scenario. Imagine that you are looking through a picture window at a gorgeous meadow backed by rolling hills. All of a sudden, a large and colorful insect lands with a smack on the pane of glass. Made aware of the window's presence, you would no longer be looking through the glass, but *at* it. And the thought may even have struck you that this window is the beginning of the space opening up before you.

The picture plane in a drawing may be thought of in the same way. In fact, if we interpret the atmosphere of natural space as a series of receding planes, we are ready to regard our "transparent" picture surface as the first plane in the series. With this in mind, let us look at two illustrations.

The female figure in Wayne Thiebaud's painting (Fig. 1–11) sits securely in a shallow space. Yet we cannot help but notice the illusion that her big toes are pressed against the back of the picture plane. In Figure 1–12, the inner

FIGURE 1–11
WAYNE THIEBAUD
Girl with Ice Cream Cone, 1963
Oil on canvas, 48 × 36″
Collection of Mrs. Edwin A. Bergman

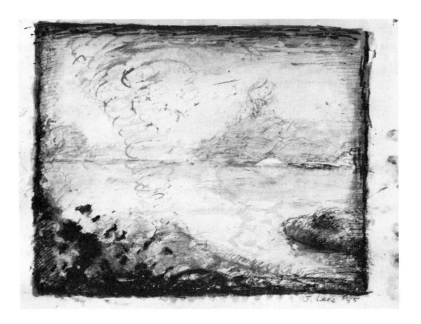

FIGURE 1–12
JOHN LEES
Study for a Landscape, 1985
Pencil, ink, gouache on paper,
12 × 15″
Courtesy, Hirschl & Adler Modern, New York

rectangle has a slablike appearance. This effect gives the picture plane a more immediate physical presence (it seems more real than the actual paper margins) and makes it clearly the initial contact point through which an atmospheric vista unfolds.

In each case, then, the primary position of the picture plane in the spatial illusion has been declared, whether by pressure against its surface, or by heightening its physical palpability.

Exercise 1A *These exercises will enable you to transform your sheet of paper into an imaginary space of unlimited depth. You will need the following drawing media: vine and compressed charcoal, conté crayon, graphite stick, kneaded and artgum erasers.*

Drawing 1. *To create your spatial illusion, use a variety of marks. These marks should not be descriptive of objects. Instead, each mark should simply indicate a distinct physical point in the illusion of space you are making. Do your best to vary your marks in terms of size, tone (lightness and darkness), and clarity to create the illusion that they are set at different depths in a spatial field (Fig. 1–13).*

Experiment freely with your media. Use your fingers, chamois, or side of your hand to blur some of the marks. Maneuver about so marks are distributed at various places across and up and down your paper. Apply some marks with heavy pressure using the motion of your entire arm; arrive at others by merely flicking your wrist. Make some fast, some slow. And do not forget to explore the mark-making possibilities of your erasers. By erasing into dark areas you can make white lines and marks that seem to glow from a brilliant inner light. Also, try smearing heavy deposits of media with your erasers, or scumbling over them (this means to rub lightly, or "feather" an area). Both of these techniques will soften dark marks, making them appear more hazy, or atmospheric (Fig. 1–14).

Drawing 2. *Your objective here is to make a more finished-looking drawing. Begin by once again using marks to represent a space. But as your drawing develops, consolidate your marks until more definite areas of light and dark appear. The Olivant drawing (Fig. 1–15) is a fine example of how this mark-making approach can be extended to yield a finished work of great textural and spatial complexity.*

The mark-making approach to drawing can also be easily adapted to an improvisatory workshop situation as in the very large mixed-media drawing illustrated in Figure 1–16.

Fundamental Methods for Creating Three-Dimensional Space

What you will have observed thus far is that although any collection of marks on a page will imply a space of some sort, strong differences in the character of marks intensify a drawing's spatial impact. The next step is to support this observation with basic information about how you can more decisively create and control an illusion of three-dimensional space in your drawings.

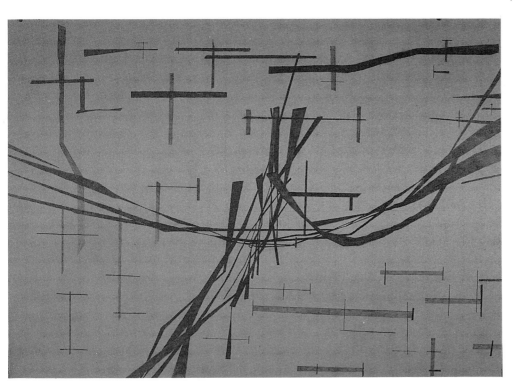

FIGURE 1–13
Dawn Morgan, University of Wisconsin at Whitewater
Student drawing: "200 straight lines" of varied tone used to represent space
Courtesy, the artist

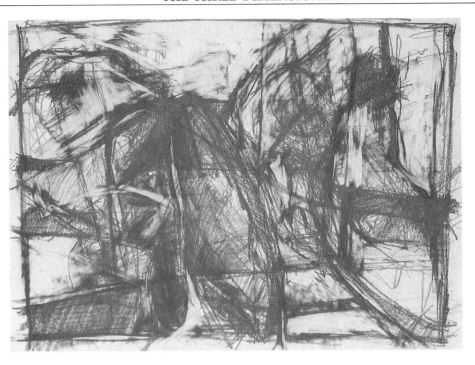

FIGURE 1–14
SEAN P. GALLAGHER
Towards the Immaterial
Courtesy, the artist

Most of the methods we describe below for creating space were used by artists before the advent of linear perspective in the fifteenth century. Although these devices were eventually united with linear perspective, they remain viable outside the strictures of that highly rationalized system.*

RELATIVE POSITION

In a spatial illusion, things located on the lowermost portion of the picture plane generally appear closest to the viewer. Conversely, the higher something is placed on the picture plane, the farther away it appears. Note, for instance, that the figures of Christ and the two Old Testament prophets in the upper section of Figure 1–17 are read as farther back in space by virtue of their position on the picture plane relative to the three kneeling Apostles below. A similar phenomenon occurs in the Thiebaud drawing (Fig. 1–18), in which the gradual upward disposition of the pastels suggests increasing amounts of depth.

DIAGONALS TO CREATE DEPTH

The diagonal is a simple but effective means for creating the illusion of depth in a picture. Its effect is, in part, derived from the fact that similar objects receding diagonally into space appear to diminish in size. (See Figure 1–19.) But to best understand the diagonal's power, we must compare it with its directional counterparts in two-dimensional art, the vertical and the horizontal.

The vertical mark echoes our vertical condition as human beings, so we most readily identify with it (Fig. 1–20). A related issue is the somewhat confrontational effect of a vertical mark: It may function as an obstacle as well as a marker in our spatial field.

The horizontal mark opposes our orientation and thereby gives refreshed emphasis to our verticality. The thrill we experience before a sweeping landscape or ocean vista is due in part to the horizontality of its lines and planes. The horizontal line often elicits a feeling of calm associated with an uninterrupted flow of space.

*A full discussion of the rules of linear perspective appears in Chapter 5.

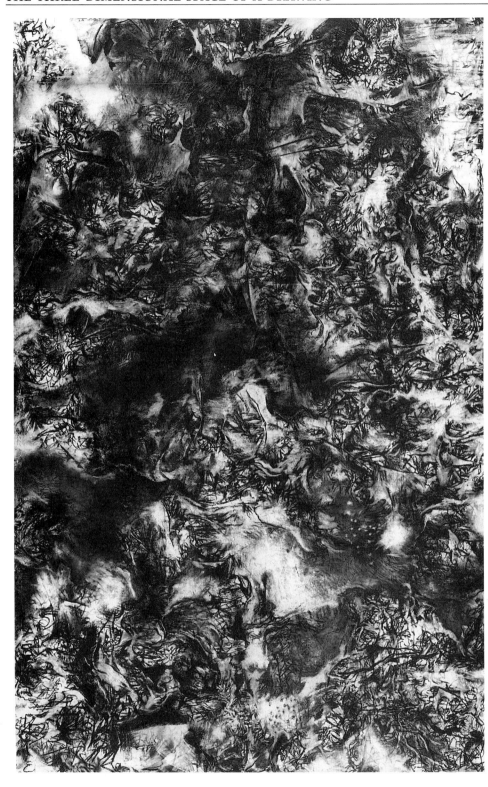

FIGURE 1–15
DAVID OLIVANT
Untitled, No. 7, 1987
Compressed charcoal on paper,
73 × 45"
Courtesy, Stephen Solovy Fine Art

It is important to realize that vertical and horizontal marks, aside from their direct relation to our human posture, also repeat the vertical and horizontal axes of the paper on which we draw (Fig. 1–21). By virtue of this harmony, vertical and horizontal marks lend drawings a feeling of structural stability. We may validly sense, then, a relationship between our vertical condition, the rectangular or square orientation of our drawing paper, and the vertical and horizontal marks we make.

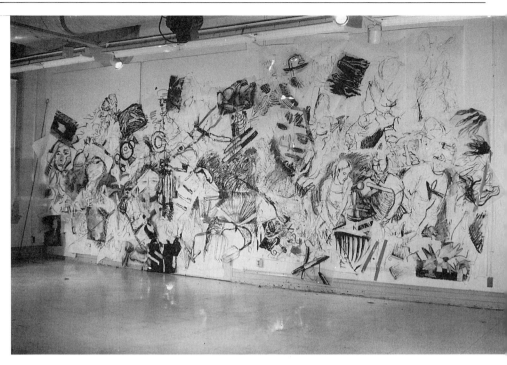

FIGURE 1–16
SUSAN MESSER workshop, Indiana
State University
Collaborative student drawing
Mixed media on paper and acetate
Courtesy, Susan Messer

FIGURE 1–17
DUCCIO
Transfiguration
Reproduced courtesy of the Trustees, The National Gallery, London

In contrast, the diagonal mark is more dramatic and suggestive of action. It is antagonistic to the stability of our bodily orientation and the orientation (horizontal and vertical) of our drawing surface. Lacking an axial equivalent, the diagonal mark creates tension as it transports us with great immediacy into an illusion of space (Fig. 1–22).

OVERLAPPING

Overlapping occurs when one object obscures part of a second object. Before the invention of linear perspective, overlapping was a very common and effective strategy for organizing space in art, as may be seen in Figure 1–23.

The phenomenon of figure–ground is made more complex by overlapping.

FIGURE 1–18
WAYNE THIEBAUD
Pastels, 1972
Pastel, 22⅛ × 30"
The Saint Louis Art Museum. Purchase: the Eliza McMillan Fund

FIGURE 1–19
EDOUARD MANET
La Rue Mosnier, c. 1878
Brush and black ink, and graphite,
on lightweight tan wove paper,
27.9 × 44.2 cm
Given by Alice H. Patterson, in memory of Tiffany Blake. Photograph courtesy of The Art Institute of Chicago (1945.15)

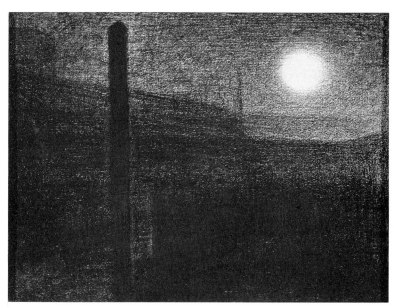

FIGURE 1–20
GEORGES SEURAT
Usines sous la lune
Conté crayon, 9 × 12"
The Metropolitan Museum of Art, gift of Alexander and Gregoire Tarnopol, 1976 (1976.243)

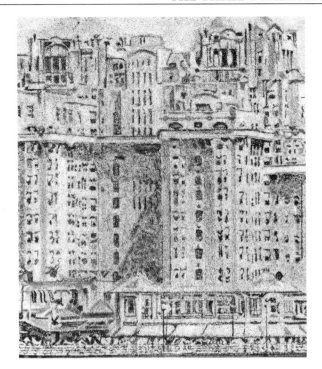

FIGURE 1–21
RICHARD ARTSCHWAGER
Destruction I, 1972
Acrylic on Celotex, 36 × 30″
*Courtesy of the Mary Boone Gallery, New York.
Photo: Rudolph Burckhardt. © 1996 Artists Rights
Society (ARS), New York*

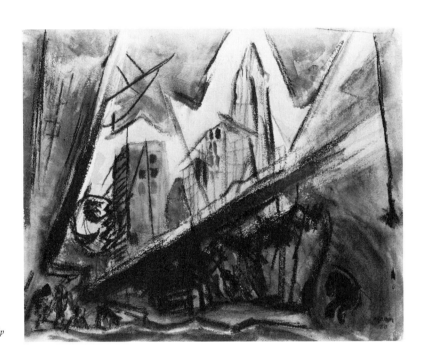

FIGURE 1–22
JOHN MARIN
Lower Manhattan, 1920
Watercolor, 21⅞ × 26¾″
*The Museum of Modern Art, New York. The Philip
L. Goodwin Collection*

When forms are overlapped, the relative nature of figure to ground becomes evident. In Charles Sheeler's *Of Domestic Utility* (Fig. 1–24), for instance, the forms moving sequentially back into space may be seen to alternate their roles as either figure or ground. The circular pan, sandwiched between two logs, serves as a ground for both the pitcher and the log that are foremost in our field of vision. In its turn as figure, the pan is seen against a variable ground that includes the distant log plus floor and wall planes. Even the body of the pitcher may be seen as a ground, for against it we observe the form of the handle. This type of progression, where figure and ground are relative designations, is often referred to as *figure–ground stacking*.

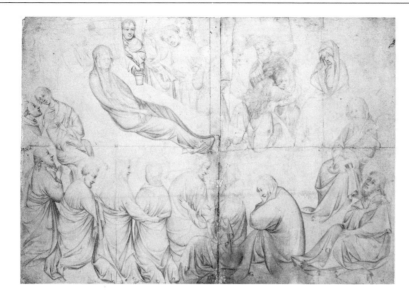

FIGURE 1–23
ANONYMOUS NETHERLANDISH
The Death of the Virgin, c. 1390
Silverpoint on blue-green prepared
paper, 11½ × 15¾"
*© 1994 National Gallery of Art, Washington, DC,
Rosenwald Collection*

FIGURE 1–24
CHARLES SHEELER
Of Domestic Utility, 1933
Conté crayon, 25 × 19⅜"
*The Museum of Modern Art, New York.
Gift of Abby Aldrich Rockefeller*

ATMOSPHERIC PERSPECTIVE

Atmospheric perspective (also called aerial perspective) has been employed by artists for a long time (the Chinese had mastered the technique by the tenth century). It is based on what any of us may observe by looking out the window: objects close at hand are crisply defined; those at a greater distance lose their definition appreciably.

Technically, it is the moisture and particles of dust in the air that obscure our vision of distant things. The greater the amount of air between us and the forms we observe, the less clearly are we able to perceive them. So, in general, atmospheric perspective is most apparent when we are confronted with deep space (Fig. 1–25) or when the atmosphere is made more dense by mist or fog (Fig. 1–26).

To be more specific, the effects of atmospheric perspective can be achieved in a drawing by paying attention to these two principles:

1. The clarity of forms diminishes as they recede into the distance. Surface detail and texture are less apparent; with very distant forms, detail and texture may disappear altogether.

2. When objects are viewed in deep space, the contrast between light and dark tonalities is reduced. Medium and dark tones often become lighter and may even blend into a uniform light gray.

Sometimes this second principle misleads students into believing that only forms close to the picture plane should be drawn with the darkest tones. This is incorrect, since there are occasions in nature when the perceived tone of a more distant form will approach, equal, or even exceed the darkness of forms that are nearby. In this case, remember that it is the tonal contrast of a form (relative to its context) in comparison with other areas of a drawing that helps determine spatial position.

ORGANIZING A DEEP SPACE

The volume of air, or atmosphere, between us and the forms we perceive in the distance can be understood as a series of receding planes (as we discussed in

FIGURE 1–25
ALEXANDER COZENS
A Mountain Lake or River Among the Rocks, 1775–1780
Brush and black ink wash
Courtesy, Courtauld Institute Galleries, London

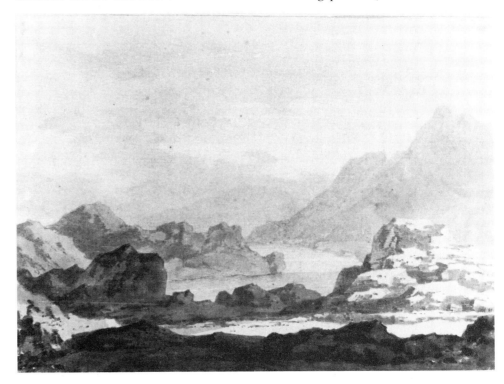

FIGURE 1–26
HASEGAWA TOHAKU
Pine Trees
Four details from a pair of six-fold screens, ink on paper, height 61"
Tokyo National Museum, Japan

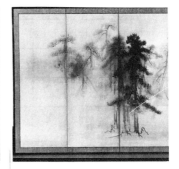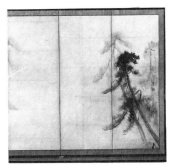

the section on the picture plane). A convenient system for organizing these planes is to group them into three distinct zones of illusory space: foreground, middleground, and background.

In the Everett Shinn drawing (Fig. 1–27), all three zones are clearly present and are coordinated with the illusion of atmospheric perspective.

RELATIVE SCALE

The concept of relative scale is closely allied to notions of foreground, middleground, and background. Things that are larger in scale usually seem to be in the foreground, or closer to us. Conversely, when there is a relative decrease in the scale of forms, we judge them to be receding into the background. Note, for instance, the drawing by Emil Nolde (Fig. 1–28). The marks are uniformly black, and Nolde's broad approach expresses only a general impression of his subject. And yet the pronounced scale changes of the marks guide us convincingly through a deep space.

The use of relative scale is particularly effective when the forms that diminish are understood to be of similar size, as in the Goya drawing (Fig. 1–29). Consider as well Goya's use of relative position, atmospheric perspective, and the diagonal to achieve a convincing sense of space.

Armed with an increased knowledge of spatial concepts, you are now in a position to choose between representing deep illusionistic space or, if it better suits your expressive ends, a flattened type of space. The following exercises are an introduction to these two alternatives.

Exercise 1B

Drawing 1. *Set up to draw on one side of the largest room available to you. Spend a few moments letting your eye travel from point to point within this space. You might also try to imagine your drawing paper as a transparent window superimposed over your subject.*

Now, select an object in the midst of this interior and put a mark on your paper representing it. Do not attempt to outline the object or depict any of its detail; your concern should be only

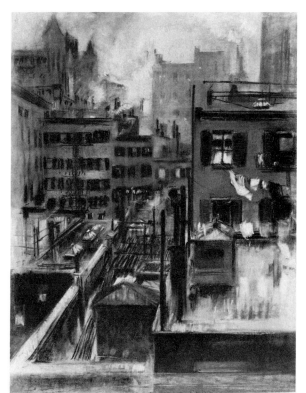

FIGURE 1–27
EVERETT SHINN
Eastside Apartment Buildings, 1898
Pastel, 29½ × 21½″
Courtesy, Hirschl and Adler

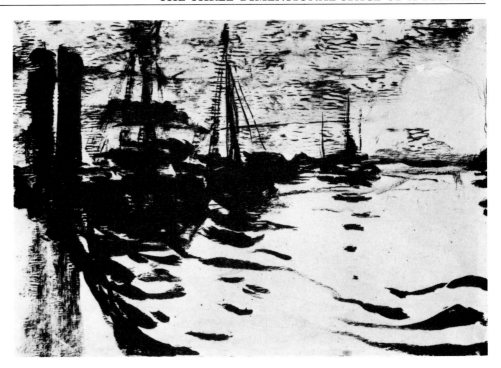

FIGURE 1–28
EMIL NOLDE
Harbor Scene, Hamburg, c. 1910
Brush with black ink, on tan
colored Japan paper,
32.3 × 46.7 cm

*Gift of Mr. and Mrs. Stanley Freehling, and Joseph
R. Shapiro. Photograph courtesy of The Art Institute
of Chicago (1965.245) © Nolde-Stiftung Seebull.
Reprinted by permission.*

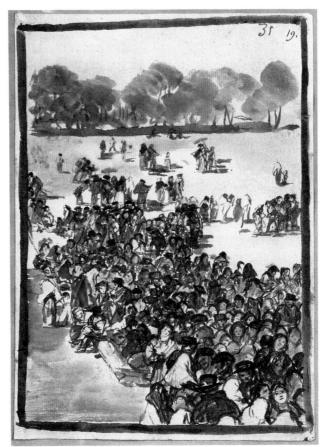

FIGURE 1–29
FRANCISCO DE GOYA
A Crowd in a Park
Brush and brown wash, 8⅛ × 5⅝"

*The Metropolitan Museum of Art, Harris Brisbane
Dick Fund, 1935 (35.103.19)*

with that object's location in space. Next, select an object or point that lies behind the first one.
Indicate its position with another mark. You will probably wish to make this mark lighter in tone,
or at least more diffuse, to have it appear farther away. Note also its relative position on the page.
Is it closer to the top?

Next, look at an object that is close to you. Using a bolder and sharper mark, indicate
this object. Continue to add marks to the page showing the relative locations of other objects in the

room. Be sure to consider the intensity and clarity of your marks and their relative position and scale; make use of any naturally occurring overlaps to reinforce your illusion of space.

Figure 1–30 is an example of marks used to create a feeling of space in a room.

Drawing 2. *Spread a number of small objects on the top of a table. Station yourself so that you are looking almost directly down at your subject. You will notice that the plane of the tabletop corresponds to the picture plane of your drawing surface. Notice, too, how the articles on the table appear to adhere closely to the plane of the tabletop. Your intent in this drawing should be to re-create the feeling of limited depth that you observe in your subject.*

Draw the arrangement of objects so as to maintain the integrity of the picture plane; that is, avoid all the devices normally used to create depth, such as overlapping, atmospheric perspective, and relative scale. To further emphasize the literal flatness of the picture plane, you may even wish to use one of your objects as a stencil (Fig. 1–31).

Looking at Space

Now that you have some experience with the very basics of spatial illusion, let us go on to investigate the various conceptions we have of space. Science tells us that space is the dominant medium, whether we consider the ample spaces seen from a mountaintop or the microscopic dimensions of space within each atom. Perhaps the most basic idea of space is as an expanse of "empty" air. But this fundamental conception may be experienced and interpreted in ways that fall into three broad categories: distance, area, and volume.

Standing in a Kansas wheat field and looking at a corn silo on the horizon, you will experience a sense of distance, or what we might call a one-dimensional measure of space. But people most often experience space with boundaries of some sort. The space of your street, for instance, or by extension your town as a whole, can be thought of as a particular area of space. Each has boundaries, definite or implied, that delineate its length and width; and each is divided into sections of space by such things as city parks, buildings, and highways (note the term *subdivison* in the builders' lexicon). As an example, look at the drawing by Sidney Goodman (Fig. 1–32), in which the sensation of a bounded spatial

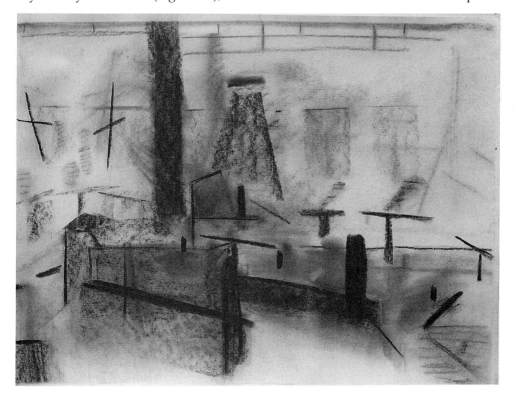

FIGURE 1–30
GEORGEANNE COOPER, University of Oregon
Student drawing: using horizontal and vertical lines to depict the spatial positions of objects within an interior
Courtesy, the artist

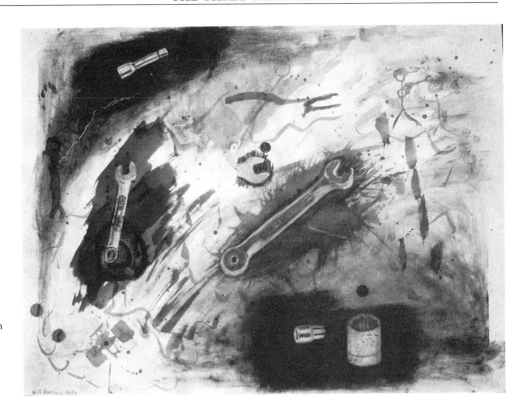

FIGURE 1–31
WILL PEREIRA, University of
Montana
Student drawing: still life in which
a table top corresponds to the
picture plane
18 × 24"
Courtesy, the artist

area is heightened by the row of massive and dramatically represented trees.

Two interesting variations on the themes of area and distance are provided by Figures 1–33 and 1–34. The Joan Nelson drawing makes a dramatic visual statement by contrasting the limited security of a barricaded, pierlike platform in the face of a formidable expanse of ocean. The Rackstraw Downes affords an aerial view of the partitioned areas, or zones, of a modern urban landscape.

FIGURE 1–32
SIDNEY GOODMAN
Wald Park, 1970
Charcoal, 23½ × 41¼"
Acquisition Fund Purchase, Collection Minnesota
Museum of American Art, St. Paul

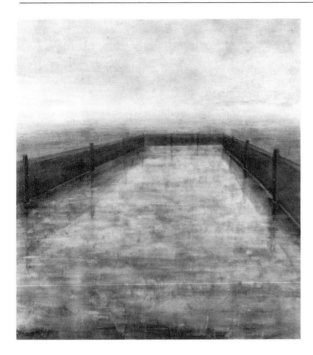

FIGURE 1–33
JOAN NELSON
Untitled, Summer 1985
Pigment and wax on hardboard,
17⅞ × 15⅞"

*Solomon R. Guggenheim Museum, New York.
Exxon Corporation Purchase Award, 1985.
Photograph by David Heald, © The Solomon R.
Guggenheim Foundation, New York (85.3333)*

FIGURE 1–34
RACKSTRAW DOWNES
*The View Looking North-West from the
Washington Bridge*, 1983
Graphite on paper, 19 × 50¾"
Courtesy, Hirschl & Adler Modern, New York

Moving down the ladder of magnitude from the Kansas wheat field and city park, our next stop is the interior space of a room. In a typical room, the space is enclosed on six sides, creating a spatial volume.

To develop an awareness of space as volume, you must learn to treat it as though it were a palpable substance. It may help to imagine the air as tinted with a color, clouded with smoke or vapor, or replaced with a substance such as water or oil. Notice in this regard the density of atmosphere portrayed in the work by Elyn Zimmerman (Fig. 1–35).

The sensation of spatial volume is maximized when objects divide a space into yet more visually manageable and intimate volumes. As an example, look at the drawing by William Wiley (Fig. 1–36), in which the depicted volume of space is pronounced. We want to poke about in the array of spaces scaled for human activity, but as we do so, we are simultaneously rebuked by the centrally placed square, which serves as a reminder of the picture plane.

Our experience of space as a volume need not be limited to rooms designed for personal use. The presence of monumental masses of air pressing against the architectural framework of large halls, church and theater interiors, and the like, can fill us with awe (Fig. 1–37). And this is not to say that our awareness of spatial volume cannot be stirred in an exterior setting. In Michael Mazur's

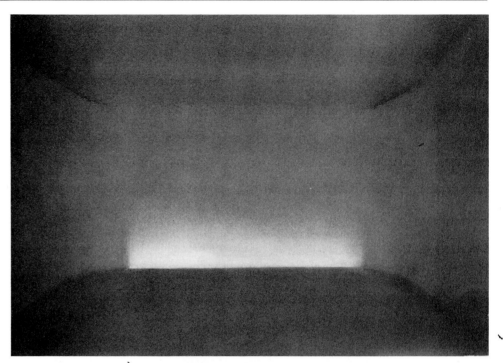

FIGURE 1–35
ELYN ZIMMERMAN
Untitled, 1976
Powdered graphite, 14¼ × 19¼″
*Courtesy of the artist and the Gagosian Gallery,
New York*

FIGURE 1–36
WILLIAM WILEY
Studio Space, 1975
Acrylic and charcoal on canvas,
83 × 80¾″
Courtesy, Wanda Hansen gallery

untitled landscape drawing (Fig. 1–38), a volume of space is powerfully implied in the center, formed by the arching canopy of tree branches.

We urge you to take account of the different spaces you encounter in daily life. A good "out-of-the-classroom" exercise is to determine whether the spaces you see can be classified by their distance, area, or volume. How about combinations? We have provided examples of area and distance combined; can you find spaces that seem poised between, let us say, area and volume?

Concentrating on spaces instead of things will probably mean reversing your normal visual habit. It is suggested you do this so you can intensify your awareness of space. But this sort of activity will have an even broader application,

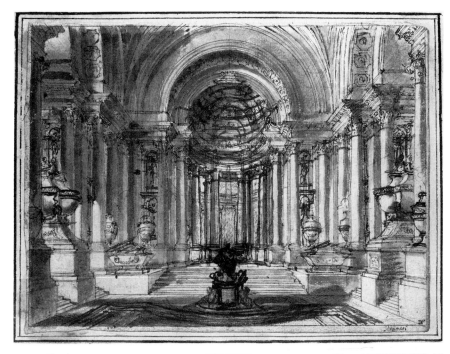

FIGURE 1–37
PIRANESI
Large Architectural Interior
The Pierpont Morgan Library, New York (1959.14)

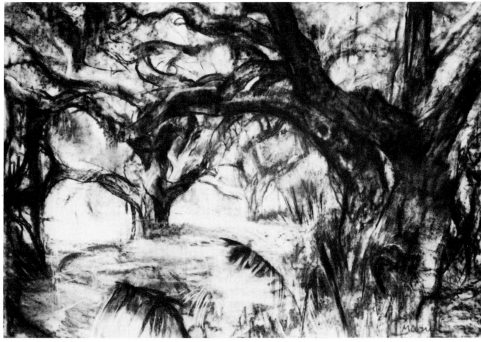

FIGURE 1–38
MICHAEL MAZUR
Untitled, 1985
Charcoal #4500, 42½ × 60″
Courtesy, Jan Turner Gallery

because when you shift your attention from what you are accustomed to seeing, you help yourself develop a new vocabulary of expectations and responses. This may be awkward at first, and it definitely takes practice. But it is good to break visual habits. Doing so makes you more receptive to, and eventually eager for, the challenge of new visual perceptions.

Gesture Drawing as a Means of Capturing Space

If you wish to address the essence of a set of spatial relationships with directness and immediacy, you will do a *gesture drawing*. In general, the term *gesture* refers

to the expressive posture of a human being, and indeed gesture drawing is an ideal means for capturing spontaneous human actions (Fig. 1–39). For artistic purposes, however, gestural characteristics may be interpreted from most of what we observe. For example, the nose of the helicopter in Figure 1–40 appears to point like a giant forefinger to the target below, mimicking a common human gesture.

Gesture drawing is a rapid sizing-up of the primary physical and expressive attitudes of an object or a space. Description in the gesture drawing is limited to the subject's essentials, which are searched out intuitively. Quick by definition, gesture drawing urges the artist into a frame of mind where details are ignored in favor of a subject's basic visual character. For this reason, artists often do gesture drawing to warm up prior to an extended period of work (Fig. 1–41).

Gestural exploration may also serve as the basis for a drawing that is meant to be developed into a finished work.* But regardless of how gesture drawing is used by the artist, it is not, in itself, usually accorded the status of a "product," or final artwork. Instead, the emphasis is on process—a process of search and discovery whereby immediate visual experiences are translated into the medium of drawing.

The more specific term *spatial gesture* may be defined as the gestural move-

FIGURE 1–39
Pierre Bonnard
Sheet of Studies, *Woman with Umbrella*, c. 1895
Graphite, pen and black ink, brush and black wash and watercolor, on ivory wove paper, 31.2 × 19.9 cm
Bequest of Grant J. Pick. Photograph © 1994, The Art Institute of Chicago (1963.397 recto). All Rights Reserved.

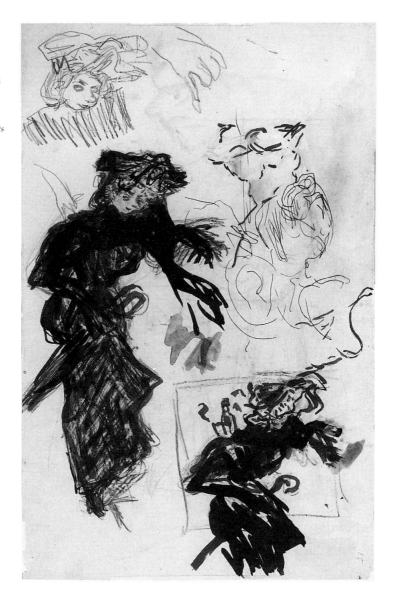

*For information about the relationship of gesture drawing to design, see Chapter 4.

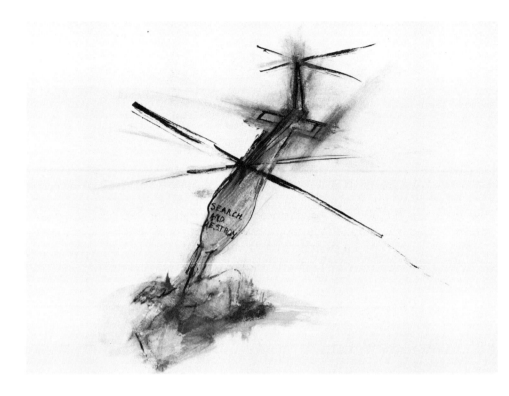

FIGURE 1–40
NANCY SPERO
Search and Destroy, 1967
Gouache, ink, 24 × 36"
Courtesy, the artist and the Josh Baer Gallery

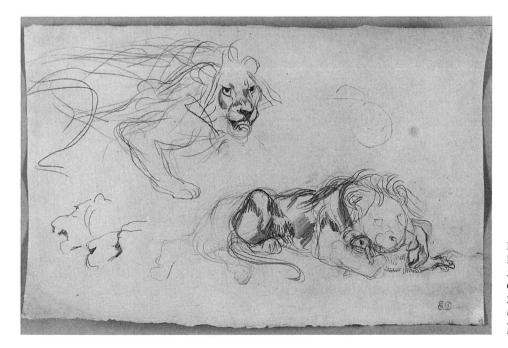

FIGURE 1–41
EUGÉNE DELACROIX
Study of Lions
Graphite on buff laid paper, 22.8 × 34 cm
David Adler Collection. Photograph © 1994, The Art Institute of Chicago (1950.1411). All Rights Reserved.

ment implied by an imagined linkage of objects distributed in space. This approach may be seen in the drawing by Piet Mondrian (Fig. 1–42), in which the sweeping, full-page gestures forego detailed description so as to capture the spatial essence of the subject. In Giacometti's drawing (Fig. 1–43), a network of spatial linkages is created by lines that careen from one point to another in the depicted interior setting.

Seeing in terms of spatial gesture takes practice. Let us suppose that you are in a room that is filled with objects. To see the gesture in this room, let your attention bounce around from object to object. You may be immediately struck

FIGURE 1–42
PIET MONDRIAN
Dunes and Sea, 1909
Pencil on paper, 10.2 × 17.1″
© *Estate of Piet Mondrian/VAGA, New York, 1989*

FIGURE 1–43
ALBERTO GIACOMETTI
Interior, 1957
Pencil on paper, 35¾ × 19¾″
*Solomon R. Guggenheim Museum, New York.
Photograph by Robert E. Mates, © Guggenheim
Foundation, New York (57.1479). © 1996 Artists
Rights Society (ARS), New York/ADAGP, Paris*

by a spatial relationship among some of the objects. You might, for instance, see how a bicycle, chair, and birdcage form an arc when viewed in sequence across a portion of the room. Now, although these objects have different names and uses in everyday reality, you have found a way to group them. You have discovered a visual connection that hinges entirely on your personal organization of the space in the room before you.

The two drawings suggested in this exercise require you to concentrate on a particular linkage of objects in space. The purpose is to heighten your awareness of how space may appear to gesturally unfold.

Exercise 1C

Drawing 1. From your easel or drawing table, choose a path through the objects in the room space before you. Take your drawing tool and re-create that path on your paper, using a simple, meandering line. It is advisable to look as much out at the space you are trying to represent and as little at your paper as possible. (Line drawings made without looking at the paper are frequently referred to as blind-contour drawings.)

As you draw, you should be convinced that you are steering your line into the space. Use sound effects as you (SQUEAL!) veer around one object to get to the next; or as you (GRUNT!) have to make several hard passes with your drawing media to get beyond an "obstacle" that is especially large, heavy, or dark in color (as in Fig. 1–44, in which a gathering of marks around a central form indicates the weight and solidity of its mass).

Drawing 2. Do a second gesture drawing using the same concept of a spatial route. But this time look at your paper and make an even more varied set of marks to express the character of what you see along this path and the feelings that are aroused in you as you proceed.

Work quickly, but be alert to the need for exerting varying pressures on your medium to suggest weight, scale, and speed changes along your journey. Remember that by thinking of objects as things that slow down and divert your course through space, you will naturally become more aware of the space between these objects.

The greater variety of marks that you use in this drawing will help you and your viewer to empathize with your subject. Evidence of this physical identity with a subject can be seen in Figure 1–45, whose veering diagonals on the ground plane conflict with the heavily hatched and smeared verticals that bar our entry into the picture space.

FIGURE 1–44
GEORGEANNE COOPER, University of Oregon
Student drawing: diagonal lines added to horizontal and vertical lines to represent obstacles in an interior
Courtesy, the artist

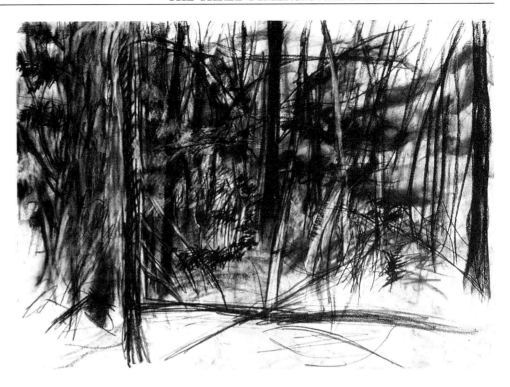

FIGURE 1–45
FUMIKO AMARO, University of
Wisconsin at Stevens Point
Student drawing: use of a variety
of marks to encourage empathy
with the subject
Courtesy, the artist

When you are finished, the expressiveness of these drawings might surprise you. But think of the personal decisions you had to make during the process. First, you singled out objects that divided the space in an interesting way; then, you had to choose what kind of marks would best express the responses you had as your eye followed along your selected path.

2

The Two-Dimensional Space of a Drawing

In Chapter 1, we explored ways to create the pictorial illusion of three-dimensional space. The picture plane in this case was conceived as a window on nature. We also noted that the second definition of the term *picture plane* is the flat surface on which a drawing is made. That flat surface, usually a sheet of paper, represents the *actual* space of a drawing.

More specifically, this actual space of a drawing is two-dimensional. It is the *area* of the drawing, the product of the length times the width of the paper or support on which an image is drawn. And it is a space limited to the paper's surface and bounded by its edges.

So flatness of surface is the fundamental property that links all the drawings you make. Indeed, even when you are concerned primarily with depicting an illusion of three-dimensional space, you also need to consider how best to lay out or divide the area of your page. This chapter stresses the primacy of the flat picture plane and introduces ways to address its two-dimensional space.

Two-Dimensional Space and Modern Art

Many twentieth-century artists have emphasized the actual two-dimensional space of the picture plane over its potential for three-dimensional illusion. Wishing to avoid what might be termed the "artificial" nature of illusionistic space, these artists have exploited the flat character of the drawing surface with the intention of "preserving the integrity" of the picture plane (Fig. 2–1).

Other artists have chosen to extend their images out from the picture plane into the spectator's space. Collage, assemblage, and relief (Fig. 2–2) are some of the ways artists have opted to incorporate the space in front of the picture plane into their two-dimensional art forms.

Later in this chapter (see "Ambiguous Space") we discuss other ways in which modern artists have asserted the integrity of the flat picture plane, but first we must define more fully the two-dimensional character of a drawing. We begin by emphasizing the shape of the surface on which we draw.

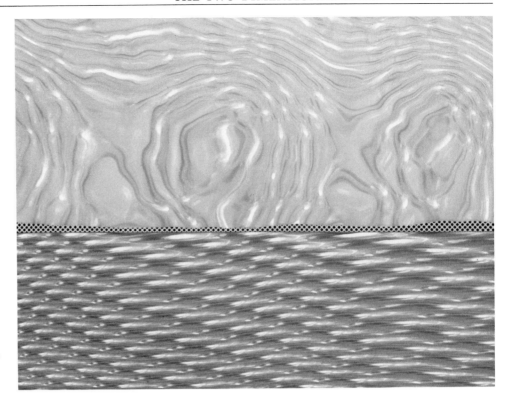

FIGURE 2–1
Roy Lichtenstein
Electric Seascape #1, 1967
Collage on paper, 22 × 28″

*Solomon R. Guggenheim Museum, New York. Gift,
Mrs. Louis Sosland, Kansas City. Photograph by
Robert E. Mates, © The Solomon R. Guggenheim
Foundation, New York (79.2528)*

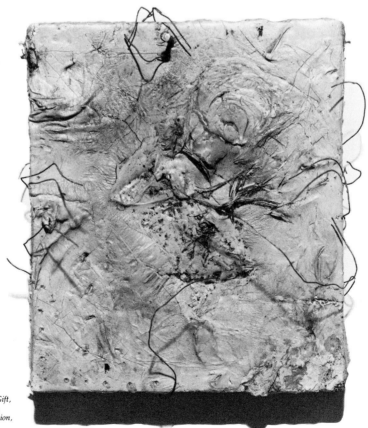

FIGURE 2–2
Bruce Connor
Untitled, 1960
Mixed media (oil, wire, nail) on
canvas, 9¾ × 8⅛″

*Solomon R. Guggenheim Museum, New York. Gift,
James J. Hanafy, 1976. Photograph by Robert E.
Mates, © The Solomon R. Guggenheim Foundation,
New York (76.2265)*

The Shape of a Drawing

The paper we draw on has a shape. (By *shape*, we mean a flat area with a particular outer edge, or boundary.) Since a sheet of paper is itself a flat shape, it follows that any image we draw on it will be, first and foremost, a shape. Let us take, for example, the drawing of a banana flower by Georgia O'Keeffe (Fig. 2–3a). It looks quite "real," suspended in space and thrown into relief by strong lighting. And yet, common sense tells us that a banana flower does not really exist on that page. Instead, we respond to a drawn image of that object; an image that is convincingly modeled with charcoal to look round but is, nevertheless, in its truest physical definition a flat shape.

Positive and Negative Shape

From an artistic standpoint, subjects in the real world consist of two basic realities: the *positive forms* of objects, and the *negative spaces* surrounding these forms or contained by them (such as the space between the handle and body of a coffee cup).

When you draw, the positive forms and negative spaces of your subject are converted into their pictorial counterparts on a flat surface: *positive* and *negative shapes*. To clarify this, let us look at Figure 2–3b (in which we have reduced the drawing by Georgia O'Keeffe to its simplest shape state) and consider the following two points:

1. The entire rectangular surface of the O'Keeffe drawing is divided into two distinct-shape areas: no. 1 (positive shape) and no. 2 (negative shape).

2. The illusion of the banana flower as a positive sculptural volume and the space that surrounds it occur within the actual shape divisions of the flat picture plane.

In truth, then, whenever we represent an object or a space on a page we are creating a shape. And the first shape that is made automatically creates one

FIGURE 2–3a (left)
GEORGIA O'KEEFFE
Banana Flower, 1933
Charcoal, 21¾ × 14¾"
The Museum of Modern Art, New York. Given anonymously (by exchange). © 1996 The Georgia O'Keeffe Foundation/Artists Rights Society (ARS), New York

FIGURE 2–3b (right)

or more additional shapes from the area of the drawing sheet. These shapes are designated as either positive or negative.

Implications of the Term Negative Shape

The term *negative shape* carries connotations that may interfere with an appreciation of positive and negative relationships in a drawing. Unfortunately, negative shapes are sometimes defined as the empty, or passive, areas of a picture that remain after the positive image has been drawn. This may lead students to believe that negative shapes are somehow "second-class" and thus do not require the attention given to positive areas.

A related problem is the tendency for students to label as "background" all the areas of their drawing that lack prominent object symbols.* Referred to in this way, *background* really means "backdrop," or the subsidiary part of a drawing against which the positive image stands out. This tendency is caused in large part by the material conditioning of our culture; those things we can name usually take precedence in our minds.

But negative shapes aren't simply a backdrop, or what's left over when a positive image is drawn. *They are an integral part of a drawing.* Expanding on this, consider that when you begin a drawing, the *entire* shape area of your empty sheet of paper is important. So it follows that *all* the shapes resulting from a division of that surface are also important and deserving of careful attention.

Each time you draw a positive shape on your page, you are simultaneously shaping the negative areas of your drawing. This means that positive and negative shapes have an immediate and reciprocal influence on one another. Therefore, any approach that neglects the negative shapes of a drawing will flaw the wholeness of a work and its expression. It will also limit your ability to take advantage of the total visual potential in both your subject and its translation onto a sheet of drawing paper. In view of all this, we are inclined to say that decisions about how best to break up the surface of your picture plane into positive and negative shapes are among the most creative of the drawing process.

Accentuating the Positive or the Negative

Summarizing what we have established thus far in this chapter, we know that a drawing surface is flat and that all parts of an image, regardless of how convincingly they are modeled as volumes, are most essentially shapes. Thus, we may conclude that the substance of a drawing is crucially linked to the quality of its positive and negative shapes.

Furthermore, each of the shapes we make in a drawing exist apart from the forms and spaces they portray. So a positive shape that represents something we recognize from the natural world is not inherently more important than a negative shape that stands for an uninhabited plane or space. The way shapes *do* derive their level of importance in a drawing is from the specific artistic treatment they receive.

Look at a second banana flower by O'Keeffe (Fig. 2–4). Here the major emphasis is on the positive image of the flower, but the surrounding negative

*The term *background* as used here is not to be confused with its spatial application in Chapter 1, where it was grouped with the terms *foreground* and *middleground.*

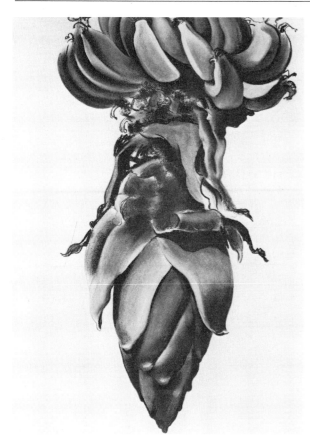

FIGURE 2–4
GEORGIA O'KEEFFE
Banana Plant, No. 4
Charcoal on paper, 21½ × 14⅜"
*Collection, Carl E. Hiller. © 1996 The Georgia
O'Keeffe Foundation/Artists Rights Society (ARS),
New York*

areas are not merely residual. They act as a buffer zone to contain the gestural energy of the positive shape. And note that the tension between the positive and negative areas extends to the edges of the paper, making them insistent wherever one scans the drawing. Furthermore, at several junctures the positive shape is open, admitting the surrounding negative area and suggesting a union between the two.

In the pastel drawing by George Segal (Fig. 2–5), it is the negative shape that presses for our attention. Thus, Segal heightens viewer fascination by providing what is least expected: a negative, "empty" shape occupying the central portion of the drawing, a place typically reserved for positive shapes.

As we have indicated in this chapter, many of us are so accustomed to looking at positive forms that negative spaces often go unnoticed. Yet by virtue of their unpredictability, the negative spaces of a subject can have greater visual and expressive potential than their positive counterparts (Fig. 2–6). By isolating them for interpretation as flat shapes, this exercise will heighten your awareness of the "hidden" resources of negative spaces.

Select some objects that have distinct negative spaces. Ladders, chairs, stools, tires, and the like make ideal subjects for this kind of drawing. Jumble and overlap these items to maximize the number and variety of negative spaces. If you turn some of these objects upside down you will find it generally easier to ignore their real-world function and concentrate instead on their shape potential. Negative spaces may also be accentuated by keeping the room light low while turning a strong spotlight on the setup.

Next, find a viewpoint that offers the best assortment of negative spaces and translate them into darkly toned shapes on your drawing paper. Avoid using an outline to describe these shapes; instead, select media that come in a block form (such as lecturer's chalk, compressed charcoal, or a graphite stick) and draw the negative shapes by applying broad, vigorous strokes (Fig. 2–7).

Exercise 2A

FIGURE 2–5
GEORGE SEGAL
1965–4
Conté on newsprint, 18 × 24″
© 1994 George Segal/Licensed by VAGA, New York

FIGURE 2–6
CONSTANTIN BRANCUSI
View of the Artist's Studio, 1918
Gouache and pencil, 13 × 16¼″
*The Museum of Modern Art, New York. The Joan
and Lester Avnet Collection*

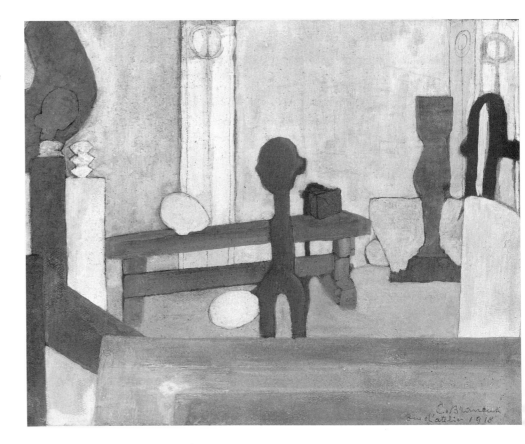

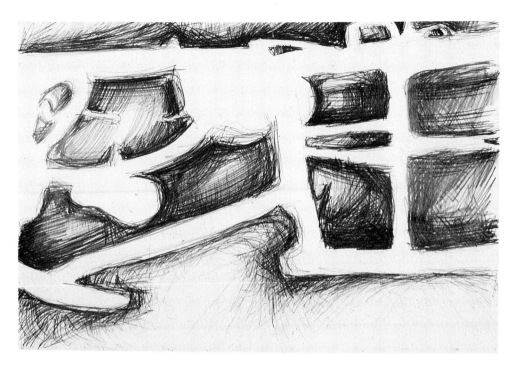

FIGURE 2–7
PAUL FLEMING, Arizona State
University
Student drawing: bold positive-
negative layout
Pencil, 18 × 24″
Courtesy, the artist

Ambiguous Space

At the beginning of this chapter we discussed how many modern artists have
de-emphasized (or rejected entirely) the illusion of three-dimensional space,
wishing instead to accentuate the two-dimensional character of pictorial art (Figs.
2–1 and 2–2). This does not mean to imply, however, that these artists abandoned
spatial interplay in their work, but rather that they wished to achieve the sen-
sation of space while maintaining for the viewer a firm awareness of the flat
picture plane.

 One of the most enduring ways for modern artists to accomplish this
seeming contradiction of space and flatness in pictorial art is by creating what
is often referred to as *ambiguous space*. Ambiguous space can be described as a
visual phenomenon in which the spatial relationships between positive and
negative shapes are rendered perceptually unstable or uncertain. To clarify this
description, we turn now to a discussion of three kinds of ambiguous space:
interspace, positive–negative reversal, and figure–ground shift.

INTERSPACE

The term *interspace* is sometimes considered synonymous with negative space,
but in the work of many modern artists it is more appropriately defined as a
subtle combination of negative shape and the illusion of positive form. To grasp
this concept, look at a watercolor and pencil landscape by Cézanne (Fig. 2–8).

 Can you detect in this work that each of the negative interstices appears
to be a slightly rounded plane (think of a contact lens) through which the hints
of space and atmosphere are seen?

 To understand how Cézanne achieved this effect, allow your eyes to follow
the contours that mutually describe tree forms and negative areas. Note that
these contours vary in their sharpness and light and dark tonalities. This fluc-
tuation in edge conveys the impression of negative planes that are alternately
raised or lowered in relation to the cylindrical tree forms (the sharper darks may
be seen as shadows cast on the tree forms by the negative shapes).

 So, Cézanne provides enough visual clues in his treatment of the negative

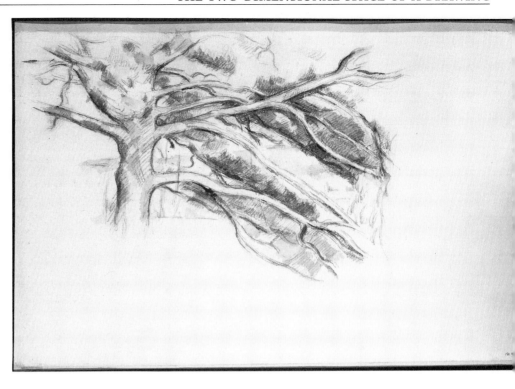

FIGURE 2–8
PAUL CÉZANNE
La Grande Arbre
Pencil and watercolor, 12 × 18⅛″

Bequest of Theodore Rousseau, 1974. Jointly owned by The Metropolitan Museum of Art and the Fogg Museum of Art, Harvard University (1974.289.1)

areas to give them the barest suggestion of volume. Although they do not compete with the more concrete tree parts, they are, nonetheless, more full than "empty" negative spaces are often deemed to be.

In other words, we have a *tactile* response to the areas of interspace in the Cézanne; that is, our visual reading of the negative shapes is influenced by how, in our mind's eye, those slightly curved surfaces would feel to the touch (think of buckled puzzle pieces). And by calling attention to the negative areas as *shapes*, Cézanne also reaffirmed the expanse of the flat picture plane.

Thus, the term *interspace* implies that instead of being merely flat and "passive," negative shapes may in fact be given a suggestion of volume and thereby assume a more "active" role in the spatial illusion of a two-dimensional work of art. Note in this regard, the drawing by Degas (Fig. 2–9), in which the negative area appears to swell and push against the horse's chin and down its neck, as if it were a cushion, to effectively bolster the quivering presence of the head.

POSITIVE–NEGATIVE REVERSAL

Ambiguous spatial relationships may also be achieved through *positive–negative reversals,* or when shapes in a drawing alternate between positive and negative identities. These alternations make the artifice of illusion more apparent and thereby acknowledge the presence of the work's actual two-dimensional surface. A good example of positive–negative reversal can be found in Figure 2–10, in which at first glance the white shapes may appear to be positive "islands" floating forward against a dark ground. But stare at the central black zone for a moment and the reverse begins to happen: the black, formerly negative, shape emerges as a positive "presence," and the white shapes seem to drop back like the sides of a box. What we may conclude from this is that either the black or the white shapes in Figure 2–10 may be understood as positive or negative according to viewer perception.

This phenomenon may also be used to great effect in drawings that feature some level of representation. Look, for instance, at how the two dark shapes at the top of Figure 2–11 may be read as either positive cloudlike images on a gray

FIGURE 2–9
EDGAR DEGAS
Head of a Horse
Pencil on paper, 6⁹⁄₁₆ × 4¾″
The Metropolitan Museum of Art. Gift of A.E.
Gallatin, 1923

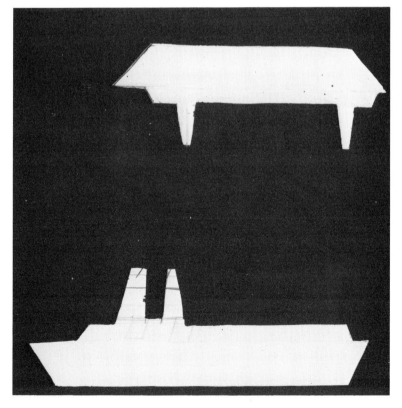

FIGURE 2–10
DONALD SULTAN
Menorca, August 17, 1978, 1978
Ink and graphite on paper, 12⅛ ×
12⅛″

Solomon R. Guggenheim Museum, New York. Gift,
Norman Dubrow, 1984. Photograph by David
Heald, © The Solomon R. Guggenheim Foundation,
New York (84.3196)

FIGURE 2–11
Sigmar Polke
Physiognomy with Car, 1966
Ballpoint pen and gouache,
11⅝ × 8¼″
The Museum of Modern Art, New York. Gift of the Cosmopolitan Arts Foundation

ground or as negative cavities representing eyes on a face. The reversal of the right-hand shape is especially apparent; it seems to change its positive–negative identities continually. This is because one end of this shape coincides with the edge of the format, which heightens our variable reading of it as either an area drawn on the paper surface or the illusion of a shape cut out from that surface.

FIGURE–GROUND SHIFT

The two previous topics have indicated ways in which individual shapes in a drawing may have two different identities. This may happen either simultaneously (as in the case of interspace) or alternately (as in the case of positive–negative reversal). A third type of spatial ambiguity aggressively combines aspects of both interspace and positive–negative reversal. It is commonly known as *figure–ground shift.*

Figure–ground shift occurs when all or most of the shapes in an image are given a suggestion of volume, and when virtually all the shapes appear to be constantly shifting, or slipping in and out of positive (figure) and negative (ground) identities.

In large part, figure–ground shift is the result of concentrating on the edges of shapes in a pictorial work of art. Varying the tone, thickness, and speed of edges can impart a positive, or figurative, weight to all the shapes in an image. And by making different portions of edges dip and rise, these variations also create an intricate webbing of overlaps that reinforces the physical existence of the flat picture plane. Consider, for example, *Black Untitled*, by Willem de Kooning (Fig. 2–12), in which each of the shapes interlock, with edges that twist back and then forward, to create complicated spatial puzzles that the viewer cannot rationalize or solve.

Exercise 2B *In this drawing you should attempt to create a sense of interspace by giving equal weight to positive and negative shapes.*

Choose a subject with a considerable number of framed negative spaces, such as

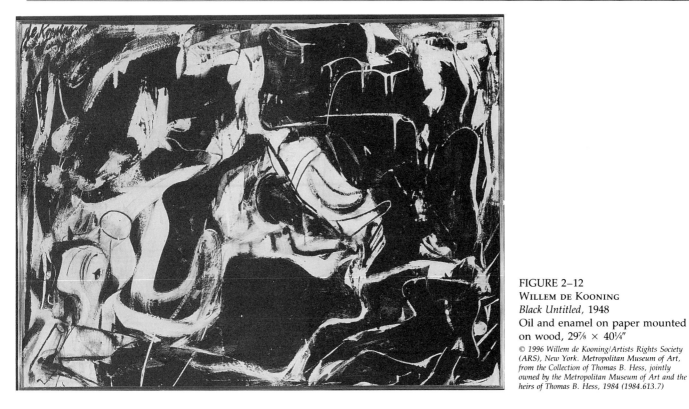

FIGURE 2–12
WILLEM DE KOONING
Black Untitled, 1948
Oil and enamel on paper mounted
on wood, 29⅞ × 40¼"

*© 1996 Willem de Kooning/Artists Rights Society
(ARS), New York. Metropolitan Museum of Art,
from the Collection of Thomas B. Hess, jointly
owned by the Metropolitan Museum of Art and the
heirs of Thomas B. Hess, 1984 (1984.613.7)*

*a construction site, playground equipment, a large plant, or a still life. No special lighting
is required.*

*As you draw, give simultaneous emphasis to both positive and negative shapes. It may
help to think of all shapes, positive and negative, as shallow volumes. This is the case in
Figure 2–13, in which the spaces between objects may easily be perceived as interspaces.*

*In this drawing you will again be looking at positive and negative shapes, but this time you
will be weighting and distributing these shapes so as to effect a positive–negative reversal.*

Exercise 2C

FIGURE 2–13
DACEY VANDER WAL, University of
Wisconsin at Stevens Point
Student drawing: negative areas
emphasized to create a sense of
interspace.
Courtesy, the artist

Although traditional dry media such as charcoal or pencil will work well, you might consider as an alternative the use of black ink on paper, or black and white paper collage.

Again construct a suitable still life or seek out in your environment a subject that suggests strong shape possibilities, such as a collection of items mingled with the drainpipes under your kitchen sink. Draw the objects using only black and white shapes. As you draw, be especially aware of how the shapes relate to each other and to the entire shape of your page. Your ultimate goal is to set up a relationship in which the dark and light shapes can be read as either positive or negative (Fig. 2–14).

FIGURE 2–14
Jamie Geiser, University of Wisconsin at Stevens Point
Student drawing: weighting and distributing dark and light shapes to create the effect of positive-negative reversal.
Charcoal on paper, 18 × 24″
Courtesy, the artist

Shape, Proportion, and Layout

In drawing from nature, you will be concerned with questions of proportion on several different levels. Perhaps foremost in your mind will be the problem of drawing your *subject* in proportion, by which we mean that you will want to observe and record correctly the relative sizes among the parts of your subject and the relationship of the parts to the whole. This problem is the focus of the first half of this chapter.

The second half of this chapter is devoted to the question of the proportional relationships *within the work of art itself.* In the most general terms, these relationships are established by how you choose to divide the two-dimensional surface of your drawing. Because these decisions are personal, they have a great impact on the expressive value of your drawing. Luckily, the same strategies for objectively observing proportion in your subject can be extended to aid you in the more subjective activity of determining the proportional relationships of your drawing as a whole.

Drawing in Proportion

Any subject you draw has proportional relationships. If the subject is a familiar one, such as a human figure, it is likely you will be able to tell when it is incorrectly drawn. In such cases, you may be able to correct the drawing using an educated guess, but in the vast majority of situations you will not have had sufficient familiarity with your subject to allow you to make intuitive judgments about its proportions.

Because artists since the Renaissance have been concerned primarily with depicting the *appearances* of their subjects, they have over time invented ways of using the picture plane to aid them in accurately measuring proportion. This chapter provides you with a number of devices, some traditional and others new, that will enable you to better judge the proportions of things as you see them.

Shape and Proportion

Take a moment and look at some common object before you. Notice the main shapes that make up the object and their proportions, or sizes relative to one another. Change your position, and you will find that those shapes have changed right along with you. Clearly then, each time you alter your position in relation to any object other than a sphere, you will be presented with a new set of shapes and proportions. And in only a few views of a subject will the proportions of its shapes as seen correspond to that subject's *actual*, measurable proportions.

To better understand this, compare the drawing by Leonardo da Vinci (Fig. 3–1) with a painting by Andrea Mantegna (Fig. 3–2a). In the Leonardo, the figure is positioned so that its relative height and width may be easily judged. In the work by Mantegna, however, the relative dimensions of the shape of the figure do not match those of the subject's real dimensions, since the vertical dimension of the shape is only slightly longer than its horizontal measurement. This may be seen quickly when the human attributes of the figure are masked out, as in Figure 3–2b.

Shape and Foreshortening

When an object is situated so that its longest dimension is parallel to the picture plane, as in the Leonardo, the object is seen in its unforeshortened view. When the longest dimension of the object is at an angle to the picture plane, the object is said to be *foreshortened*. In the Mantegna, the longest dimension of the body is almost perpendicular (at a right angle) to the picture plane, making it an example of extreme foreshortening.

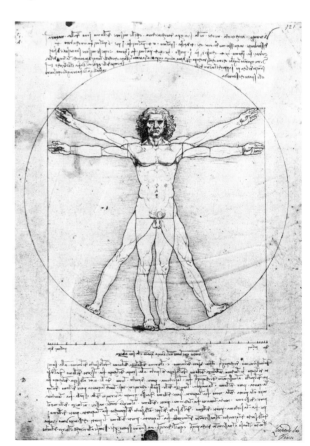

FIGURE 3–1
LEONARDO DA VINCI
*Study of Human Proportions
According to Vitruvius*, 1485–1490
Pen and ink
Alinari/Art Resource, NY

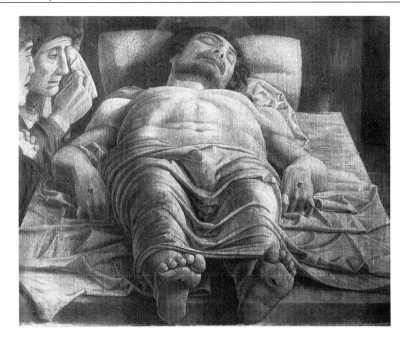

FIGURE 3–2a
ANDREA MANTEGNA
The Dead Christ
Alinari/Art Resource, NY

FIGURE 3–2b

Leonardo's figure, comfortably circumscribed by circle and square, is not in conflict with the two-dimensional space of the page. In this case, the representation of the figure does not demand that we become involved with pictorial space. Mantegna, on the other hand, pushes this demand almost to its limit. The peculiar shape of the figure lets us know that we are seeing a body extended into space. And at the same time that we are made to acknowledge this deep fictive space, we may also become aware of the compression of the figure into a flat shape on the picture plane.

Herein lies the paradox of shape: it is in itself flat. Yet when we try to reconcile the peculiarities of its proportions with those of the object it represents, it becomes a powerful indicator of that object's spatial disposition in relation to us.

So when an image of an object is projected onto the picture plane, it becomes a shape. This shape has measurable proportions within itself. And as a unit of area on the picture plane, it may be compared in size with other shapes

and with the shape of the whole page. Therefore, whenever you have difficulty seeing an object's proportions relative to itself, or to its surroundings, it is helpful to ignore its three-dimensional character and concentrate instead on its shape.

Measuring with Your Pencil

Measuring with your pencil will assist you in seeing the proportions of a particular shape. To measure with your pencil, look at the shape of the object you wish to draw and decide which are the longest and the shortest of its dimensions, or axes. Then determine how many times the smaller dimension of the shape goes into its larger dimension by following the steps demonstrated in Figure 3–3.

This procedure may be used to compare any measurements in your drawing. The accuracy of the procedure depends on maintaining the pencil at a constant distance from your eyes (full arm's length is advised) and on keeping the pencil parallel to your imaginary picture plane.*

Using the Viewfinder to See Proportion

A viewfinder may be described simply as a framed opening through which you can view a selected portion of the visual field in front of you. More than likely, you have already had the experience of looking into the viewfinder of a camera to anticipate how your subject will look in the photograph.

When you are making a drawing, a viewfinder is helpful in selecting the exact subject you wish to draw, because the shape of the viewfinder corresponds to the shape, or format, of your drawing paper. In discussing a drawing, therefore, the word *format* is used to describe the total shape and size of the drawing surface.

You can make a viewfinder by cutting a window in a piece of lightweight

FIGURE 3–3

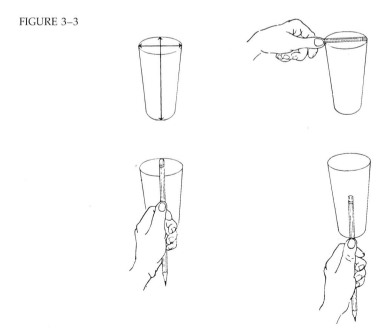

*See ''The Picture Plane'' in Chapter 1.

cardboard. The proportions of this opening should correspond to the format of your paper. As an example, if the dimensions of your paper are eighteen inches by twenty-four inches, the ratio of the sides of the viewfinder window will be three to four, and the opening that you cut in your cardboard will be three inches by four inches (Fig. 3–4).

You will probably find the viewfinder an invaluable aid when it comes to observing proportion, largely because it will enable you to instantly recognize the shapes inherent in your subject. This is because the (usually rectangular) opening of the viewfinder itself will impress you as a strong shape, encouraging you to readily perceive the objects seen framed within the opening as smaller shape divisions of the whole.

When using a viewfinder, imagine that its format edges match exactly the edges of your drawing paper. Then draw the shape of your subject so that it fills the page in the same way the image fills the viewfinder. It is helpful to pay special attention to the negative shapes lying between the subject's outer edge and the boundaries of the viewfinder because you may find it easier to judge the proportion of these abstract shapes than the shapes of nameable objects.

For the sake of greater accuracy, some students prefer to use a gridded viewfinder. This can be made by punching holes into the margins of the view-finder at equal intervals and running thread from one side to the other, forming a grid. If you place the holes at one-inch intervals in a three-by-four-inch open-ing, you will divide the opening into twelve one-inch squares (Fig. 3–5a). To use this viewfinder effectively you should also divide your eighteen-by-twenty-four-inch paper into twelve six-inch squares. What appears in each square of the viewfinder can then be transferred to the corresponding square on your drawing.

A simpler alternative is to divide your viewfinder into only four rectangles. This will keep you aware of how your composition is centered without requiring that you painstakingly copy exactly what you see in each square of the grid (Fig. 3–5b).

FIGURE 3–4

FIGURE 3–5a (right)

FIGURE 3–5b (left)

Spatial Configurations

Thus far in this chapter we have been discussing how seeing objects as flat shapes can aid you in drawing them in correct proportion. However, this process may also be applied to help you see proportional relationships between various points in the spatial field before you. By connecting selected points on objects and surfaces distributed through a space, a distinctive shape is formed.

The best analogy to this activity is the practice of naming constellations. Constellations are actually three-dimensional configurations; in other words the stars making up a constellation are located at various distances from the earth, and the difference between these distances may be measured in thousands of light years. But we are generally unaware of the vast depth discrepancy between stellar positions in the deep space of the universe; consequently, we perceive the apparent groupings of stars as flat shapes. So when we see the shape of a big dipper or a scorpion in the night sky, we are actually seeing the *shape aspect** of a configuration of points in very deep space.

Angling and the Picture Plane

Our environment is full of horizontal and vertical lines. Linear elements from the environment that are vertical almost always appear as verticals on the picture plane. But linear elements that are horizontal (such as window sills, baseboards, and so forth) often appear as diagonals on the picture plane. To transfer the angle seen in the environment to the drawing surface, we use a technique called *angling.*

We have broken down the angling procedure into the following steps:

Step 1. Stand at about arm's length from your easel. If you are right-handed, position your easel so that you are looking at your subject past the left margin of your page.

Step 2. Face your subject. Now imagine that a pane of glass is at about arm's length in front of you. Grasping your pencil between thumb and fin-

*By *shape aspect,* we mean the shape of something seen from any one vantage point.

gers, move the pencil up and down to get the feel of this imaginary plane.

Step 3. Single out some item in the room that has a vertical line (such as a doorjamb). Still keeping your pencil pressed against the "glass," align it with the vertical line of the doorjamb. Now single out a line that is not vertical, such as one formed by the junction of the ceiling and the wall. Pivot your pencil on the imaginary pane so that it is lined up with that diagonal (or horizontal). Practice aligning your pencil with various linear elements in your environment, *taking care not to point through (or into) the imaginary pane of glass.*

Step 4. Station yourself at your easel. Choose one of the lines you have just practiced angling. Now swing your arm to your paper, keeping the angle of the pencil constant. Lay the pencil against the paper and draw a line parallel to it.

Step 5. Check the angle by repeating the process until the angle comes out the same each time.

A variation on the angling method is to pretend that the imaginary pane of glass in front of you is the face of a clock and that your pencil represents the hands of that clock. Grasping your pencil in the middle, hold it on a vertical—that is, six o'clock. The correct "time" for a horizontal is, you guessed it, quarter of three. When you apply this technique to angles in real space, first decide if the angle in question is closer to the vertical or the horizontal. If it is closer to the vertical, line up your pencil with the actual angle and, looking only at the top half of your pencil, determine how much before or after six that angle represents (five of six, ten after six, and so on). In the case of a horizontal, you will gauge the direction of the left half of your pencil to determine whether the actual angle is closer to two-thirty or three o'clock (twenty-five of three, or five of three, and so on). When you transfer the angle to your paper, check to see that it tells the same time as the actual angle you are drawing.

ANGLING BETWEEN SPATIAL POINTS

The method just described for angling linear elements in your subject may also be used to measure the degree of angle formed by any two points in your visual field.

First, select two easily distinguished points in the space before you (such as the corner of a table and the center of a clock). Next, angle these two points with your pencil (taking care not to point through the picture plane) and transfer that angle onto your drawing.

TRIANGULATION

Angling between a set of three points on the picture plane can be an invaluable aid in correctly positioning the overall image on your page. To triangulate, first angle between two points and then angle from these two points to locate the third.

The procedure for triangulation is shown in Figure 3–6. When you have followed this procedure, and if you have angled accurately, you will have established three widely spaced points in your drawing. You may then proceed to find other points in your picture by angling from any two points already determined.

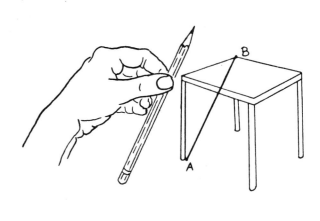

a. Look at the subject through a viewfinder and select three points that roughly form an equilateral triangle

b. Angle your pencil between A and B, record this angle, and mark the points

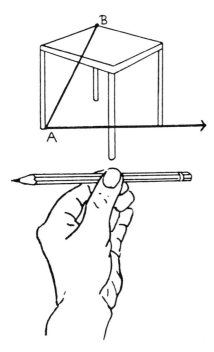

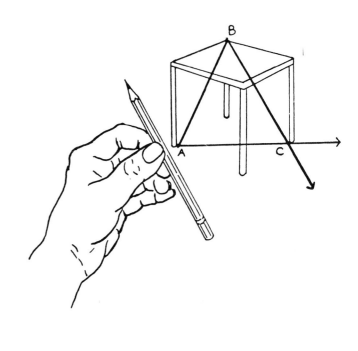

c. Now record the angle that goes from A through C. Extend the line from A beyond where you think C is located

d. Record the angle from B through C. Where this line intersects the previous one is the location of point C

FIGURE 3–6

TIPS ON TRIANGULATION

1. Always look for the largest possible triangle of points within your subject matter. The closer the points come to filling up your format, the more valuable the triangle will be in setting up the entire image.

2. Always try to find a roughly equilateral triangle. If your triangle is made of obtuse and very acute angles, any error in angling will throw off your proportions. If all legs of the triangle are about the same length, a slight miscalculation of angle will not make much difference.

3. If your pencil is not long enough to angle between the two desired points, you have two options: (a) find something longer to angle with, such as a ruler or yardstick; or (b) hold the pencil closer to your eyes.

4. If you have great difficulty picking up the technique of angling, try using the edge of a broad ruler or plastic triangle in lieu of a pencil. The plane of the ruler or triangle will remind you where your picture plane is so that you will have less of a tendency to point through it.

Advice on the Use of Proportioning Techniques

All the devices introduced in this chapter require that you make conscious use of shape and the picture plane to arrive at correct proportions. In many circumstances, the viewfinder will be the first proportioning device to which you will turn. Not only can it help you to select that part of your subject that you wish to draw, but its use will enable you to quickly lay out the overall proportions of your subject on your page. With the information you gather from observing the way in which the shape of objects fill up the opening of your viewfinder, you will be able to sketch in the skeletal structure of your drawing before concerning yourself with any fixed measurement.

Your second choice should be triangulation, the method used to fix the larger relationships between spatial points. It is a speedy and accurate way to proportion the overall image of your drawing. For more localized measurements, you may use the techniques of angling and measuring with your pencil.

Measuring with your pencil on the picture plane will give you a sense of the proportions of any individual shape you see and may also be used to determine the relative dimensions of separate shapes.

Although an overdependence on these mechanical devices can result in drawings that look stilted, the procedures described are beneficial beyond their immediate use for plotting proportions more accurately. First, they sensitize you to the presence of the picture plane. Second, these techniques will, through repeated use, become internalized, so that eventually you will begin to see shape relationships without actually having to go through the motions of angling, measuring, and so forth.

And anytime you are perplexed because a subject is unusual or overwhelming, you may be helped by recourse to one or more of these proportioning devices.

Drawing 1. This drawing will help you understand how the viewfinder may be used as a proportioning device for drawing complex subjects. Choose or set up a subject such as a large still life or a couple of live models in such a way as to yield an interplay of positive and negative spaces. Looking through your viewfinder, scan your subject until you find a good balance of positive and negative spaces. Do a series of quick studies that record the size, position, and shape of those spaces (Fig. 3–7).

Exercise 3A

Drawing 2. In this drawing you will be using triangulation to measure the relationship of points in your visual field.

Look for three widely spaced points in your visual field and triangulate between them. Remember that the three points that compose the corners of your triangle do not need to belong to the same object or be on the same plane, as illustrated in the example in Figure 3–8, in which the lowest rib and toe of one model are connected by triangulation with the groin of the second model, located closer to the viewer. Note also in this example that the student has combined triangulation with the use of a viewfinder, a practice that assists in determining the widest possible spacing of points.

Laying Out Your Drawing

The basic arrangement of the parts of an image within a two-dimensional format is referred to as the *layout* of a drawing. Before you lay out the basic blueprint of your drawing, however, it is crucial that you spend some time considering the visual and expressive potential of your subject.

EXPLORING THE VISUAL POTENTIAL OF YOUR SUBJECT

Because almost any subject you choose to draw will yield a variety of shapes when regarded from different points of view, it is generally advisable to explore your subject's visual potential before you begin to lay out your drawing. Spend

FIGURE 3–7
Student drawing: image made with the assistance of a viewfinder
Charcoal pencil

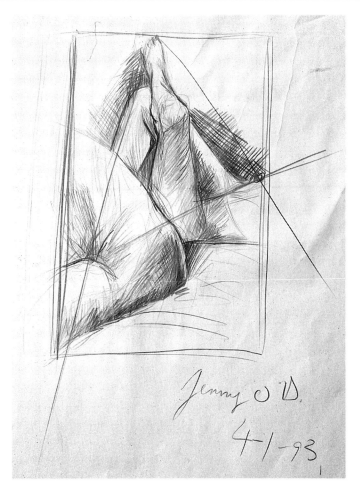

FIGURE 3–8
JENNIFER O'DONOGUE, Cochise College, AZ
Student drawing: proportion achieved with the combined assistance of viewfinder and triangulation
Charcoal pencil
Courtesy, the artist

some time moving around your subject, sizing it up from various vantage points and generally experiencing how different orientations provide different visual aspects of the same source material.

Avoid the all-too-common practice of taking the same seat or easel each time you enter the classroom and then remaining there as if anchored. On the face of it, this practice may seem harmless enough, but it amounts to allowing chance to determine what you will draw.

So as a beginner, you must consciously take the initiative to find a meaningful approach to your subject matter. And remember that the drawing process really begins as you look at your subject to see and weigh the aesthetic possibilities it offers. This process of personal exploration is vital because you will gain a sense of control over what may be a complex situation; your ambitions for your drawing will be more clearly formulated; and you will feel that whatever point of view you ultimately take is one you have chosen for its expressive potential.

PROPORTION AND LAYOUT

Until now we have been discussing proportion in terms of correctly observing and recording the size relationships within your subject. However, proportion is also an issue when you as an artist must decide how best to subdivide the surface area of your drawing.

Artists usually lay out, or sketch in, the major shape divisions of their drawing before working on any one area. But even before you put down the first mark, you are faced with the overall proportional relationship of your drawing surface, namely, the ratio of its length to its width. In standard drawing

pads, the ratio of length to width is often three to four. But you do not have to accept the ratio dictated by the manufacturers of your pad. If you wish a particular drawing to have a square format (or a circular, triangular, or cruciform format, for that matter) you can either cut your paper to the desired shape or even more simply, draw the new format border within the paper you have at hand.

Before you begin to draw you should also decide how to turn your pad so that it is best suited for drawing your subject. Because the standard pad is usually bound along one of its smaller sides, many students automatically set the pad with the bound side uppermost, so that the paper will not flop over. When the pad is in this position, with its longer dimension vertical, the format is called a *vertical format*. Turn the pad ninety degrees and you have a *horizontal format*. (If you customarily stand your pad at a bench or easel and wish to leave your paper in the pad while using a horizontal format, you can use clips to keep the paper from falling forward.)

SCALING THE IMAGE TO THE FORMAT

A major consideration of layout and proportion is how large you should draw a subject in relation to the page.

Some students draw a subject so large that it will not fit comfortably on their paper. But a far more common problem, especially for beginners, is that of drawing a subject so small that it resembles an island floating in the middle of the page. Aside from looking timid, such drawings suffer from a lack of illusionistic depth, since the drawn image in this case reads as a single figure in an unspecified ground. And the overall surfaces of these drawings remain visually inactive, as there is little or no tension between the drawn image and the edges of the format.

The process of adjusting the size of what you draw to the size of your page is called "scaling the image to the format." If you have difficulty scaling the image to your format, consider using the proportioning devices introduced earlier in this chapter.

When using triangulation as an aid in scaling your image to the format, choose three points from your subject which form an approximate equilateral triangle and then transfer them to your paper as described in the section on triangulation. To fill your format, locate these points as close to the edges of the format as possible.

By adjusting the distance at which you hold your viewfinder (anywhere from a couple of inches from your face to full arm's length) you can view a subject at various sizes in relation to the format. If the viewfinder is held very close, the subject may appear to dwindle in relation to the space around it; at half arm's length, it may appear to push insistently against the edges of the format, and at full arm's length you may observe only details of the object. The experience of changing the distance at which your viewfinder is held is akin to manipulating a zoom lens on a camera.

USING THE VIEWFINDER TO INFLUENCE LAYOUT

Scaling the image so as to most expressively utilize your format is just one of the major considerations related to the larger issue of the layout of your drawing. Another major consideration is the placement of the various parts of your subject in relation to the edges of your format. Just as the viewfinder is perhaps the single most helpful proportioning device for scaling your image to your format, so too will its use make you almost instantly aware of the range of possibilities for the placement of the image on the page.

Before you begin to draw, try studying your subject for a few moments

through the viewfinder, not only holding the viewfinder at different distances from your eyes but also shifting it vertically and laterally so that you can see different areas of your subject in relation to a format. Note that when you can focus on details, some of the objects may not be seen in their entirety. This tends to make those objects less recognizable and therefore more easily perceived as abstract shapes.

Figure 3–9 shows different views of a subject as they might be discovered by experimentation with a viewfinder.

Tips on Selecting a Vantage Point

Generally, a subject seen in a foreshortened view will appear to engage space more actively than it will in an unforeshortened view. To demonstrate this, compare a drawing of a bicycle by Alan Dworkowitz (Fig. 3–10) with a catalog illustration of the same subject (Fig. 3–11).

Both drawings may be considered realistic in that they depict the subject in a fair amount of clear and precise detail. There are, however, some fundamental differences between the two. The catalog illustration presents the bicycle in an unforeshortened view so that the potential consumer may see at a glance the various components and accessories this model has to offer. Correspondingly, the illustration avoids a unique vantage point because any part of the presentation that calls attention to itself would detract from the primary intent of the drawing: to sell bicycles.

On the other hand, the intent of Dworkowitz's drawing is not to saturate us with facts but rather to captivate us *visually.* Depicted from a much less expected vantage point, the foreshortened frame of the bicycle enters the illusory space of the drawing in a very aggressive way. With the handlebars and front wheel turned out to the right-hand margin of the page, we may sense an invitation to mount the bicycle, straighten the wheel, and go off touring countrysides.

Tips on Laying Out Your Image

In Figures 3–10 and 3–11 we saw very different treatments of a bicycle in space. A further comparison will show how differently these two images have been

FIGURE 3–9

laid out on the page. In both drawings, the bicycle is featured as a single isolated figure. But in the catalog illustration, the entire bicycle is depicted and there is no boundary between the picture space of the illustration and the printed part of the page. For the purposes of the illustrator, the ground has no character in its own right; it does not imply space, nor does it have any limits that define it as a shape.

In contrast, the drawing by Dworkowitz is made visually exciting by its layout. How the image is laid out is as important as its depicted spatial disposition and precise detail. The fact that the image is cut off so that we see only the front half of the bicycle directs our attention to the space beyond. The empty ground here is dramatically contained; like an empty stage it anticipates action.

You can see, therefore, that while you are examining the subject from various angles, you should at the same time be thinking about how you are going to lay out that subject on your paper. Even when you are concerned primarily with the spatial aspect of your subject, the expressive potential of your page as a flat surface with a particular shape must be reckoned with. The flat piece of paper is all the two-dimensional space allotted to you for your statement; therefore, you should make the greatest possible use of it. If you respond fully to the presence of the drawing's entire surface, all the areas, positive and negative, will have meaning, as in the student drawing in Figure 3–12.

Exercise 3B *As this chapter suggests, such seemingly mechanical decisions about where to sit, which way to hold your pad, and the format to use are actually the underpinnings of your drawing's expression. This project is designed to guide you through these early stages of making a drawing, helping you to understand their sequence and their importance.*

Drawing 1. Choose a subject that is visually diverse and also allows you to view it from a number of angles. Next, with viewfinder in hand move around your subject, carefully considering its visual potential from different vantage points. Narrow down your options and make a set of studies.

FIGURE 3–10
ALAN DWORKOWITZ
Bicycle II, 1977
Graphite, 20 × 18″
Courtesy, Louis K. Meisel Gallery, New York

FIGURE 3–11
Bicycle advertisement
Courtesy of Kuwahara USA and Everything Bicycles, Compton, California

Begin your studies by loosely (gesturally) describing your subject. Take into account the scale of the entire image in relation to its format and how the flat surface of your drawing is being laid out, or subdivided, into positive and negative zones. You may want to blow up selected portions of your subject for individual study, altering the formats as appropriate (Fig. 3–13).

Drawing 2. Once you have become accustomed to the process of selecting portions of your visual field for their design potential, you might try improvising on what you see within your viewfinder. Look at the student drawing in Figure 3–14. In the left-hand side of the page, the student has started with some fairly straightforward details of a clothespin. In the remaining frames, she has let her imagination take control, bending the forms in space and repeating them out of scale.

FIGURE 3–12
Student drawing: effective subdivisions of the drawing's surface into positive and negative areas

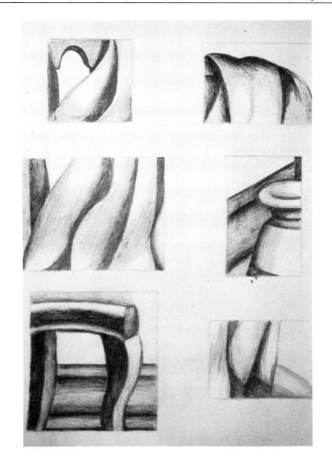

FIGURE 3–13
Karen Roman, University of
Arizona
Student drawing: page of layout
studies

FIGURE 3–14
Angela Burch Tingle, Oklahoma
State University
Student drawing: four studies, two
of which introduce improvisation
Pencil, 18 × 24″
Courtesy, the artist

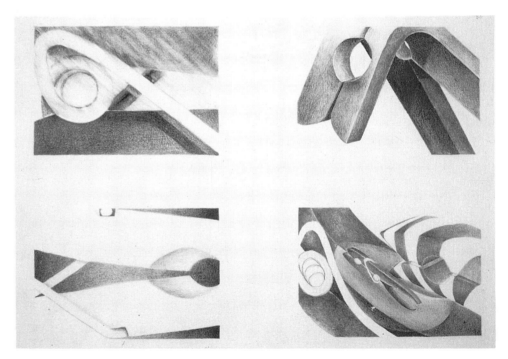

4

The Interaction
of Drawing
and Design

In previous chapters, we established the concept of the flat picture plane. This chapter enlarges on that discussion and in the process confirms that the responses to two-dimensional organization are integral to the practice of expressive drawing, representational or otherwise.

Drawing and Design: A Natural Union

Design, on some level, plays a part in our everyday existence. But much of the order in our lives is taken for granted, from the simple matter of organizing daily routines to managing the more complex forces of, let us say, career and home life into a state of equilibrium.

Indeed, design is such a natural part of our consciousness that when we witness something that is superbly organized—as, for instance, the consummate execution of a double play in baseball—we recognize immediately how wonderfully all the parts had to fit together for that to happen. We are thrilled, and it feels good to witness something so well realized, perhaps because the order in our own lives seldom reaches that pitch of resolution.

In drawing, as in all the arts, design is just as natural and ever-present. In fact, you cannot draw *without* designing. Science revealed decades ago that visual perception itself is an automatic process of selecting and making patterns. This means that when we look at things our eyes and mind begin immediately organizing visual differences and similarities so that we might create order out of potential chaos.

So when you draw to represent your subject, you are simultaneously recording sensations of perceived order. By this we don't mean to imply that you will necessarily create well-designed drawings from the outset of your drawing practice but only that there is no mystery connected with the qualities of design; they are simply a part of common experience.

Principles of Design

When transferred to the art-making process, these qualities of order are generally referred to as the principles of design. They are given names such as *unity* and *variety, contrast, emphasis, balance, movement, repetition* and *rhythm,* and *economy.* The principles of design are used by artists to organize the so-called *visual elements* (lines, tones, shapes, textures, and colors) into a unified drawing.

Distinguishing these design phenomena by name may give the impression that they can be set apart from one another and given fixed definitions. On the contrary, they are frequently inseparable and seemingly unlimited in their interactions. Thus, the descriptions below must, of necessity, be neither final nor precise. These summaries are offered only as a set of guidelines to reinforce what you will quite naturally discover on your own.

UNITY AND VARIETY

Imagine, if you will, a country with a population so diverse that it suffers from internal dissension. Its leaders, recognizing that such discord makes the nation vulnerable, look for ways to encourage unity, or a state of oneness, so that the nation's people may stand consolidated against external aggression.

The process of drawing is in many ways the same. A blank sheet of drawing paper, before you put a mark on it, is a totality. Make a mark and you have interrupted its unity of surface—and thereby created tension. Adding more marks increases the potential for variety, or difference, while also causing areas of potential agreement, or similarity, to emerge. Your goal when drawing is to find ways to harmonize the conflict of varied forces by building on those areas of agreement so that a sense of unity may be restored.

Thus, we may say that the major polarities in a work of art are unity and variety. Unity underlies a work's impact as a complete event; variety is the agent that enlivens a work and sustains interest. In this regard, look at Figures 4–1

FIGURE 4–1
James Rosenquist
Short Schedule, 1972
Pencil, charcoal, pastel, 30 × 40"
© 1994 Estate of James Rosenquist/Licensed by VAGA, New York

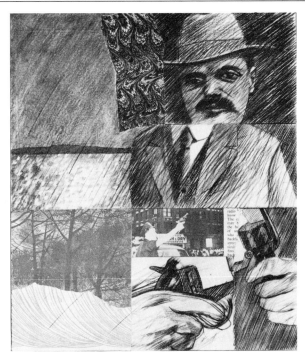

FIGURE 4–2
R. B. KITAJ
Untitled: Cover of the Times Literary
Supplement, c. 1963–1964
Pencil and pasted paper, 15 × 10¼"
The Museum of Modern Art, New York. John B.
Turner Fund

and 4–2. Both are complete visual statements, and yet each in its own way has sufficient variety to leaven the experience. The variations in *Short Schedule* (Fig. 4–1) consist essentially of subtle modifications among the nail groupings; in comparison, the multiple images in Figure 4–2 differ more distinctly in their tonal and textural combinations.

CONTRAST

When aspects of variety in a drawing become more emphatic, contrast is the result. Contrast may refer to pronounced differences in, for example, scale, lights and darks, shape, handling of media, and activity (busy versus quiet).

In the drawing by Lee Bontecou (Fig. 4–3), look at the startling tonal contrasts and also how rounded masses are poised against larger stretches of flat, unbroken shape. As often happens when contrasts are this extreme, the areas in conflict animate each other. They form a relationship based on an attraction of opposites that intensifies their respective differences and helps to bind the drawing together.

EMPHASIS

Looking further at Figure 4–3, you will notice that a definite center of interest has been established in the area of the black ellipse above and to the left of center. This portion of the drawing attracts attention because it represents the largest volume not held in check by an overlapping shape. Note as well the secondary centers of activity to the right of and below the ellipse that echo this dominant elliptical shape.

Levels of emphasis in a drawing are achieved through aesthetic handling (giving certain areas more contrast or a prominent texture, for example); or through the unusual placement or scale of selected lines, tones, or shapes. Without emphasis, the visual clues needed to establish the artist's expressive priorities would be absent. Emphasis assists viewer perception by calling attention to significant parts of a drawing. And by placing the elements in dominant and subordinate roles, emphasis lends a hierarchical structure to a drawing and thereby advances unity.

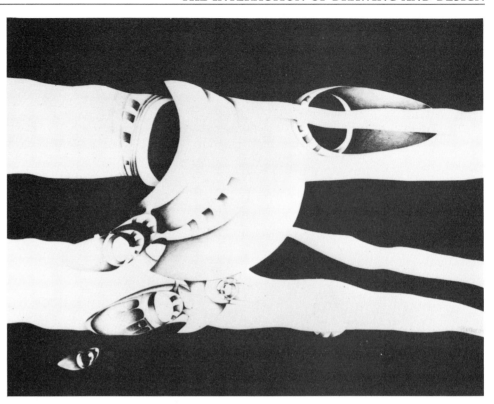

FIGURE 4–3
LEE BONTECOU
Untitled, 1967
Pencil, ink on paper, 20 × 26″
Courtesy, Leo Castelli Gallery

BALANCE

Balance refers to a sense of equilibrium among all parts of a drawing. Typically, drawings are organized on the basis of either symmetrical or asymmetrical balance. The term *symmetrical balance* applies to an image that is divided into virtually mirrorlike halves. Perfect symmetry imparts a formal bearing and is therefore usually reserved for works that are emblematic in character (Fig. 4–4). Many artists who wish to reap the unity that symmetry provides but avoid the cere-

FIGURE 4–4
MYRON STOUT
Delphi I, 1969–1972
Graphite on paper, 4⅞ × 5⅛″
Courtesy, Oil and Steel Gallery. Photographer: Charles Unt

monious quality often attached to perfect symmetry employ instead what is sometimes referred to as *near*, or *approximate, symmetry* (Fig. 4–5).

Ordinarily, though, your working drawings will exhibit a diversity of image characteristics—that is, different shapes, tones, textures, sizes, directions, and so forth—unevenly distributed across the picture plane. In this case you will want to use "asymmetrical balance." *Asymmetical balance* entails adjusting the "visual weights" of what you draw (*visual weight* refers to how much an area attracts the eye) to bring these contrasting forces of your drawing into a state of equilibrium. For example, avoid clustering large, complex events on one side of your page without establishing areas on the other side that, although dissimilar in their visual impact, serve as a counterbalance. In Figure 4–6, for instance, the bold, slightly bowed form moving off the right side of the drawing is in a state of asymmetrical balance with the large, overlapped images and dark, textural markings on the left.

MOVEMENT

When selected lines, tones, and shapes are given emphasis in a drawing, they will often imply direction. These separate directions should be organized into a pattern of movement to fluidly guide the viewer's eye across the entire two-dimensional space of the drawing.

Look at Figure 4–7. Although there is a central focal point in this drawing, the artist has not allowed our eyes to remain idle. We are swept around the surface by a series of curves and opposing diagonals, which are given momentum by changing line weights and clusters of shaded, smaller shapes.

REPETITION AND RHYTHM

Artists often repeat similar shapes, lines, tones, textures, and movements to create organizational relationships in their drawings. Repeated elements do not

FIGURE 4–5
DANA SALISBURY
Grecourt Gates, 1981
Charcoal, 19 × 25″
Courtesy, the artist

FIGURE 4–6
ROY DeFOREST
Untitled, 1974
Pastel and crayon on paper,
22 × 30"
*Courtesy, Frumkin/Adams Gallery. Photo:
Schopplein Studio*

FIGURE 4–7
PIRANESI
Capriccio
*The Pierpont Morgan Library, New York
(1966.11:19)*

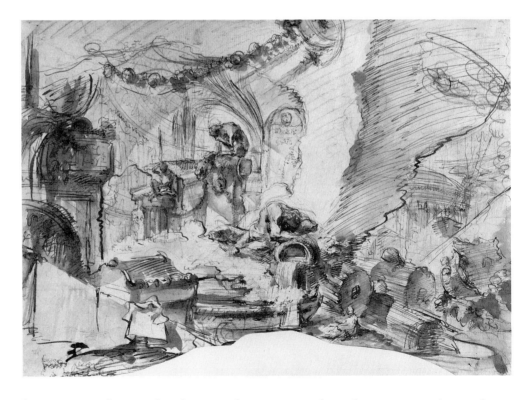

have to reproduce each other exactly, nor must they always appear in an altogether obvious manner. In Figure 4–8, for example, the figure X on the horizon (representing a windmill) is echoed by a larger X in the foreground that is embedded in the landscape, as is made evident in Figure 4–9. This subtle use of pictorial repetition helps to unify both the two-dimensional and the illusory three-dimensional space of the drawing.

When a visual element, such as a line, shape, or unit of texture, is repeated

FIGURE 4–8
EMIL NOLDE
Landscape with Windmill
Brush and black printer's ink on
tan paper, 17½ × 23¼"
*Private collection. © Nolde-Stiftung Seebull.
Reprinted by permission.*

FIGURE 4–9

often enough to make it a major unifying feature in a drawing, it creates what is referred to as a *motif*. In this regard, note the circular variations in Figure 4–10, which assume the various guises of flowerpot, head, rocks, and clouds. And if a particular unit of a drawing is repeated extensively, a marked pattern will result. When a drawing is largely constituted of such a pattern, sufficient variation should occur to avoid visual boredom. In Figure 4–11, two strong motifs create contrasting patterns that enliven the surface of the drawing.

Rhythm is based on the measured repetition of features in a drawing. The more these related elements are stressed, especially if the accents and visual pace (or tempo) are varied, the more pronounced the rhythm will be in a work of art. Look, for example, at Figure 4–12, in which both the similar movements of the tree trunks and the intervals of negative space between them are charged with an alternation of stronger and weaker accents.

Rhythm can also be used to invest an otherwise uniform pattern with a sense of pulse. In René Magritte's *The Thought Which Sees* (Fig. 4–13), the delicate tonal changes in the marks create a unified surface that optically vibrates. This work is also a prime example of how organizational properties in a drawing can

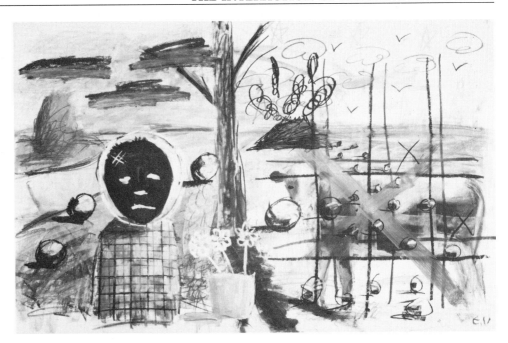

FIGURE 4–10
ED VALENTINE
Sketch Page with Dead Tree, 1986
Oil crayon/pastel on paper,
26 × 46"
Courtesy, the artist

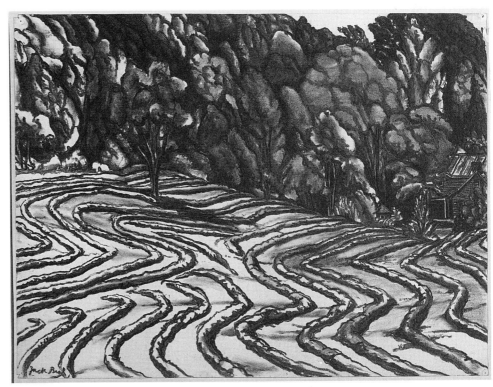

FIGURE 4–11
JACK BEAL
Fat Landscape, n.d.
Charcoal and white chalk

extend meaning: the meter of the finely woven pattern of marks recalls the hypnotic rhythms of the depicted waves and rolling clouds.

ECONOMY

From time to time, you may find a drawing you are working on is too complicated and, as a result, appears disorganized. In that case, it will be important for you to rework certain aspects of the drawing, strengthening latent areas of similarity and eliminating nonessential areas of difference. By this means, you will clarify relationships so that a simpler arrangement is achieved, thus imparting to your

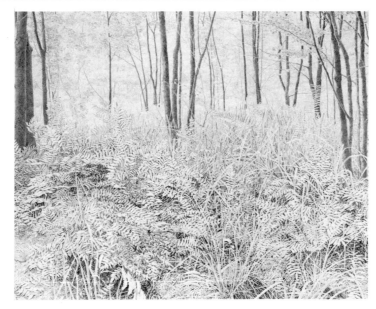

FIGURE 4–12
BILL RICHARDS
Fern Swamp, 1974
Graphite on paper, 17 × 21½″
Courtesy, Nancy Hoffman Gallery, New York

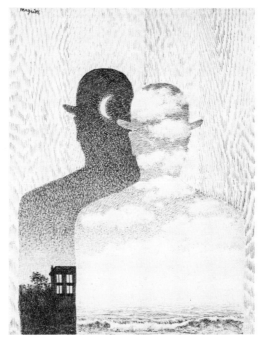

FIGURE 4–13
RENÉ MAGRITTE
The Thought Which Sees, 1965
Graphite, 15¾ × 11⅝″
The Museum of Modern Art, New York. Gift of Mr. and Mrs. Charles B. Benenson. © 1996 C. Herscovici, Brussels/Artists Rights Society (ARS), New York

drawing an economy of expression. Economy is not based on limiting the number of things portrayed, however. Instead it depends on each part of a work contributing to a larger system of order, as in Figure 4–14. In this drawing the complicated patterns are organized into a simpler system of tonal areas and offset by the strategically placed banners. Note as well the variously accented rhythm of the heads.

Here are three simple exercises that will provide countless hours of challenging drawing in your sketchbook.

Exercise 4A

Drawing 1. *Choose a subject that clearly exhibits a particular design principle. A landscape, for example, may be perceived as having asymmetrical balance, and ivy growing on a wall may demonstrate the concept of pattern. Carefully observe and draw your subject, paying special attention to its particular design implications and how they may be extended. Refer to the drawing of a piano (Fig. 4–15), in which the contrast between large and small parts is emphasized.*

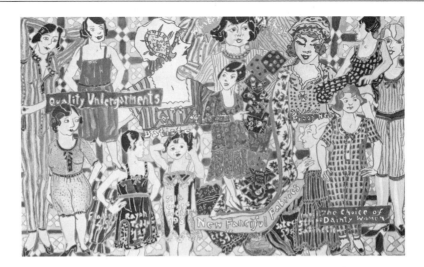

FIGURE 4–14
MIMI GROSS
The Choice of Dainty Women, 1973
Crayon and gouache, 14 × 21¾"
Courtesy, the artist. Photo: Bevan Davies

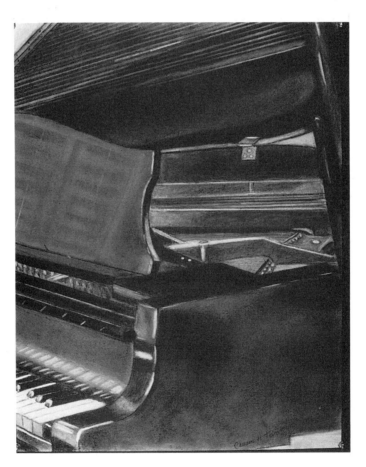

FIGURE 4–15
CHEREEN TANNER, Arizona State
University
Student drawing: contrasting size
relationships as an organizing
device
Charcoal, 18 × 24"
Courtesy, the artist

Drawing 2. *Choose a common object as the source of a motif for your drawing. Repeat the object, or selected parts of it, across your paper. Provide some variety by, for instance, turning the object over to depict its other side, as in Figure 4–16, or overlapping some of the images. Alternatively, you may wish to draw your objects in different visual guises, that is, change their scale, clarity, positive–negative status, and so forth. Or perhaps as the drawing proceeds, you may wish to place more emphasis on certain areas to establish a center of interest and also to develop paths of movement to guide the eye through your drawing (Fig. 4–16).*

Drawing 3. *The goal of this drawing is to combine two or more design ideas without sacrificing either unity or variety. In Figure 4–17, the generally globular shape of the vegetables constitutes*

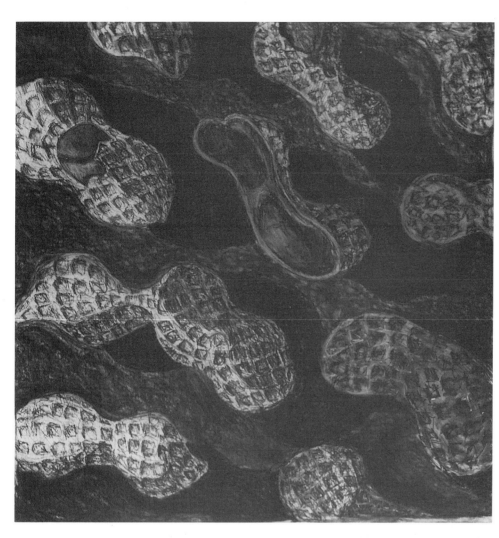

FIGURE 4–16
Gregory Boas, Pratt Institute
Student drawing: peanut motif
4 × 4'
Courtesy, the artist

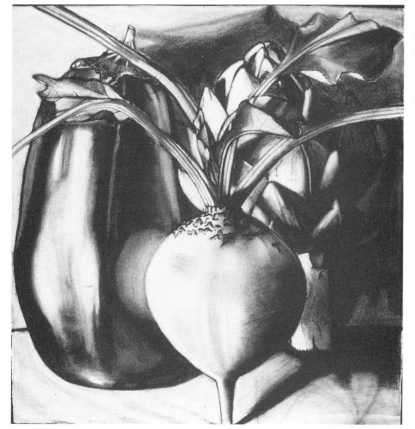

FIGURE 4–17
Marcia Smartt, Middle Tennessee
State University
Student drawing: still life
combining motif, contrast, and
repetition of forms
Charcoal, 28 × 22"
Courtesy, the artist

a unifying motif, a unity that is strengthened by the near-symmetrical arrangement. But note how the linear stalks of the beet top provide a strong contrast to the relatively broad, gleaming sides of the eggplant.

Gesture Drawing as a Means to Design

In Chapter 1, gesture drawing was presented as the primary way for artists to grasp the essential visual character of an object or a space. But a gesture drawing may also serve as the foundation, or "rough," for the more sustained development of a particular image.

At times, artists will divide a page into several formats to test, in a sort of gestural "shorthand," how a subject may best be laid out in preparation for a sustained work (Fig. 4–18).

But just as frequently, marks from gestural explorations serve as the underpinning for a work in progress and so are not apparent in the finished product. The gestural spirit of search and discovery remains embedded, however, in the naturalness with which the subject has been represented.

A particularly illuminating example of this may be found in Figure 4–19. In this drawing, Giacometti, the twentieth-century Swiss artist, has penetrated below the surface detail of a section of a fifteenth-century painting by Hubert and Jan van Eyck (Fig. 4–20) to expose the work's latent gestural energy and structural conviction.

FIGURE 4–18
Max Beckmann
Study for the Night
Pen and ink

Allan Frumkin Collection of Prints by Max Beckmann. Photograph © 1994, The Art Institute of Chicago (RX3265). All Rights Reserved.

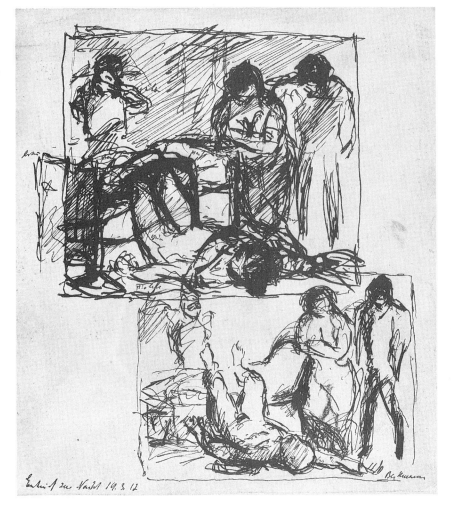

FIGURE 4–19
ALBERTO GIACOMETTI
Landscape
Pen on paper
© 1994 Artist's Rights Society (ARS), New York/
ADAGP, Paris

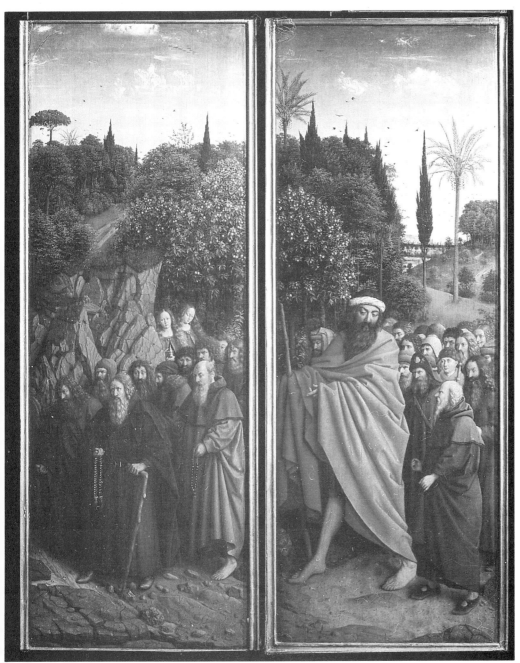

FIGURE 4–20
HUBERT AND JAN VAN EYCK
"The Adoration of the Mystic
Lamb," detail of *The Ghent
Altarpiece,* front right-hand panels,
1432
Tempera and oil on wood
Giraudon, Art Resource, NY

The Giacometti is thrilling to look at not only because it is a beautiful drawing in its own right but also because it functions as a sort of x-ray, interpreting for the onlooker what takes place inside another work of art. This latter point is especially significant for us, since it suggests that artists may use gesture drawing as a tool to diagnose the basic state of their *own* works in progress. Let us suppose, for example, that after a drawing is well under way you decide that parts of your image are lacking in structure or that the overall design is in some way deficient. In response, you might very well make gestural studies on separate sheets of paper so as to analyze these shortcomings prior to resolving them in the actual work.

Giacometti's interpretive drawing has another far-reaching implication for the drawing student. You will notice that he deliberately made a format border to enclose the excerpt of the Ghent altarpiece he chose to draw. His awareness of the rectangular shape within which to conduct his search suggests that gestural activity may be intimately linked with the design conception of a drawing.

In fact, we may say that design in a drawing is often initiated when gestural responses to a subject are laid out and scaled to the limits of the drawing's format. Barlach's gestural study (Fig. 4–21) has admirably taken into account the overall proportions and rudimentary structural properties of this running figure. But what interests us most here is the way in which the figure's extension into space coincides with the paper's edge. This is significant because, while Barlach took visual possession of the man's image, he simultaneously took physical possession of his drawing surface.

This simultaneous seizing of the gesture of the subject along with the total engagement of the picture's surface is typical of gesture drawing at its best. In the heat of the moment, the artist's own eye and arm generalize the expressive attitudes and organization of parts that are characteristic of the subject. At the same time, the artist is intuitively aware of how the placement and directional energies of the emerging image relate to the rectangular page on which it is drawn. While in the act of drawing, the edges of the drawing constitute the boundaries of the artist's visually created world, so the artist feels the necessity of making the image within those bounds as absolutely real and immediate as possible. Consequently, we are often excited when looking at a gesture drawing, at seeing so much energy packed into a small, flat space. This principle applies even to the drawing of nonobjective images, as may be seen in the gestural study by sculptor Richard Serra (Fig. 4–22), in which a quadrilateral form has been dramatically represented on an unusually large sheet of paper.

FIGURE 4–21
ERNST BARLACH
Running Man, 1918
Charcoal on white drawing paper,
22.8 × 30 cm

*Courtesy, Ernst und Hans Barlach
Lizenzverwaltung Ratzeburg, Hamburg, Germany.
Photo: Thormann*

FIGURE 4–22
RICHARD SERRA
Zonder Titel
Rijksmuseum Kröller-Müller, Amsterdam, The
Netherlands. © 1996 Richard Serra/Artists Rights
Society (ARS), New York

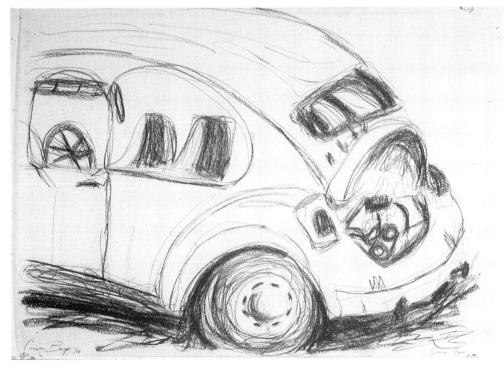

FIGURE 4–23
CRYSTAL BRAY, Arizona State
University
Student drawing: gesture drawing
of a single object
Charcoal, 18 × 24"
Courtesy, the artist

Beginners often start with single objects to get the feel of gesture drawing and its design implications (Fig. 4–23). But the gestural approach is equally appropriate for subjects comprised of multiple objects, such as still lifes, interiors (Fig. 4–24), and landscapes (Fig. 4–25). Drawing multiple objects challenges the artist to empathize with the unique gestural expression of each part of a subject. And as individual gestures are realized, the artist must be alert to correspondences that emerge between areas, since they will suggest larger gestural patterns, which may in turn point to options for organizing the drawing overall.

Look, for example, at *The Farm* (Fig. 4–26) by John Bennett. Each area has its own kind of gestural shorthand, producing a work that is fresh and altogether unstudied in expression. But as an outgrowth of its spontaneity, the trailing lines from each major division of the page create a zigzagging pattern that purposely binds together the spatial illusion and surface design of this drawing.

FIGURE 4–24
EDGAR DEGAS
Study for Interior
Pencil
Bibliothèque Nationale, Paris

FIGURE 4–25
FRANK AUERBACH
Study for Mornington Crescent, 1967
Pencil, 9⅞ × 11¾"
Private Collection, New York

It is interesting to see how the drawing by Gaspar Van Wittel (Fig. 4–27) retains a similar gestural freshness. In this work, the slashing marks and abruptly brushed areas of wash summarize the major spatial planes. At the same time, they describe the edges of a mountain range, cuts in the landscape, and the underside of a mass of vegetation that advances toward the picture plane. But much as with Bennett's drawing, these same marks are also the agents of an inventive design strategy in which positive and negative zones are melded into a cohesive unit.

To clarify this last point, compare Figure 4–27 with Figure 4–28. Note that Van Wittel divided his page into three major areas, and also see how he grouped the dominant dark masses into a tilted, rectangular shape that rests on the bottom edge of the drawing, poised, it would seem, to move into spectator space.

Exercise 4B *These two projects will urge you toward a more gestural conception in your work.*

Drawing 1. *Imagine some scene or narrative that involves numerous figures distributed across a ground plane. Taking a broad medium, such as lecturer's chalk or a good-sized brush charged with ink or paint, draw the figures in such a way as to indicate their spatial position while at the same time taking possession of the entire drawing format (Fig. 4–29).*

FIGURE 4–26
JOHN BENNETT
The Farm, 1981
Pencil, 9 × 6″
Courtesy, the artist

FIGURE 4–27
GASPAR VAN WITTEL
View of Tivoli, 1700–1710
Pen and brown ink
Courtesy, Courtauld Institute Galleries, London

Drawing 2. *Drawing from an observed subject, gesturally record its major axes and spatial movements. Be sure to draw the image large enough so that your gestural marks are also responsive to the two-dimensional area of your paper.*

Finish your drawing, developing its design implications but without losing the spontaneous character of your initial gesture drawing (Fig. 4–30).

FIGURE 4–28

FIGURE 4–29
ANN CARROLL, Indiana State
University
Student drawing: gesture drawing
used as a means to design
Courtesy, the artist

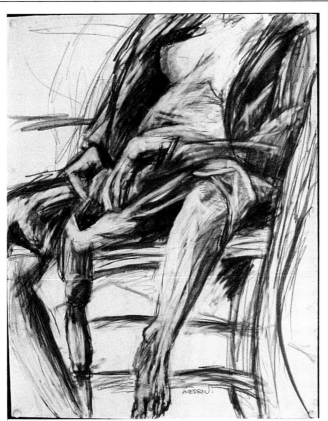

FIGURE 4–30
JILL ANDERSON, University of
Arizona
Student drawing: sustained gesture

Linear Perspective

Because linear perspective has the aura of a technical subject, many students think it is difficult to understand. But while perspectival systems involving complex mechanical procedures have been developed for people who do technical drafting (such as architects, designers, and engineers), the basic concepts behind linear perspective are few and simple, and therefore easily within the grasp even of those who are not technically minded.

Point of View

In its broadest sense, perspective drawing refers to the representation of things as they are arranged in space and as they are seen from a *single point of view*. Therefore, what is central to the issue of drawing in perspective (whether we are employing linear or atmospheric perspective)* is the concept of the artist's bodily position in relation to the things represented.

When looking at a drawing or painting, we tend to identify with the implied point of view; that is, we instinctively know whether the artist was looking up, down, or straight ahead at the subject. In the drawing by Henry Schnakenberg (Fig. 5–1), for instance, there is no doubt about the artist's viewpoint. In con-

FIGURE 5–1
HENRY SCHNAKENBERG
Forest Carpet, 1924
Watercolor on paper, 11¾ × 15¾"
Collection of Whitney Museum of American Art,
New York (31.463)

*See Chapter 1 for a discussion of atmospheric perspective.

sequence, our own inferred position is consistent and clear, perched as we are above this forest floor covered with leaves and needles.

Because a fixed viewpoint in a picture helps establish a convincing illusion of space, it is generally recommended that aspiring artists understand how to achieve a fixed viewpoint in their work. It is important to recognize, however, that an artist's choice to develop a consistent viewpoint in a particular work depends on the demands of subject matter and expression. In this regard, let us compare two works.

The multiple points of view in Mstislav Dobuzinskij's drawing (Fig. 5–2) serve to disorient the viewer and reinforce the work's phantasmagorical quality. On the other hand, the untitled drawing by Vincent Desiderio (Fig. 5–3) elicits a strong response from the viewer due to its unconventional, yet thoroughly consistent, point of view.

THE CONE OF VISION

To better understand the three-dimensional character of things you see, think of your field of vision as a conical volume whose apex is located at your eyes. Since this cone extends as far as you can see, there is no fixed or actual base to the cone, but when you imagine a picture plane (window on nature) intersecting this cone, its base lies within the plane (Fig. 5–4a).

FIGURE 5–2
Mstislav Valerianovic
Dobuzinskij
The End, ca. 1918–1921
Brush and black and gray wash
with charcoal and graphite on ivory
wove paper laid down on cream
wood-pulp laminate board, 61.5 ×
45.5 cm

FIGURE 5–3
Vincent Desiderio
Untitled (one of a series of four drawings dedicated to Salvador Allende), 1985
Charcoal on paper, 50″ (diameter)
©1994 Vincent Desiderio/Licensed by VAGA, New York. Courtesy, Everson Gallery

(a)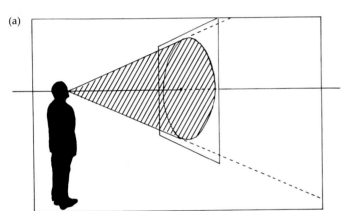

(b)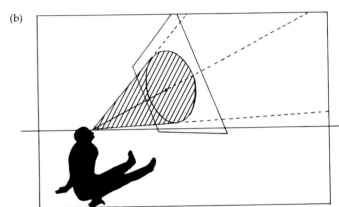

FIGURE 5–4

Let us take a moment to investigate the cone of vision. If you were to lift your eyes from this book and look across the room, or better yet, out a window, you would note that your eyes can take in the entire image of something large when it is a fair distance away. For instance, you would be able to see the full image of a medium-sized building at a single glance if it were across the street from you. Something much smaller and yet far closer, such as this book held broadside against your nose, however, could more than fill up your cone of vision. This little experiment should make you more conscious of the fact that what we think of as a field of vision is actually a conical volume.

If you tilt your head back to look up, the cone of vision will be angled away from the ground. The picture plane, which contains the base of the cone of vision, will also be at an angle, as illustrated (Fig. 5–4b) but still in the same relationship to the eye.

FIXED POSITION

Artists not trained to draw in perspective often combine what they *see* with what they *know* in such a way as to produce contradictory information. As an example, let us compare the freehand drawing a beginning student might make of a square-topped table (Fig. 5–5a) with the drawing the student would make if the image were traced on glass (Fig. 5–5b).

The student knows that the table has a square top and four vertical legs. But the top of the table is perceived as a square only when it is parallel to the picture plane (as when seen from directly above), and from this vantage point it is impossible to see any of the table legs. So, the student makes the compromise of drawing what is known (that the tabletop is square) with what can actually

be seen from that vantage point (three out of four table legs). In effect, Figure 5–5a attempts to show two entirely different views of the table.

The drawing in Figure 5–5b, on the other hand, shows what the table would look like from a single point of view. Notice that you still have no difficulty recognizing that the tabletop is square, although it is not drawn that way. The irregular shape that represents the tabletop is, in fact, what we expect to see when a square is at that particular angle to the eyes. Furthermore, it is consistent with the position of the table legs.

A picture in which all elements are drawn so as to be consistent with a single point of view conveys a sense of fixed position. *Fixed position* may be defined as the exact location of the viewer's eyes in relation to the subject. To achieve a consistent point of view in your drawing, it is important to maintain a fixed bodily position in relation to your subject. In other words, do not move closer or farther to the left or the right, do not stoop down or stand on tiptoe, to obtain another view of what you are drawing.

THE CONCEPT OF EYE LEVEL

Eye level may be defined as the height at which your eyes are located in relation to a ground plane. So often taken for granted, an awareness of eye level is essential to the understanding of fixed position.

In respect to a three-dimensional space, eye level should be thought of as the horizontal plane in which your eyes are located. To get a better idea of this concept, it might be helpful to hold up a piece of thin cardboard horizontally to your eyes so that you can see only the edge of it. Since you can see neither the top nor the bottom of the cardboard, we can describe the cardboard in this position as a diminished horizontal plane.

If you are standing on level ground, the diminished horizontal plane will be parallel to the ground plane. But because of your vantage point, the ground plane will *appear* to tilt up to meet the diminished horizontal plane. The apparent intersection of these two planes forms what we will call the *horizon line*.

Eye level is described as high or low by virtue of its distance from the ground plane. We think of normal eye level as that of an average person when standing up—say about five and a half feet above the ground plane. Many representational drawings make use of this conventional eye level, but any time a drawing is executed from a vantage point radically different from the normal one, we are aware that its implied eye level is unusually high or low. In the Michael Heizer work (Figure 5–6), we identify with the bodily position of the aerial photographer because our experience tells us that only from an extremely high vantage point are we able to see so much of the ground plane.

When looking at works of art, however, we are generally more concerned with the implied eye level in relation to the subject than we are with the artist's actual eye level at the time of execution. In the Joel Janowitz drawing (Fig. 5–7), the artist's actual eye level is unknown, but we have no reason to believe that it departs radically from the height of a standing person. What we do notice is

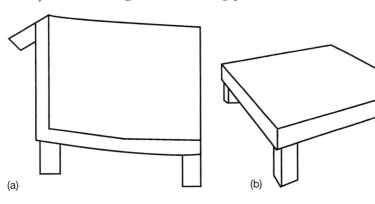

FIGURE 5–5

(a) (b)

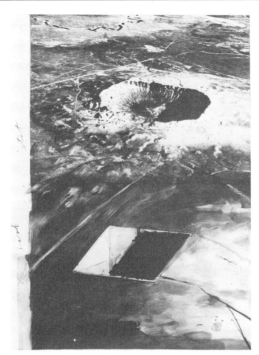

FIGURE 5–6
MICHAEL HEIZER
Untitled, 1969
Photograph, graphite, and
watercolor on paper, 39 × 30"
*Collection of Whitney Museum of American Art,
New York. Gift of Norman Dubrow (80.26.1)*

FIGURE 5–7
JOEL JANOWITZ
The Painter, 1974
Charcoal, 28 × 38¾"
Courtesy, the artist

that we seem to be looking almost straight up at the subject. So in this case, we would describe the eye level of the drawing as low because of its relation to the subject. Notice that in both this drawing and in the Heizer, the eye level is so extreme that horizon lines do not even appear within their formats.

Establishing the eye level in a drawing means simply acknowledging that the things portrayed have been seen by looking up at them (they are above eye level, or seen from what is commonly referred to as "worm's-eye" view), or looking down at them (they are below eye level, or seen from what is commonly referred to as "bird's-eye" view). Sometimes artists draw a horizontal line across their paper to indicate their eye level. Placement of this line is discretionary; what does matter is that once the eye level is determined in a drawing, all descriptions of objects should be consistent with that viewpoint.

Exercise 5A

A consistent viewpoint in a drawing helps to establish a convincing illusion of space; it also immediately communicates to the viewer an important aspect of the way you perceived your subject.

For this exercise, draw a still life that consists of small objects, or even a single object, from various eye levels. Figure 5–8 shows a simple arrangement of objects from different points of view.

Convergence and Fixed Position

One of the concepts central to the study of linear perspective is that parallel lines in nature appear to converge (come together) as they recede. This phenomenon is such an integral part of common experience it has even been the basis of a popular cartoon (Fig. 5–9). If you followed the angling exercise in Chapter 3, you probably verified the apparent convergence of parallels in your subject for yourself. And if you were very observant or already possessed some knowledge of linear perspective, you noticed that this convergence occurs at eye level.

Before the invention of the system of linear perspective, artists had recognized that receding parallels translate into diagonals on a picture's surface. The rules governing the use of these diagonals were very general. As you may see in the Giotto fresco (Fig. 5–10a), there is an understanding that sets of parallel lines should converge. But the idea is not extended to include all sets of parallel lines. Notice, however, that, if extended, all the parallel lines in this painting do converge on a vertical axis (Fig. 5–10b).

Now, compare the Giotto fresco with the one painted by Masaccio in 1425, shortly after the development of linear perspective (Fig. 5–11). We see a marked difference between the new system used here and the less complete system used by Giotto. Notice in Masaccio's fresco that all the diagonals in the architecture can be extended to meet at a single point located at the base of the cross. This point indicates the viewer's fixed position as centered laterally on the composition and at an unusually low eye level.

Our own culture has come to expect pictures to have a fixed point of view. The prevalence of photography in our society reinforces this expectation. (The forerunner of the photographic camera is in fact the *camera obscura*, an instrument that aided the artist in recreating a perspective view of a subject by funneling its image through a small aperture, thus simulating a single point of view.)

FIGURE 5–8
MELISSA BARTELL, University of Arizona
Student drawing: still life at three different eye levels

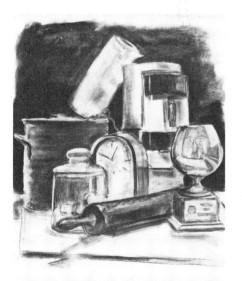
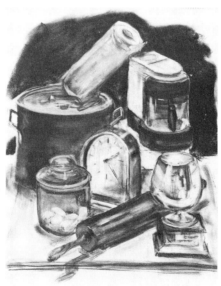

FIGURE 5–9
WEBER
"Look here, men, shouldn't that be the other way around?"
Cartoon
Reprinted by permission of Esquire. © 1966 by Esquire Magazine and the Hearst Corporation.

Artists in general, but especially filmmakers, often use perspective to make the viewer more aware of a specific viewpoint, with the intent of heightening the suspense of a scene. Look at the movie still in Figure 5–12. Although you may be disoriented by the tilted camera angle and the dramatic shadows, you can follow the converging lines so as to obtain a strong indication of the camera's position (just inside the lower left-hand corner of the frame). As a viewer, you naturally identify with the camera's "eye," and as a result you feel that you are a half-hidden witness to the scene. It is this sense of being a voyeur to terrifying or sordid events that the makers of psychological melodrama wish to exploit.

Having made these general observations about the artistic uses of two concepts central to linear perspective—fixed position and the convergence of parallel lines—we will now explain the whole system in greater depth.

FIGURE 5–10a (left)
GIOTTO
Innocent III Approves the Rule of the Order
Alinari/Art Resource, NY

FIGURE 5–10b (right)

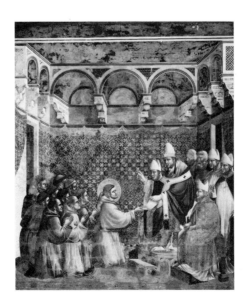

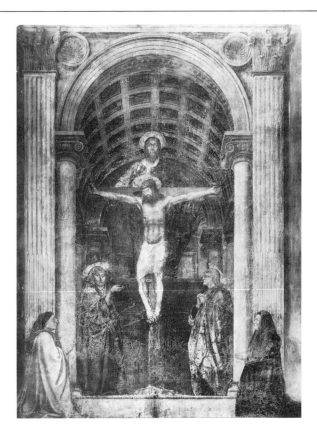

FIGURE 5–11
MASACCIO
Trinity with the Virgin and St. John
Alinari/Art Resource, NY

THE DIMINUTION OF OBJECTS

The convergence of parallel lines on the picture plane is directly related to the phenomenon of more distant objects appearing smaller. This phenomenon can be explained by examining how two things of identical size, but at different distances from the spectator, relate to the spectator's cone of vision.

Let us suppose you are standing in a position where you can see two

FIGURE 5–12
Film still from Peter Lorre's *Stranger on the Third Floor*, shot with Peter Lorre and John McGuire on a staircase
Museum of Modern Art, New York/Film Stills Archive

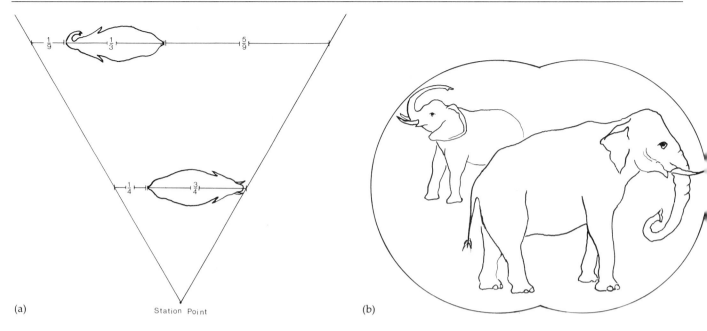

(a)

Station Point

(b)

FIGURE 5–13

elephants in profile. One is perhaps thirty feet away from you, and the other only ten feet. The closer elephant will be located near the apex of your cone of vision. In an illustration of this (Fig. 5–13a), the trunk is barely included within the farthermost right ray of vision. There is a space of about one-third of the elephant's body length left between the tail and the left ray of vision. Therefore, in Figure 5–13b, the shape of the elephant fills three-quarters of the binocular shape that makes up the field of vision. Let us say that the second elephant is the same size as the first. As it is farther from the apex of the cone of vision, the length of its body takes up a far smaller proportion of the cone. The image will, therefore, take up correspondingly less area in the field of vision.

THE CONVERGENCE OF PARALLEL LINES

The principle of the diminution of objects can be used to explain the apparent convergence of parallel lines as they recede from the spectator's station point. We will use the familiar image of the railroad track disappearing into the distance to demonstrate the idea of convergence. (Note that when dealing with the system of linear perspective, the fixed position you occupy in relation to your subject is referred to as the *station point*, abbreviated SP in our illustrations.)

In Figure 5–14a, you are standing on a railroad track, midway between the two rails. The track a few feet ahead of you fills up the lower part of your field of vision. As the track recedes, it takes up proportionately less space in both your cone of vision and your field of vision (Fig. 5–14b).

One-Point Perspective

The example of the railroad track is a classic demonstration of *one-point perspective*. The "one-point" referred to is the vanishing point.

THE VANISHING POINT

The illustrations in Figure 5–14 depict only the near sections of the railroad track. If you were to stand at the center of a straight stretch of railroad track you could look down the rails until they appear to finally converge. This point of conver-

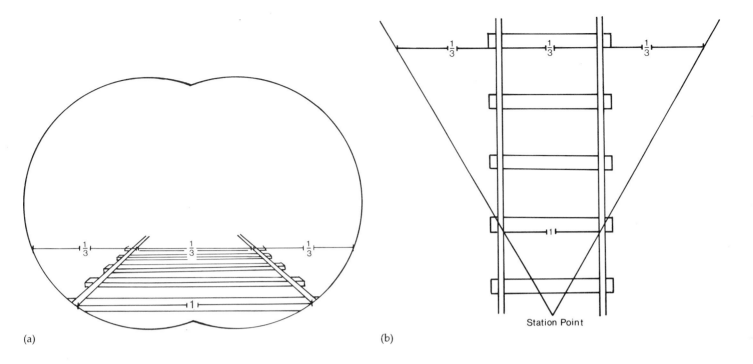

(a)

(b)

FIGURE 5–14

gence is called the *vanishing point* (abbreviated VP in our illustrations). Presuming that the ground we are standing on is flat, the vanishing point will be located on the horizon line.

EYE LEVEL AND THE RATE OF CONVERGENCE

If one had a view of the track from the top of an engine, one would see the tracks converging at a slow rate toward a high vanishing point (Fig. 5–15a). If, however, one had the misfortune to be tied to the railroad track, one would see the tracks converging sharply to a low vanishing point (Fig. 5–15b).

DIMINUTION OF UNITS ON A RECEDING PLANE

In studying the preceding illustrations, you probably noticed that the spaces between the railroad ties became progressively smaller as the tracks converged. Refer to the illustration in Figure 5–16 and follow the three steps below used to arrive at the proper spacing of the ties.

FIGURE 5–15

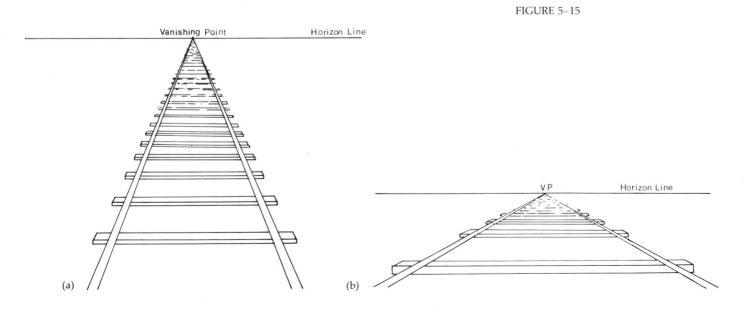

(a)

(b)

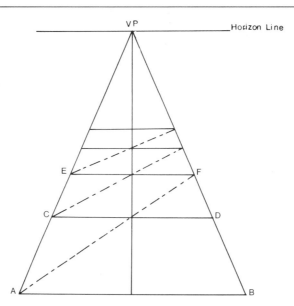

FIGURE 5–16

1. Draw the first tie at the bottom of your page. Carry a line from the center of the first tie up to the vanishing point. This line will bisect the angle formed by the two tracks. Draw the second tie at an appropriate distance from the first. (If you were drawing from nature, you could arrive at this appropriate distance through angling or measuring with your pencil, as described in Chapter 3).

2. Draw a diagonal line from point A through the point at which the line bisecting the angle of the tracks intersects with tie CD. Where this diagonal line intersects the track on your right put another horizontal for EF.

3. Successive ties can be located by repeating the procedure.

THE RECTANGULAR VOLUME: INTERIOR VIEW

The preceding demonstration showed how to draw a railroad track from a vantage point above the center of the track. In this case, there was one set of parallel lines that appeared to converge at one point on our eye level. Now we will add a second set of parallel lines above the eye level (Fig. 5–17). A line of telephone poles running parallel to each track would carry cables that also vanish at the same point as the railroad tracks. (Note that in spacing the telephone poles we use a procedure similar to that described for placement of the railroad ties. In this case, the first operational line is extended from the midpoint of the first telephone pole to the vanishing point. This line will divide the height of each pole in half.)

If we were to enter a long, rectangular room from a doorway located at the center of one of its shorter walls (Fig. 5–18), we would see a space similar to that of the railroad track flanked by telephone poles. The perspective of the room is, of course, more subtle, since the vanishing point is obscured by the end wall. But note that in the illustration, the receding lines of the floor, wall, and ceiling, if continued, converge at one vanishing point located at eye level. The horizon line in this case may be observed through the windows.

Note also that all horizontal lines on the wall facing the viewer, and any other horizontal line parallel to the picture plane, appear as horizontal. Any horizontal line located at the eye level appears as a horizontal, regardless of its angle to the picture plane. All vertical lines retain their vertical aspect.

Exercise 5B *To apply what you've learned about one-point perspective, find a long, rectangular room or corridor. Station yourself at the center of one end. Notice that all the receding horizontal lines on the walls, ceiling, and floor converge at the same point.*

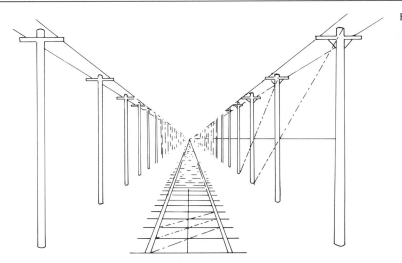

FIGURE 5–17

Draw the corridor, using your skills at angling to find the vanishing point. To achieve proportion, use a combination of triangulation and measuring with your pencil, as discussed in Chapter 3. The student drawing of a subway car (Fig. 5–19) is a good example of the use of one-point perspective seen from a normal eye level.

Figure 5–20 shows another subject seen in one-point perspective. In this case, the low eye level makes the massive architectural elements more dramatic.

THE RECTANGULAR VOLUME: EXTERIOR VIEW

Now that you have an understanding of the interior of a rectangular volume viewed from one end, the next step is to look at the volume from the outside. If the rectangular volume or box is held at eye level so that its front face is parallel to the picture plane, it will appear as a flat rectangle (see Fig. 5–21a). This view does not give any information about the three-dimensional nature of the box. If, however, the box is lowered slightly so that we see its top as well as its front, it will appear as it does in Figure 5–21b. Right away we have an indication not only of the box's three-dimensional nature but also of our own eye level in relationship to it.

If the box is shifted so that it is not quite centered on your line of vision,

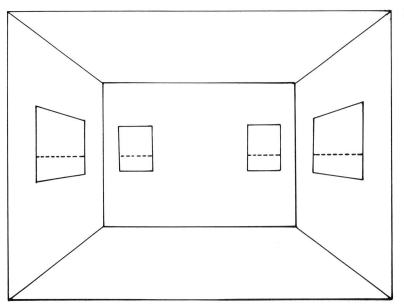

FIGURE 5–18

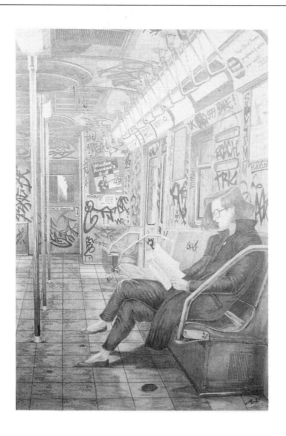

FIGURE 5–19
KEVIN NGAI, Jarvis Collegiate
Institute, Toronto
Student drawing: subway car in
one-point perspective
Courtesy, the artist

but not so far that you can see a third face (see Fig. 5–21c), you will still be able to draw it in one-point perspective.

Study Figure 5–22 to understand how the concealed faces of these boxes would be drawn if the boxes were transparent.

Exercise 5C *Find a rectangular volume of some sort. A box or block of wood will do. It may be a cube but it need not be.*

Place it so that one face is roughly parallel to the picture plane. Draw the box at different relations to your eye level. To determine the vanishing point, angle the converging lines.

Two-Point Perspective

THE RECTANGULAR VOLUME IN TWO-POINT PERSPECTIVE

When a rectangular volume is positioned so that none of its faces is parallel to the picture plane, you will no longer be able to draw it using one vanishing point. Figure 5–23 shows three cubes positioned so that their vertical faces are at a forty-five-degree angle to the picture plane. Notice that in this schematic drawing, the cubes are stacked so that they all share the same two vanishing points.

In most drawing encounters with boxlike forms, you will make use of two-point perspective. But although all items in a given situation may require treatment in two-point perspective, they will not necessarily share vanishing points. Figure 5–24 shows a variety of boxes drawn in two-point perspective. As they are all positioned with their base planes on or parallel to the ground plane, the vanishing points will be located on the horizon line.

Notice that the cluster of boxes labeled A shares common vanishing points whereas cluster B does not. Box C is drawn as if transparent. Box D is positioned so that we see a great deal more of one face than the other two. In such a case,

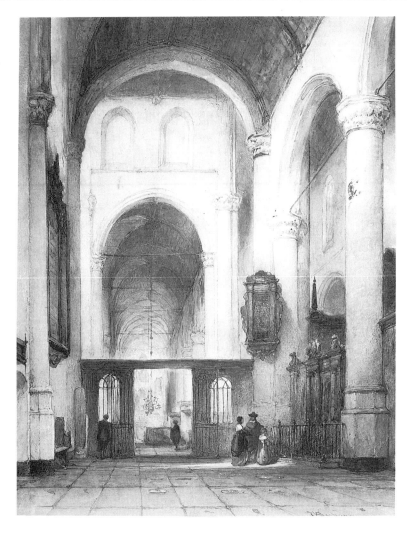

FIGURE 5–20
JAHANNES BOSBOOM, Dutch
(1817–1891)
Church Interior
Watercolor and gouache over
graphite on cream laid paper, n.d.,
41 x 31.2 cm.
Bequest of Irving K. Pond (1939.2243). Photograph
© 1994, The Art Institute of Chicago. All Rights
Reserved.

the vanishing point for the greater face will be located farther away. (The place-
ment of vanishing points is based on judgment. Sometimes you may find it
necessary to locate either or both points outside the format of a drawing. What
you want to avoid, however, is the distortion that occurs from placing the van-
ishing points too close together, as in box E.) The top of Box F is located at eye
level and is therefore not visible.

Try these two applications of two-point perspective.

Exercise 5D

Drawing 1. *Draw a group of rectangular volumes in two-point perspective. A bunch of
cardboard cartons or an architectural setting would serve as good models for this exercise.
The drawing in Figure 5–25 shows a two-point perspective rendition of a couple of cottages
that are fancifully watched over by a large nude.*

Drawing 2. *Design a piece of furniture or architectural conglomeration using your knowledge
of two-point perspective. Your design may be practical, or fantastic, as in Figure 5–26, but
make sure to apply the rules of linear perspective consistently.*

THE BOX TILTED AWAY FROM THE GROUND PLANE

So far we have been dealing with boxes that *sit on, or float parallel to,* the ground
plane. The faces of these boxes are all either horizontal or vertical, and so all
the vanishing points are located at eye level. If the box is *tilted* in relation to the
ground plane, however, it will no longer have any horizontal or vertical planes,
and none of the vanishing points will be located at eye level. Normally, a box

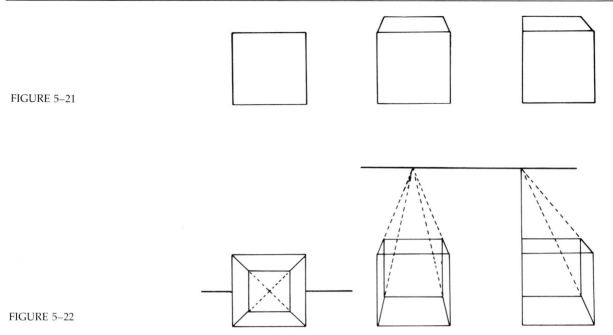

FIGURE 5–21

FIGURE 5–22

positioned in this way will be drawn using two-point perspective (see Fig. 5–27). Later in this chapter, a case will be made for drawing some tilted boxes in three-point perspective.

The Circle in Perspective

Circles in perspective are drawn as ellipses. When it is necessary to find the center of a circle in perspective, the ellipse is drawn within a square in perspective. Figure 5–28 shows how this is done.

Figure 5–28a is an unforeshortened view of the circle within a square; its center is found at the intersection of the diagonals connecting the corners of the square.

FIGURE 5–23

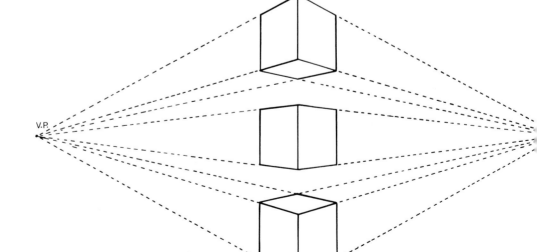

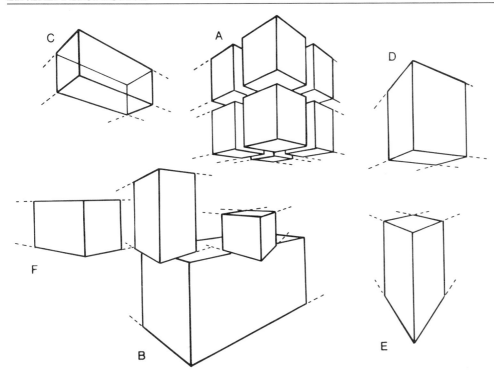

FIGURE 5–24

If the square containing the circle is tipped away from the picture plane, the circle appears as an ellipse (Fig. 5–28b). We have added a dotted horizontal line to divide this figure in half. This has been done to show that the front half of the circle appears fuller than the rear half. Note also that the undotted horizontal line through the center of the circle does not correspond with the fullest horizontal measurement of the ellipse. This is indicated by the dotted line.

Figure 5–29 demonstrates what is happening to the circle in relation to the cone of vision. In Figure 5–29a, the center line of vision goes through the center

FIGURE 5–25
Andrea Hernandez, University of Arizona
Student drawing: buildings in two-point perspective

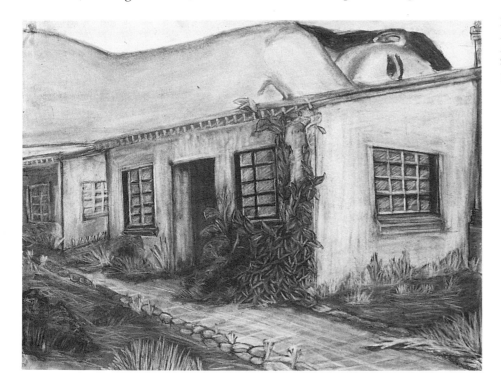

FIGURE 5–26
TONI SPAETH, Art Academy of
Cincinnati
Student drawing: imaginary
architecture in two-point
perspective
Ink and colored pencil
Courtesy, the artist

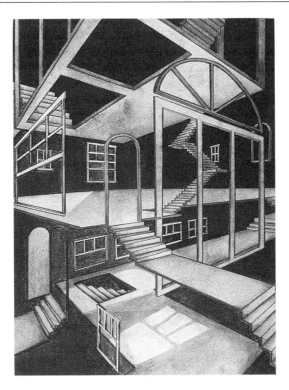

of the circle. The rays of sight from the Station Point (SP) are tangential to the circle. A horizontal line connecting these two tangential points locates the fullest dimension of the circle that the eye will perceive. This line falls well below the horizontal through the center of the circle.

This fullest visible dimension of the circle seen in perspective (indicated by a dotted line) becomes the major axis of the ellipse when the circle is drawn on the picture plane (Fig. 5–29b). To locate the major axis of the ellipse, draw a rectangle around it and then draw diagonals connecting the corners of the rectangle. The major axis of the ellipse is drawn horizontally through the point where the diagonals intersect (Fig. 5–29c).

The minor axis of the ellipse coincides in this case with the vertical line going to the central vanishing point. *The minor axis of the ellipse is always drawn perpendicular to the major axis.*

This method of drawing ellipses pertains to any situation in which the major axis of the ellipse is horizontal and parallel to the picture plane.

Whenever the major axis of an ellipse is horizontal, the ellipse can be drawn within a square in one-point perspective. This is because the circle, unlike any other shape, appears the same when rotated within its plane.

Other Geometric Volumes and Near-Geometric Volumes

You can apply your knowledge of drawing boxes and circles in perspective to drawing other basic geometric forms, such as cylinders, cones, pyramids, and spheres (Fig. 5–30). Many manufactured objects can be drawn with greater understanding if you try to relate them to the geometric forms they most closely resemble. Flowerpots, drinking glasses, and lampshades are basically conical; most furniture is rectangular; tree trunks and bottles are cylindrical; and many vegetable forms, such as fruits, flowers, bushes, and trees, are spherical.

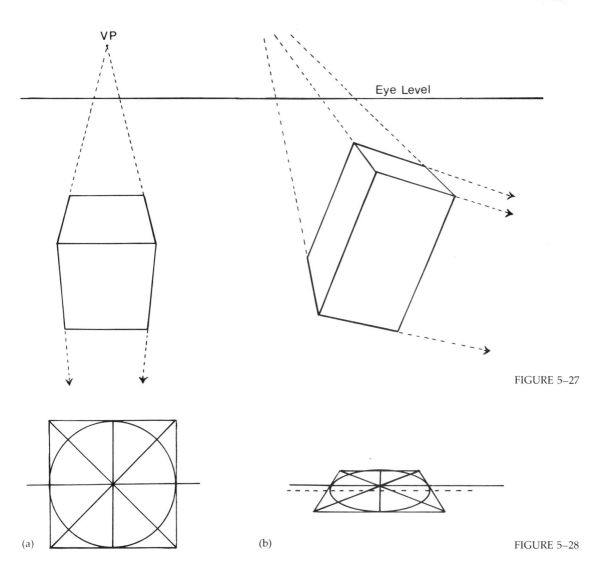

VP

Eye Level

FIGURE 5–27

(a) (b) FIGURE 5–28

The Advantages and Shortcomings of Linear Perspective

Throughout this chapter, we have stressed combining the use of proportional devices with a knowledge of linear perspective whenever you draw from a subject that suggests perspectival treatment. But it is entirely possible to draw a form such as a building correctly even without a theoretical knowledge of perspective, as long as you triangulate to find the angle and length of every single line.

Obviously this is a very tedious and time-consuming process, especially when a knowledge of linear perspective equips you to anticipate the angles of a good many of the lines and thus shorten your drawing time. Furthermore, this knowledge will enable you to quickly assess mistakes in a drawing and help you to determine which lines stand in need of correction. Therefore, many artists who have no interest in perspective as an end in itself feel that linear perspective has an important role to play in support of careful seeing.

At times, however, the information you gain through measuring and angling will be at odds with your knowledge of perspective. When this happens, you will probably want to check the measurements in your drawing to make them agree with your expectations. A beginner, given the choice of trusting either what is seen or the system of perspective, will usually opt to trust the system; the system is, after all, rational. This is a healthy response and in most cases will yield the desired result. But in some cases, a subjective hunch, fortified by careful angling, will turn out to be correct.

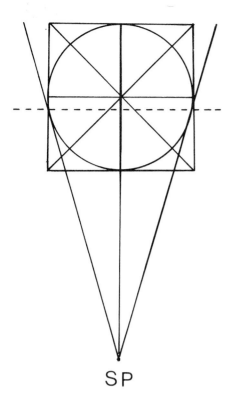

(a)

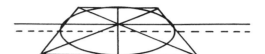

(b)

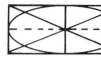

SP

FIGURE 5–29

This is because in certain situations traditional one- or two-point perspective does not help to create an image that most closely resembles what is seen in the visual field. Although it will always yield an image consistent with its own logic, the sterile look typical of some perspective drawings is due to the fact that the system is based in part upon some false assumptions.

The first of these false assumptions is the belief that fixed position is absolute. This notion may pertain to the more instantaneous medium of photography; but drawing involves a physical and mental activity, and because it takes time, it is virtually impossible for the artist to maintain an actual fixed position in relation to the subject. A quality missing from many strict perspective drawings is the sense of intimacy between artist and subject, an intimacy that is built up during that *duration*, however short, in which the artist is accumulating, recording, and sorting out visual impressions.

A related false assumption is that our vision is monocular (one-eyed), when in fact it is stereoscopic (two-eyed), meaning that what we see includes two separate cones of vision. Normal visual perception of an object therefore consists of two slightly different views of that object incorporated into a single image. The phenomenon of stereoscopic vision is especially apparent when you regard something very close to you, since in this case the discrepancy between the two images of the object is greater.

Another assumption on which the systems of one- and two-point perspective operate is that the picture plane is literally a vertical plane. But as we pointed out earlier in this chapter, the picture plane is not necessarily vertical; rather, it occupies a position perpendicular to your line of vision (Fig. 5–4b).

The box in Figure 5–31a is drawn in traditional one-point perspective, assuming that the front plane of the box is parallel to the picture plane. However, since the box is located below eye-level, our gaze must be directed downward to see it. This means that the picture plane is tilted slightly off the vertical. In theory, then, the use of one-point perspective can be justified only when drawing an object or space that is truly centered on our line of vision, as in Figure 5–31b. As a consequence, the corrected perspective for Figure 5–31a would be as that seen in Figure 5–31c.

In most circumstances, the inclination of the picture plane is so slight that the convergence of the vertical sides of a box is imperceptible. If, however, the

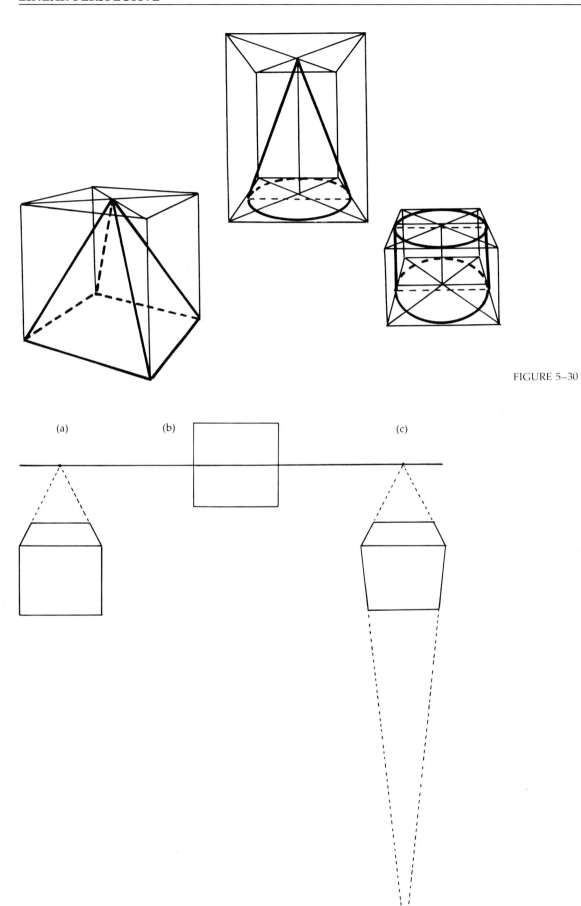

FIGURE 5–30

(a) (b) (c)

FIGURE 5–31

box were extremely large, or you were very close to it, you would notice the second vanishing point. Compare the Diane Olivier drawing in Figure 5–32 with Figure 5–31c. Note that the converging verticals in Figure 5–32 not only give you an indication of your low eye level in relation to the subject but also contribute to a sense of intimacy by implying that you are very close to it.

Three-Point Perspective

When you are situated so that you see two vertical faces of a very large (or very close) boxlike form, you may wish to draw it in three-point perspective. This means that when you stand at street level looking up at the corner of a skyscraper, you will see vanishing points not only for the horizontal lines but also for the vertical ones. In Figure 5–32, notice that the sides of the buildings converge at a point beyond the top of the page.

THREE-POINT PERSPECTIVE AND THE TILTED BOX

When a box is tilted away from the ground plane, a case can be made for drawing it in three-point perspective. The necessity for this treatment is especially clear when you tilt an oblong box toward or away from your picture plane, as in Figure 5–33.

Exercise 5E *These projects will enable you to apply the rules of three-point perspective.*

Drawing 1. *Find an oblong box or block of wood. Prop it up so that it is leaning toward you. Draw it, taking care to angle all the sides carefully.*

Drawing 2. *Put a large cardboard box on the floor. Situate your easel as close to it as you can, yet retain a view in which you can see two side faces and a top face (or interior) of the*

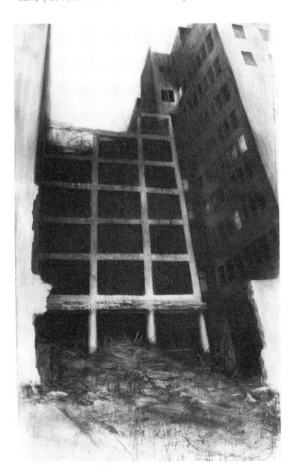

FIGURE 5–32
DIANE C. OLIVIER
Sansome and Battery
Charcoal on paper, 84 × 66″
Collection of the artist. Courtesy, Dorothy Weiss Gallery, San Francisco. Photo: Robert Haavie

FIGURE 5–33

box. *Do the vertical sides of the box appear to converge at a point below the floor? Draw the box, using a combination of angling and your knowledge of perspective.*

Any rectangular object or group of objects, such as the stack of books in Figure 5–34, can be substituted for a box in this exercise.

Drawing 3. *Situating yourself cater-cornered to a very tall building, draw it in three-point perspective.*

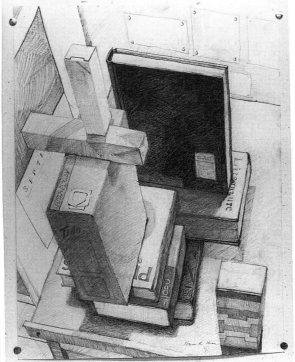

FIGURE 5–34
NAM KIM, Pratt Institute
Student drawing: stack of books in three-point perspective
18 × 24″
Courtesy, the artist

Form in Space

Have you ever had the experience of looking at an object and suddenly feeling that it possessed an extraordinary power? It may have been an intricately organized flower that you investigated carefully for the first time, a worn coiled rope glistening with tar and resins that you unexpectedly glimpsed along the railroad tracks, or a rusted, unidentifiable machine part that you picked off a vacant lot as a child and kept for years before throwing it out in a fit of spring cleaning.

The word *presence* is used to describe this mysterious power that is sometimes inferred from the forms of objects. Objects are said to command our attention in this way when they seem to be charged with hidden meanings or functions that, like some secret code, we cannot penetrate. This can hold true even for things we have seen and used and taken for granted, such as objects of common utility. Seen in a different context or from an unusual viewpoint, an otherwise ordinary object may suddenly assume a totally new identity.

From time to time, many people experience this rather romantic and usually fleeting impression that objects have a transcendental meaning. This is especially true of artists, who are accustomed to finding significance in form and who return to these experiences as models for the quality of presence that they wish to achieve in their own works.

Most artists, in fact, become so sensitized to visual experience that they regularly discern unnameable powers in forms they encounter. For them, the powers sensed in an object can be translated into expressive potential when they draw. But first they must complement these sensations with a more deliberate search for the prominent form characteristics of the object in question. For example, in his drawing of a screw (Fig. 6–1), Claes Oldenburg identifies spiraling movement and linear direction as those characteristics essential to the form. He exaggerates these properties by transferring to the shaft the movement that properly belongs to the threads themselves, thus greatly increasing the object's spatial gesture. Moreover, the monumental scale that he gives this most commonplace of small objects invests the image with all the fearsome torque of a tornado.

The Oldenburg drawing succeeds in evoking presence because it takes distinctive characteristics of "screwness"—spiraling movement, tensile strength, and linear direction—and gives them unanticipated emphasis. But to achieve

FIGURE 6–1
CLAES OLDENBURG
Giant Balloon in the Shape of a Screw,
1973
Charcoal, pencil, wash on paper,
29 × 23"
Courtesy, Leo Castelli Gallery

this without resorting to caricature, the artist had to have a clear concept of the actual physical form of the screw.

The Visual and the Tactile

We use two perceptual systems to acquaint ourselves with the three-dimensional condition of an object: vision and the sense of touch. Psychologists tell us that these two senses work in tandem and that knowing what one sees is to a great extent dependent on being able to verify it by the sense of touch.

Although drawing is a visual medium, those drawings that strike the deepest chord within us usually recall a memory of tactile sensations. In the portrait by Edwin Dickinson (Fig. 6–2), the illusion of the elderly woman's soft flesh and thinning hair evokes an almost physical response in the viewer. In the Michelangelo drawing, on the other hand (Fig. 6–3), the tactile stimulus is located in the concentric searching lines. The viewer empathizes with the artist's repeated attempts to recreate on the surface of the paper how it would feel to physically embrace each of these forms.

Form and Gestalt

All three-dimensional objects possess mass, volume, and form. For the purpose of the artist, *mass* can be defined as the weight or density of an object. In most cases, weight and density are experienced through tactile, as opposed to visual, means. The term *volume* expresses the sheer size of an object and by extension the quantity of three-dimensional space it occupies.

Form refers to the three-dimensional configuration of an object. Form sets the specific spatial limits of an object and also encompasses the notion of its structure or organization. Of these three properties, mass, volume, and form, it is the latter that interests artists the most.

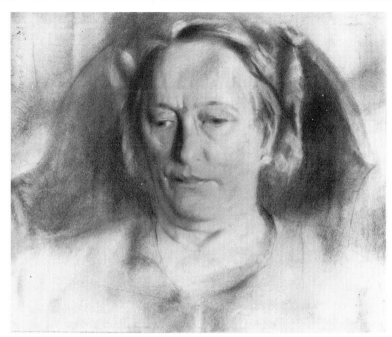

FIGURE 6–2
EDWIN DICKINSON
Portrait of a Woman, 1937
Pencil, 27.8 × 32.9 cm
The Baltimore Museum of Art, Thomas D. Benesch
Memorial Collection (BMA 1974.5)

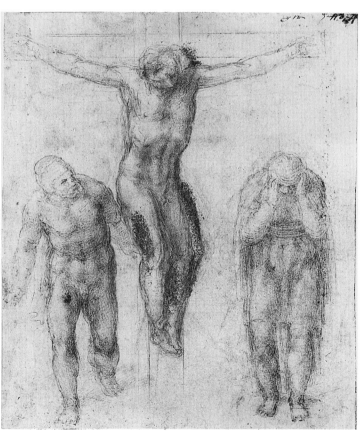

FIGURE 6–3
MICHELANGELO
The Crucifixion
Ashmolean Museum, Oxford

Form is most easily grasped by visual means, and yet we can receive only a limited amount of information about an object's form from any single point of view. To get a more complete picture of a whole form, we must obtain several views of it and synthesize them in our mind's eye. The more complex and unfamiliar a form is, the more difficult this process will be. Figure 6–4 shows how Leonardo da Vinci gradually rotated an arm to assist his understanding of its musculature.

The term *gestalt* is used to describe a *total* concept of a form. Some objects

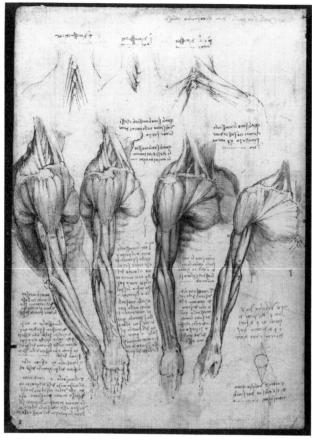

FIGURE 6–4
LEONARDO DA VINCI
Muscles of the Right Arm, Shoulder and Chest
The Royal Collection © 1994 Her Majesty Queen Elizabeth II

have a strong gestalt; that is, when seen from a single point of view, their entire three-dimensional character is readily comprehended, as is the case with simple structures, such as the basic geometric solids (the sphere, cone, cylinder, pyramid, and cube). The instant gestalt recognition of these forms is due in part to our familiarity with them. But they are also each defined by a set number of surfaces that are at predictable relations to each other.

Take a moment to try obtaining a gestalt (or total picture) of something with which you have daily contact—say, a coffee mug. Pick it up and get to know its various surfaces. Can you remember the motions you go through when washing it? How much coffee does it hold compared with other mugs that you use? After you have asked these questions, set the mug down and look away from it. You should be able to retain a concept of its three-dimensional form in your mind's eye and even be able to re-create different views of it. This exercise will greatly increase your ability to imagine forms in the round and draw them convincingly.

Approaches to General Form Analysis and Depiction

At some point you have probably had the desire to draw a highly complex form. Confronted with an object whose surface was characterized by a wealth of detail or numerous subtle turns, you may have felt at a loss about where to begin. But essential to a strong representation of any form is a feeling for its overall spatial structure. To assist you in depicting the overall structure of forms, we now present several simplified approaches to form analysis. While it may benefit you at the start to try these approaches separately, you will eventually wish to use them in combination to produce richer and more resonant drawings.

GENERALIZING THE SHAPE AND STRUCTURE OF COMPLEX FORMS

When setting out to draw a complex object, you should simplify your initial approach to its form. Such an approach might entail that you rely solely upon what you see to generalize the form; or you might try to understand the form through a combination of observation and imagination to visualize that part of its essential structure which you cannot actually see. Form summary and shape summary are two specific methods for summarizing the form of complicated objects.

Form summary is a technique that is used to describe a more complex or articulated (jointed) form in simpler terms. When summarizing such a form you need not feel restricted to using boxlike volumes. In his drawing of a bull crouching, Reuben Nakian plays taut, rounded forms against each other to achieve an effect that is as virile as it is decorative (Fig. 6–5).

Shape summary is another means to generalize form. Shape summary does not entail an exact delineation of the outer contour of a shape. Rather, when making a shape summary, one first sizes up the major areas of a three-dimensional form and then records them in terms of flat shape. The Theo van Doesburg drawing of a cow (Fig. 6–6) is a good example of shape summary. Notice that the head is seen in terms of a series of rectangular shapes, the neck and shoulder as a triangle, and the haunch as an inverted triangle.

GESTURE AS A MEANS OF EXPLORING FORM

In previous chapters, we have discussed gesture drawing as a way to represent the general pattern of things as they are arranged in space (Chapter 1) and also as a primary means of organizing a drawing's surface design (Chapter 4). Extended to the practice of depicting form, gesture drawing can be useful not only for revealing those aspects of a form that can be seen but also for suggesting something of the form's internal forces and stresses.

Gesture drawing necessarily involves a good measure of empathy on the part of the artist for the subject; that is, the artist must feel out with marks, tones, or lines the essential structure and energies of what is being drawn. To this end, Rodin let the gesture of his pencil line recreate the spirit of a dance (Fig. 6–7).

The subject in the Matisse (Fig. 6–8) is more static in nature. Here the outer contour of the figure seems to have been arrived at through a series of trials

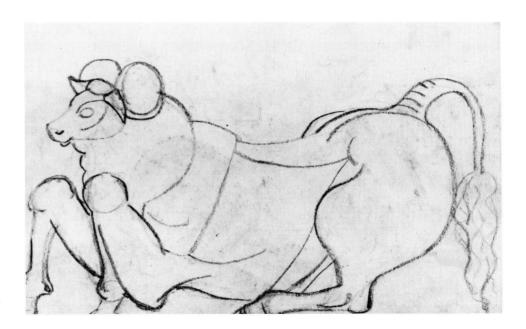

FIGURE 6–5
REUBEN NAKIAN
Bull Crouching, c. 1921
Crayon on paper, 8 × 12¼"
Collection of Whitney Museum of American Art,
New York (31.562)

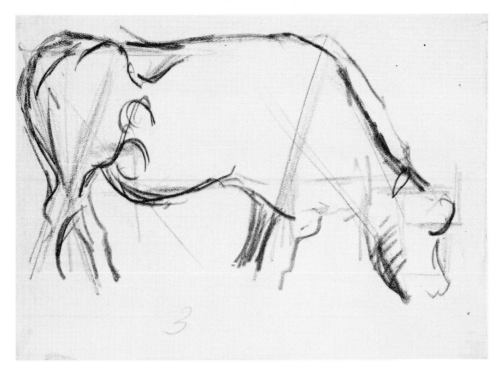

FIGURE 6–6
THEO VAN DOESBURG
Study for the Composition (The Cow),
1917
Pencil, 4⅛ × 5¾″

© 1994 Theo van Doesburg/Licensed by VAGA,
New York. Courtesy of The Museum of Modern
Art, New York. Gift of Nelly van Doesburg

FIGURE 6–7
AUGUSTE RODIN
Isadora Duncan
Pencil and watercolor on paper
Philadelphia Museum of Art. Gift of Jules E.
Mastbaum (F'29–7–151)

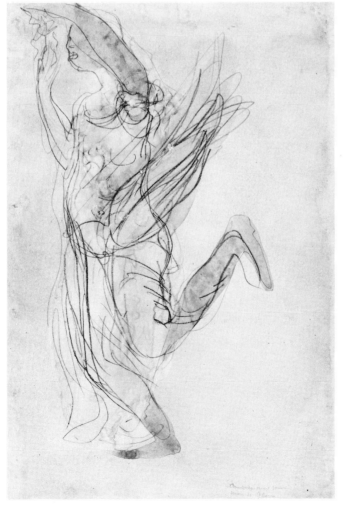

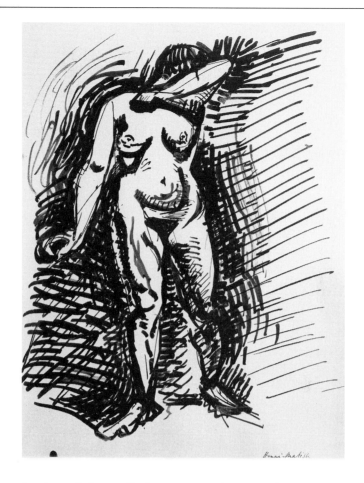

FIGURE 6–8
HENRI MATISSE
*Study of a Standing Nude, Her Arm
Covering Her Face,* Paris, c. 1901–
1903
Brush and ink on paper,
10⅜ × 8″

*The Museum of Modern Art, New York. Gift of
Edward Steichen. © 1995 Succession H. Matisse,
Paris/Artists Rights Society (ARS), New York*

that have left a radiating energy about its form. But much of the gestural force
of the drawing is a result of the feeling for internal stresses expressed by the
sharply contrasting lights and darks in the weight-bearing leg. This plus the
effect of the other leg dragging through the shadows helps us to identify with
the physical gesture of the model.

Artists frequently use gestural marks to diagnose and express the relative
position and scale of an object in space. These marks are generally called *dia-
grammatic marks* because they are often so direct and graphic, as in Figure 6–9.
Or look at the drawing by Wolf Kahn and see how his stroking, gestural marks
"feel out" his tactile impressions of a cow (Fig. 6–10). And note how the contrast
between the well-defined marks portraying the handlelike tail and the sketchier
ones indicating her head gives us a strong sensation of the way the cow is
oriented in space. This differentiation in clarity of marks is an example, if you
will, of aerial perspective used to show varying distance within a single object.

Gesture drawing is generally done rapidly and is thus admirably suited to
a moving subject, as in Figure 6–7. But the intense energy and level of identi-
fication required for gesture drawing also make it a most important means for
quick studies of inanimate objects. So before undertaking a drawing of longer
duration, an artist frequently does a series of gesture drawings to invest the
more prolonged drawing of a stationary subject with greater energy (Fig. 6–11).

But even when drawing for a long period of time, a feeling for the subject's
gesture may be sustained. The Mondrian drawing (Fig. 6–12) is just such an
example of how a subject of considerable complexity can be accurately drawn
without sacrificing the gestural energy of its overall form. In this drawing, seem-
ingly countless petals come curling aggressively out from the center of the flower
toward the viewer. But notice that although each petal is individually modeled
and thus holds its own space, their unruly conglomerate adds up to a clearly
felt spherical mass. Such a powerful illusion of a writhing mass would not have

been possible unless the artist had had from the very start a clear idea of the overall form of the flower head. Thus, by combining an initial analysis of the general form with careful observation of the spatial activity of the individual petals, he gave to the insubstantial flower an immense spatial presence.

FIGURE 6–11
JAMES R. HAWKS
Student drawing: studies of a piano
Courtesy, The artist

FIGURE 6–12
PIET MONDRIAN
Chrysanthemum, 1906
Pencil, 14¼ × 9⅝″
*The Museum of Modern Art, New York. Gift of Mr.
and Mrs. Armand P. Bartos*

LINE AND SPATIAL STRUCTURE

You will find that line is an invaluable tool for analyzing the spatial aspects of
form, and many artists recommend the practice of linear drawing as the most
expedient way to improve perceptual skills (Fig. 6–13). What makes line so
effective in showing the turn of surface on a three-dimensional form is, strangely

enough, its unidirectional character. By definition, line travels from point to point. To illustrate this, look at the drawing by Agnes Denes (Fig. 6–14), in which the delicate diagrammatic lines connect carefully plotted points to direct the eye around the form in a measured way.

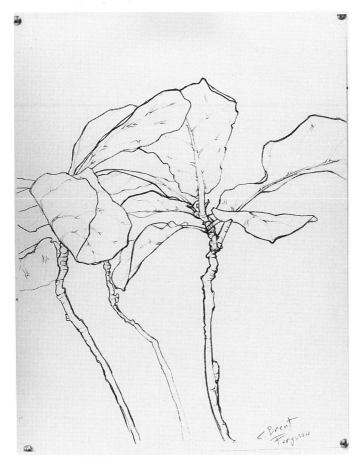

FIGURE 6–13
C. Brent Ferguson
Student drawing: contour study of a houseplant
18 × 24"
Courtesy, the artist

FIGURE 6–14
Agnes Denes
Map Projection—The Snail, 1976
Lithograph, printed in color, composition, 24$\frac{1}{16}$ × 30$\frac{1}{16}$"
The Museum of Modern Art, New York. John B. Turner Fund

OUTLINE VERSUS CONTOUR LINE

Before we proceed to discuss the potential of line to depict form, however, it is necessary to differentiate between outline and contour line. Outline can be defined as a boundary that separates a form from its surroundings. Usually regarded as the most primitive of all artistic techniques, outline works best when it is reserved for depicting literal flat shapes, such as the illustrations of road signs in a driver's manual. The tendency for outline to direct the viewer's attention to the two-dimensional spread of the area it encloses confounds any power it might have to depict three-dimensional form. Additionally, the uniform thickness, tone, and speed of an outline does not distinguish between those parts of a form that are close to the picture plane and those that are farther from it. Thus, the outlined image of a man walking his dog (Fig. 6–15) looks as flat as the images of road signs.

Another long-held objection to outline is that in recording the outer edge of an object, one unavoidably draws attention to that part of the object farthest from the eye. Because of the dynamics of figure–ground play, this line tends to push forward, allowing the interior of the shape to fall back. Thus, a circle drawn to represent a sphere will look more like an empty hoop, especially if it is drawn with a line of consistent thickness.

An alternative to outline is the *contour* line, which can also be used to describe the outer edge of an object. But unlike the outline, which functions as a neutral boundary between the object and its surroundings, the contour line gives the impression of being located just within this border. So contour line more properly belongs to the form of an object, as we can see in the Picasso work *Portrait of Derain* (Fig. 6–16). When you look at the outer contour, you will see that the artist is alluding to this edge as the last visible part of the form before it slips away from sight.

It is its varying thickness, and often tone and speed, that gives contour line its capacity to suggest three-dimensional form. To demonstrate this, we have traced the Picasso drawing with a drafting pen so as to render the image

FIGURE 6–15

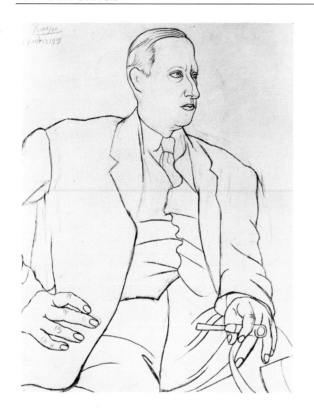

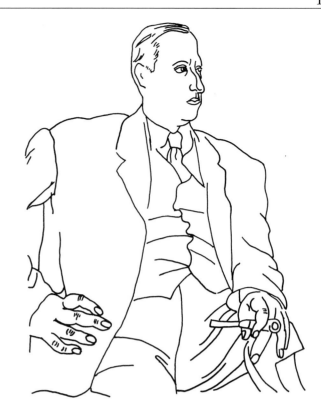

with a line of uniform thickness. The result (Fig. 6–17) appears flat when compared with the original, in which no line retains the same thickness for long.

Contour line can also be applied within the outer borders of a depicted form. In the Picasso drawing, this use of contour is especially evident in the delineation of the folds in the sitter's jacket sleeve. An even more structural use of contour may be observed in the way the nose is drawn. Here contour is used to indicate a break in planes.

A further example of the modeling effect of contour can be found in the drawing by Jean Ipousteguy (Fig. 6–18). Here line is used with great economy; a single line, indicating the weighted outer contour of the belly, travels up into the form to reveal the structure of the rib cage. A dark smudge representing the shadow cast by the protruding hipbone feeds into a line that tapers as it travels away from the picture plane over the form of the body, disappearing finally where the curve of the breast melts into the underarm.

Blind contour is one of the best ways to get acquainted with how line may be used to express the structure of forms in space. It is a tactic used by artists to heighten their awareness about how the form of what they draw "feels" to the eye.*

Drawing 1. *Using a pencil, marker, or technical pen, do a series of blind contour drawings of some fairly complex subject, such as a model's face (Fig. 6–19) or your own hand in different positions. Remember that blind contour drawing entails letting your eye creep very slowly around the contours of a form while your drawing hand follows the movement of your eye. Be sure to enter within the confines of the form's outer contour to indicate major plane breaks.*

Blind contour drawings will always look slightly imperfect, as if parts of the subject have been somewhat jostled. Even so, these drawings have the appeal of the immediacy of optical perception. If you wish, you can choose to stabilize your blind contour drawing with the addition of tone, as in Figure 6–20.

*Blind contour drawing is also discussed in Chapter 1.

FIGURE 6–16 (top left)
PABLO PICASSO
Portrait of Derain, 1919
© *1994 Artist's Rights Society (ARS), New York/ SPADEM, Paris*

FIGURE 6–17 (top right)

Exercise 6A

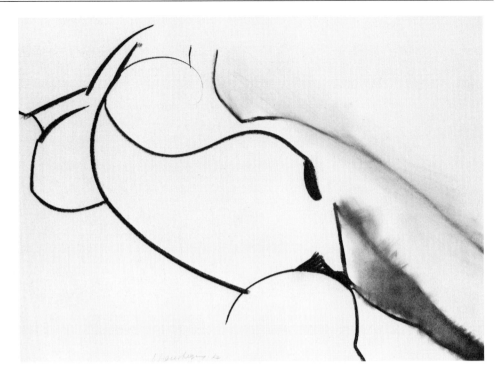

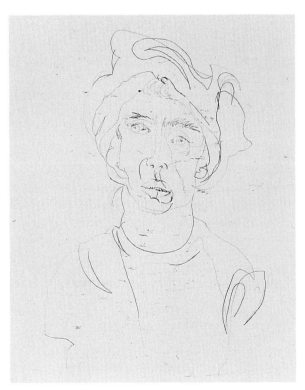

Drawing 2. *Arrange some objects that have a lot of curves into a simple still life. Vegetables such as cabbage or cauliflower, kitchen gadgets, and overstuffed furniture all make good subjects. Do a blind contour drawing of these objects, but this time change the thickness and value of the line more emphatically, exaggerating to some extent the principles of atmospheric perspective. In other words, where a form moves aggressively toward you, increase the speed and pressure with which you draw to thicken, darken, and add clarity to your line. But as edges begin to drop from sight, slow down and let up on the pressure so that your line becomes thinner and less distinct.*

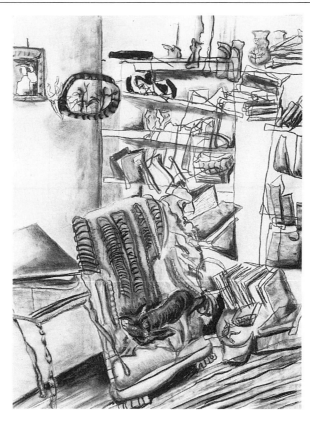

FIGURE 6–20
JENNIFER BOGARD, Indiana State
University
Student drawing: blind contour
with tone added later
Courtesy, the artist

Suggested media include a fountain pen or brush with ink, a sharpened conte crayon or graphite stick, or a carpenter's pencil.

Drawing 3. *Use the insights you've gained from your second blind contour study to make a more precise contour-line representation of a still life, this time looking at your paper.*

Refer to Figures 6–21 and 6–22, both intelligent line drawings. Note that one uses line of uniform thickness to define the forms and their orientation in space while the other expresses the weight of the bunches of bananas through variation in line thickness as well as a judicious use of smudges to indicate shadow.

MASS GESTURE

We use the term *mass gesture* to describe a complex of gestural marks that expresses the density and weight of a form. Artists have several ways of communicating that forms have weight and spatial presence. Among them is the laying in of marks, one on top of the other, until a sense of impenetrable mass is achieved, as in the drawing of a clay form (Fig. 6–23). In the Mazur drawing (Fig. 6–24), dark gestural marks imply the bulk of a human head.

Prepare yourself for this exercise in mass gesture by imagining what it would be like to tunnel into a mountain or to bore a hole through a block of granite.

Exercise 6B

Drawing 1. *Using a stick of charcoal, draw from objects that are simple and compact in form (such as boulders, root vegetables, tree stumps, or stacks of books), concentrating on the sheer quantity and density of their matter. As you draw each object, begin by scribbling some tight, hard, knotlike marks to represent its core, or most active part. Ask yourself, if you had x-ray vision, where would your eyes have to pass through the most matter to come out on the other side? Without lifting your charcoal from the paper, build out from the core with random scribbling, gradually lightening your pressure on the charcoal until you have reached the outer surfaces of the form (Fig. 6–25).*

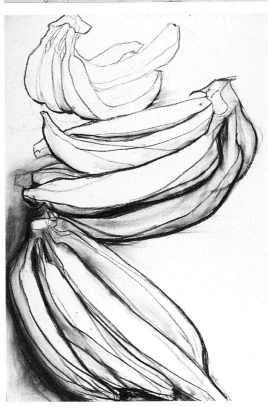

Drawing 2. *Another way to indicate mass is through exploratory contour. Choosing a more complex subject this time (such as a human figure), indicate with a flurry of small marks those portions of the form that are turning away from the picture plane (Fig. 6–26).*

CROSS CONTOUR

Cross contours are lines that appear to go around a depicted object's surface, thereby indicating the turn of its form. You have already seen cross-contour lines in the drawing by Agnes Denes (Fig. 6–14).

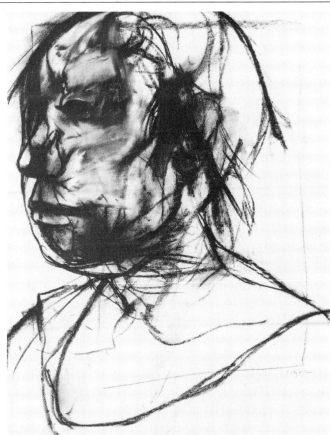

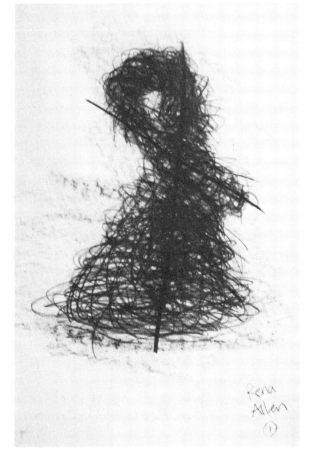

FIGURE 6–23 (top left)
WILLIAM KESTERSON, University of
Arizona
Student drawing: mass gesture

FIGURE 6–24 (top right)
MICHAEL MAZUR
Untitled (Head), 1965
Charcoal on paper, 25 × 19″
*New York University Art Collection, Grey Art
Gallery and Study Center. Gift of Paul Schapf,
1969. Photo: Charles Uht*

FIGURE 6–25
RENA ALLEN KLINGENBERG,
University of Arizona
Student drawing: mass gesture

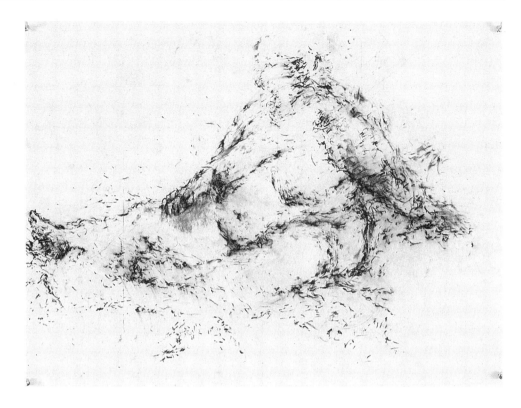

FIGURE 6–26
TAMARA MALKIN-STUART, New
York Studio School of Drawing,
Painting and Sculpture
Student drawing: mass expressed
using an exploratory contour
Conte crayon, 22 × 30"
Courtesy, the artist

Some forms have cross-contour lines inherent to their structure, such as the wicker beehives in Figure 6–27. In the Rockwell Kent drawing (Fig. 6–28), the natural contour lines existing on the ribbed surface of the lifeboat are visible in the small illuminated triangle on the right. On the other side of the boat, these lines are lost in shadow, but the artist indicates the shadow with lines that curve around the boat's surface in the way that the natural cross-contour lines do.

Cross-contour line need not be as precise or literal as in the above-mentioned illustrations. In the drawing by Ernst Barlach (Fig. 6–29), the cylindrical masses of the woman's body are forcefully shown by the gestural lines sweeping

FIGURE 6–27
Workshop of Pieter Brueghel the
Elder
The Bee Keepers
Pen and brown ink, 204 × 315 mm
*The Fine Arts Museums of San Francisco,
Achenbach Foundation for Graphic Arts purchase,
William H. Noble Bequest Fund (1978.2.31)*

FIGURE 6–28
ROCKWELL KENT
The Kathleen, 1923
Ink on paper, 6⅞ × 7⅝"
*Collection of Whitney Museum of American Art,
New York (31.548)*

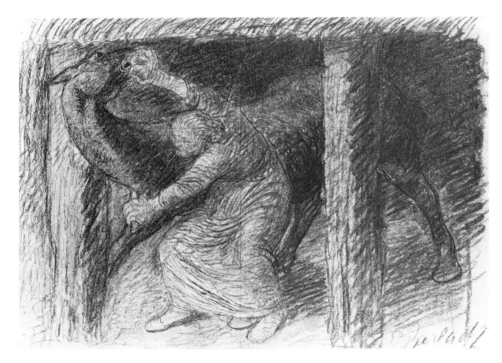

FIGURE 6–29
ERNST BARLACH
Woman Killing a Horse, 1910–1911
Charcoal on paper, 10⅝ × 15¼"
*Solomon R. Guggenheim Museum, New York.
Photograph by Robert E. Mates, © The Solomon R.
Guggenheim Foundation, New York. (48.1172
×189)*

across her form. These lines impart to her image an illusion of solidity and power that makes credible the idea that she is more than a match for the much-larger horse.

In his drawing of vessels, Figure 6–30, glass artist Dale Chihuly develops a strong sense of form with no recourse at all to outer contour. The heavily dimpled surface of the top study is amply indicated by a loose and varied collection of cross-contour lines and marks. In the two spherical forms at the bottom of the page, the lines weave about in a more continuous fashion, giving the impression of massive but transparent receptacles.

FIGURE 6–30
DALE CHIHULY
Untitled, 1983
Graphite and watercolor on paper,
22 × 30″
Courtesy of the Charles Cowles Gallery, New York

Exercise 6C *Cross-contour marks and lines reinforce the apparent solidity of depicted forms. To become more adept at executing cross contour, follow the steps of this exercise.*

Drawing 1. *Find a subject with naturally occurring cross-contour lines. Objects such as birdcages or open-weave baskets make ideal subjects because their relative "transparency" allows you to trace their cross-contour lines around to the far side of their forms.*

Observe how the cross-contour lines reveal the structure of your object. Avoiding the outer edges of your subject, draw lines that record the relative angles or sweeping curves of its cross contours. Be selective, especially if your subject is very detailed. In other words, draw only those lines that best give a sense of the form.

Drawing 2. *Find an object with both swelling and indented surfaces. If possible, draw directly on the object, creating a series of parallel lines that circle around its form. (Think of them as the latitude lines on a globe.)*

Represent your subject with a loose system of cross-contour marks, referring to the parallel lines on the form to better understand the major turns of direction of the form's surface. If your approach to this drawing is very gestural, use marks that appear to wrap around the entire form, as in the Chihuly drawing (Fig. 6–30).

PLANAR ANALYSIS

To investigate and give spatial definition to curvaceous forms, artists sometimes turn to planar analysis. Planar analysis entails a structural description of a form, in which its complex curves are generalized into major planar, or spatial, zones.

Planar analysis is especially helpful when the surface of the form is composed of numerous undulations or if the outer contour of the form gives no clue to the surface irregularities within its shape. A pillow, for instance, may have a geometric shape from some aspects, but this shape will not communicate the plump curves of its form. In Figure 6–31, the volume of a cushion has been expressed through planar treatment.

Artists frequently find planar analysis a valuable aid in portraiture, as it forces the artist to abstract the general forms of the face rather than be misled

FIGURE 6–31
KIRT BARR, University of Arizona
Student drawing: planar analysis of
a pillow
Courtesy, the artist

into making a "composite drawing" of individual features. Notice that in Figure 6–32, each facet has been given an informal "hatched-line" pattern that further defines the structure of the face. (The term *hatched line* refers to an area of massed strokes that are parallel or roughly parallel to each other.)

FIGURE 6–32
SEAN P. GALLAGHER
Interior (planar analysis self-portrait)
Graphite, 24 × 18"
Courtesy, the artist

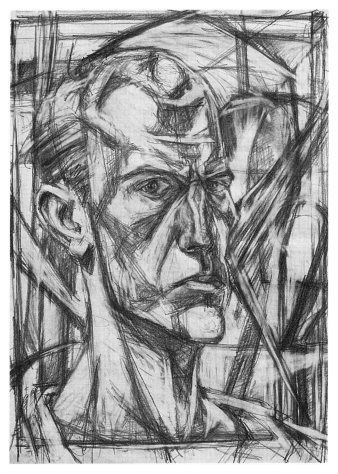

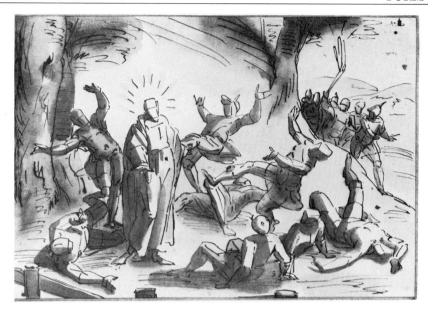

FIGURE 6–33
Luca Cambriaso
The Arrest of Christ, 1570–1575
Pen, ink, and wash
*Courtesy, the Frederick & Lucy S. Herman
Foundation*

In Figure 6–33, planar analysis is used to make the spatial gesture of articulated forms more apparent. And in turn, the choreographing of these blocked-in figures dramatizes the depth of the stagelike space.

Exercise 6D *Planar analysis is an excellent way to uncover the large, more simple structure that underlies complex-looking forms. As a practical introduction to planar analysis, we have designed this exercise.*

Choose a soft or semisoft form to draw. A sofa cushion, a slightly dented felt hat, or a half-stuffed canvas or leather bag are all good subjects. If you are particularly ambitious, you may choose to make a planar analysis of a model's face, as in Figure 6–34.

Look at the curved surfaces of your subject. Can you consolidate them into a series of abutting planes? To help, look for any slight crease, raised or indented, that might be interpreted as a planar division. A small lamp or flashlight may help you see these subtle divisions. If possible, outline them by drawing directly on the surface of the object. Continue tracing these planar divisions until the entire form appears to be made up of small facets.

FIGURE 6–34
Chinban Chang, University of
Arizona
Student drawing: planar analysis
with pattern applied to portraiture
Courtesy, the artist

Do a drawing of your object, copying the planar structure that you have imposed on it. To indicate the changing inflections of the surface, you may wish to add a hatched line pattern to the individual planes, as in Figure 6–32.

Surface Structure of Natural Forms

In examining a natural form, you may want to consider whether its surface character is a result of the play of internal or external forces. The surfaces of living things are generally determined by internal forces and structures, whereas the surfaces of inanimate objects are generally determined by external forces, such as gravity or erosion.

Concavities in forms are often a result of erosion. In the landscape by Ruskin (Fig. 6–35), one sees a huge concave scar in the mountainside, evidence of the grinding passage of a departed glacier. Within a much shorter temporal span, we may witness the concave shapes caused by the action of wind on sand dunes, or the pressure of wind on a sail.

Forms that are a result of natural growth rarely possess any true concavities. If you carefully scrutinize any apparently concave surface on a living form, chances are you will discover that it is actually made up of several convex areas. This is demonstrated well in the Segantini (Fig. 6–36), where there are many points at which the outer contour of the form becomes concave. Yet in all cases, these apparent concavities are explained by the coming together of two or more convex forms.

Convex forms give the impression of dynamic internal forces. Most organic forms possess an internal structure that thrusts against the surface at particular points. Bones protrude against the skin at the joints, contracted muscles bulge at specific places, peas swell in their pods, and so forth. The presence of internal force points is elegantly shown in Ingres's drawing of a male nude (Fig. 6–37).

Because the interpretation of the surface qualities of figures is dependent on an understanding of the underlying anatomical structure, figurative artists often devote considerable study to anatomy. If you expect that you will be engaged in work with the human figure, you ought to be familiar at least with the human skeleton (Fig. 6–38).

Whenever you draw a form that has compound curves, you should stop to analyze the forces that make them concave or convex. And remember that concave forms are generally caused by external forces, and that organic forms, or those created by growth from within, are generally convex. (This holds true as well when you make sculpture. Convex surfaces seem to belong naturally to their volume, whereas concave forms suggest the hand or tool of the sculptor.)

FIGURE 6–35
JOHN RUSKIN
Study of Part of Turner's Pass of Faido
© *Copyright reserved to the Ashmolean Museum, Oxford*

FIGURE 6–36
GIOVANNI SEGANTINI
Male Torso
Crayon and charcoal fixed on buff
wove paper. 312 × 196 mm
*Courtesy of The Fogg Art Museum, Harvard
University Art Museums. Bequest of Grenville L.
Winthrop*

TOPOGRAPHICAL MARKS

Topographical marks are any marks used to indicate the turn of a depicted object's surface. Cross-contour lines and the hatched lines that artists frequently use to show the inflection of planes are both topographical marks.

Topographical marks can be seen in the Kollwitz (Fig. 6–39), in which short, parallel strokes follow the surface curvature of the heads. This work is of special interest because the smaller sketch, in which the marks describe the general form of the head, appears to be preparatory to the larger one, in which the topography of specific facial forms as well as the texture of the hair are indicated.

A looser and more spontaneous application of topographical marks can be seen in the drawing by Marsden Hartley (Fig. 6–40). The speedy marks in this drawing clearly suggest the presence and turn of rounded surfaces but seem reluctant to pin them down, an effect well befitting a portrayal of human work rhythms.

Topographical marks can also be highly controlled, as in the drawing by Victor Newsome (Fig. 6–41). This drawing uses several different systems of marks to indicate the form of the head. The general form is built out from the

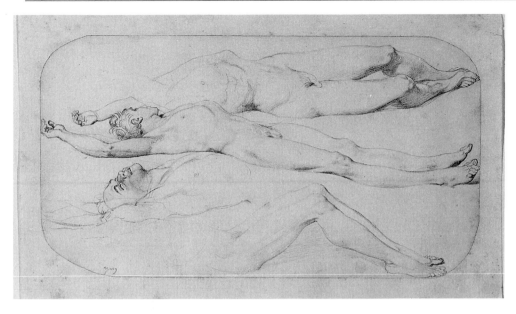

FIGURE 6–37
JOHN AUGUSTE DOMINIQUE INGRES
Three Studies of a Male Nude
Lead pencil on paper, 7¾ × 14⅜"
The Metropolitan Museum of Art, Rogers Fund, 1919 (19.125.2)

FIGURE 6–38
CHRISTINE McKAY, University of Montana
Student drawing: study of a skeleton
18 × 24"
Courtesy, the artist

picture plane by a set of concentric oval shapes, which function similarly to the contour lines showing relative altitude on a topographical map. A second set of lines crosscuts and circles the head, like the latitude lines on a globe. A third set includes the ribbed bands that wrap around the head turban-style, and the fine lines running in general over the terrain of the skull which indicate the play of light and shadow.

TEXTURE

Another topographical feature that you might wish to consider when dealing with the surface of an object is *texture*.

The texture of an object is sometimes directly related to its overall structure or organization, as in the convolutions of the human brain or the spiny, corru-

FIGURE 6–39
Kathe Kollwitz
Two Studies of a Woman's Head,
c. 1903
Black chalk on tan paper,
19 × 24¾″

*The Minneapolis Institute of Arts. Donated by
David M. Daniels. © 1996 Artists Rights Society
(ARS), New York/VG Bild-Kunst, Bunn*

FIGURE 6–40
Marsden Hartley
Sawing Wood, c. 1908
Graphite on paper, 12 × 8⅞″
*Collection of Whitney Museum of American Art.
Gift of Mr. and Mrs. Walter Fillin (77.39)*

gated texture of a cactus. The texture of foliage, so skillfully rendered by Thomas Ender (Fig. 6–42), is a further example of texture that is inseparable from form.

At other times, texture is a mere surface effect that bears no direct relation to the internal structure of the form; fur on an animal, the clothes on a human body, and the shiny chrome on a car fender are all examples of texture that is "skin deep."

But even a superficial texture will sometimes provide you a valuable clue about the particular turn of a form, as can be seen by looking again at Figure 6–39, in which the chalk strokes that indicate the coarse texture of the hair also model the volume of the head.

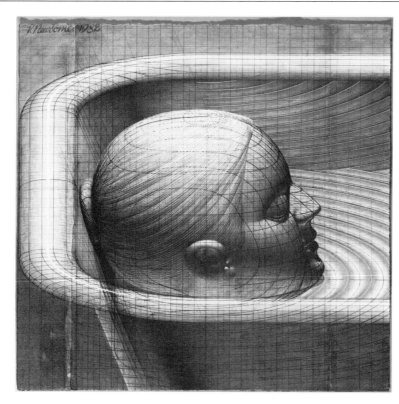

FIGURE 6–41
VICTOR NEWSOME
Untitled, 1982
Pencil, ink, and tempera, 22⅞ ×
23½″
Private collection. Courtesy, the artist

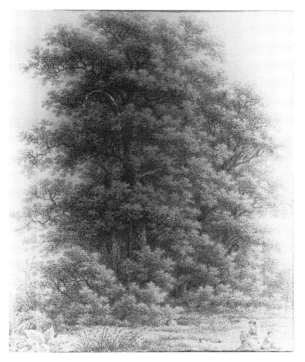

FIGURE 6–42
THOMAS ENDER
*Woman and Children in Front of a
Tree*
Pencil, 9 × 7¼″
*Courtesy, the Frederick and Lucy S. Herman
Foundation*

PATTERN

Surface pattern helps a viewer grasp the curvature or shifting angles of a surface.

In the Grant Wood drawing (Fig. 6–43), note the pattern on both flat and rounded surfaces. On the angled flat surface of the dividing wall, the wallpaper

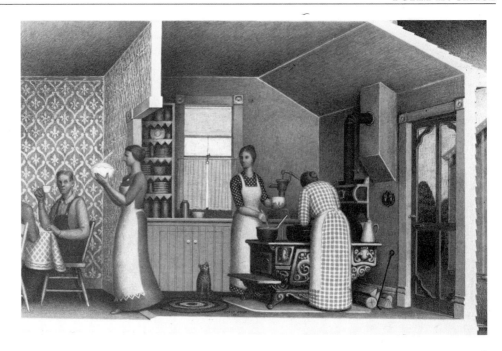

FIGURE 6–43
GRANT WOOD
Dinner for Threshers (right section),
1933
Graphite and gouache on paper,
17¾ × 26¼"
© *1994 Estate of Grant Wood/Licensed by VAGA,*
New York. Collection of Whitney Museum of
American Art. Purchase (33.80)

pattern is drawn in perspective. The lattice pattern found on both the tablecloth and a farm woman's dress is an example of the way patterns can illusionistically wrap around a curved form, adding to its impression of solidity.

Exercise 6E *Explore the surface structure of a form by using topographical marks, pattern, or texture. In the drawing of a seashell (Fig. 6–44), the student has used a tight system of topographical marks to indicate the numerous protrusions on this natural form.*

FIGURE 6–44
KARI PATTERSON, Arizona State
University
Student drawing: topographical
marks used to represent a seashell
Pencil, 10 × 15"
Courtesy, the artist

Form in Light

The vivid impressions of form we receive through certain lighting effects have preoccupied Western artists for a long time. Consider the following observations recorded by Leonardo da Vinci in his *Trattato della Pittura:* "Very great charm of shadow and light is to be found in the faces of those who sit in doors of dark houses. The eye of the spectator sees that part of the face which is in shadow lost in the darkness of the house, and that part of the face which is lit draws its brilliancy from the splendor of the sky. From this intensification of light and shade the face gains greatly in relief . . . and beauty."

This admiration for light's descriptive and transformative powers persists unabated today. In the drawing by Claudio Bravo (Fig. 7–1), the dramatic use of light and shadow has changed an unremarkable subject into a thing of great loveliness. We are transfixed by the sheer voluptuousness of the form, and also by the quality of light in which it is bathed.

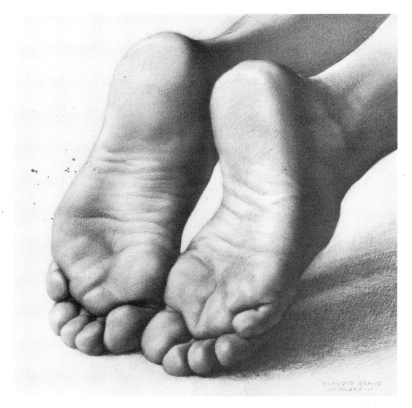

FIGURE 7–1
CLAUDIO BRAVO
Feet, 1983
Charcoal and pencil on paper,
15 × 15″, signed and dated lower
right

Private collection. © 1994 Claudio Bravo/Licensed by VAGA, New York. Courtesy, Marlborough Gallery

The Directional Nature of Light

In the Bravo drawing, we have a strong impression that the light, diffused as it may be, is nevertheless coming from one dominant direction. If we were to attempt to pinpoint the source of the light within three-dimensional space, we would say that it is located in front, above, and to the left of the subject. We make this calculation by observing the position of the lights and darks on the form and also by observing the angle of the shadow cast by the feet on the floor.

We can locate the light source in Figure 7–2 with just as much certainty. Since the left-hand walls and portions of roofs in this drawing are illuminated, and the shadows are cast in front of the buildings, we can assume that the light source is fairly high and located off to the left and in back of the subject. (By observing the length of the cast shadows we can even conjecture that the subject is portrayed at midmorning or midafternoon.)

Now, look at this drawing overall and you will see that a definite pattern of light and dark emerges. Most of the planar surfaces that face left, most of the ground plane, and all surfaces parallel to the ground plane (such as the tops of the broken walls) are illuminated. All surfaces roughly parallel to the picture plane and those portions of the walls that are under eaves are in shade.

As a last example, note the direction of light in the drawing by Wayne Thiebaud (Fig. 7–3). In this case, the fairly high light source is located directly to the right of the subject. That it is neither in front nor in back of the subject is clear from the horizontal direction of the cast shadows.

Value Shapes

Value refers to black, white, and the gradations of gray tone between them. Figures 7–2 and 7–3 can be described as drawings that emphasize value over line. Notice that in both of these drawings, the subject's lights and darks have been represented by value shapes; that is, each shape in the drawing has been assigned a particular tone that is coordinated with the values of other shapes in the drawing.

FIGURE 7–2
VALENTIJN KLOTZ
View of Grave, 1675
Pen and brown and gray ink and blue watercolor washes
Courtesy, Courtauld Institute Galleries, London

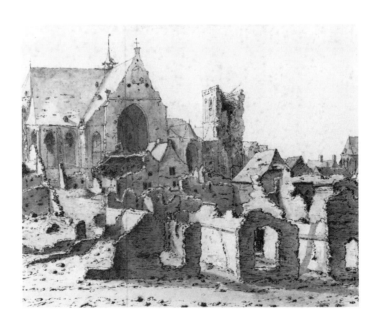

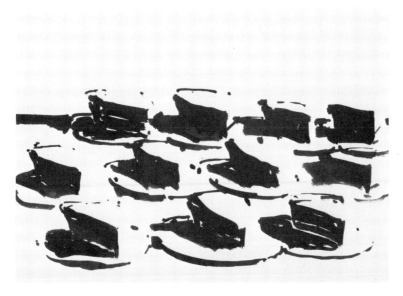

FIGURE 7–3
WAYNE THIEBAUD
Pies, 1961
India ink on paper, 19 × 24⅞"
Rose Art Museum, Brandeis University, Waltham, Massachusetts. Gift of the Friends of the Rose Art Museum Acquisition Society

Take special note of how the subject in Figure 7–3 has been restricted to shapes of black and white, making it a two-tone drawing. Two-tone drawings are not limited to black and white, however; they can be made by pairing any two values from black, through the intermediate grays, to white.

As we have just seen, the use of value shapes is admirably suited to creating an illusion of light striking flat surfaces. But rounded surfaces can also be implied in a drawing if the value shapes correspond to the way areas of light and dark follow the curve of the form.* In the drawing *Isabelle* (Fig. 7–4), value has been

FIGURE 7–4
MARVIN CHERNEY
Isabelle, 1962
Oil on paper, 14⅝ × 12⅝"
Collection of Whitney Museum of American Art. Gift of Samuel Shore (62.35)

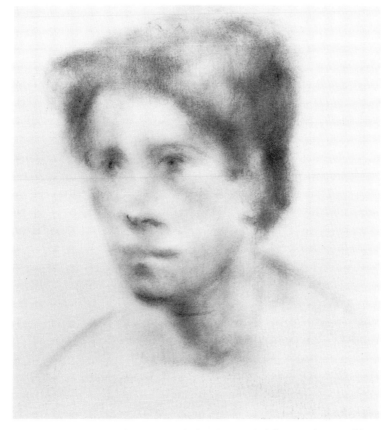

*The use of *chiaroscuro* to create the illusion of tones blended on a rounded form is discussed later in this chapter.

massed into semi-amorphous shapes that convey an impression of form in a shimmering haze of light.

Exercise 7A *This exercise in value shapes will assist you in expressing a convincing sense of form and light with a minimum of means. Appropriate media include charcoal, brush and ink, black and white gouache or acrylic, and collaged papers.*

 Before proceeding, remember that when using value to distinguish between two planes that are located at different angles to a light source, you should be careful to carry the tone all the way to the edge of the shape. Notice that in Figure 7–5a, in which the boundaries between planes are indicated by lines surrounded by white margins, the illusion of abutting planes is not so clear as in Figure 7–5b.

Drawing 1. *This drawing will be done using two tones. In a somewhat darkened room, arrange some brown cardboard cartons so they are illuminated by one strong spotlight. Under this kind of lighting, the shadowed sides of the cartons, their cast shadows, and the darkened surroundings (or "background") will be converted into a single, uniform, dark tonality. The illuminated tops, sides, and ground plane will figure as the light value.*

 Draw two squares in the margin of your paper. Fill one with the dark tone you see in your subject, the other with the light tone. If white is to be the lightest value and you are using gouache or acrylic, paint the one square white; otherwise leave it the tone of your paper.

 Using the squares as your tonal key, draw the subject as areas of light and dark. Since a system of value shapes is the emphasis of this exercise, it is not necessary to make a preparatory line drawing. Remember that adjoining planes identified as all dark or all light should be consolidated into one shape (for an example, refer to Fig. 7–3).

Drawing 2. *This time you will use three values. Depict the cartons (or other angular objects) by making a collage of torn paper, in tones of black, white, and middle gray (Fig. 7–6).*

Drawing 3. *On a sheet separate from your drawing paper, make a row of five contiguous tones, from light through middle gray to dark. Note that tones two and four will be an average of the middle gray and, respectively, the lightest and darkest values in the end squares.*

 Utilizing all five tones, depict a set of common objects against a ground plane of one constant value (Fig. 7–7).

 Figure 7–8 shows a variation on this exercise employing collaged photocopies to achieve a greater number of values.

FIGURE 7–5

(a)
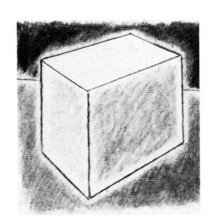

(b)
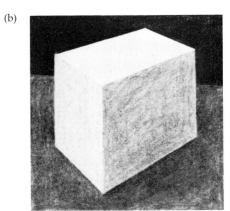

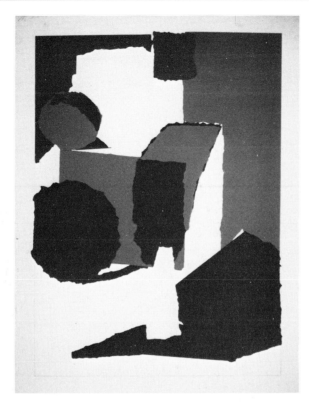

FIGURE 7–6
Student collage: torn paper collage
in three values

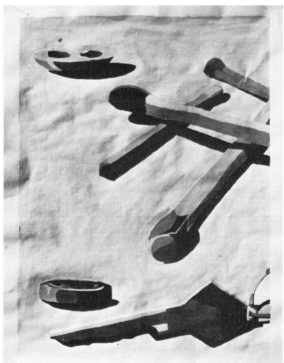

FIGURE 7–7
Student drawing: use of five values
to express light and form

Local Value

Two factors regulate the amount of light that is reflected off a surface. The first is the degree of illumination the surface receives. This is determined by the angle of the surface in relation to the light source: surfaces perpendicular to the rays of light will appear the brightest; those parallel to the rays will

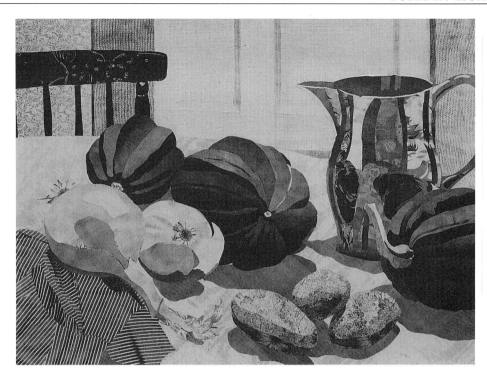

FIGURE 7–8
MILLY TOSSBERG, University of
Montana
Student value study: value study
using collaged photocopies
18 × 24″
Courtesy, the artist

be of middle brightness; and those turned away from them will be the darkest.

The second factor is the inherent color of an object's surface. The surface of an object that is dark in color, such as a desk with a deep walnut finish, will reflect less light than one that is equally illuminated but of a paler color, such as a powder blue telephone. So a basic attribute of any color is its relative lightness or darkness. Artists who work with traditional black-and-white drawing media analyze the lightness or darkness, or color tone, of objects and record them as value.

Often, artists squint at their subjects, concentrating on how the eye, much like the lens mechanism of a camera, admits the relative lights and darks of the colored surfaces they want to draw. This strategy allows them to more readily ignore the colors and identify the *inherent* tonality of each object's surface. This inherent tone, free of any variations that result from lighting effects or surface texture, is commonly referred to as the *local value* of an object.

Local values can be broadly translated into shape areas, as in Figure 7–9. In this early drawing by Picasso, the dark tone of the seminarians' robes contrasts sharply with the paleness of their faces and likewise with the delicate tones of the ground plane and surrounding walls. The middle gray of the trees has a calming and softening effect on this otherwise stark portrayal.

Picasso's decision to limit his tonal palette to the local value of each individual area in Figure 7–9 heightens the work's expressive impact. Frequently, though, artists wish to consider not only the local value of their subject but also the major variations of surface tone caused by light. In this case, the local value can function as a tonal center, or constant, to which artists can relate the variable lights and darks they interpret from an object. To clarify this point, look at Figure 7–10, in which the rectangular shafts of light are each divided into three carefully measured tones to register respectively the local values of the wall, molding, and blackboard.

Armed with an awareness of local value, you will gradually become more sensitive to the intimate alliance between the essential lightness or darkness of an object and the value variations that appear on its surface. As a consequence, any tendency to represent all light as white and all shadows as black will be moderated by personal observation. In actuality, such extremes of light and dark

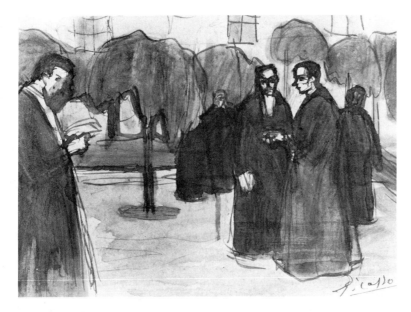

FIGURE 7–9
PABLO PICASSO
Priests at a Seminary
Pen, ink, watercolor
Private collection. Photo courtesy of the Museum of Art, Rhode Island School of Design. © 1996 Artists Rights Society (ARS), New York/SPADEM, Paris

FIGURE 7–10
NORMAN LUNDIN
San Antonio Anatomy Lesson, 1982
Pastel and charcoal, 28 × 44″
Courtesy of Space Gallery, Los Angeles

on a single form are rare under normal lighting conditions. More often you will notice that only objects with a local value of dark gray will approach black in the shadows, and the highlight on such a form will seldom exceed middle gray. Similarly, the local value of an egg simply does not permit a coal black shadow.

Directional Light and Local Value

In his watercolor "Houses in Gloucester" (Fig. 7–11), Edward Hopper indicates both a directed source of light and a range of local values. Although any sense of a tonal center in most of the roofs is obliterated by the powerful light of the sun, local values are clearly evident in the shaded portions of the houses. Compare this image with Figure 7–2, in which all the buildings and the ground plane are treated as if they were of identical local value.

When you combine an interest in directed light with the use of local value, it is best, whenever possible, to control the source of illumination. Strong lighting, such as that provided by direct sunlight or the use of a spotlight alone, produces a sharp contrast between lights and darks and thus makes it difficult

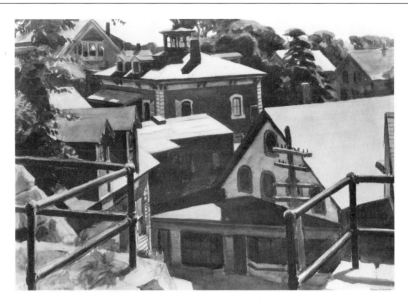

FIGURE 7–11
EDWARD HOPPER
Houses in Gloucester
Watercolor, 13½ × 19½"
*Collection of Mr. and Mrs. James A. Fisher,
Pittsburg, Pennsylvania (APG 10044 d)*

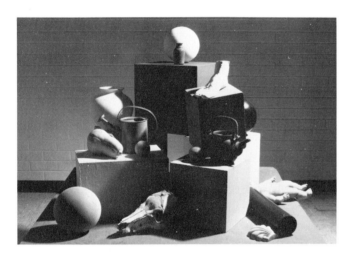

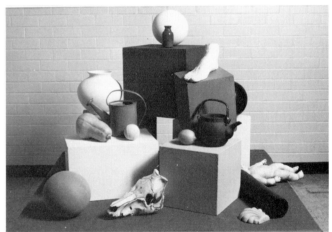

FIGURE 7–12a (left)

FIGURE 7–12b (right)

to see local value (see Fig. 7–12a). An even light, such as found in a room well lit by fluorescent tubes, reveals local value very well, but since such light is nondirectional it does not show the form of an object to advantage. The ideal lighting condition for observing both the local value and the form of an object is one in which the light is directional but not harshly so, such as might be found by a window that does not admit direct sunlight (Fig. 7–12b).

To give the illusion of both directional light and local value, you need to have a command over a range of tones. To acquaint yourself with the tonal spectrum of which your medium is capable, we suggest that you make a scale of nine separate values. The value scale in Figure 7–13 is particularly useful because the dot of middle gray in the center of each square demonstrates the relative nature of value. The same middle gray that appears as a dark spot in the midst of light-toned squares appears as a pale spot within the context of the darker values.

In making a scale of this kind, we suggest that you start by lightly outlining nine adjoining squares with a circle in the middle of each one. Place the darkest and the lightest tones that you can achieve with your medium on opposite ends of the scale, taking care to leave the circles blank. Then proceed to fill the middle square and the circles with a middle gray. Finally, fill in the remaining squares

so that there is an equal jump in tone between them. Remember to blend each individual tone thoroughly, leaving no white margin or black dividing line between the squares.

Optical Grays

Certain dry media, such as pastel and charcoal, and wet media, such as ink wash, watercolor, gouache, and acrylic, are commonly used to make solid *actual* gray tones. Media more suited to a linear approach, such as pen and ink, pencil, felt-tip marker, and silverpoint, can be used to create *optical* gray tones. Optical grays are commonly the result of hatched or ''crosshatched'' lines, which the eye involuntarily blends to produce a tone. The term *hatched lines* refers to an area of massed strokes that are parallel or roughly parallel to each other. *Crosshatching* is a technique that results when sets of these lines intersect one another.

Optical grays can be utilized to achieve the same ends as blended or actual grays. In the drawing by Gaspard Dughet (Fig. 7–16), hatched parallel lines indicate the relative tones of trees and sky. Notice that the hatched lines do not change direction in an attempt to show the topography of the form. Instead, their role is restricted to the depiction of light and dark. In spite of their mechanical look, hatched lines of this sort are well suited to drawing natural subjects. And in contrast to areas of subtly blended tone, the rapid laying in of hatched lines appears to allow a form to breathe.

A robust and gestural use of crosshatched lines to construct shadows can be seen in Figure 7–17. Notice how varying densities of hatched lines help to establish the spatial position of the forms and their gradual emergence from the shadows. This approach to value is an additive one; in other words, the artist began with some selective scribbling and continued to add marks here and there until the form was sufficiently developed.

An additive approach is particularly evident in Figure 7–18, which showcases an unorthodox technique for achieving optical grays. In this stamp pad-

FIGURE 7–14
Student drawing: self-portrait using
toned shapes to express local value

FIGURE 7–15
M. Austin Gorum, Pratt Institute
Student drawing: use of local value
to enrich the depiction of common
objects
3.5 × 4′
Courtesy, the artist

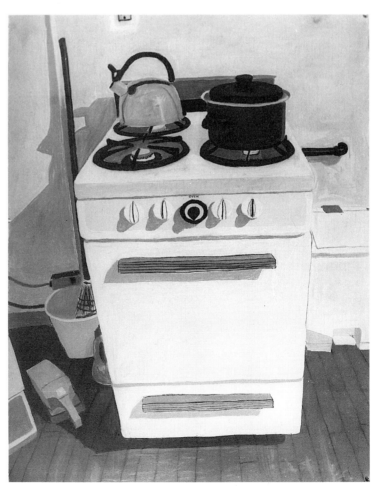

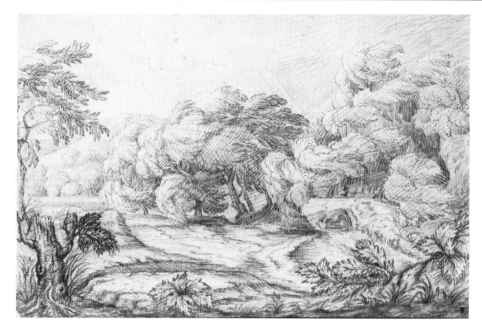

FIGURE 7–16
GASPARD DUGHET
Landscape
Red chalk, 27.4 × 41.3 cm
*The Art Museum, Princeton University. Gift of
Margaret Mower for the Elsa Durand Mower
Collection*

FIGURE 7–17
HENRY MOORE
Women Winding Wool, 1949
Watercolor, crayon, and brush,
13¾ × 25"
*The Museum of Modern Art, New York. Gift of Mr.
and Mrs. John A. Pope in honor of Paul J. Sachs*

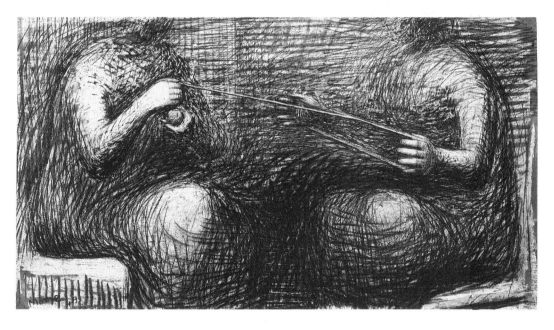

ink drawing by Chuck Close, fingerprints of different intensities have been
carefully dabbed onto a grid.

*Drawing with hatched and scribbled lines is an excellent way to record your spontaneous
impressions of things observed. For this reason, scribbled-tone drawing is an especially useful
sketchbook practice, so you will probably have ample recourse to it in the future.*

 *For this exercise, we suggest using a felt-tip marker, since it is ideal for fast render-
ings of objects. Start by making a value scale of nine optical grays (Fig. 7–19). This will
help you to gain sufficient control with your felt-tip marker to begin making drawings of actual
objects.*

 *Next, find an object that possesses a fairly complex system of concavities and convexities
and place it where it will receive illumination from basically one direction. Draw the major
shadows with your marker, using either a carefully hatched or scribbled line. Continue adding
marks until the form starts to appear. Areas of darkest shadow will ultimately receive the most
attention. Fig. 7–20 is an example of carefully controlled scribbled line used to build optical
grays.*

Exercise 7C

FIGURE 7–18
CHUCK CLOSE
Phil/Fingerprint II, 1978
Stamp pad ink and graphite on
paper, 29¾ × 22¼″
*Collection of Whitney Museum of American Art.
Purchase, with funds from Peggy and Richard
Danziger (78.55)*

Chiaroscuro

Chiaroscuro is an Italian term that basically translates to mean light and dark. In the pictorial arts, chiaroscuro refers more specifically to a gradual transition of values used to achieve the illusion of how light and shadow interact on actual, three-dimensional forms.

However, only certain kinds of light adequately reveal the curvature of a rounded form. A very harsh light, for instance, tends to flatten areas of light and dark into value shapes, as the earliest masters of chiaroscuro knew. Leonardo cautioned against drawing under any lighting conditions that cast strong shadows. In his *Trattato della Pittura* he outlines specific recommendations for illuminating the head of a young woman so that it can be drawn with all its delicacy and charm: the model should be seated in a courtyard with high walls that are painted black, and direct sunlight should be excluded from the space by a roof fashioned of muslin. Whether or not Leonardo ever followed his own set of guidelines, the drawing in Figure 7–21 is certainly evidence of his fascination with the ability of light to model form.

Impractical as Leonardo's advice may be, the general point it makes is sound: a very strong light source must be avoided when the intention is to concentrate on the three-dimensionality of a subject. But, so too, must the situation be avoided in which the subject is illuminated entirely by *ambient light*.

Ambient light is the opposite of a unidirectional light source since it appears to come from all directions. The familiar white-walled institutional room, lit with banks of fluorescent tubing, is drenched with ambient light. Although in some circumstances daylight can also be defined as an all-enveloping ambient light, the daylight that comes into a studio with north-facing windows is traditionally favored by people who draw. This is because it is sufficiently directional to reveal form yet not strong enough to cast harsh shadows.

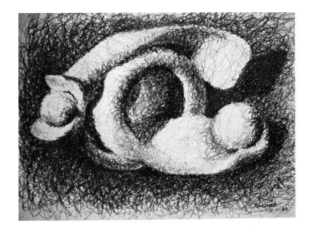

FIGURE 7–20
Student drawing: scribbled line to achieve optical grays

Let us imagine that you are situated in a studio with north light and that the back of your left shoulder is pointed toward the window. The light source is, therefore, behind you, above you, and to the left. In front of you is a light-gray sphere softly illumined by light coming in the window and by reflected light from the light-gray tabletop.

The gradations of light that you would see on the sphere can be separated for convenience sake into five separate zones. A sixth zone is the sphere's cast shadow. These zones, illustrated in Figure 7–22, are as follows:

1. The *highlight,* or brightest area of illumination. The highlight appears on that part of the surface most perpendicular to the light source. If the surface is a highly reflective material, such as glass, the shape of the light source will be mirrored on the form's surface at the point of the highlight. If the surface of the sphere is very matte (dull, or light-absorbing, as is velvet) you may see no highlight at all. In Figure 7–22, the surface of the form may be assumed to be semimatte.

2. The *quartertone* or next brightest area. On a semimatte object, the highlight is blended well into the quartertone.

3. The *halftone,* which is located on that part of the surface that is parallel to the rays of light.

4. The *basetone,* or that part of the surface that is turned away from the rays of light and is, therefore, the darkest tone.

5. *Reflected light,* or the light bounced off a nearby surface. This light is relatively weak and will be observed on the shadowed side of the form just inside its outer contour.

6. The *cast shadow,* which is thrown by the form onto an adjacent or nearby surface in a direction away from the light source. Although there are rules of linear perspective governing the use of cast shadows, you would do best to rely on your own visual judgment to record the shapes of these shadows.

A similar organization of tones can be found in curved forms other than true spheres, as can be seen in the still-life drawing by Martha Alf (Fig. 7–23).

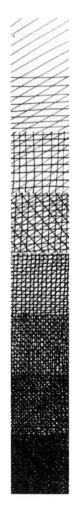

FIGURE 7–19

Set up a subject of a uniform color, such as a ball painted a flat light gray or a substantial piece of drapery (Fig. 7–24). Establish a light source a little behind you and off to one side.

Using compressed charcoal or black conté crayon, do a chiaroscuro drawing of the subject, taking care to include all five areas of tone and the cast shadow. Use a piece of wadded

Exercise 7D

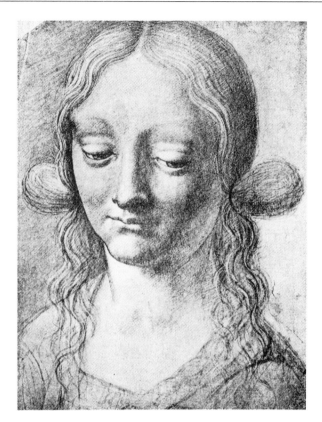

FIGURE 7–21
LEONARDO DA VINCI
Portrait of a Woman
Picture Collection, The Branch Libraries, The New
York Public Library

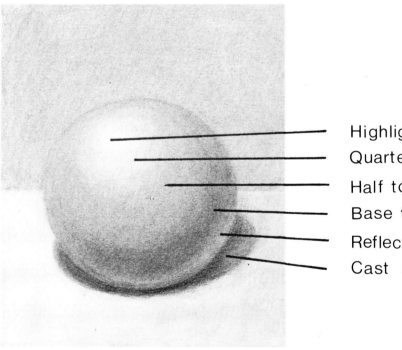

——————— Highlight
——————— Quarter tone
——————— Half tone
——————— Base tone
——————— Reflected light
——————— Cast shadow

FIGURE 7–22

newsprint or a store-bought paper stump to blend the areas of tone, thus achieving smooth
transitions between them.

Avoid exaggerating the size and brightness of the highlight and reflected light. You will
need to blend the edges of these areas into the surrounding tones; if you do not, they will
have the illusion of pushing forward from the volume's surface.

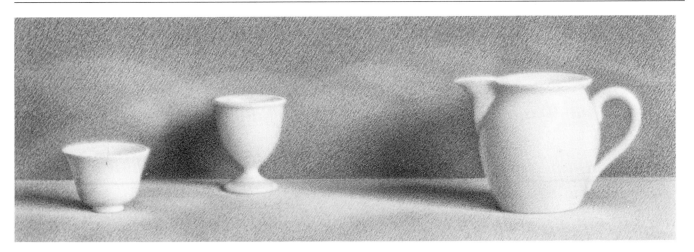

FIGURE 7–23
MARTHA ALF
Still Life #6, 1967
Charcoal on bond paper,
8½ × 24½"
Collection, the artist

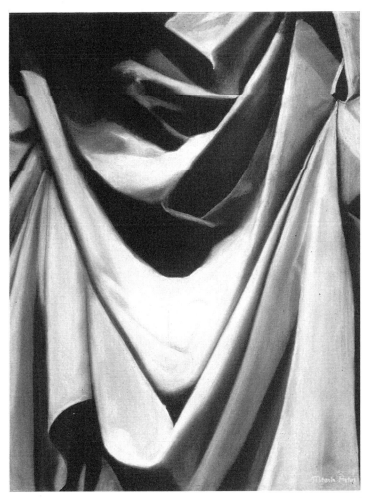

FIGURE 7–24
MITOSH PATEL, Oklahoma State
University
Student drawing: drapery study
using chiaroscuro
Black and white conté, 18 × 24"

CHIAROSCURO AND TOPOGRAPHICAL MARKS

Of all the techniques used to render form, the one traditionally favored combines the observation of the way that light falls on a form with a judicious use of topographical marks.* This technique requires that the lines or marks used to create optical grays also follow the turn of the form's surface. A finely wrought example of this can be seen in Figure 7–25, in which a dense web of fine lines

*See "Topographical Marks" in Chapter 6.

FIGURE 7–25
FRANK PIATEK
Abstract Configuration Number One,
1990
Acrylic, gesso, graphite, white
chalk, collage on paper,
50¼ × 65¾"
Courtesy, Roy Boyd Gallery, Chicago

defines the turning surfaces of the imagined forms while at the same time
indicating a play of subdued light.

By analyzing the topography of a form simultaneously with recording the
accidental play of light upon its surface, one can achieve a more convincing
sculptural effect than would result from the use of either optical grays created
by hatched line, or by the use of topographical lines alone. This technique, after
all, combines the knowledge of form that can be gained through the tactile senses
with knowledge that is gained through our observation of light and shadow.
And when employed in a highly controlled way, this technique is unsurpassed
for its capacity to model forms of the greatest complexity and subtlety, as we
have seen in Figure 7–1.

CHIAROSCURO AND LOCAL VALUE

From the High Renaissance to the early nineteenth century, chiaroscuro was
considered virtually indispensable to the art of drawing. A premium was placed
upon the modeling of form in the sculptural sense, as may be seen in Michel-
angelo's drawing of the Libyan Sybil (Fig. 7–26).

During this extended period, local value in drawing was not generally
deemed important, although many artists used local color to great compositional
effect in their paintings. In the nineteenth century, however, the Renaissance
tradition of the picture plane as a window onto infinite space was replaced with
a new concern for the flat working surface used by the pictorial artist. As a
result of this concentration on the flatness of the picture plane, shape became
a more primary means of expression than the traditional illusion of sculptural
form. And with an emphasis on shape arose an increased preoccupation with
local value.

By the end of the nineteenth century artists had become adept at using
local value shapes to arrive at striking compositions. Furthermore, they found that
by controlling the figure–ground relationship of local values, they could achieve
a graphic illusion of space, as we have seen in the Picasso drawing (Fig. 7–9).

Artists will frequently elect to concentrate on either the chiaroscuro mod-
eling of a subject or its local value. This may be demonstrated by comparing the
Degas study of drapery (Fig. 7–27) with the drawing of a Spanish dancer by

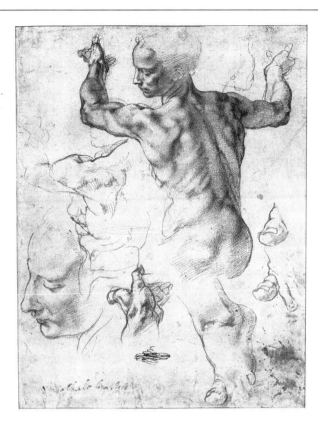

FIGURE 7–26
MICHELANGELO
Studies for the *Libyan Sybil*
Red chalk, 11⅜ × 8⅜″
The Metropolitan Museum of Art. Purchase, 1924.
Joseph Pulitzer Bequest (24.197.2 obverse)

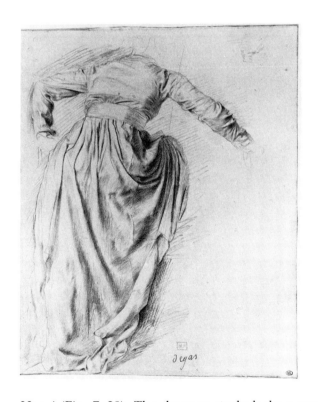

FIGURE 7–27
EDGAR DEGAS
Draped figure, *Study for Seramis*
Pencil, 30.9 × 23.5 cm
Courtesy, the Louvre, Paris (RF15.500)

Henri (Fig. 7–28). The drapery study lacks a sense of local value; whether the cloth portrayed is of the palest rose or the deepest purple we do not know. But since Degas' concern was to develop the intricacies of this draped garment in a sculptural manner, the tone of the actual color is of no account. In the *Spanish Dancer*, however, Henri found the play of relative local values essential to the portrayal of his colorful subject. We get a strong sense of boldly rouged lips and

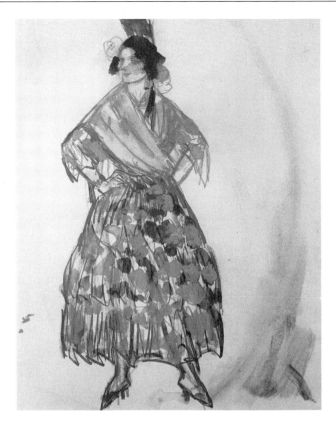

FIGURE 7–28
ROBERT HENRI
Spanish Dancer
Watercolor, pencil, 10½ × 8"
Phoenix Art Museum. Gift of Edward Jacobson

cheeks, dark hair, and fabric gaily splashed with a floral motif. But note that there is very little sense of chiaroscuro in this drawing.

That artists have often chosen to concentrate on either a chiaroscuro modeling of form or local value does not rule out that the two can be successfully combined in one drawing, as we see in Figure 7–29. To represent the play of light and shadow on his subject, Pearlstein employs the systematic changes of value identifiable with chiaroscuro technique. But instead of blending the tones, he records them as a sequence of value shapes that are carefully contoured to the form. The profusion of these lighting effects is always, however, kept within the boundaries of a tonal "home base," or local value. And when joined with

FIGURE 7–29
PHILIP PEARLSTEIN
Male and Female Mirrored, 1985
Conté crayon on paper, 32 × 40"
Courtesy, Hirschl & Adler Modern, New York

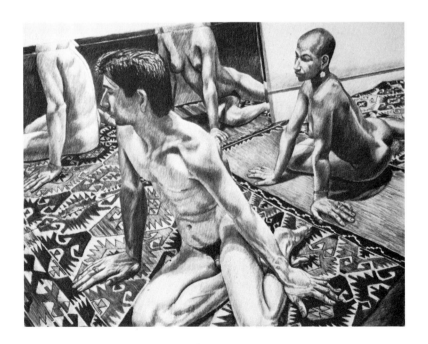

a spectrum of clear and relatively unmodulated local values, as in the patterned rug, the almost clinical sensibility that emerges can be disquieting.

When you wish to balance chiaroscuro and local value you must be careful not to let the chiaroscuro get out of hand. In the Vuksanovich drawing (Fig. 7–30), note that the tonal identity of the model's skin is almost lost because of the wide range of values used to describe harsh shadows, highlights, and reflected lights. The startingly glossy appearance that this application of value yields can in this case be explained by the artist's near-photographic rendering of the dual light source.

A related issue concerns the belief that value richness in a drawing is always dependent on the use of a full range of tones, including the high contrast of black and white. This is far from true, since many fine drawings in the history of art are composed of a limited series of closely related values that establish a dominant mood, or *tonal key.*

Tonal keys can be high (ranging from white to middle gray), middle (tones within the middle range of the value scale), and low (the dark half of the scale). *Tonal key* refers to the *overall* choices and effect of a coordinated group of values. So it would not preclude, for example, the use of dark accents in an otherwise high-key drawing.

Establishing a tonal key can be a means to both unifying the value schema of a drawing and expressing a distinctive condition of light and mood, as can be seen in Figures 7–31 (a low tonal key) and 7–32 (a high tonal key). Interestingly, artists sometimes transpose the actual values of their subject into another key, making sure to adjust each tonal area proportionately.

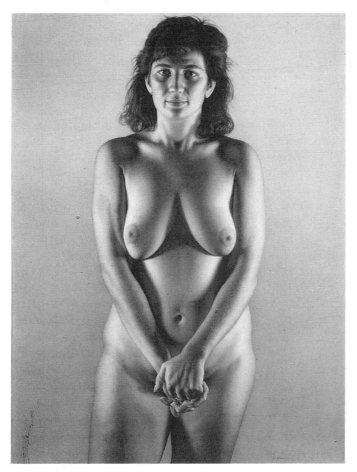

FIGURE 7–30
BILL VUKSANOVICH
Nude, 1990
60 × 44"
Courtesy, Struve Gallery, Chicago

FIGURE 7–31
MELL DANIEL
The Forest, 1923
Crayon, pen, and ink, 12 × 9″
*The Museum of Modern Art, New York. Gift of
Willem and Elaine de Kooning*

In summation, you can employ chiaroscuro without sacrificing the tonal
identity of your subject as long as the range of tones used to model a form is
responsive to that form's local value. Figure 7–33 demonstrates how chiaroscuro
used within the confines of three different tonal keys—high, middle, and low—
can give the impression of forms of distinct local values.

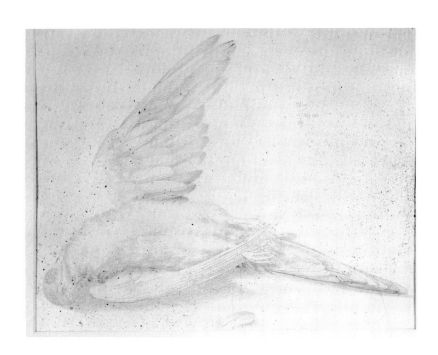

FIGURE 7–32
JOHN WILDE
Objecta Naturlica Divini, 1949
Silverpoint and ink on gessoed
paper
*Robert Hull Fleming Museum, University of
Vermont. Gift of Henry Schnakenberg*

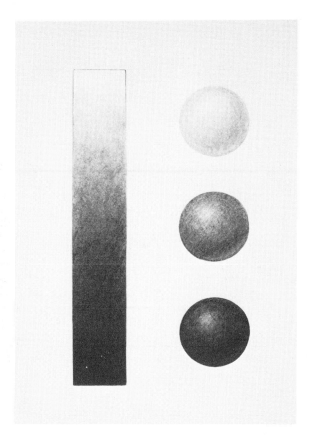

FIGURE 7–33

CHIAROSCURO AND TEXTURE

The texture of an object can be drawn using chiaroscuro technique if you consider the various protrusions and indentations of the surface as form in the miniature. One example is the exposed grain of weathered wood, which, when held at the correct angle to the light, reveals itself as a pattern of shallow hills and valleys. An unusual application of this concept is found in Figure 7–34, in which an area of ocean has been conceived entirely in terms of chiaroscuro and texture.

As Figure 7–34 clearly shows, texture is best revealed by raking light, that is, a light that is directed from the side to throw textural details into visual relief.

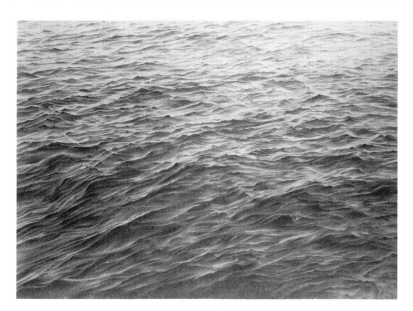

FIGURE 7–34
Vija Celmins
Ocean Image, 1970
Graphite and acrylic spray,
14¼ × 18⅞"
The Museum of Modern Art, New York. Mrs. Florene M. Schoenborn Fund

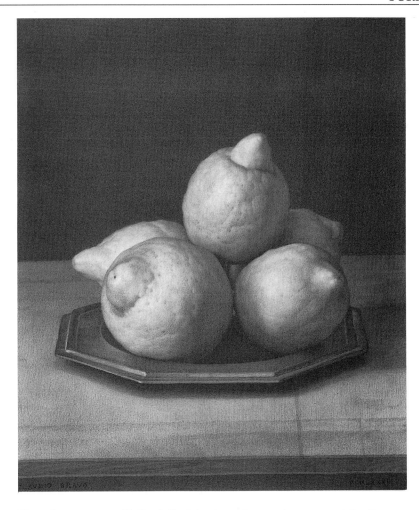

FIGURE 7–35
CLAUDIO BRAVO (b. 1936)
Lemons, 1982
Drawing on paper, 15¾ × 13⁵⁄₁₆″
Private Collection. Courtesy, Marlborough Gallery

Therefore, you will find that texture is most apparent in the areas of halftone where the rays of light are most parallel to the surface of a form. This can be seen in the Claudio Bravo drawing, Figure 7–35, in which the wrinkled and pitted surface of each lemon is most visible where the form starts to turn away from the light. In the more illuminated areas of the surface, where the angle of the rays is most direct, the texture is saturated with light. In the darker areas of the form, the texture is lost in shadow.

Texture includes the idea of the ultrasmooth as well as the very rough. When a surface is so smooth that it is shiny, the normal guidelines of chiaroscuro do not apply. In such cases, the surface reflects values from the surrounding environment, and frequently very light and very dark tones appear next to each other. An example of this can be seen in the reflective surface of the pot in the Currier drawing (Fig. 7–36).

Texture need not receive the literal interpretation seen in the last three illustrations. Instead, it can be approximated by a more spontaneous system of marks, as in the Arneson self-portrait, Figure 7–37. Notice that the light and dark marks in this drawing are graded so as to show the general turn of the form.

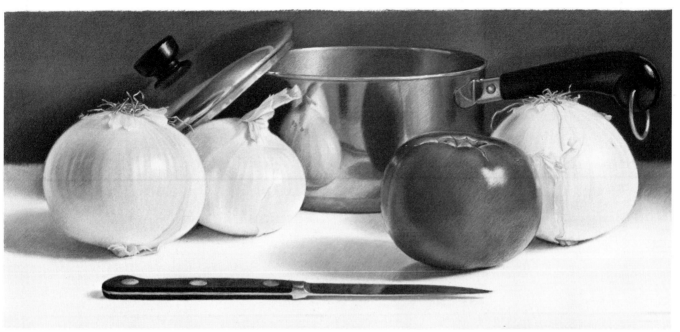

FIGURE 7–36
MARY ANN CURRIER
Onions and Tomato, 1984
Oil pastel on museum board,
26½ × 56″
Courtesy, Tatistcheff Gallery, New York

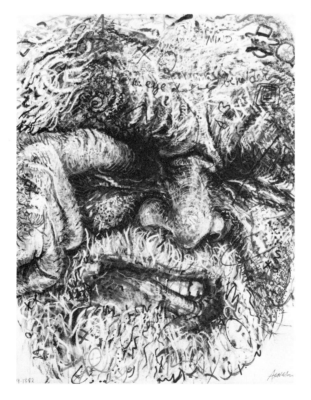

FIGURE 7–37
ROBERT ARNESON
Eye of the Beholder, 1983
Acrylic, oil stick on paper, 38 × 53″
Courtesy, Allan Frumkin Gallery

8

Subject Matter: Sources and Meanings

The preceding chapters of this book were designed to help you to master the basics of drawing. In the midst of learning these fundamentals, you may at times have wondered when you would be able to put your "basic training" aside and begin to make expressive drawings. But in truth, the drawings you have been making all along have been involved on some level with self-expression. Maybe you have even noticed that your drawings have consistently exhibited certain visual characteristics that are different from those of your classmates, even when a very specific assignment had to be carried out? Features that distinguish your drawings from those of your peers reflect your particular way of seeing and making visual order and, once recognized, will give you an inkling of your own artistic identity.

From this chapter forward, our emphasis is more fully on expressive issues in drawing. We examine how self-expression is rooted in *what* you draw and *how* you draw it and also how these two factors combine to affect the thoughts and emotions of a viewer. Or, in art terminology, we are speaking of what are often called the components of an artwork's expression, namely, subject matter, form, and content. As an introduction to these terms, we provide the following definitions:

Subject matter refers to what artists select to represent in their artwork, such as a landscape, portrait, or imaginary event.

Form refers to the set of visual relationships that artists create to unify their responses to subject matter.

Content is the sum of meanings that are inferred from the subject matter and form of an artwork.

Subject matter, form, and content are indivisible in a work of art. To explore their expressive possibilities in depth, however, we discuss each of these components separately. We begin by focusing on traditional subject matter areas.

Traditional Subject Matter Areas

There are four major areas of subject matter—the human figure, landscape, still life, and the interior—that may be considered "classic" since they have survived the test of time. That all four categories are still viable today attests to the fact that they are both meaningful enough in themselves to have relevance for contemporary life and general enough to allow almost unlimited scope for personal expression.

Almost any subject you draw will in some way include the human figure, landscape, still life, or the interior. An awareness of the rich heritage of meaning attached to each of these subject matter areas should help you to consolidate your own emotional and intellectual reactions to any particular subject you choose to draw.

Although the four major subject matter areas were sometimes accorded separate treatment in Classical (Greek and Roman) art, in the Middle Ages they were for the most part subsumed into narrative works, which were usually religious but occasionally allegorical or historical. When these subjects were not essential to the story illustrated, they often appeared as incidental detail that nonetheless had allegorical content that reflected back on the larger meaning of the narrative.

Starting in the Renaissance, each of these formerly incidental areas began to reemerge as a subject in its own right. And as new symbolic content gathered around them, the set of meanings these subject areas carried from narrative painting evolved over the centuries. What follows now is a brief survey of themes found within these four major subject matter areas.

THE HUMAN FIGURE

The figure as a subject in itself was the first to reemerge from the narrative art of the early Renaissance. This happened at a time when the philosophy of humanism was initially taking shape. The humanist movement upheld the inherent dignity of the individual with the assertion that one could be ethical and find fulfillment without help or guidance from supernatural powers. The rationalist basis of this philosophy is embodied in the drawings of idealized nudes by Leonardo, and to a lesser degree in the earlier drawings of Michelangelo. This secular bent of humanism made possible a view in which human beings stand heroically alone and responsible for their own destiny. Today, the essential loneliness of the individual is a central theme around which many portrayals of the figure are constructed.

The male nudes by Sylvia Sleigh (Fig. 8–1) and Stephan Hale (Fig. 8–2) are contemporary variations on the notion of the ideal body. Although a genuine affection and admiration characterizes the drawing by Sleigh, the prettifying of the young adult male seems to be a wry comment on the traditional depictions of the female odalisque as object of the male gaze. No such personal involvement is evident in the drawing by Hale, but rather the means for idealizing, and even glamorizing the figure—the level gaze, the floodlighting that reveals the facial structure and musculature, the single prop, and the shallow space—are all appropriated from the field of fashion photography.

In contrast, the figures in the Pearlstein drawing (Fig. 8–3) are devoid of both idealized beauty and glamour, making them appear more naked than classically nude. Instead of stylizing the figures, this artist has more directly addressed the corporeality of the human body, a property that has been exaggerated by the way in which the figures fill the picture space.

In the Modern era, the idea of the lonely state of the individual found its extreme expression in the theme of alienation, of which the Georg Baselitz drawing is a contemporary example (Fig. 8–4). What is of particular interest

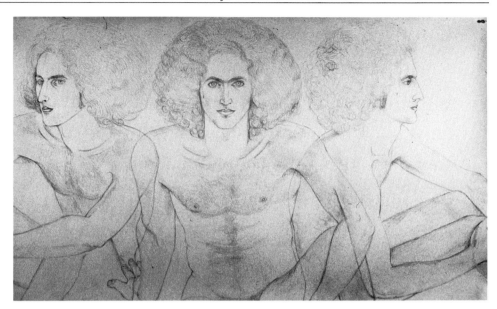

FIGURE 8–1
SYLVIA SLEIGH
The Seasons, 1976
Pencil on paper, 36 × 60″
Courtesy, the Zaks Gallery

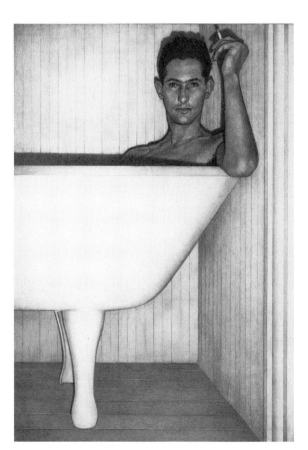

FIGURE 8–2
STEPHEN HALE
Untitled, 1985
Graphite on paper, 40 × 30″
Private collection, NYC. Courtesy, Bridgewater/
Lustberg Gallery

here is the way in which the viewer is implicated in this topsy-turvy world. Common sense tells us that when we perceive the world upside down, it is our own bodily position, and not the world's, that is inverted. But common sense is absent from this drawing, for the figure is losing its head; and that head, detached literally and figuratively from the hysterical body, invites us to question whether it is we, as individuals, or the world that is insane.

Portraiture, which may be considered a subcategory of figurative art, is often concerned with the rank or social position of the individual portrayed. In the Jan van Eyck painting (Fig. 8–5), the social rank and respectability of the

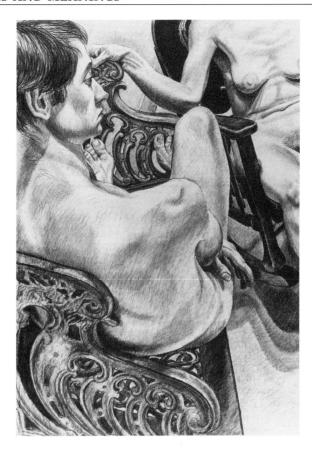

FIGURE 8–3
PHILIP PEARLSTEIN
*Male and Female Model with Cast-Iron
Bench and Rocker,* 1982
Charcoal, 44 × 30"
Courtesy, the artist

FIGURE 8–4
GEORG BASELITZ
Edvards Kopf (Munch), 1983
Charcoal, 61.2 × 43.2 cm
Offentliche Kunstsammlung, Basel

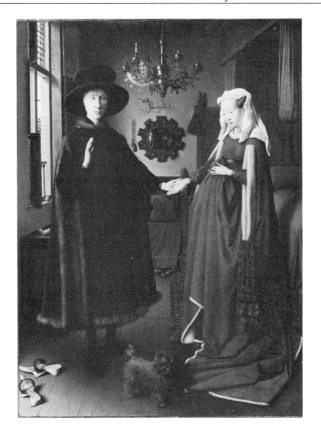

FIGURE 8–5
JAN VAN EYCK
The Marriage of Giovanni Arnolfini and Giovanna Cenami
Oil on panel, 33 × 22½"
Reproduced by courtesy of the Trustees, The National Gallery, London

Arnolfini household is alluded to by representing the couple in the context of the Sacrament of Holy Matrimony (the single candle signifies the all-seeing Christ; the little dog signifies fidelity; and the cast-off shoes signify the bridal chamber as holy ground).* In the Valerio drawing (Fig. 8–6), an updated version

FIGURE 8–6
JAMES VALERIO
Mark and Barbara, 1972
Pencil on paper, 29 × 23⅛"
Solomon R. Guggenheim Museum, New York. Gift, Norman Dubrow. Photograph by David Heald, © The Solomon R. Guggenheim Foundation, New York (83.3123)

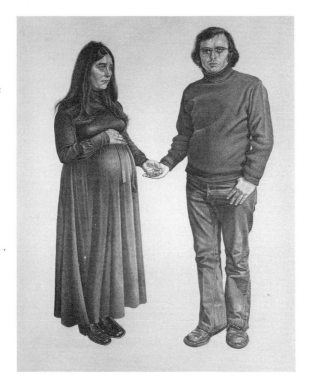

*H. W. Janson, *History of Art* (Englewood Cliffs, N.J.: Prentice-Hall, 1967), p. 292.

of this well-known image, the symbolic elements that conferred special status on the Arnolfini couple are conspicuously absent. Additionally, the shabby gentility evident in the clothing and hairstyles of this couple leaves us in little doubt about their social position.

Like Valerio, Alice Neel is concerned with depicting her subjects in the context of the "Zeitgeist," or prevailing spirit of the times. Her drawing (Fig. 8–7) is an impassioned yet ironic portrayal of the conflict between her subject's image of himself and the way she sees him as a member of society at large. His angry and impatient glance and the furtive, admonishing gesture of his forefinger seem to imply that he is some kind of revolutionary. But the artist has played up the dandyish aspect of his hippy's garb so that he ultimately recalls the politically retrograde seventeenth-century cavalier.

The self-portrait is a category of figurative work to which many artists turn if for no reason other than the availability of the model. In addition, we are all curious about our own identities and often wonder how the perceptions others have of us might square with what we know about ourselves; self-portraiture can be used to explore this universal question. In expression, self-portraits range from idealized or romantic images to ones that are more insightful or even unsparing. The self-portrait by Roche Rabell (Fig. 8–8) is one of the latter sort, consisting of an unusually close-up view objectively recorded.

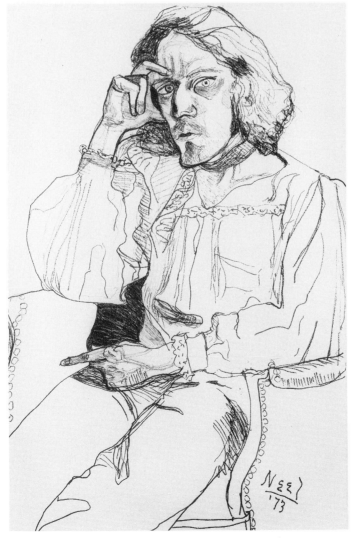

FIGURE 8–7
ALICE NEEL
Stephen Brown, 1973
Ink on paper, 44 × 30"
(approximate)

Courtesy, Robert Miller Gallery. © The Estate of Alice Neel

FIGURE 8–8
Arnaldo Roche Rabell
Self-Portrait #2, 1985
Oil on paper, 24½ × 18½″
Courtesy, Struve Gallery, Chicago

LANDSCAPE

Landscape as a separate subject came into its own in the Low Countries sometime in the sixteenth or seventeenth centuries. The early Dutch landscape artists often found work as cartographers, and assuredly there was a crossover between the disciplines of mapmaking and landscape art at that time. Maps of countries were often decorated with topographic views of major cities, and maps of specific locations often included horizon lines (Fig. 8–9). So in the earliest phase, landscape had as an aim the portrait, so to speak, of a particular place or region.

This interest in the specific features of a place was often in relation to the use made of those features by the region's inhabitants, whether they were soldiers (as in Fig. 8–9), farmers, or townspeople. Later this idea was enlarged and became an early romantic concept, that is, a feeling for the "genius" or resident spirit of a place.

In romantic landscape, human existence is regarded as basically irrelevant, although today we may detect in such works the contrived human presence that results from an infusion of the subject with poetic spirit. All the same, the firsthand involvement that artists of this time had with nature, while they tried to catch its ever-changing spirit, often resulted in studies of surprising objectivity (Fig. 8–10).

In the work by John Virtue (Fig. 8–11), the ambition to capture the portrait of a place has been achieved by including several views of a particular locale, in this case a hamlet in Lancashire, England. Arranged on a maplike grid, these intimate portraits may be presumed to be glimpses of a single group of buildings from a series of different vantage points. Taken as a whole, the group evokes a sense of familiarity with place that grows from the experience of daily country walks close to home.

FIGURE 8–9
C.V. Kittensteyn, after Pieter
Saenredam
The Siege of Haarlem
Etching
Muncipal Archives, Haarlem, The Netherlands (nr. 9219G)

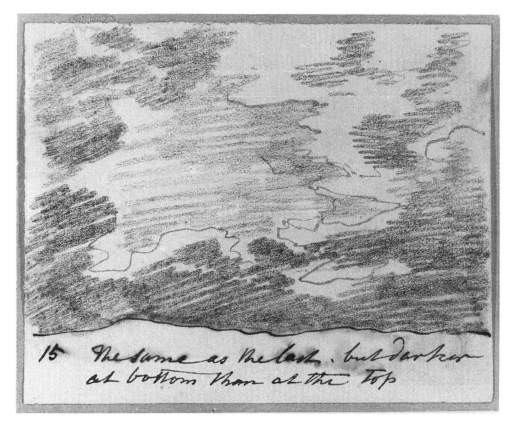

FIGURE 8–10
John Constable
*One of Seven Cloud Studies After
Alexander Cozens No. 15,*
c. 1822–1823
Pencil on white paper
Courtesy, Courtauld Institute Galleries, London

We can consider the drawings by Bittleman (Fig. 8–12) and Lees (Fig. 8–13) to be concerned primarily with a romantic view of nature, since human landmarks are absent from both works. In the sultry landscape that Bittleman creates, everything appears in closeup. The minutely textured hedges in the foreground forbid entry into the space, while the boiling clouds overhead seem to rush forward. Even the horizon is brought disturbingly close by a series of

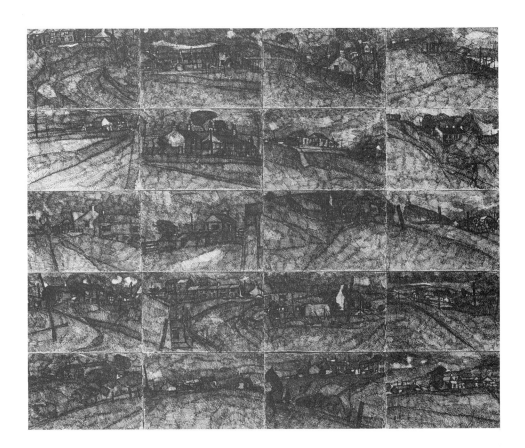

FIGURE 8–11
John Virtue
No. 32, 1985–1986
Ink on paper on hard board
mounted on wood, 50 × 56″
Courtesy Lisson Gallery, London

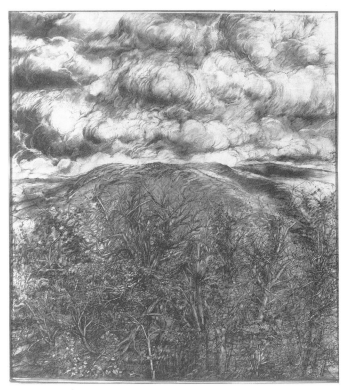

FIGURE 8–12
Arnold Bittleman
View of The Green Mountains, 1977
Charcoal heightened with white
conté, 67½ × 60½″
Courtesy, Alexander F. Milliken Gallery

not-too-distant hills. It is a landscape intimate in its detail, yet one that threatens to ensnare with twigs and smother with demonic clouds.

The image in the Lees drawing, on the other hand, seems more remote. The impenetrable mass of nondescript bushes coalesces into a shape that hovers quietly in the middle of the page. Here is nature at its wildest, with forms that are inexplicable to human understanding.

The four studies by Carol Brown (Fig. 8–14) reflect her confidence in ap-

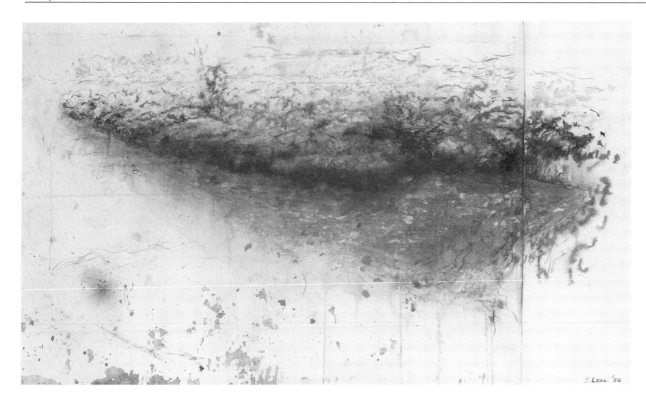

FIGURE 8–13
JOHN LEES
Bog, 1986
Ink, watercolor, pencil, and mixed media/paper, 22½ × 37½"
Courtesy, Hirschl & Adler Modern, New York.
Photo: Pelka/Noble

proaching the mystery of nature and the spirit of place. The sparsely vegetated landscape of the American Southwest, which is the subject of these studies, is certainly awe-inspiring and inhospitable terrain. Yet this artist, who works almost entirely outdoors, captures the essence of grandly scaled geological features within an intimate format. Concentrating on a feeling for the land as mass or form, the artist simplifies localized texture so that geological formations take on a fleshlike quality.

The romantic conception of nature as being in a constant state of flux finds its contemporary counterpart in Figure 8–15. Here, commuters careen over precipitous Bay Area streets under a network of cables transporting invisible electrical impulses. The buildings, like the stunted trees, seem temporary in this cityscape, where yearnings for place and permanence are secondary to the imperatives of rapid transit and telecommunication.

STILL LIFE

Still life became a subject in its own right in the Low Countries at about the same time as the appearance of landscape. The still-life genre, more than landscape or the figure, retained a strong allegorical content long after it was removed from the context of religious narrative. Paintings and drawings depicted in detail both flowers and insects (Fig. 8–16) that were symbolic of the variety and also the impermanence of Creation. Vast piles of food—fruits, vegetables, dead poultry, game, fish, and raw flesh of all kinds—were evidence not only of the wealth and abundance of the bourgeois household but also a cheerful recognition of the transience of all life. The moralistic theme of the temporality of all material things finds its culmination in the *Vanitas* still life (Fig. 8–17). (The Latin word *vanitas* literally means "emptiness," but in Medieval times it became associated with the folly of empty pride.)

The vanitas theme is one that has survived to this day in still life. In the drawing by William Wiley (Fig. 8–18), the objects on the left-hand side are the memento mori so commonly found in Dutch vanitas paintings: the apple is a symbol of the mortal result of Original Sin; the dice and chess piece are symbolic

FIGURE 8–14
CAROL BROWN
Sand Spring Monument Valley, 3
Nov. 81, 4 PM; *Monument Valley
Sand Springs*, 18 October 81, 3:30
PM; *Sand Spring Monument Valley*, 3
Nov. 81, 2 PM; *Aspens-Betatakin*, 17
October 1981
Colored pencil, 2 × 4″ (each)
Courtesy, Carol Brown

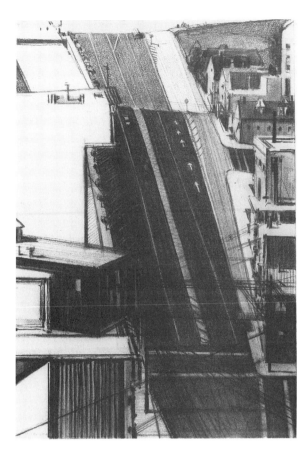

FIGURE 8–15
WAYNE THIEBAUD
Down 18th Street (Potrero Hill), 1974
Charcoal on paper, 22⅜ × 14⅞″
Private collection. Courtesy, Allan Stone Gallery.
Photo: Ivan Dalla Tana

of life as a game of chance; the steaming beaker suggests the futile search for the elixir of life; the jewels are symbols of earthly pride; and the knife, skull, and candle all belong to the iconography of human mortality. A framed mirror near the center of the drawing bears the fleeting inscription ''What is not a

FIGURE 8–16
AMBROSIUS BOSSCHAERT, The Elder
Large Bouquet in a Gilt-Mounted Wan-Li Vase
Oil on panel, 31½ × 21½″
Norton Simon Art Foundation (M.1976.10.P)

FIGURE 8–17
HERMAN STEENWIJCK
Vanitas, c. 1640
Panel, 14⅞ × 15″
Courtesy, Museum De Lakenhal, Leiden

FIGURE 8–18
WILLIAM WILEY
G.A.D., 1980
35½ × 53½″
Collection of Shelley and Ann Weinstein

bridge to something else?" a reference to the passing of all material things. Below it is a long-stemmed pipe common to both Dutch and American still life. The pipe and tobacco box (tobacco is a New World plant) act as a bridge between the fatalistic iconography of the Old World and the iconography of death by (mis)adventure of the American frontier. The items on the right side of the drawing—the pistol, the key, the pewter cup, the quill, and the American battle standard—are objects common to the already nostalgic trompe l'oeil ("fool the eye") painting of the nineteenth century (Fig. 8–19).

Larger-than-life portrayals of food and other consumable items locate the contemporary Pop Art movement within the vanitas tradition. The Wesselman drawing (Fig. 8–20) concentrates on the packaged nature of frequently consumed

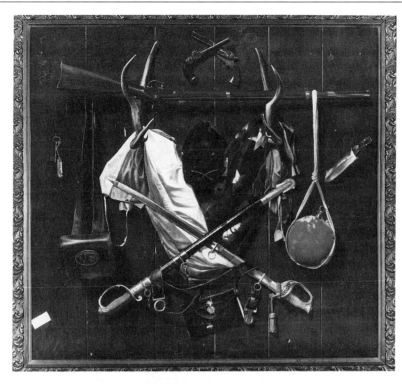

FIGURE 8–19
ALEXANDER POPE
Emblems of the Civil War, 1888
Oil on canvas, 137.6 × 129.8 cm
The Brooklyn Museum, Dick S. Ramsay Fund,
Governing Committee of the Brooklyn Museum, and
Anonymous Donors (66.5)

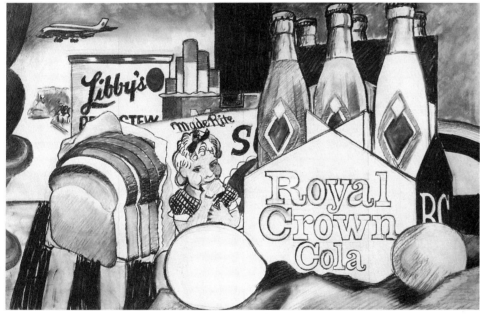

FIGURE 8–20
TOM WESSELMAN
Drawing for Still Life No. 35, 1963
Charcoal, 30 × 48″
© 1994 Tom Wesselmann/Licensed by VAGA, New
York

goods. It even goes so far as to equate the glamour and convenience proclaimed for name-brand foods with the glamour and convenience of jet travel (another packaged experience). The only natural foodstuffs in this drawing are the two lemons, whose acerbic juices hardly promise the immediate gratification enjoyed by the Sunshine Girl on the bread wrapper. And the cigarettes, the cola, and the highly processed foods are presented as objects of questionable desire. They are not linked overtly to the issue of life and death as are the poultry, fish, game, and so forth, of Dutch still life, but they are nonetheless icons of death, first because of their own throwaway identities, and second because their consumption may prove more harmful than nourishing.

Glass drinking vessels, such as the overturned wine goblet in the Steenwijck painting or the ominous-looking liquor glass in the Wiley drawing, are common vanitas symbols. Among the characteristics that make them such a fitting symbol

of temporality are: They can be drained of their contents; they are fragile; and they are transparent (as are ghosts), with surfaces that reflect an evanescent world in miniature.

Janet Fish exploits the theme of reflection in her depiction of glassware (Fig. 8–21). The shapes of the rather sturdy and commonplace restaurant glasses are subdivied into countless shimmering splinterlike pieces. Just as the forms of the glasses are lost in the myriad reflections, so too are the forms of the immediate environment distorted almost beyond recognition in the reflections on the glass surfaces. In the end, we get a picture of a world that is composed of fugitive appearances.

THE INTERIOR

The domestic interior has long been associated with the contemplative life. In Medieval and Renaissance painting, meticulously rendered interiors appeared in such subjects as St. Jerome in his study, or in Annunciation scenes in which the Virgin is usually depicted with a book. In the Romantic era, poets and artists became increasingly preoccupied with exploring the workings of an imagination that could have free rein only in solitude. In literature, the novel delved into the

FIGURE 8–21
JANET FISH
Three Restaurant Glasses, 1974
Pastel on paper, 30¼ × 16"
Acquisition Fund Purchase. Collection Minnesota Museum of American Art, St. Paul

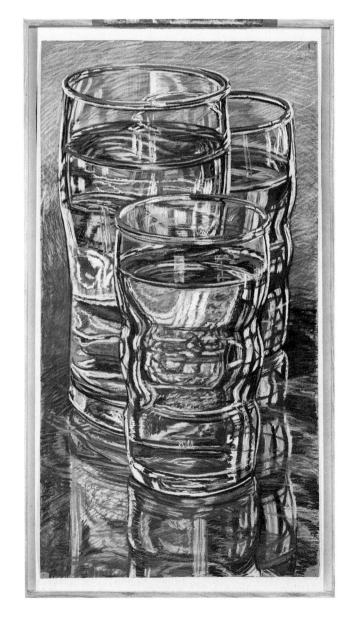

private thoughts of fictitious characters who had the middle-class leisure to reflect on all the petty intrigues of domestic life. Thus, the rooms to which a person could go to ruminate, reminisce, or daydream took on special significance.

The drawing by Lucas Samaras (Fig. 8–22) is in the tradition of the room as metaphor for the private mind. This interior is devoid of any personal domestic effects, but it is populated by memories or daydreams of amorous trysts that have left their imprint on the walls.

The drawings of empty interiors by Lundin (Fig. 8–23) and Lopez Garcia (Fig. 8–24) are far less confessional. Both may be regarded as images of the mind

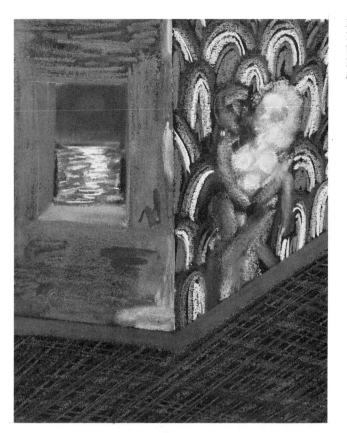

FIGURE 8–22
LUCAS SAMARAS
Untitled, 8/18/87
Pastel on paper, 13 × 10″
Photograph courtesy of The Pace Gallery, New York

FIGURE 8–23
NORMAN LUNDIN
Studio: Light on the Floor (small version), 1983
Pastel, 14 × 22″
Courtesy of Francine Seders Gallery, Seattle, Washington

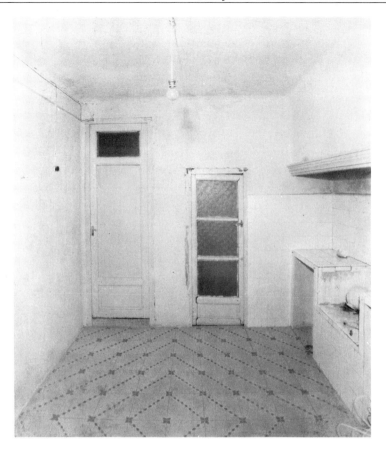

FIGURE 8–24
ANTONIO LÓPEZ GARCÍA (b. 1936)
Cocina de Tomelloso (The Kitchen in
Tomelloso), 1975–1980
Pencil, 29⅛ × 24"
Private collection. Courtesy, Marlborough Gallery

swept clean. The Lundin drawing shows a section of what appears to be a spacious empty studio. The softly polished floor and the slender shaft of weak sunlight that falls on it exude a meditative calm. In the Lopez Garcia drawing, the uncluttered kitchen contains several clues that attest to a life that is more austere than meditative. The only relief from the bare, brightly lit surfaces is the stark geometric pattern on the floor.

The high vantage point in the drawing by Robert Birmelin (Fig. 8–25) gives us a sense of a room as a deep, cavelike space steeped in melancholic darkness. The angles of the furniture and the arc inscribed on the floor counteract the quickly vanishing perspective lines so that the space appears to pivot around the two figures isolated in their weariness on the couch; and the protective darkness that seems about to envelop these figures suggests the slow winding down of daytime energies toward the ultimate refuge of sleep.

The Hollis Sigler drawing *Crawl Back to Safety* (Fig. 8–26) shows the interior as literally a place of refuge. The inner sanctum of the house or apartment is the bathroom, which in most homes is the only room with a lock on the door. Here a person can be safely alone; and in the revitalizing comfort of the warm bath that is being drawn, one can soak away the grime and tensions accumulated during the day. The discarded clothes on the floor and the neatly set-out bathrobe and slippers promise a cozy retreat from the crazy world still visible through the window.

Subject Matter as a Source of Meaning

That aspect of content that is derived from subject matter in a work of art is generally referred to as *subject-meaning*. Subject-meaning is most often literary in character; that is, it is meaning that is interpreted from the depiction of an event, story, or allegory.

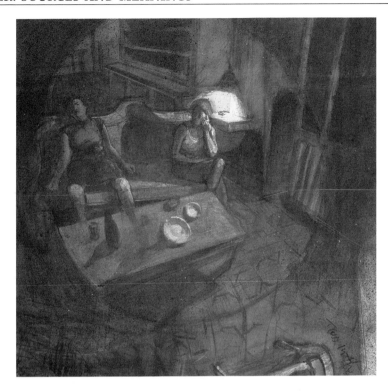

FIGURE 8–25
ROBERT BIRMELIN
Two Women on a Sofa, 1963
Watercolor, gouache, and pencil,
24⅞ × 24½"

*The Museum of Modern Art, New York. Gift of
Nancy and Arnold Smoller in memory of Esta H.
Josephs*

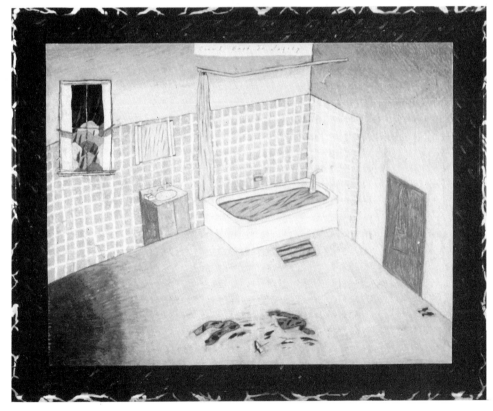

FIGURE 8–26
HOLLIS SIGLER
Crawl Back to Safety, 1982
Craypas on paper, 28½ × 34"
Courtesy, Printworks Gallery

The content that is taken from pictorial subject matter can be loosely cat-
egorized as inhabiting either public or private spheres of meaning. Artists in-
terested in tapping content from the public domain often do so with the intent
of addressing universal truths. The Daumier, for instance (Fig. 8–27), boldly
engages the issue of crimes against humanity, portraying as it does the brutal
murders of a household of innocent workers by the French civil guard in 1834.

A more recent and reassuring example of topical content can be found in

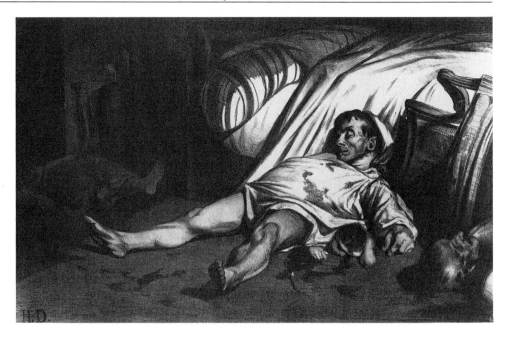

FIGURE 8–27
Honoré Daumier
The Murder in the Rue Transnonain,
1834
Lithograph
Bildarchiv der Österreichischen Nationalbibliothek

Red Grooms's *Local 1971* (Fig. 8–28). In this satirical narrative, Grooms's characterizations are not only amusing; they also betray the curiosity we all have about the facts and foibles of humankind.

Leaving the public side of life, let us now turn our attention to works with more private, or personal, content. The harrowing image in Figure 8–29 is a record of this artist's intense personal vision. Yet, in its own eccentric way, it bespeaks of modern-day barbarism by inciting in us simultaneously the emotions of fear (of death and dismemberment) and compassion (for a victim).

But content in a work of art does not have to depend on spectacle, or

FIGURE 8–28
Red Grooms (b. 1937)
Local 1971
Color litho from ''No Gas''
portfolio, 22 × 28"
*Courtesy, Marlborough Gallery. Photo: Eric
Pollitzer. © 1996 Red Grooms/Artist Rights Society*

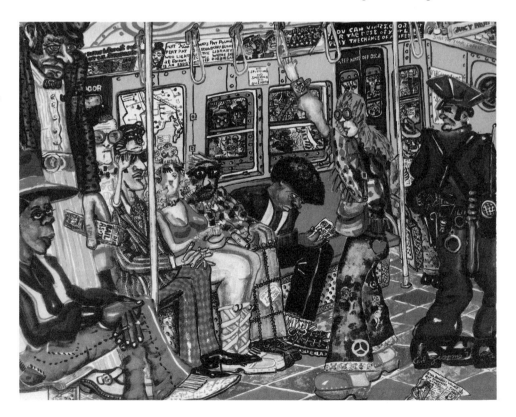

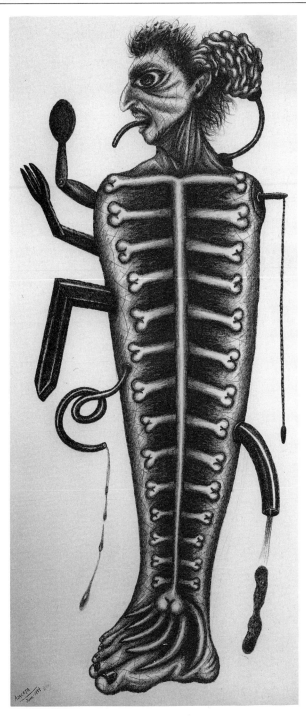

FIGURE 8–29
LUIZ CRUZ AZACETA
Self-Portrait: Mechanical Fish, 1984
Colored pencils, conté crayon on
paper, 103 × 44"
Courtesy, Frumkin/Adams Gallery (AFG #4385)

subject matter that makes an aggressive appeal to extreme states of emotion. In the portrait by Mary Joan Waid (Fig. 8–30), for instance, meaning is insinuated gradually. Presented with the most enigmatic of subjects, the gaze of another human being, we might be moved to wonder about this woman's particular story, or what thoughts lie behind her melancholy glance. Content may also be effectively derived from humble subjects that the artist found personally moving, as in Figure 8–31, which depicts the mundane but beautiful event of sunlight streaming into a room.

FIGURE 8–30
MARY JOAN WAID
Dream Series IX, 1984
Pastel, 29¾ × 41½″
Collection David S. Brown. Photo: Sarah Wells

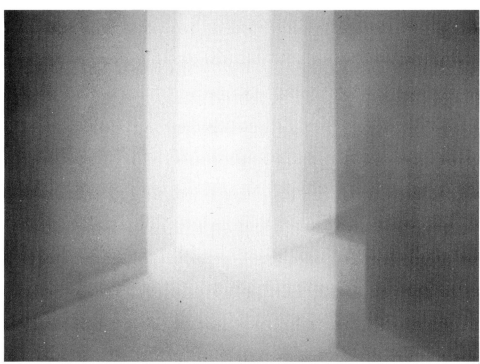

FIGURE 8–31
ELYN ZIMMERMAN
Untitled, 1980–1981
Graphite on Mylar, 18 × 24″
Courtesy, the artist and Gagosian Gallery, New York

Thematic Variations

As a student working in the structured environment of the classroom, you may not always have free rein in your choice of subject matter. But even so, this should not put a damper on the expressive values of your work. One way to inject more personal excitement into your drawing is to cast the subject in a new thematic light. For an example of how a potentially banal subject can be charged by a reality existing outside the realm of ordinary studio surroundings, look at the still-life variations by Paul Wonner (Fig. 8–32) and Manny Farber (Fig. 8–33).

FIGURE 8–32
PAUL WONNER
Study for *Still Life with Cracker Jacks and Candy*, 1980
Synthetic polymer paint and pencil, 44¾ × 30″
The Museum of Modern Art, New York. Gift of R.L.B. Tobin in honor of Lily Auchincloss

FIGURE 8–33
MANNY FARBER
Cracker Jack, 1973–1974
Oil on paper, 23¼ × 21¼″
Collection of Sheila A. Sharpe

Art-historical context provides the guiding impulse for the Wonner drawing. The deep space and suggestion of ever-changing light, plus the flowers, delicate vessels, and comestibles that melt in the mouth all hark back to early Dutch still-life paintings. And lest we should be in any doubt about this allusion to an art-historical precedent, the artist has included a representation of a Droste chocolate bar (a Dutch brand).

In the Farber, the presence of space, form, and light is minimized. Seen from directly above, the unforeshortened matlike shape does not invite us into an illusionistic space but rather stops us short. The only recourse the viewer has is to follow the clockwise movement around the periphery of the square, a movement that recalls the advance of markers on a gameboard. Taken further, this clockwise motion suggests a hidden storyline in which the cheery pieces of confectionery and the more ominous cork, eyedropper, and cigar play out their dramatic roles.

So in the end, we have two works with basically the same subject matter but that stir up a very different set of associations. In the Wonner, we are taken up by the Dutch-inspired theme of the temporality of all earthly delights; in the Farber, *we* are the subject of the work, acting as sleuths trying to decipher inexplicable clues within the narrative.

Exercise 8A *The illustrations in this chapter are meant to indicate the vast storehouse of expressive potential inherent to the four subject matter categories: human figure, landscape, still life, and interior. It is important that you use this resource as a starting point for your own continuing personal research into subject-matter meanings. Look at monuments from art history on a daily basis, and to learn more about those works for which you feel an especial affinity, read about the social context in which they were created. An art-historical perspective will help you grasp how classic subject matter has been utilized and adapted over the ages as a basis for countless means of cultural expression.*

The following projects are intended to help you begin assembling personal insights into subject matter themes.

Drawing 1. *Draw an interior that clearly reflects the way that space functions for you on a daily basis. Do cramped quarters and clutter suggest that you live at a frenetic pace, as in Figure 8–34? Or is your place one of domestic comfort, as in Figure 8–35? Alternatively, you*

FIGURE 8–34
Bobbette Gilliland, University of Arizona
Student drawing: animated interior
Courtesy, the artist

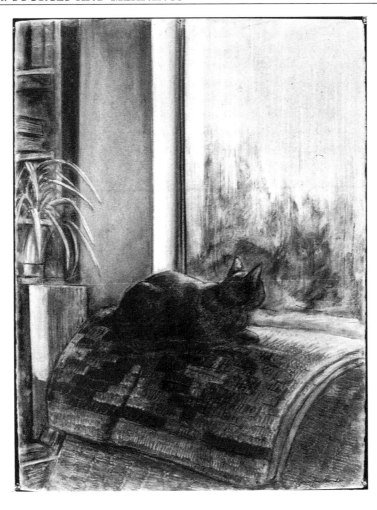

FIGURE 8–35
JENNIFER PLOURDE, Arizona State University
Student drawing: meditative interior
Charcoal, 22 × 30″
Courtesy, the artist

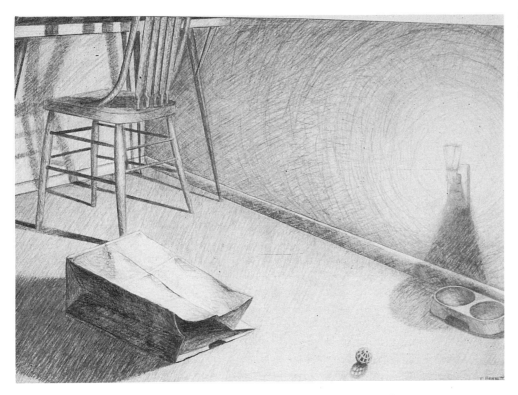

FIGURE 8–36
TOM BENNETT, Arizona State University
Student drawing: interior with suggested narrative
Pencil, 18 × 24″
Courtesy, the artist

might look for a narrative within your interior. In Figure 8–36 the pet bowl and toys along with the spooky cast shadows make us look around for the absent cat.

Drawing 2. *Draw a diaristic or autobiographical still life using objects that have collected quite naturally, for example, on top of your desk, dresser, or television set. Alternatively, you might select objects thematically related, as in Figure 8–37, which retells some of the complexities of a long auto trip.*

Drawing 3. *Draw firsthand a portrait of a landscape that for you embodies a sense of genius or romantic spirit, free of the trappings and overtones of human existence. Create strong*

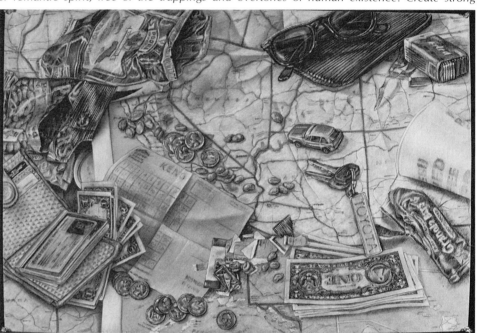

FIGURE 8–37
Jennifer Plourde, Arizona State University
Student drawing: autobiographical still life
Charcoal, conté, 22 × 30″
Courtesy, the artist

FIGURE 8–38
David Larson, University of Montana
Student drawing: landscape detail enlarged
40 × 40″
Courtesy, the artist

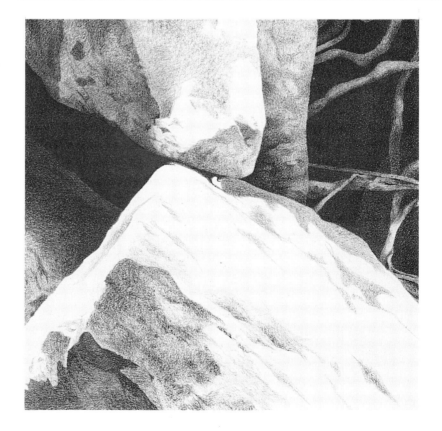

contrasts of marks and values to express the intense feelings this landscape elicits in you. Another option is to select from a landscape a detail that arouses those same feelings of awe you would experience when confronted by a vast panorama (Fig. 8–38).

Drawing 4. *Do a portrait of an obliging friend or relative. Include some narrative elements to identify who they are or how they would like to be perceived. On the other hand, you might wish to do a self-portrait that explains something about your current life situation (Fig. 8–39).*

Alternatively, try using subjects or themes belonging to more than one of the major categories. Such is the case in Figure 8–40, which may be considered a still life, since it consists of a skeleton and a draped piece of furniture. But the skeleton's gesture recalls the presence of a living figure, insinuating that the draped desk is more than a mere studio prop. In this context, it suggests something sinister, such as a shrouded tomb or a piece of furniture stored in a house after the death of its occupant. Or look at Figure 8–41, in which a figure and an interior combine to create an unmistakably haunting narrative.

Exercise 8B

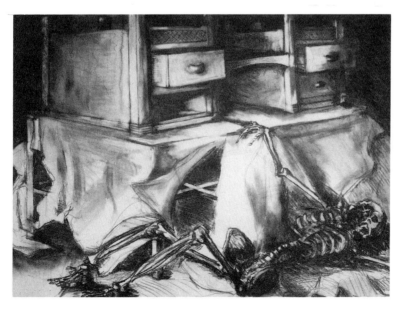

FIGURE 8–39
FELIX CHAN, University of Arizona
Student drawing: self-portrait
Courtesy, the artist

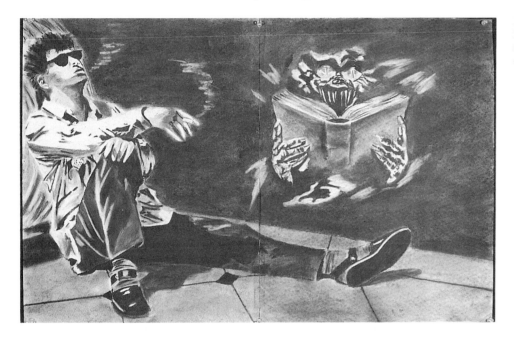

FIGURE 8–40
SHERILYN HULME, University of Arizona
Student drawing: still life with psychological content
Courtesy, the artist

FIGURE 8–41
MELISSA PETERSON, University of
Arizona
Student drawing: interior with
psychological content
Courtesy, the artist

9

The Form
of Expression

In earlier chapters, we introduced ways to organize the two-dimensional space of a drawing, from the initial layout to the development of a more complex set of design relationships. This chapter enlarges on the topic of pictorial order by linking more fully the artist's orchestration of the visual elements to the creation of expressive *form* in a drawing. Also included is a set of strategies to help you troubleshoot problems of observation and design in your drawings.

The Two Definitions of the Term **Form**

As defined previously,* form may refer to the shape, structure, and volume of actual objects in the environment and to their depiction in a work of art. The second meaning of *form,* and the way in which we use the term in this chapter, refers to a drawing's total visual *composition,* or that quality of visual order that sets the drawing apart as a complete and unique object in its own right, independent of the real-world subject matter it represents.

In other words, form is the "visual reality," the lines, shapes, colors, tones, and textures, and their organization, that we actually *see* when looking at a drawing. And by virtue of its material existence, form distinguishes itself from both subject matter and content. In this regard, subject matter exists symbolically, but not actually, in a drawing, and content exists only as an interpretation made by the viewer.

To further clarify this second meaning of the term *form,* we shall examine the composition of a masterwork.

Studying the Form of a Masterwork

Our stress on the visual reality of form does not mean to imply that the form of a specific drawing can be comprehended at a single glance. On the contrary,

*See Chapter 6.

the structural composition of a good drawing is often multileveled and requires some degree of study to penetrate.

To illustrate this point, we shall briefly analyze the formal qualities of a drawing by Charles Sheeler, *Feline Felicity* (Fig. 9–1). We will use a blurred state of the same work (Fig. 9–2) and the accompanying diagrams (Figs. 9–3 to 9–7) to aid us in our analysis.

Note first the two large shapes that make up the positive image (Fig. 9–3) and the way the edges of these shapes have been controlled so the eye moves over them at varying speeds—more slowly through complicated areas, more rapidly over relatively uninterrupted stretches. Variety has also been achieved by contrasting round edges with more-angular edges.

Figure 9–4 schematically depicts contrasts and similarities among the major

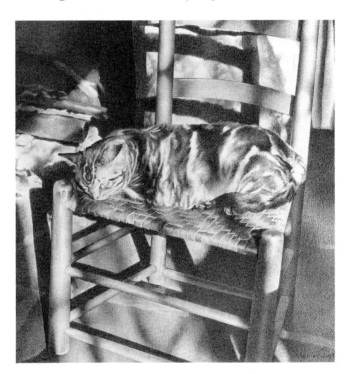

FIGURE 9–1
CHARLES SHEELER
Feline Felicity, 1934
Conté crayon on white paper,
559 × 457 mm
Courtesy of The Fogg Art Museum, Harvard University Art Museums. Louise E. Bettens Fund

FIGURE 9–2

FIGURE 9–3
The major positive-negative breakdown of *Feline Felicity*. Note the implied interaction between the two rodlike shapes in the lower right-hand corner.

FIGURE 9–4
The major linear configuration in this drawing is an X, formed by diagonals 1 and 2. The arrows in opposite corners indicate forms pushing outward, making the format edges more apparent.

directional lines in Sheeler's work. The main configuration created by these linear motives is an X, the foremost device for expressing an opposition of forces in pictorial art. Figure 9–5 shows the major diagonal being echoed by a smaller diagonal to its right, and how these movements in combination subdivide the page into three unequal zones.

Perhaps the most startling visual trait revealed by the blurred state of *Feline Felicity* (Fig. 9–2) is that the image of the cat is broken into three clear-cut sections. Starting on the right (Fig. 9–6), look at how the bold, arching pattern of light stripes on the cat's hindquarters creates a circular rhythm that includes the illuminated corner of the chair seat (as represented by the white "V" in the diagram).

Now, let's turn to the cat's midsection, which can be seen as a single shape

FIGURE 9–5
This figure shows how the repeating diagonals 1 and 2 subdivide the page into three unequal areas A, B, and C.

in Figure 9–7. (This shape is also evident in Figures 9–2 and 9–11a.) Note that the vertical stripes throughout this shape echo the uprights of the chair. In fact, this area possesses the most pronounced light-and-dark pattern of all three sections—and for good reason. It is the pivotal "central hub" of the drawing, acting as it does to join several important movements.

The head of this tabby cat differs in several important ways from the remainder of the body and from the visual character of the drawing as a whole, which, for the most part, emphasizes angular, flat areas of pattern. The drawing in general is also contrasty in its play of light and shadow and grainy in its surface texture. In comparison, the head is a more fully developed spherical volume. It also exhibits less tonal contrast and a sharper focus on topographical detail. Collectively, these differences distinguish the head as the drawing's focal point.

The Matter of Pictorial Invention

Although our analysis of *Feline Felicity* was far from exhaustive, it nonetheless revealed some of the compositional relationships, or interactions between parts, that underlie the almost photographic detail in this drawing. The next step is to acknowledge that the full complex of relationships in *Feline Felicity* has recast the subject matter into a new and invented totality of *pictorial* form.

We stress the word *pictorial* because the special network of lines, shapes, values, and so forth, that Sheeler created not only contributes to the form-unity of the drawing but it also has no reality outside of that two-dimensional surface. To understand this, you have only to look at the shapes plotted in Figures 9–3, 9–6, and 9–7 and realize that they have no names in the real world; or consider that the linear movements in Figure 9–4, which link up sections of the two-dimensional surface, are not bound to the contours of individually depicted objects. These lines and shapes are in the truest sense pictorial inventions that have grown from the master artist's imaginative reworking of subject matter information, and as such they are freed from the confines of everyday things and the everyday conventions of looking at things.

In view of all this, we may make two general observations:

1. That artists, in the process of making their ideas and emotions comprehensible to others, manipulate the visual elements beyond the service of pure description to create new pictorial entities, which for purposes of convenience are often referred to as "pictorial shapes," "pictorial lines," and so on.

2. That the sum of pictorial invention, that is, all the created shapes, linear movements, and orchestrations of value taken together in a particular drawing, constitute that sense of form that we experience in a fine work of art.

To summarize, we have established that the form of a drawing refers to its entire structural character; or to put it simply, form refers to that compositional reality of a drawing that we can apprehend with our eyes.

We have also determined that the form of a drawing has a visual and material identity that is distinct from its subject-matter source in the real world. In fact, we can say that what all artworks have in common, regardless of stylistic, media, or historical differences, is their separateness, or *abstractness* from reality.

This matter of why the form of any artwork is undeniably abstract, and how this concept can be understood in relation to the common designation of an "abstract style" in art, is the focus of our next topic in this examination of form.

FIGURE 9–6 (top left)
The repeating V-shaped angles point the eye down the right chair leg 1 toward an imminent relationship with the chair rung 2. And the movement begun at the upper right-hand corner 3 is channeled diagonally through the cat's hindquarters 4.

FIGURE 9–7 (top right)
1 continues the lateral diagonal begun on the right side of the drawing and joins the straighter movements of the front edge of the seat 2 and the nearly vertical upright of the chair back 3, all three of which intersect just below the shoulder of the cat.

What Is Abstraction Anyway?

When applied to drawing, the term *abstraction*, like the term *form*, has more than one meaning. First of all, a drawn image is by definition removed or abstracted from a sensory experience of actual subject matter by virtue of its physical properties. In Figure 9–1, for example, no cat is present. What does exist is a visual symbol for a cat, a symbol that is embodied by a deposit of media on a flat paper surface.

Second, abstraction refers to a multilayered *process* that is inherent to the making of all visual art. Let us clarify this by simplifying the operation of making a drawing into three steps.

1. Out of the world of experiences, which has been described by the philosopher William James as a "blooming, buzzing confusion," the artist selects something to draw. This method of singling out, or generalizing from concrete reality, is an *abstracting process.*

2. Thereafter, each choice an artist makes while drawing continues to reflect the abstracting process of the mind. Such early decisions as format orientation, vantage point, plus the character of the initial layout wherein superficial detail is overlooked in favor of summarizing the proportional and gestural essences of forms and spaces are all part of this process.

3. As a drawing's specific form definition proceeds toward completeness, its existence as an independent object, governed by its own pictorial order, becomes more distinct. The basis for this abstract wholeness is the essential arrangement and unity of the visual elements. Consideration for the abstract function of the visual elements is a feature of all good drawing, even if the image is a representational one.

Third, the term abstraction also refers to certain styles in the history of art. The term *abstract art* gained currency in the early twentieth century when numbers of artists subordinated naturalistic representations of subject matter in favor of formal invention (Fig. 9–8). But abstraction as an image "condition" was not unknown in earlier phases of art, as we can see from a page from the *Book of Kells* (Fig. 9–9).

Today, the designation *abstract art* is often used to describe not only quasi-representational imagery but also works of art that are completely devoid of subject matter. More precisely, though, when an image is solely the product of an artist's imagination, and is therefore without reference to an external stimulus (Fig. 9–10), the style of the work is *nonobjective.*

Exercise 9A *The benefits of drawing from fine works of art cannot be overestimated. By making penetrating, analytic studies of a masterwork (as opposed to merely copying it), you experience more intimately why certain formal choices were made by the artist, which in turn expands your general understanding about formal organization in pictorial art. Studies of masterworks are also to some extent expressive endeavors, since the formal attributes you find in a work, and the way you represent them, depend on your own subjective values, as evident from the two student drawings of Feline Felicity in Figure 9–11a and b (see Fig. 9–1 for the original).*

FIGURE 9–8
FRANZ MARC
Sketchbook from the Field, 1915
Pencil, 9.7 × 16 cm
Staatliche Graphische Sammlung, Munich

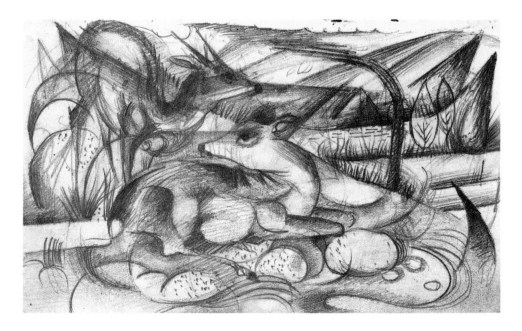

FIGURE 9–9
Book of Kells
Courtesy of the Board of Trinity College, Dublin, Ireland (fol. 34r)

FIGURE 9–10
HANS HOFMANN
Red Shapes, 1946
Oil on cardboard, 25¾ × 22"
Private collection. Courtesy André Emmerich Gallery, New York

Using Tasley's Truck *(Fig. 9–12), let us review some of the steps you will want to take when making your own analytic drawings.*

1. Sketch out the fundamental layout, or subdivision, of the work's surface (Fig. 9–13).

2. Determine the major positive–negative arrangement (Fig. 9–14).

3. Locate repeating shapes, patterns, or textures that build relationships between different areas of the work (Fig. 9–15). In this case, note the integration of round and angular shapes that are varied in size and tonality and are at times fully delineated, and at other times only suggested.

FIGURE 9–11a
AMY MCLAUGHLIN, University of
Arizona
Student study of *Feline Felicity*
Courtesy, the artist

FIGURE 9–11b
KRISTIN KIGER, University of
Arizona
Student drawing: study of *Feline
Felicity*
Courtesy, the artist

4. Examine the linear movements and accents that guide the eye (Fig. 9–16). Note that in Tasley's drawing, the flowing movements on the left side contrast with the relative congestion of marks on the right.

In summary, when drawing from a masterwork, uncover as many compositional relationships as you can. Part of your goal should be to discover how any one area of a work

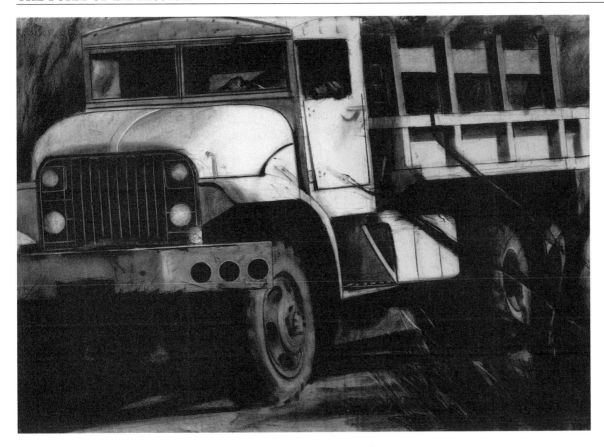

FIGURE 9–12
MATT TASLEY
Truck, 1985
Charcoal on paper, 60$\frac{1}{16}$ × 84$\frac{1}{4}$″
Courtesy, The Arkansas Arts Center, Foundation Collection

FIGURE 9–13

may have several organizational roles to play. If you are analyzing a work from a book or magazine, placing a sheet of translucent paper over the reproduction will suppress subject matter detail sufficiently to allow you to concentrate on the work's organizational virtues.

For this exercise, you will apply what you have discovered in a masterwork to a drawing of your own.

* When you have completed an analysis of a masterwork (see the four steps outlined in Exercise 9A), find a subject in your immediate environment that exhibits some of*

Exercise 9B

FIGURE 9–14

FIGURE 9–15

the abstract form qualities of that masterwork. Note that the subject of the masterwork and the subject matter you choose to draw do not have to be the same.

Lay out your drawing so that its arrangement recalls the basic surface organization of the masterwork. And as you proceed to define the subject matter in your drawing, keep in mind the major compositional themes of your source material. But once this groundwork has been established and your drawing is fully underway, concentrate more on its emerging form and less on the particular design qualities of the masterwork. Finish your drawing with the aim of creating a variation on the formal themes of the masterwork.

Exercise 9C *Many artists prefer working abstractly because doing so allows them freedom to invent with the visual elements of line, shape, value, texture, and color. This two-step project will guide you toward working in a more abstract style.*

Drawing 1. *Select a subject that possesses a variety of forms, patterns, and textures. Emphasize these contrasts as you develop your drawing into a full-page composition (Fig. 9–17a).*

FIGURE 9–16

Drawing 2. *Using your viewfinder, scan your first drawing. Find a section that strikes you as the most visually appealing on the basis of its overall layout, spatial illusion, and its particular combination of marks, tones, shapes, and so forth. This section will serve as the subject, or point of departure, for your second, and this time more abstract, drawing.*

Gesturally sketch in the layout of this section on another full sheet of paper, blowing up the image so that it fills the entire format. Proceed to define the forms, but as you do so, manipulate them to intensify both their differences and the relationships that bind them together.

By focusing on a small part of your first drawing, you have already moved a step away from recognizable imagery. Continue this process by altering and simplifying the forms according to the design dictates of your drawing. Work until you have achieved a finished drawing (Fig. 9–17b).

The Primacy of Form in the Visual Arts

Form is often considered to be at the heart of the artistic enterprise. One reason for this belief is that form is an artwork's single visual reality. In other words, and as stated earlier, form is what you see in an artwork—its lines, shapes, colors, and tones, which have been organized in a particular way. This means that in a work of art, the subject matter is inevitably seen through the filter of form. Or, to put it another way, the depiction of subject matter in an artwork (or *what* has been represented) cannot be divorced from its form (or *how* the subject matter has been treated). This is why versions of the same subject by different artists may vary in content so dramatically, as in Figures 9–18 and 9–19.

Form is what the artist manipulates when giving expression to ideas and emotions, so it may also be regarded as the primary source of content in a work of art. In fact, properties of form are thought so essential to the meanings we take from an artwork that, for many, the terms *form-meaning* and *content* are synonymous.

Form as a Source of Meaning

That aspect of content that is derived from the form of an artwork is commonly referred to as *form-meaning*. Form-meaning is provoked by the visual character

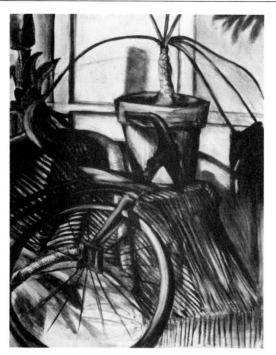
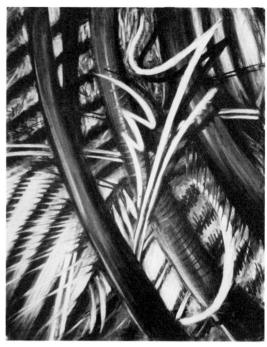
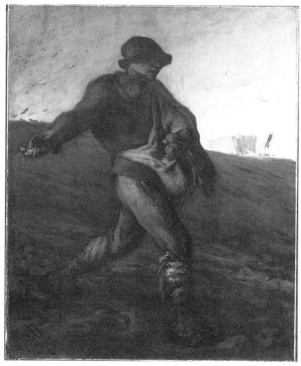

FIGURE 9–17a
Kristin Kiger, University of
Arizona
Student drawing: still life
Courtesy, the artist

FIGURE 9–17b
Kristin Kiger, University of
Arizona
Student drawing: abstraction from
a portion of still-life drawing
Courtesy, the artist

FIGURE 9–18
Jean-François Millet
The Sower
Oil on canvas, 40 × 32½"
Gift of Quincy Adams Shaw through Quincy A.
Shaw, Jr., and Mrs. Marian Shaw Haughton.
Courtesy, Museum of Fine Arts, Boston

of a work of art; so in contrast to the literary character of subject-meaning,* the
content taken from form, by its very nature, cannot be expressed adequately in
words.

The meanings we attribute to form in art have their origin in our experiences
and associations from birth with qualities of form in the real world. For example,
jagged forms belong to a large class of objects that have the potential to inflict
pain and injury, such as teeth, claws, thorns, and knives. Similarly then, jagged
lines or shapes in a drawing (Fig. 9–20) may well give rise, at least on the
subconscious level, to feelings of anxiety.

In Figure 9–21, Graham Nickson has effectively capitalized on form-

*See "Subject Matter as a Source of Meaning" in Chapter 8.

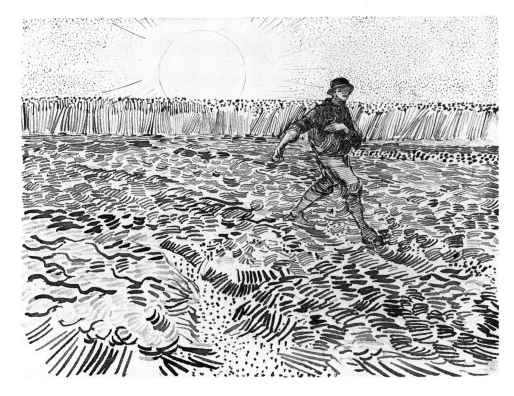

FIGURE 9–19
VINCENT VAN GOGH
Sower at Sunset
Reed pen
*Vincent Van Gogh Foundation/National Museum,
Amsterdam, The Netherlands*

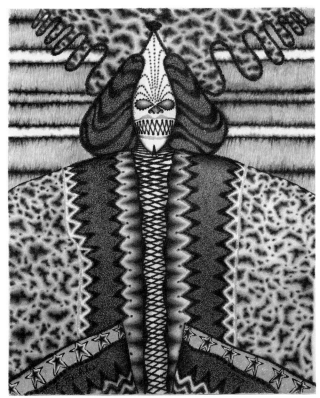

FIGURE 9–20
ED PASCHKE
His and Hers, 1977
Graphite, colored ink, and colored
pencil on paper, 29 × 23⅛"
*Collection of Whitney Museum of American Art.
Purchase, with funds from the Drawing Committee
(84.46)*

meanings that are commonly attributed to horizontal, vertical, and diagonal
movements. The figurative image in this work echoes our upright human condition
in opposition to the flat plane of the landscape. The stability of this relationship
is heightened by the way in which the clear and simple intersection of the
standing figure and the horizon line repeats the geometry of the format. How-
ever, this static harmony is interrupted by the diagonal direction of the out-
stretched arms; a direction that in everyday life signifies action that is often
unpredictable. Note that the diagonal creates a similar effect in Figure 9–22,
which is nonobjective in style.

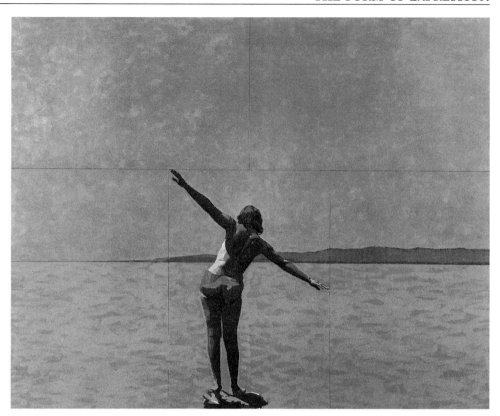

FIGURE 9–21
GRAHAM NICKSON
Bather with Outstretched Arms III,
1983
Acrylic on canvas, 100 × 120″
Courtesy, Hirschl & Adler Modern, New York

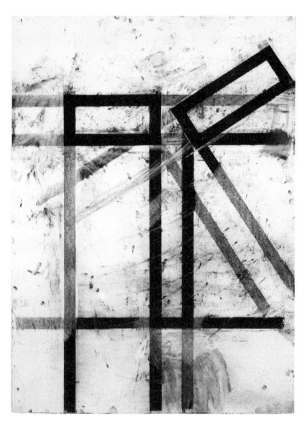

FIGURE 9–22
JOEL SHAPIRO
Untitled, 1984
Charcoal on paper, 43 × 30¾″
Courtesy, Pace Gallery of New York. Photo: Geoffrey Clements

Let us conclude our discussion of form-meaning with three more examples of contemporary drawing.

Looking at the Alex Katz (Fig. 9–23), we are immediately struck by its simplicity of line, overall paleness of tone, and general lack of strong visual contrast. Line is reduced and understated. The eye provides the single dark

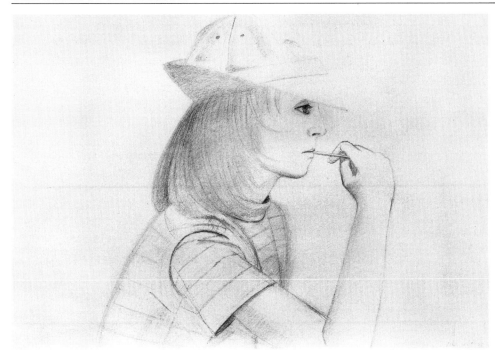

FIGURE 9–23
ALEX KATZ (b. 1927)
Thomas, 1975
Pencil, 15 × 21¾"
© 1994 Alex Katz/Licensed by VAGA, New York.
Courtesy, Marlborough Gallery, New York

accent, but even this, seen as it is in profile, is nonconfrontational. So by carefully limiting visual differences, the artist sustains a mood of genteel contemplation.

Meaning in Figure 9–24 is heightened by masking out, or cropping, all but one small section of a wall. This intensifies our recognition of aspects of the subject's form, such as its density and rough physical texture, and the irregular rhythms of the bricks and mortar. From so vivid a depiction of a lively surface we might interpret an allusion to organic growth and change, perhaps going so far as to sense an inner life within something ordinarily thought of as mute and inanimate.

The structural motif underlying the nonobjective drawing by Eva Hesse (Fig. 9–25) is the grid, which we may think of as connoting order, measure, and reason. The disclike shapes, built up with beautifully graded values, continue this theme of measure and control. But taken as a whole, we may see that these delicate tonalities and subtle variations are also the means to express a very

FIGURE 9–24
ROBERT ROHM
Untitled, 1975
Graphite on paper, 19¾ × 26½"
Collection of Whitney Museum of American Art.
Gift of Dr. Marilynn and Ivan C. Karp (75.50)

FIGURE 9–25
Eva Hesse
Untitled, 1966
Pencil and wash, 11⅞ × 9⅛"
The Museum of Modern Art, New York. Gift of Mr. and Mrs. Herbert Fischbach

different kind of content. Viewed together, the discs begin to pulse or vibrate, resulting in the illusion that the entire field is fluctuating before our eyes. This unpredictably expanding and contracting movement upsets the stability and harmony first observed in the drawing and makes the surface appear to breathe.

In conclusion, form-meaning is significant in art because it is based on memories that are innate to virtually all human beings, regardless of their geographic or ethnographic differences. That is to say, people in general are able to find meaning that they cannot express verbally in, for example, contrasts between light and dark, sharp and fuzzy (Fig. 9–26), and so on. In comparison, the communication of subject-meaning in a work of art is most often dependent on a viewer's ability to identify the depicted subject matter. We may, for example, admire the form in Figure 9–27 and yet from the standpoint of the subject matter be left to wonder, "What does it mean?"

Troubleshooting Your Drawings

This last section of the chapter raises questions you may want to ask when you are evaluating or troubleshooting the form of one of your drawings in progress.

CRITICIZING YOUR DRAWINGS

Almost everyone who takes a drawing class is familiar with the "class critique," when members of the class comment on each others' work. Class critiques are valuable for many reasons; perhaps the most important of which is that they enable you to distance yourself from your own drawing and see it with a "critical eye." However, it is also important that you extend this critical outlook beyond the class critique and apply it during the process of making your own drawings.

While a drawing is in progress, you should step back from it periodically to ask critical questions about its development. This is a natural and constructive

FIGURE 9–26
DAVID SMITH
Untitled, 1962
Spray paint on paper, 27 × 39⅝″

© 1994 Estate of David Smith/Licensed by VAGA, New York. Collection of Whitney Museum of American Art, New York. Purchase, with funds from an anonymous donor (79.40)

FIGURE 9–27
ED RAINEY
Beef Chart, 1985
Mixed media on paper,
41½ × 29½″

Courtesy, Damon Brandt Gallery

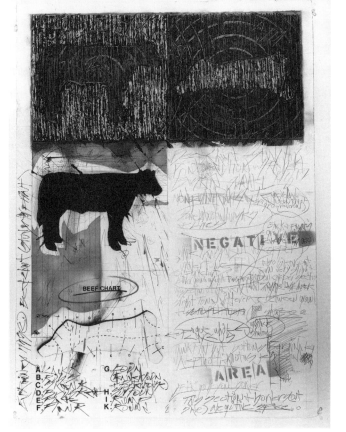

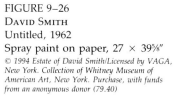

part of the drawing process. Without this activity, you run the risk of making drawings that are structurally or expressively weak, or both. Also remember that the critical assessments you make about a drawing are always to some extent personal value judgments and are therefore expressive of your subjective life experiences.

Finally, it can be argued that each time you examine the form of one of your drawings (or a work made by another artist), you are feeding your "intuitive bank." In other words, what you put into your consciousness through a deliberate learning process you will in the future be able to tap as if by second nature. This relationship between self-conscious learning and the ability to react unerringly is common to scores of other disciplines: think of the concentration necessary to first learn the basics of how to bat a baseball, or how countless hours of practice bear fruit when we are dazzled by the performance of a fine musician.

Critical Questions to Ask About Your Drawings

The criteria employed when studying the form of a drawing in progress usually fall into two categories. On the one hand, you will be assessing how well you have observed and depicted the subject matter. And on the other hand, you will need to determine whether the organization of the visual elements best serves your aesthetic and expressive ends.

The following is a set of questions to assist you in each of these two categories. Your use of these questions (or any other questions you might ask) should always be considered against the overall objectives you have for your drawing. Moreover, it is advisable to combine the process of asking critical questions with the practice of making diagnostic studies from your drawing. Studies of this sort can often be of invaluable assistance in getting to the crux of a formal problem and in making design alternatives more apparent.

Questions pertaining to observation and depiction

1. Do areas that you want to read as three-dimensional volumes appear flat? Perhaps they are bounded by either an outline or an unmodulated dark tone that has the effect of making them look "cut-out"? Or perhaps the tones are not organized according to spatial planes or are too inconsistent in their application to build a convincing volume? Figure 9–28 successfully avoids these pitfalls.

2. Is the spatial illusion consistent? Check to see whether some areas of your drawing "pop," that is, advance ahead of their desired spatial position.

3. Is your depicted light source consistent?

4. Are all objects seen from a consistent eye level? Do the converging lines of your depicted objects conform to a vanishing point (Fig. 9–29)?

5. Are the scale and part-to-part proportional relationships accurate when compared with the actual subject matter?

6. Does each of the depicted objects have tonal integrity (Fig. 9–30)? Or are they splintered into too many tones to establish in each case a local value? Have you expressed light with essentially the same tone throughout (a common error is to have the untouched surface of a light-colored paper stand in for all the varying qualities of light in a subject), and have you made all the shadows equally dark?

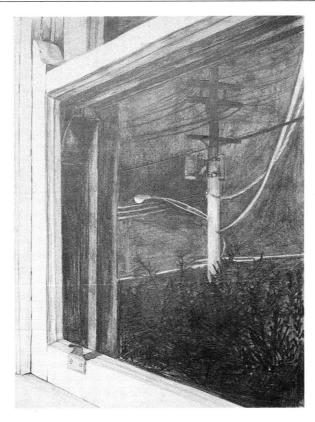

FIGURE 9–28
CHRISTOPHER SICKELS, Art
Academy of Cincinnati
Student drawing: convincing spatial
planes
Courtesy, the artist

FIGURE 9–29
TAYLOR HSIAO, University of
Arizona
Student drawing: effective use of
perspective
Courtesy, the artist

Questions pertaining to the organization of the visual elements

1. Is the format subdivided so that all areas, positive *and* negative, have been given definite or implied shape (Fig. 9–31)? Generally speaking, a layout that divides the page into equal or near equal areas will reduce a drawing's impact, no matter how much attention is given to its imagery.

2. Are there enough variations among the visual elements to create tension?

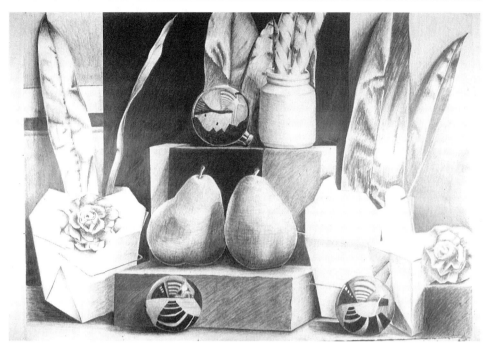

FIGURE 9–30
NOELLE FRIDRICH, Arizona State
University
Student drawing: still-life objects
rendered with tonal integrity
Pencil, 22 × 30″
Courtesy, the artist

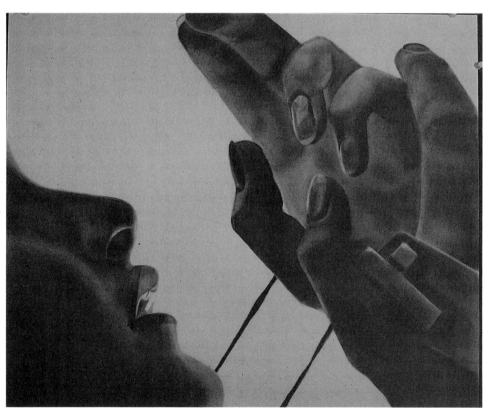

FIGURE 9–31
JENNIFER DIORIO, University of
Wisconsin at Whitewater
Student drawing: bold positive and
negative layout
Courtesy, the artist

3. Have the visual elements been orchestrated sufficiently to create unifying relationships? Is there a cohesive pattern of emphasis and de-emphasis that leads the eye at varying speeds across the surface and through the illusion of space (Fig. 9–32)?

4. Is the value range sufficient to furnish your drawing with a dynamic tonal character (as opposed to a sameness among values that may cause visual boredom)?

5. Do the marks and lines function in expressive as well as descriptive roles? Are linear elements grouped to form larger motives in the drawing (Fig. 9–33)?

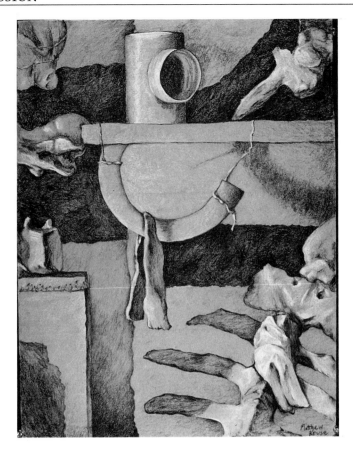

FIGURE 9–32
Matthew Kruse, University of
Arizona
Student drawing: guiding the
viewer's eye across the surface
Charcoal, 18 × 24"
Courtesy, the artist

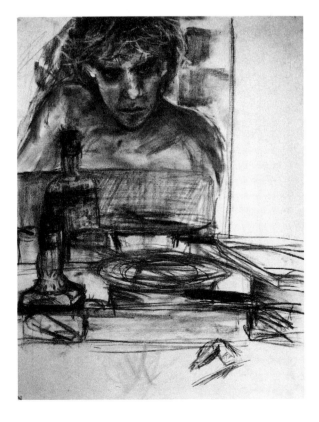

FIGURE 9–33
Bob Graham, University of
Arizona
Student drawing: self-portrait
employing a variety of expressive
and descriptive marks and lines
Courtesy, the artist

6. Finally, where is your drawing going? Does it register clearly your aesthetic and expressive intent? Or has your intent become muddled because, for example, you've concentrated too heavily on the detail of a few areas? Moreover, does your drawing contain visual clues that, if developed, could lead to unexpected richness in form and content? For example, could you intensify the mood of your drawing by consolidating the values into a lower or higher tonal key, or could you tighten its design by stressing a particular motif that was formerly not apparent to you in either the actual subject matter or your drawing?

COMMON ARTISTIC BLOCKS AND THEIR SOLUTIONS

At times when you are drawing, a problem may arise that you cannot seem to solve. As a result, you may feel frustrated and even suffer a loss of confidence. Being stymied by a drawing in this way is one example of a syndrome often referred to as an *artistic block.* Artistic blocks of one kind or another are common to the experience of most artists, beginners and professionals alike. Some typical artistic blocks and some possible solutions for them are as follows:

1. *You can't get an idea.* Ideas for drawing are everywhere. You may find expressive potential in the most modest of circumstances—your unmade bed, the dishes collected on a countertop, the visual diversity that has accumulated in a closet, or something as unprepossessing as a laundry basket (Fig. 9–34). With domestic or otherwise mundane subject matter, try working from unusual points of view or at unconventional hours and see if those settings you normally take for granted do not take on a wealth of mystery and narrative (Fig. 9–35).

2. *You have an idea but don't know how to get it down.* Try a two-pronged attack for this one. First, to inspire yourself, find examples by other artists who have dealt with a similar idea. Second, since many of the problems will work themselves out in the act of drawing, break the ice and start to draw.

FIGURE 9–34
LYNE RAFF, Arizona State University
Student drawing: dramatic drawing of common subject matter
18 × 24"
Courtesy, the artist

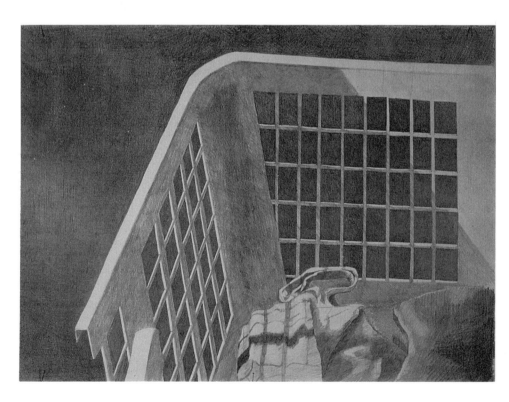

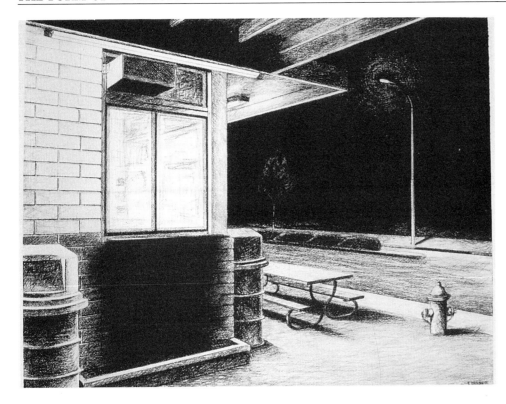

FIGURE 9–35
TOM BENNETT, Arizona State
University
Student drawing: mundane subject
at night
Charcoal, 18 × 24"
Courtesy, the artist

3. *A problem arises in a drawing and you can't figure out how to correct it.* Put the drawing aside for a few days, even a week, and go on to another. Working on a new drawing will bolster your confidence, and when you return to the earlier drawing you will probably find that your "mental distance" from the work enables you to more clearly diagnose and act on its deficiencies.

4. *You like one area of your drawing and don't want to change it.* Trying to adapt a drawing overall to fit one area that you don't want to lose usually results in a fragmented image and an artistic block. To restore healthy forward movement in your process, it will be necessary to manipulate or change the blueprint of that part of the drawing. Once you start to see ways to integrate that area into the drawing as a whole, the preciousness attached to it will subside, and you will be prepared even to completely reconceive the area if necessary.

10

Using Color
in Drawing

Color is one of the most powerful visual elements that artists have at their disposal. Color may be used objectively to record observed appearances with great fidelity to nature (Plate 10–16). Frequently, however, it is the subjective, expressive impact of color that reaches out and grabs our attention (Plate 10–6). Color affects us involuntarily—and we take it personally. Color harmonies, or the associations they waken, can cheer us up or darken our mood. We may even notice our pulses quicken in the presence of some colors, and the clash or intensity of other color combinations may make us avert our glance.

The pervasive use of full-blown color in drawing is a modern phenomenon. Before the advent of modern art in the mid nineteenth century, color drawings were infrequent; most drawn images either celebrated the use of line or were conceived on the basis of a tonal grisaille, an arrangement of varied steps of gray values. Interestingly, in seventeenth-century France, a commonly held opinion identified drawing with reason and color with irrationality. The gradual emergence of color drawing as we know it today is the result of many influences that have occurred during the Modern epoch. What follows is a brief, and less-than-exhaustive, summary of some of those contributing factors.

In one sense, technology set the stage for uniting color with drawing. By 1856, the first synthetic aniline dyes were manufactured, producing an array of brilliant colors previously unavailable to artists. The new dyestuffs also impacted the clothing industry. The new availability of more vibrant, high-key color apparel, coupled with the introduction of the more brilliant kerosene and gas lamps, conspicuously changed the artist's environment.

The proliferation of new colors coincided with studies about the nature of color. From approximately 1850 until the turn of the century, numerous theories and principles of color organization were pioneered by prominent theoreticians and leading painters of the day, including Eugene Delacroix, Georges Seurat, and artists belonging to the schools of the French Impressionists and Neo-Impressionists. Their efforts were augmented by several scientific treatises on the relationship between color and the behavior of light, published during the same period.

The revival of printmaking during the last quarter of the nineteenth century was an important stimulus for the use of color in the graphic arts. This is

especially true of lithography as practiced by Toulouse-Lautrec, Edouard Vuillard, and Pierre Bonnard, who by the end of the century were achieving color effects in lithography not possible in painting. Lithography is the printmaking medium most akin to drawing, and the success of the color lithographs by the above artists was probably in large part responsible for the new interest in color drawing in the twentieth century.

The twentieth century has been characterized by exuberant explorations of polychromatic images in all the visual arts. Gifted colorists like Matisse and Josef Albers, and entire art movements, from the Fauves during the first decade of the century to the color field painters in the 1960s, have concentrated on abstract color interactions, free from the limitations of subject matter and objective references to nature. But as this century progressed, perhaps the most vital influences on color awareness have been the new palette of colors made available by technology and the mass media.

Today we are immersed in color images. Not as in touch as our ancestors with the colors of our natural environment, we nonetheless are saturated daily by literally thousands of artificially generated colors through print and electronic media, home and office decor, packaging, industrial design, and fashion. Entering the classroom or studio from this kaleidoscopic profusion of color, it is no wonder that the professional artist and student alike often gravitate toward full-spectrum color in drawing.

The purpose of this chapter is to inspire you to discover your own color aesthetic, while providing you sufficient introduction to the fundamentals of color so that you have a solid basis for experimentation. Before we proceed, there are two points to keep in mind: first, color is relative. Similar to the interrelationships of value in a drawing, our perception of a color is influenced, to a greater or lesser extent, by the other colors around it. Second, there are no "bad" colors. Any color can be used successfully, depending on your ability to integrate that color into a work of art as a whole.

Basic Color Theory and Terminology

The three basic properties of color are hue, value, and intensity. We discuss all three in relation to the diagrams in Plate 10–1.

HUE

Hue refers to the common names used to distinguish colors, such as red, green, and yellow-orange. Mixing one color with another changes its hue. For example, blue added to red in gradually increasing amounts changes the hue of red to red-purple, then to purple, and finally to blue-purple (see the figures on the left in Plate 10–26). The term *chromatic* is sometimes used to refer to the property of hue.

The opposite, *achromatic*, means without hue and refers to the so-called *neutrals:* black, white, and gray. At times, artists selectively introduce hue into an otherwise black-and-white image to add another dimension of visual interest or meaning, as in Plate 10–2.*

Figure 10–1a arranges the twelve major hues into a color wheel. These twelve hues can be divided into different categories of color relationships that are useful to the artist. The *primary colors*, red, yellow, and blue, cannot be made by mixing other colors. When mixed in pairs or in admixtures of all three, the primaries are the source for all other hues on the color wheel. The *secondary colors*, orange, green, and purple, are each the result of mixing two primaries; for example, yellow and blue create green. The remaining six *tertiary* colors are

*For more discussion of this work, see "Color Economy" (p. 226).

obtained by combining a primary and a secondary color: mixing yellow with green produces the tertiary yellow-green, and so on.

The farther apart colors are from one another on the color wheel, the more their relationship is based on hue contrast. Hues that are directly opposite one another represent the strongest hue contrast and are called *complementary colors*. The three basic pairs of complements are red and green, blue and orange, and yellow and purple.

The closer colors are to one another, the more they exhibit hue concord. Hues that are adjacent to one another on the color wheel represent the strongest hue similarity and are called *analogous colors*. One set of analogous colors is red, red-orange, orange, and yellow-orange.

VALUE

Value refers to the lightness or darkness of a color when compared with a gray scale (black, white, and the steps of gray between). Look at the pure colors displayed in the color wheel and try to determine their relative values. To help you get started, observe that yellow is the lightest hue (closest to white on a gray scale), red and green are approximately middle gray, and purple is the darkest (closest to black). Squinting may help you to see the value differences more readily.

The value of a color can be lightened by adding white to produce a range of *tints*, or darkened by adding black to produce a range of *shades*. Adding white or black to a color will not change its hue: pink, created by adding white to red, is a light-red hue; maroon, achieved by adding black to red, is a dark-red hue (Plate 10–1b). But mixing a hue with either of these neutrals will diminish its purity to some extent, depending on the proportions of the admixture. (The purity of a color is discussed in more detail in the next section.) Creating tints and shades of a color is useful, for example, when dramatic effects of form through chiaroscuro are desired (Plate 10–3). (For a related discussion, see the use of monochromatic color under "Color Schemes" on pp. 219–21.)

A color can be lightened or darkened without being neutralized by mixing it with a second pure color that is analogous and lighter or darker in value, as needed. Mixing two pure, analogous colors, however, will produce a hue change (the steps in Plate 10–1c move from yellow through yellow-green and green to blue-green and blue). In contrast to the use of tints and shades, adjusting color value in this manner has the advantage of creating colors that express a greater sensation of color light across a form, not only in the most illuminated passages but also in the most shallow to deepest shadows.

Intensity

The term *intensity* refers to the saturation, or purity, of a color. Rich, pure colors, as they usually come directly from the tube, are at maximum intensity.

Students often experience difficulty at first in distinguishing between the concepts of color intensity and color value. Keep in mind that pure hues, as found on the color wheel, vary in their values (blue-purple is darker than red, yellow-green is lighter than red-orange), but all pure hues are *equally* intense.

Two concepts sometimes associated with intensity are color brilliance and luminosity. There is practical use in distinguishing between these terms. *Brilliance* refers to the *quality* of light that emanates or is reflected from a color. (Remember, this is different from value, which designates the *quantity* of light reflected.) Both the brilliance (vividness) and the intensity (purity) of any single color will be diminished by mixing it with white, black, or another color. Note,

however, that while it is true that the most brilliant colors are always fully saturated, not all fully saturated colors possess brilliance. A pure yellow ochre straight from the tube, for example, can be considered fully saturated although it is far less brilliant than a saturated yellow or green on the color wheel.

Luminosity refers to a glowing light that appears to be radiating from *inside* a color area, as in the large central shape of the drawing by Margaret Lanterman (Plate 10–4). The stunning effect of a mysterious emission of light from this drawing is achieved by juxtaposing the cool, light yellows and greens of the central shape against the series of warm and generally lower value forms that make up the remainder of the image. Also observe how the delicately modulated colors in the luminous area create the sensation of a translucent gaseous medium in contrast to the surrounding opaque and comparatively heavy masses. To help you grasp this concept, compare the luminous color light coming from within the major form in Plate 10–4 with Plate 10–5, where the objects are bathed by an external light source.

The concepts of hue, value, and intensity cross over when an artist mixes "chromatic grays." The term *chromatic gray* refers to a gray created by adding hue to a neutral or by mixing complements to achieve a neutralized color. Achromatic grays are uncommon in nature; chromatic grays are not. Line up a series of small stones in daylight and you will probably be surprised by the number of color grays you see. There are several ways to make a chromatic gray. Mixing a hue with an achromatic gray of a different value will neutralize the intensity of the hue and change its value. Mixing a hue with an achromatic gray of the same value will diminish the intensity of the hue without altering its value. Chromatic grays obtained by mixing a hue pigment with an achromatic gray are generally flat and dull in appearance and are, for example, excellent for depicting the opacity of surface and weight of solid forms.

Chromatic grays of a different order can be achieved by mixing two complementary colors. When made with complements, these chromatic grays appear as though they are permeated with light, and they are coloristically richer than grays arrived at by mixing achromatic neutrals with color. As Plate 10–1d illustrates, when complements are mixed, they generally result in neutralized color tones. However, if the mixture is carefully adjusted, a chromatic gray will result, as demonstrated in the middle box of our example, where a slate gray appears. (The richness of a chromatic gray will be more apparent if a small amount of white is added, as in our illustration, but that will further neutralize the color intensity.) The hue and value of the gray that results depends on which of the two complements was used in the larger amount. With some commercially available pigments, a pure gray can be achieved by scrupulously mixing equal amounts of both complements.

In Plate 10–6, color grays are obtained by using what is often called "optical color." *Optical color* refers to the eye's tendency to mix small strokes of color that are placed side by side or overlapped. For example, adjacent strokes of red and yellow in a drawing will be perceived as orange from a normal viewing distance. Note, however, that complements applied this way will cancel each other's intensity as they blend in the eye to produce vibrant chromatic grays. In Plate 10–6, red, orange, blue, and yellow were applied in a dense tangle of strokes, dabs, and dragged lines, with the addition of white, to produce neutralized complementary relationships of red-purple with yellow and yellow-green, and blue passages flecked with orange.

Color Schemes

The term *color scheme* refers to an association of selected colors that play a major role in the organization of a work of art. A color scheme also establishes a

principal color harmony or color key in an artwork and in so doing is an important carrier of content. Two or more color schemes can coexist in a work, usually in a dominant–subordinate relationship.

The inventory of color schemes is large, but five in particular can be considered fundamental since they are used most often, either individually or in combination, and they form the basis from which more personal color schemes can be improvised. They are the monochromatic, triadic, analogous, complementary, and discordant color schemes.

A *monochromatic* color scheme is limited to the value and intensity variations of one hue. A monochromatic work can be achieved by adding white and black to a hue, as in Plate 10–3, in which the monochromatic color scheme is effectively used in creating a tonal grisaille to depict the illusion of three-dimensional form and space. A second means for producing a monochromatic color scheme is to dilute a hue pigment to various strengths, as in Plate 10–7. Here, the monochromatic red ground, extremely harmonious and consistent in its visual dynamic, establishes a subdued backdrop for the smaller, more intricately colored image.

Triadic color schemes are based on three hues that are equidistant from one another on the color wheel. There are three categories of triadic relationships: the primary triad (red, yellow, blue); the secondary triad (orange, green, purple); and two sets of tertiary triads (red-purple, blue-green, yellow-orange; and yellow-green, red-orange, blue-purple). The primary triad is the most common, not only in fine works of art, but also in mass-media advertising. This is because the bold, elemental potency of this triad, as in the high-key color drawing by Al Held (Plate 10–8), has broad appeal.

The secondary and tertiary triads tend to produce more subtle relationships. One reason for this is that, in contradistinction to the primary triad, which consists of hues that are unique and basic, each of the hues in the secondary and tertiary schemes shares a color with the two other hues of the triad. For example, in the secondary triad, orange shares yellow with green and red with purple; in one of the tertiary triads, red-purple shares red with yellow-orange and blue with blue-green.

So although each of the triads is based on contrasting hues that can enliven the surface of a drawing, the colors that constitute the secondary and tertiary triads have built-in bridges that shorten the intervals of difference. Artists frequently capitalize on the unifying potential of secondary and tertiary schemes, as in Plate 10–9, in which roughly the upper half of the drawing is pulled together by a secondary triad. Note as well the softening effect of the secondary triadic arrangement in Plate 10–8.

As alluded to earlier, artists often use a particular color scheme to establish a dominant harmonic key or mood, without precluding the coexistence of other colors in the work (as in Plates 10–8 and 10–9). A more rigorous application of the triadic concept can be found in Plate 10–10, all of whose colors have been mixed by using the same three hues of red, yellow, and blue in conjunction with black and white.

Analogous color schemes involve several hues (usually three or four) that are adjacent to each other on the color wheel. Yellow, yellow-green, green, and blue-green constitute one analogous color scheme. Analogous hues create extremely harmonious color relationships because of the short intervals between the neighboring hues on the color wheel, and also because one common color links the hues in any analogous sequence (yellow is the common color in this example).

The dominant colors in Jim Nutt drawing (Plate 10–11) lie within the analogous scheme of red-orange, orange, yellow-orange, and yellow. This warm set of colors* expresses an almost claustrophobic sense of intimacy and heats

*For more discussion on this concept, see "Warm and Cool Color" on p. 222.

up the tension in the farcical female/male relationship. Smaller areas of the comparatively cool hues of blue-green, blue-purple, and red-purple act as color accents to jangle the nerves of the viewer. This group of colors skips over blue and purple, demonstrating that an analogous color scheme does not necessarily depend on all the colors in a contiguous series on the color wheel being represented.

Plate 10–12 more strictly follows a series of analogous steps across orange, yellow-orange, yellow, yellow-green, and green. Note in this work the striking illusion of colored light achieved by mixing analogous hues in varying proportions to adjust intensities and values.

Complementary color schemes employ hues that are directly across, or opposite, from one another on the color wheel. For example, red/green, orange/blue, and yellow-green/red-purple are all pairs of complementary colors.

A complementary color scheme can be built around one pair of complements, or pairs of complements can be used in combination. In the watercolor and colored-pencil drawing by Lostutter (Plate 10–13), three pairs of complementary hues are used: red-orange/blue-green, red-purple/yellow-green, and yellow-orange/blue-purple. A variation on the complementary color scheme may be achieved by using three hues in a "split-complementary" relationship. Split complements are obtained by using a hue in combination with the colors on either side of its true complement. In Plate 10–23, for example, the intense yellow shapes in the center and on the right of the drawing are juxtaposed with blue-purple and red-purple areas.

A *discordant* color scheme is based on hues that compete or conflict, resulting in a relationship of disharmony. There are no absolute rules for creating discordant color schemes, but generally speaking, a combination of hues that are far apart on the color wheel (except complements) will achieve discord. Also, an already discordant relationship can be heightened by equalizing the values of the colors or by reversing their natural value order.

The clash of some discordant schemes can agitate, even shock, an audience, grabbing its attention. The content embodied in such a combination of colors is valued by artists who wish to create visual metaphors for extraordinary phenomena. The power of Plate 10–26, for example, is not derived from the imagery but from complementary contrasts and the combination of the following colors in a series of intensely discordant relationships: yellow-orange/blue-green, orange/yellow-green, and red-orange with purple and blue-purple.

More gentle discord can still arouse unsettling feelings. In Plate 10–14, the reversed tonal order of the light purple strokes to the left of the figure in relationship to the darker greens of the ground, together with the passages of yellow interspersed among areas of blue-green, are visually unpleasant (the viewer may feel subtle waves of queasiness). In the final analysis, the color discord in this drawing is inseparable from the content associations it evokes: the self-absorbed, anguished characterization of the figure and its stale, sickly aura of decadence.

Using Color to Represent Space and Form

A spatial dynamic is inherent in the perception of color. In the world around us, color is light, and light reveals the dimensions of space and form. It is up to the artist to control the interactive energies of color pigments to convincingly depict the volume of individual forms and the impression of depth. This section concentrates on four concepts that are basic to representing space and form with color: local color, warm and cool color, color value, and the optical phenomenon of push–pull.

LOCAL COLOR

Local Color refers to what is generally understood to be the actual color of an object's surface, free of variable, or unnatural, lighting conditions. The yellow of a lemon, the blue of a swimming pool, the fluorescent orange of a Frisbee are all examples of simple local color.* Local color, as the readily identifiable color characteristic of an object, provides a conceptualized home base for more complex local-color explorations.

Complex local color refers to the natural range of hues of some objects that, seen under normal light, constitutes the overall impression of a dominant local color. In Plate 10–15, for example, many of the green peppers include several hues of green and blue-green with subtle patches of yellows, and reds, and oranges. (The peppers that are half green and half red represent a variation on this idea in that they do not possess a dominant local color. A red-and-white-checkered tablecloth and a plaid shirt are two more examples of objects with more than one local color.)

An allied concept is perceived color. *Perceived color* refers to observed modifications in the local color of an object because of changes of illumination or the influence of colors reflected from surrounding objects. Dramatic changes in the color of objects can occur, for example, at twilight, under artificial illumination, or during volatile atmospheric conditions, such as stormy weather. Plate 10–16 records the darkened colors of crops, grasses, and earth under an overcast sky. In Plate 10–17, notice the radical hue and value change on the side of the bowl in the right-hand corner of the drawing. This color change is caused by reflected dark green from the table surface blending with the bowl's local color of light pink. In Plate 10–24, we see on the apple a combination of complex local color (the oranges, greens, and yellow-greens on the illuminated side) and perceived color (the bronze-green mixture on the shadowed side, the result of reflected color). And in Plate 10–15 observe the varied muted colors that make up the shadowed sides of the cardboard box and paper bag.

So on the one hand, the problem posed for the artist is to render sufficiently well the rich colors that appear on an object so that its image in the drawing rings with authenticity. On the other hand, there should not be such a profusion of hues describing an object that the integrity of the local color is compromised. Furthermore, the colors selected to describe an object should serve the needs of the illusion of three-dimensional form *and* the design motives of the work.

WARM AND COOL COLOR

In addition to the qualities of hue, value, and intensity, colors are perceived to have temperature. Colors are usually classified as either "warm" or "cool" (of course, the visual mercury may rise to a hot color or dip to a cold one). Dividing the color wheel in half provides an easy means for general identification: in our color wheel (Plate 10–1a), the top half is occupied by the warm colors yellow, yellow-orange, orange, red-orange, red, and red-purple; the bottom half by the cool colors yellow-green, green, blue-green, blue, blue-purple, purple. This division should serve as a reference point, not a formula. Warm blues and cool yellows are common phenomena in works of art, and color interaction can cause the temperature of any hue to change, or appear to change, depending on its color context. A yellow-green, for instance, will look cool when surrounded by reds, oranges, and warm browns but look downright hot in the context of gray-blues and blue-violets.

Related to the definition of warm and cool color is the broader concept of *color climate*, which associates sensations of moisture or aridity with color temperature. In Plate 10–12, for example, there is a conspicuous difference

*For a discussion about a similar concept in black-and-white drawing, see Local Value in Chapter 7.

between the more baked-dry sections of yellow-orange scaffolding illuminated by sunlight and the neutralized orange and green shadowed spaces where, it would seem, algae could flourish.

We instinctively identify temperature differences among hues; as an example, think how we instantly comprehend a colored weather map, quickly distinguishing between cold fronts expressed in blue and warm fronts expressed in red, orange, or yellow. Based on deep-seated sensory experiences, we associate the warmer colors of the spectrum with sunlight, fire, or the stove burner that was too hot to touch. Conversely, on a hot day, who is not tempted to wade into a stream or lake rippling with blue and green reflections or to collapse on a carpet of cool, green grass?

Generally, warm colors appear to advance and cool colors to recede. But this does not mean that we should not depict blue, green, or purple objects in the foreground of our drawings, since the illusory advance or retreat of any color depends on its intensity and value in relation to the surrounding colors as well as on the spatial structure of the image as a whole (Plate 10–8). All things being equal, however, if two objects, identical except that one is orange and the other green, are placed at an equal distance from an observer, the orange object will seem to be closer.

What this general rule also refers to is the effect of atmospheric perspective, the same phenomenon we discussed in Chapter 1 in relation to value. Atmospheric perspective has two effects on our perception of color. First, because the wavelengths of warmer colors have less energy than those of cool colors, the light rays of warm colors are absorbed more quickly by particulate matter in the atmosphere. This is why objects perceived at a great distance appear to have a blue cast. Second, the farther objects are away from us, the more the atmosphere disperses the rays of colored light reflected from them. As a result, the color intensity, brilliance, and contrast of all objects, regardless of whether they are warm or cool in hue, are reduced as we perceive them at increasing spatial depth, as can be seen in Plate 10–18.

COLOR VALUE

When using color to create the illusion of three-dimensional volume and weight, apply the same rules of atmospheric perspective discussed above, although on a smaller scale. Keep in mind, however, that convincing depictions of form are much more dependent on adjustments of color value and intensity than on hue selection. And do not underestimate the power of monochromatic images or the use of a reduced number of hues to express mass and form. The fine-tuning of value relationships when working with a limited palette not only can sensitize you to a structural use of color but it can also help you to avoid being visually seduced by an array of local color in a complex subject.

Plate 10–5 exhibits an effective use of color value to represent the illusion of three-dimensional form. Particularly effective is the way chromatic grays render the play of light and shadow on the yellow-green material under the sewing needle. The shadowed left side changes from a neutralized yellow-green to a warm color gray with the admixture of red-purple (complement of yellow-green) to a cooler blue-gray as the cloth recedes. Note as well the cooler-color light in the shadow under the cloth, the very subtle shifts of color neutrals along the background plane, and the strategic use of small shapes of saturated color at various pitches of brilliance (yellow to orange to red to blue) that act like jewels sparkling out from under encrusted surfaces.

Plate 10–5 stirs strong emotions with its dramatic lighting; macabre overtones; and distinct changes in color intensity, brilliance, and value. By comparison, Plate 10–17 exhibits almost classical virtues. The emphasis on form in this drawing is the result of color used almost entirely as value. Round volumes are modeled by light to dark and warm to cool adjustments of hue; the planes of

the cloth napkin are rendered with delicate arrangements of chiaroscuro indicating the subtle rise and fall at the edges and creases—note also how the addition of blue to the peach on the back plane of the note card results in a rich color value that securely holds its spatial position in the illusion. All in all, the keenly measured proportions of tonality express a solidity and weight of volumes bathed by uniform lighting. Correspondingly, although the color interactions between the oranges, blues, pinks, and greens at one and the same time are restrained and richly dynamic (most notably the visual "zing" of the peach-colored bar on the note card in contrast to the blue-gray ground and the powder blue bottom of the large bowl), hue selection did not constitute the crucial set of choices in this work. (Would you know the difference if another set of hues were used in the same pattern of relationships?) It is also important to note that when looked at by themselves, the blue ground and green table surface are on the *warm* end of the blue and the green ranges. It is only the surrounding oranges, pinks, and warm blues and blacks that enable us to perceive the blue and green as *relatively* cool.

PUSH–PULL

Up to this point, we have focused on the use of color in image-based drawings to clarify volume and space. Colors by themselves, however, have dynamic energies that can create a sensation of space that is free of both subject matter connotations and the traditional methods for achieving three-dimensional illusion (perspective, chiaroscuro modeling, etc.). Spatial tension created purely on the basis of color interaction is often referred to as *push–pull*.

Push–pull can be loosely described as shifting relations among colors that appear to attract or tug on one another as if magnetized, with one color seeming to rise and pull forward and another pushed back. This refers to a manipulation of color that creates an "optical space" that, remarkably, appears to exist within the flat picture plane. Optical space is not a space that we understand rationally; it is a space that we react to as the result of our involuntary sensory response to color. So optical space exists as a physiological fact. This is in contrast to the representation of three-dimensional space in a two-dimensional work, creating the illusion of a space you can walk through inhabited by things you can touch.

Controlling the push–pull dynamic depends on many coloristic factors. The intensity, value, and temperature of an individual color must be considered relative to other important influences on the creation of color space, such as texture, placement, context, and the shape and area of a color (intense warm colors generally appear to expand, intense cool colors to contract).

Typically, artists achieve push–pull energy by working with relatively pure areas of color in a shallow or flat space. The Heizer drawing (Plate 10–19) combines aspects of linear perspective with push–pull activity to create a limited, but compelling, layered space. The black-and-white photo image provides an illusion of depth through converging parallel lines receding diagonally from the picture plane. A series of intense color splashes and gestural scrawls superimposed over this image, like graffiti on a window, creates a second spatial arrangement based on push–pull. These areas of color establish a sequence of color planes that, for example, appear to be pressed against the back of the transparent picture plane (the green shape in the upper left), compressed inside the picture plane (the blue shape), rising to the surface (the red shape in the center), sitting on the surface (the white splotch at the bottom), or lifting off the surface to glide in front of the work (the yellow shape in the center graduated to a red-orange passage along the right-hand margin).

A selective use of push–pull color action serves up surprises in the otherwise-consistent spatial fabric of the Colescott drawing (Plate 10–20). Push–pull is most pronounced in the purple-edged blue area at the center, which, rather than receding as we would expect a cool color to do, appears to balloon

upward to assert the flat picture plane. Similarly, in the upper left-hand corner, the cerise smear advances, again contrary to our expectations of this portion of a picture, which we normally associate with sky or distance. However, the strategic placement of such a warm color there firmly anchors that corner to the drawing's surface. Note also that the near-complementary relationship of the red and yellow-green forge a bold, diagonal cross tension. This is in contrast to the series of overlapping shapes, starting at the lower left-hand corner, that march counterclockwise around the margin. Finally, observe how further advancement of the blue and red areas is thwarted by the shapes of the yellow-green shirt and yellow hair, which pull forward to hold their slightly more frontal planes.

Color and Design

Color should be wedded to design from the early stages of a drawing's conception. In a successful work, it is impossible to separate the contributions of color from the organizational relationships that constitute an image; but when color is added as an afterthought, the result is often as disjointed as a colorized photo.

The remainder of this section focuses on design concepts already introduced in Chapter 4, but our purpose here is to suggest the mutuality of color and two-dimensional design in a drawing.

UNITY AND VARIETY

Since color adds the potential for greater variety in an artwork, it is important to find patterns of coloristic similarity to unify an image. For this reason, many artists find that preparatory studies are particularly crucial when working in color. Plate 10–21 reproduces an example of a student's process of laying out a color drawing. After the initial black-and-white sketch was completed, two color variations were made to test approaches to orchestrating the drawing's color and design. In the first color variation, a series of analogous reds, yellows, and oranges organizes most of the major planes of the image, with cooler blues and greens used judiciously as contrasting accents to guide the eye and open up the spatial illusion. The second variation reorganizes the pictorial shape formations in conjunction with a general muting and cooling of the color scheme. Note by the way how much more effectively integrated the triangular deployment of intense yellow-orange shapes is in this variation.

VISUAL EMPHASIS

A powerful way to create or strengthen visual emphasis in a work of art is to use simultaneous color contrast. *Simultaneous contrast* refers to the enhancement of contrast that occurs between two different colors that are placed together. Color contrasts are created by differences of hue, value, intensity, brilliance, and temperature. The artist may opt for different degrees of simultaneous color contrast. For example, a grayed red-purple appears relatively intense against a neutral gray ground, but it seems more charged against a chromatic gray ground that has a yellow-green cast. On the other hand, that same mixture appears less intense if surrounded by a saturated red-purple.

Hues in a complementary relationship produce the most striking effects of simultaneous contrast (Plate 10–22). When two complements are unequal in saturation, the hue of the lower-intensity color will seem strengthened, as is the case with the recumbent figure in the middle of Plate 10–22, which appears more decidedly green than it would in a context of less color opposition. When high-intensity complements of equal, or nearly equal, value are used, the pair of colors will appear to vibrate, as can be seen with the smaller, blue archlike

shape against the red-orange ground in the same drawing (Plate 10–22). Remember that complementary contrast depends on at least one of the pair of colors occupying an area in the artwork that is comparatively large. As mentioned earlier, small adjacent shapes or strokes of complements will neutralize each other.

Plate 10–23 is a good example of how diverse gestural energies and color ideas in a drawing can be ordered into a hierarchy of visual emphases based on color contrast. Observe first the larger framework of similarities consisting of a geometry of facades and flattened cubicles colored with a series of generally close-valued, darkish hues.

The large blue-purple facade with its bright-yellow doorway is the main focal point of the image. The near-complementary contrast of these two colors, heightened by their differing quantities and stark contrast in value and color brilliance, creates a nucleus around which the smaller, congested areas circle and group. The larger yellow rectangle to the right moves us out of the center and adjacent to the red-purple square that completes the split-complementary relationship. All three yellow shapes create an area of emphasis at strategic points in the drawing. Notice also the secondary network of accents that enliven the surface, which is based on relatively subtle changes in value, hue, and saturation (the lime green rectangle in the lower left, situated against a ground that slips from orange to pink, is especially rich). Before you leave the drawing, be sure to note the brilliance of color light that issues from the yellow shapes, in contrast to the comparatively dull light of the hues that have been heightened with white.

COLOR ECONOMY

Related to visual emphasis is the economic use of color in a drawing to achieve dramatic expressive or aesthetic effects. Refer back to the drawing by Itatani (Plate 10–2) and note how the introduction of muted red-orange charges the emotional relationships among a group of figures that, by virtue of their almost stereotypical heroic bodies and achromatic depiction, might otherwise seem distant from each other and from the viewer. Color economy can also contribute to formal clarity, as in the Currier drawing (Plate 10–24). Notice here how expanses of cream and white-yellow contrast with the subtle handling of gradually more saturated hues (climaxing in the intense yellow-green of the apple). These differences are united at diagonally opposed corners by russet triangles that, like wedges, hold everything in place.

BALANCE AND MOVEMENT

The quantity and quality differences among colors, and the way in which they are consolidated or divided, affect our perception of balance and movement in a drawing. In Plate 10–25, a nearly symmetrical image is created by the massing of color into large planes that are roughly equivalent in size and emphasis on either side of a vertical axis and by an essentially even distribution of visual accents across the field of the drawing. The sense of color balance is strengthened by the use of complementary colors, which by their very definition as complements give the impression of "completing" each other.* In terms of movement, the color contrasts among the shapes along the border create an almost hypnotic series of irregular beats. In the lower half of the main image, the movement is more regular, sustained by the comparatively subtle hue contrast of the muted-green tree trunks against the pink sky; the graduated progression of analogous colors across the landscape; and the evenly spaced value contrasts represented by holes in the ground, mounds of dirt, and saplings to be planted. And note that when you arrive at the illuminated center of the drawing, the resting place

*The notion of complements completing one another is based on physiological fact. Staring at any intense hue tires the eye, and to compensate, the eye perceives in that intense color the flicker of the color's complement. And less intense or neutral colors adjacent to an area of intense hue will appear to have the cast of that color's complement.

PLATE 10-1
10-1(a) Twelve-Step Color Wheel, 10-1(b) Tint/Shade Scale, 10-1(c) Color Value Scale,
10-1(d) Complementary Color Scale (middle gray heightened with white)

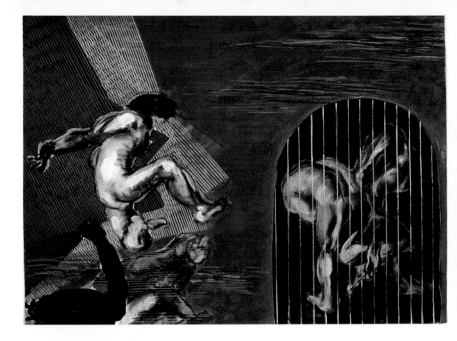

PLATE 10–2
MICHIKO ITATANI
Untitled, 1991
Mixed media on paper, 22 × 30″
Courtesy, Deson-Saunders Gallery and Printworks Gallery,
Chicago

PLATE 10–3
TIM JOYNER, University of Montana
Student drawing: monochromatic color
Courtesy, the artist

PLATE 10–4
MARGARET LANTERMAN
Chair for Don Juan, 1983
Pastel on paper, 26 × 36″
Courtesy of Roy Boyd Gallery, Chicago

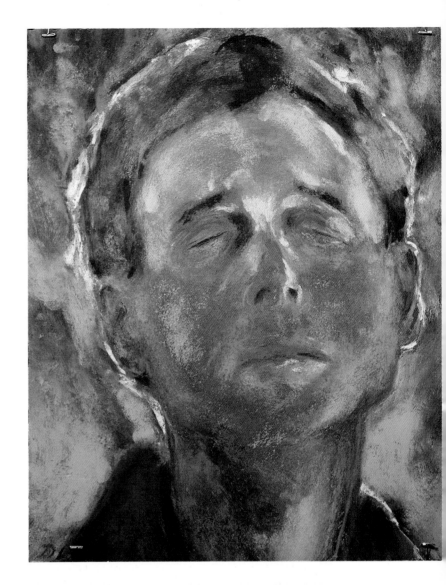

PLATE 10–29
DAN LEARY
Self-Portrait XXIII, 22½ × 17½"
Pastel and powdered pigment on paper
Courtesy, Printworks Gallery, Chicago

PLATE 10–30
MARY FRISBEE JOHNSON
The Heartland Narratives: Radon, 1990
Pastel on paper, 30 × 44"
Courtesy, the artist

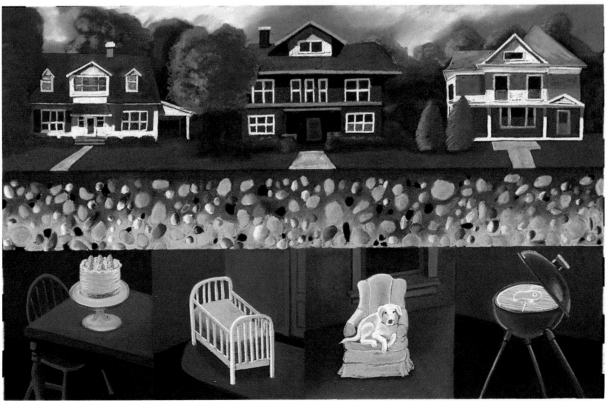

PLATE 10–27
THERESA MARSHALL, Arizona State University
Student drawing: using color
to enhance movement in a design

PLATE 10–28
ADOLF WOLFFLI
Untitled, c. 1920
Color pencil on paper, 12¾ x 20″
*Courtesy of the Phyllis Kind Gallery, Chicago and New
York. Photo: Wm. H. Bengston*

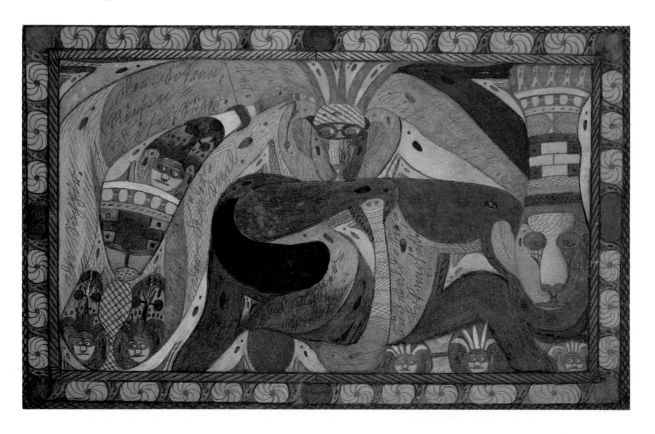

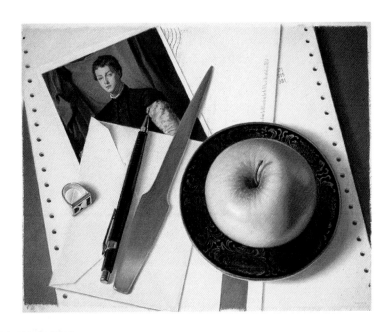

PLATE 10–24
MARY ANN CURRIER
Apple Bronzino, 1993
Oil pastel on museum board, 25½ × 31¾″
Courtesy Tatistcheff Gallery, New York

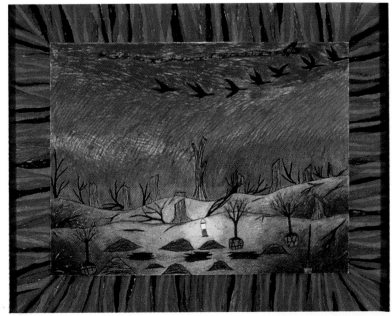

PLATE 10–25
HOLLIS SIGLER
She Is Hoping She Can Make Up for Lost Time, 1990
Oil pastel with painted frame, 33½ × 28½″
Courtesy, Printworks Gallery, Chicago

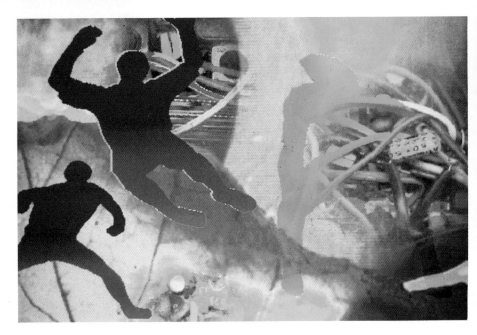

PLATE 10–26
© JOAN TRUCKENBROD
Refraction Explosion, 1991
Computer imaging, cibachrome, 24 × 30″
Courtesy, the artist

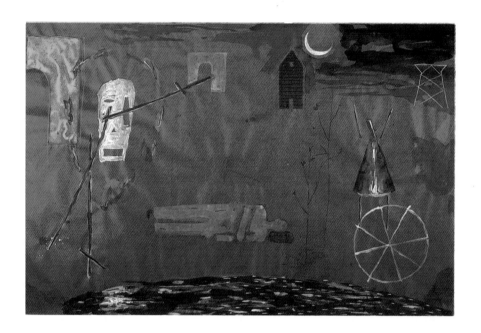

PLATE 10–21
JAN GREGORY, University of Arizona
Student drawing: preparatory color studies
Courtesy, the artist

PLATE 10–22
BILL CASS
The Good Man, 1988
Watercolor on paper, 25½ × 37″
Courtesy, Roy Boyd Gallery, Chicago

PLATE 10–23
RICHARD HULL
Untitled, 1987
Crayon on paper, 22 × 30″
*Courtesy of the Phyllis Kind Gallery, Chicago
and New York. Photo: Wm. H. Bengston*

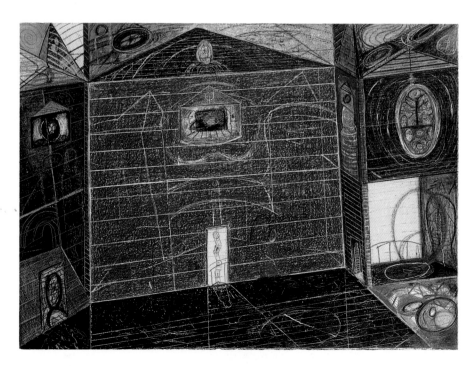

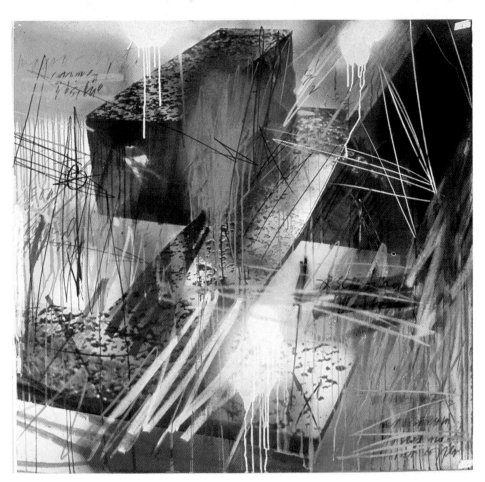

PLATE 10–19
MICHAEL HEIZER
Mausoleum, 1983–1987
Silkscreen, oil pastel, colored
pencil, gouache, 48 × 48″
Courtesy, the artist

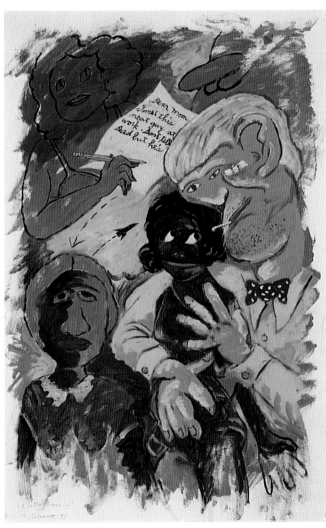

PLATE 10–20
ROBERT COLESCOTT
A Letter Home, 1991
Artist's proof, acrylic on paper, 40½ × 26″
Courtesy, the artist

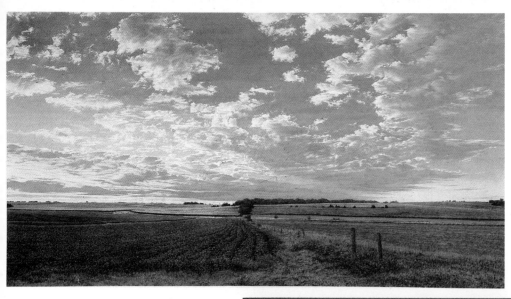

PLATE 10–16
GEORGE ATKINSON
East of Heywood, 1987
Pastel on paper, 25 × 45″
Courtesy, Struve Gallery, Chicago

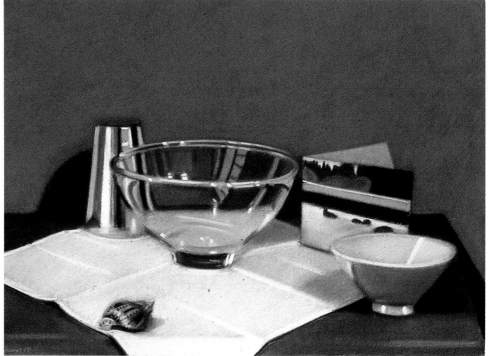

PLATE 10–17
ROBERT SEAVER
Untitled, 1988
Pastel on paper, 21 × 28¾″

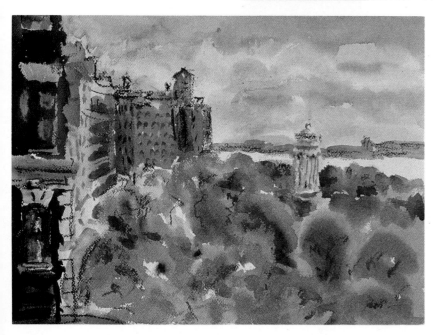

PLATE 10–18
NELL BLAINE
Grey Skies, 1992
Watercolor and pastel on paper, 12 × 16″
Courtesy, Fischbach Gallery, New York

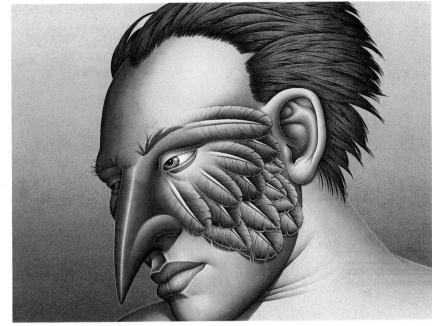

PLATE 10–13
ROBERT LOSTUTTER
Indian Forest Kingfisher, 1992
Watercolor, pencil on paper, 41½ × 31"

*Courtesy of the Phyllis Kind Gallery, Chicago
and New York. Photo: Wm. H. Bengston*

PLATE 10–14
FRANCESCO CLEMENTE
Untitled, 1987
Pastel on paper, 26¼ × 19"
Courtesy, Sperone Westwater, New York

PLATE 10–15
ED ROLLMAN SHAY/
CHARLOTTE ROLLMAN SHAY
Pepperbox, 1979
Watercolor, 40 × 60"

Courtesy, Roy Boyd Gallery, Chicago

PLATE 10–10
JEFF NEUGEBAUER
Arizona State University
Student drawing: primary triad
Courtesy, the artist

PLATE 10–11
JIM NUTT
Really!? (thump thump!), 1986
Color pencil, 14 x 16"
Courtesy of the Phyllis Kind Gallery, Chicago and New York. Photo: Wm. H. Bengston

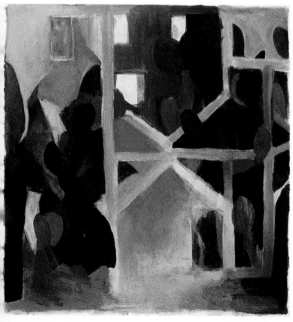

PLATE 10–12
JAN GREGORY
University of Arizona
Student drawing: analogous color

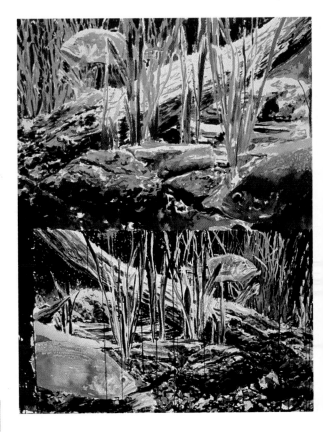

PLATE 10–7
ED SHAY
Myth, 1991
Watercolor, 36¼ x 29¼"
Courtesy of Roy Boyd Gallery, Chicago

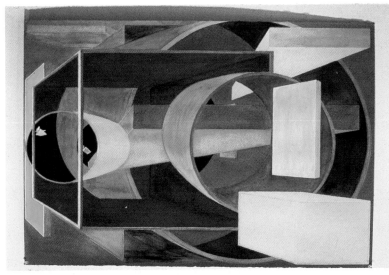

PLATE 10–8
AL HELD
Apus IV, 1986
Watercolor on paper, 27½ x 39¼"
Courtesy, Jean and Lewis Wolff

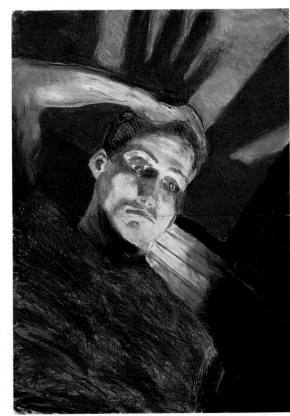

PLATE 10–9
TADD TRAUSCH, University of
Wisconsin at Stevens Point
Student drawing: use of secondary
triad as a unifying factor
Pastels on paper
Courtesy, the artist

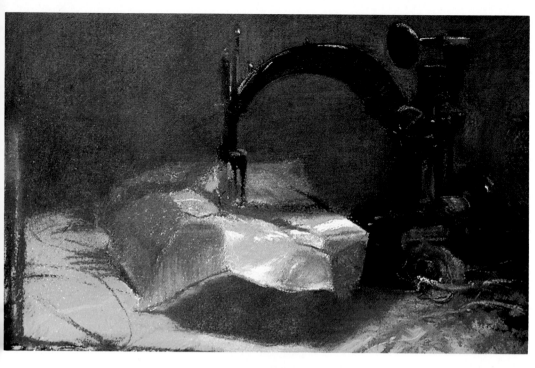

PLATE 10–5
JIM BUTLER, Middlebury College
Sewing Machine, 1986
Pastel on paper, 12 × 16″
Courtesy, the artist

PLATE 10–6
ARNALDO ROCHE RABELL
We Have to Disguise, 1986
Oil on canvas, 84 × 60″
Courtesy, Struve Gallery, Chicago

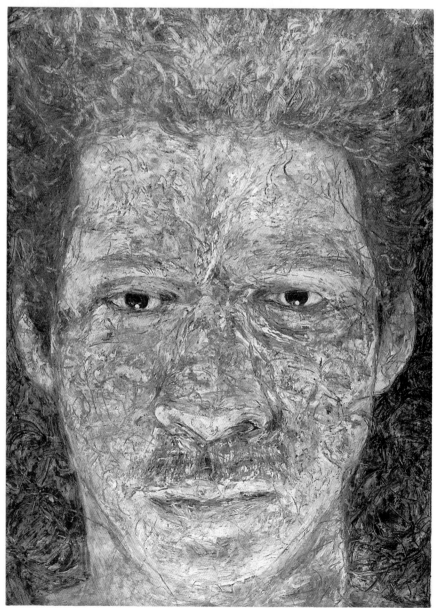

of the lamp cannot be viewed without a peripheral awareness of the color "noise" on the edges. This is a canny color movement strategy used by the artist to express the conflict between the yearning for inward calm to better marshal one's forces and the insistence of outward distractions.

In Plate 10–26, the coordination of very different color weights along with the placement and directional forces of the figures achieve asymmetrical balance while at the same time conveying the impression of turbulent motion. The sense of a burst is effected in large part by the breakup of the surface into crisscrossing areas of intense warm/cool, complementary, and discordant color oppositions. Because of their vigorous action, the figures to the left are destabilizing elements, and the use of hot, blended color enhances the perception of their velocity. Yet within this work, accumulated tensions are checked by the employment of dominant and subordinate analogous color schemes that balance one another.

Brief discussion of two other asymmetrical images is in order. Plate 10–22 demonstrates how small proportions of color in a large, differently colored field, have the power to attract our attention and counterbalance other types of visual weight in a drawing. In Plate 10–27, the use of similar forms, carefully repeated in subtly changing spatial intervals, creates a unifying rhythm and a relaxed, harmonious balance. The overall effect of regulated movement, like railroad cars shuttling past a crossing, is enhanced by the way hue, value, color temperature, and color brilliance are used to clearly distinguish the "moving" parts from the stationary parts of the image. Evenly paced changes in the hatched-mark patterns further advance the sensation of unity in this drawing.

Color and Expression

The potential of color in art to evoke associations and express feelings, from the most powerful of emotions to the most delicate of aesthetic insights, is incalculable. Correspondingly, since color perception is grounded primarily in the deep structures of personal experience, each artist will capitalize on color's expressive potential in a different way.

Color used to expressive ends is not the domain of a particular artistic style. It would be a mistake to conclude that the expressive values of a highly representational, or naturalistic, artwork are necessarily any less rich than those of a more blatantly expressionistic image. Absorbed in local and perceived color, representational artists do not necessarily copy the color relationships they see in the world before their eyes but rather use some combination of reason and intuition in interpreting those relationships. Even when using color to capture the particulars of light, space, and form of a subject, you will find that the abstract processes of color selection and the orchestration of color with compositional motives inevitably infuse your so-called naturalistic work with a sensibility unique to you. What is important, regardless of the style in which you work, is to use color in a way that contributes to the content and structure of your drawing.

Having said that, it is important to note that throughout the twentieth century to the present day, the visual arts in Western society have been characterized by the coexistence of two fundamental streams of color conception: one stream continues the Renaissance practice of descriptive color, based on references to nature; the second stream has liberated color from its purely descriptive role, broadening the artistic inventory of expressive response. The remainder of this section focuses on the latter, that is, the more overt manipulation of color for subjective purposes, as distinct from a more objective approach aimed at emulating nature. (We distinguish between the terms *subjective* and *objective* for the sake of clarity only. Once again, we acknowledge that the application of these terms is as relative as color itself.) Accordingly, we begin with a definition of subjective color.

Subjective color refers to arbitrary color choices made by the artist to convey more powerfully emotional or imaginative responses to a subject, or to compose with color in a more intuitive or expressive manner.

Realize that the use of the word *arbitrary* in this context is not meant to imply superficial motives for deciding on an arrangement of colors. Instead, it suggests deeply felt impulses or convictions about color that are not dependent upon references to the natural world.

In the drawing by Adolf Wolffli (Plate 10–28), subjective color is used both to promote the design and to serve decorative rather than spatial purposes. The evenly applied, pleasing colors have an ornamental, almost ceremonial splendor. Carefully plotted into active zones, the intense hues are balanced against the gray areas of rest to enhance sensations of order and harmony. Moreover, the motif of brilliant yellow accents, accompanied by variously scaled human and animal heads, some in multicolored womblike sacs, all circling around the central black and brown shapes that are in a yin–yang relationship, imbues this drawing with an air of formality usually reserved for symmetrical images.

Heightened or exaggerated color can strengthen our emotional identification with a subject. The color in Dan Leary's self-portrait (Plate 10–29), for example, expresses a radiance that transcends realism. Certainly, the facial expression drawn close-up together with the vulnerable gesture of the head and neck contribute to the poignancy of this image. But it is the scalding intensity of the color that is paramount in creating an immediacy of emotional impact; we cannot help but respond to such an acute state of mind without attributing our own subjective feelings to the plight of the subject.

The central role of color in setting the mood of Leary's work is instructive. In general, color can stimulate a wide range of psychological and associative responses, consciously or unconsciously. It is not uncommon, for example, for a viewer to associate certain colors and properties of colors with specific feelings (warm colors get our attention and can inspire a robust, aggressive, or hopeful temperament; cool colors are more withdrawn, suggesting a serene, reserved, or melancholy disposition—"I got the blues"). Associations can also be made with sensory experiences (red is often equated with a sweet taste and things hot to the touch, green with outdoorsy smells, and orange with brassy sounds).* Particular hues may also trigger symbolic associations with abstract concepts: for instance, we are culturally conditioned to associate yellow with treachery or cowardice and purple with royalty; we may even have a red-letter day because of our green thumb!

Returning to the Leary drawing, note that the face is an island of intense oranges, a color that often symbolizes irradiation, surrounded by dark values that connote brooding or introspection. In comparison to the naked emotion displayed in Leary's drawing, the substitution of a fanciful color system for local color in Roche Rabell's self-portrait (Plate 10–6) results in a concocted image of ritualistic power that conceals the sitter's identity. A dead giveaway is the flamboyant color of the hair. Looking as if it has just ignited, with curls of flame licking the edges of the face, this badge of an assumed persona might summon responses of fear, amazement, or even irreverence, but it is not easily ignored. The claylike color grays of the face suggest inertia and depersonalization and as such are the perfect foil for the animated, intimidating stare of the eyes, the only clue to the true personality behind the disguise.

Initially, it may be easiest to understand the emotive force of color when a specific set of colors is intimately linked with identifiable subject matter. However, nonobjective artworks, in which abstract color interactions form not only the structure but also carry the content, can be just as emotionally charged an experience for the sensitive viewer. (Indeed, some artists would contend that

*Having a subjective sensation accompany an actual sensory experience, such as hearing a sound in response to seeing a color, is known as "synesthesia," a phenomenon explored by many, particularly nonobjective, artists during the twentieth century.

abstract color is one of the purest means of artistic expression, since color directly affects the senses.) It is safe to say, for instance, that the extroverted, technicolor grandeur of Al Held's hard-edged drawing (Plate 10–8) can instantaneously promote feelings of excitement in a viewer.

The symbolic connections the mind makes with a particular color can be contradictory (red can mean sanctity or sin). Interestingly, the color green is most frequently associated with nature, and by extension it symbolizes the positive concepts of life and growth. Given that, how effective and startling is the negative representation of this hue in Plate 10–30. Here, a fluorescent green, made to look radioactive against the dark blue ground in the lower third of the drawing, creates a compelling symbol for the silent but lethal effects of radon poisoning.

Although there may be a level of shared response to color within a society, the attribution of meaning to colors is highly variable among individuals and across cultures (contrary to American practice, in China, green means stop and red means go). For this reason, it makes sense for you as an aspiring colorist to periodically analyze for content your own color preferences, as gleaned from your personal work and from masterpieces that strike you as particularly effective in their use of color. The reactions that color in an artwork provokes from an audience are, of course, impossible to predict. What is important is that the subjective color choices that an artist makes possess the *authenticity* to move viewers toward responses that are similarly strong, if not identical in kind, to the artist's expressive intentions.

11

Visualizations: Drawing Upon Your Imagination

Our brains are active places, and among the flow of information and snatches of verbal thought appear mental pictures of things remembered or imagined. These mental pictures often crop up quite unexpectedly and like dreams may recur uninvited. Most people are happy to simply live with their personal repertoire of mental images and manage to shove them aside to get on with their lives.

But an artist may find these images harder to ignore. Have you ever had a mental image be so persistent that you felt the only way to put it out of your mind was to draw, paint, or sculpt it? This is a common experience among artists and is perhaps one of the things that best differentiates us from other people. We experience a drive to give outward form to our personal experience.

Fortunately, our culture still treasures personal vision, this in spite of the fact that we are constantly bombarded with images by the mass media. While the imagery produced by the advertising industry is often undeniably clever, we generally perceive it as shallow and lacking the meaning we hunger for. So the role of the artist today includes recharging the vast pool of imagery around us with images that are at once personal and also recognizable as pertaining to a more universal human condition (Fig. 11–1).

Representations that are based on imagined or recalled material are commonly referred to as *visualized images*. Visualized images can range from the humble sketch someone makes prior to buying lumber for a bookcase to such surreal artistic conceptions as Figure 11–2. And in complexity and degree of finish, envisioned images can span the gamut from the gestural drawing of a sphinx by Leon Golub (Fig. 11–3) to the much more elaborately detailed drawing by Oskar Schlemmer (Fig. 11–4).

Some of the most expressive drawings in this book were derived entirely from the artists' imaginations. But visualized-image drawing is also an excellent way to test concepts in the planning stages of a larger project. In Figure 11–5, for example, the Swiss sculptor Jean Tinguely has made a series of spirited studies of a machine propelled by waterpower. Creative brainstorming is equally a feature of the commercial art world. As an example of how envisioned drawing is used at various levels of commercial production, consider Figure 11–6, which

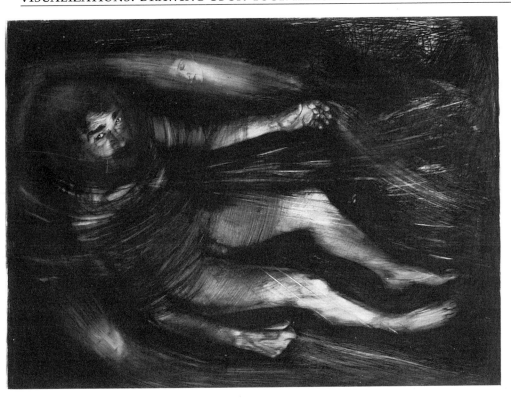

FIGURE 11–1
MADDEN HARKNESS
Untitled, 1988
Mixed media on vellum, 47 × 36″
Courtesy, Roy Boyd Gallery, Chicago

FIGURE 11–2
GEORGE CONDO
Untitled, 1984
Conté, 11½ × 9″. © 1996 George
Condo/Artists Rights Society
(ARS), New York

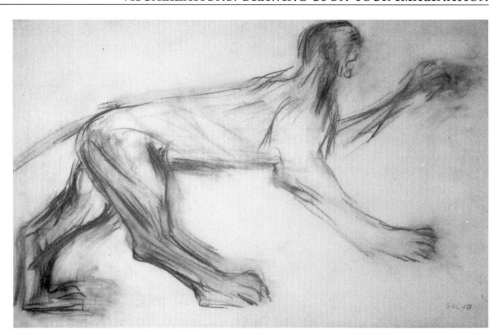

FIGURE 11–3
LEON GOLUB
Untitled (Sphinx), 1963
Conté on vellum, 23¾ × 39″
Courtesy, Printworks Gallery, Chicago

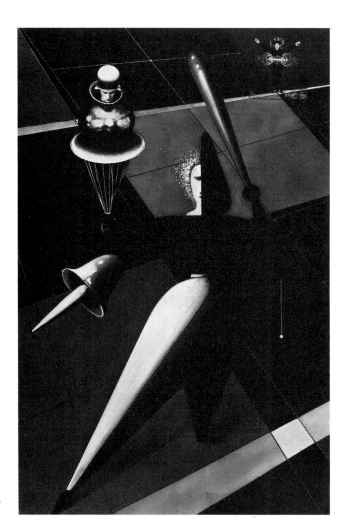

FIGURE 11–4
OSKAR SCHLEMMER
Study for The Triadic Ballet, 1922
Gouache, brush and ink, incised
enamel, and pasted photographs,
22⅝ × 14⅝″ (irregular)
*The Museum of Modern Art, New York. Gift of Lily
Auchincloss*

FIGURE 11–5
JEAN TINGUELY
Fontein, 1968
65 × 50 cm
Rijksmuseum Kröller-Müller, Amsterdam, The Netherlands. © 1996 Artists Rights Society (ARS), New York/ADAGP, Paris

shows a set design representing a Victorian clockshop, a photograph of the actual film set, and then a storyboard used to plan the sequence of the advertising narrative.

Freeing Up Your Imagination

Sometimes the toughest part of making a visualized-image drawing is coming up with an idea. To compound the problem, when looking at the work of others, you may surmise that the images have poured out effortlessly, making you feel in comparison as though your imagination has completely dried up.

To set matters straight, while some artists create invented imagery of the highest order in a seemingly effortless manner, as we might suspect to be the case with regard to Cuevas (Fig. 11–7), most of us have to prod or "crank up" our imaginations before visualized images of merit begin to emerge. Fortunately, there are some fairly universal ways to free up the imagination.

To begin with, since you'll always be using aspects of the real world to kindle your creative thoughts (no one can get outside of nature), we recommend that you get in the habit of playing uninhibitedly with what you see in your daily life. For example, as you walk down the street, have fun by projecting new and reversed relationships between things. Personify a group of parked cars, making them into good or evil characters, or imagine that, for a change, a fire hydrant soaks a dog with a stream of water. In this regard, take note of the fanciful narrative in Joanne Brockley's drawing (Fig. 11–8) in which backstage props cavort in a manner that may read as either comedic or mildly threatening. You might also try concocting composite images in your imagination that could never occur under normal circumstances, as in John Wilde's portrait of *Emily Egret* (Fig. 11–9).

Uninhibited play with media can be another springboard for visualized images. For example, Otto Piene passed smoke from a flickering candle through a screen to create the pattern of sooty deposits in his *Smoke Drawing* (Fig. 11–10), and Lucas Samaras transformed his Polaroid SX-70 self-portrait by manip-

FIGURE 11–6a (above)
FALLON McELLIGOTT
Set design of Victorian clockshop
drawing
Courtesy, Dow Jones & Company, Inc., Fallon McElligott. Note: a, b, and c made in conjunction with an advertisement for The Wall Street Journal

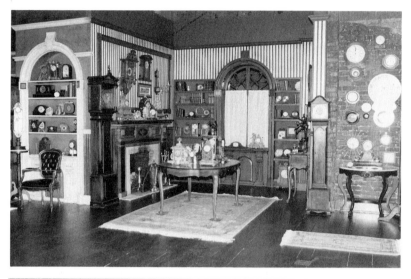

FIGURE 11–6b
FALLON McELLIGOTT
Actual film set of Victorian
clockshop
Photograph
Courtesy, Dow Jones & Company, Inc., Fallon McElligott

FIGURE 11–6c
FALLON McELLIGOTT
Storyboard for Victorian clockshop
drawing
Courtesy, Dow Jones & Company, Inc., Fallon McElligott

ulating the photo emulsion as the image was developing (Fig. 11–11). In your own work, taking rubbings of surfaces to obtain textures or transferring images of current events from the popular press can be a catalyst for new drawing adventures. Or you might overlay onto the ground of your drawing found materials, such as menus, posters, or sheet music. Another possibility is to involve

FIGURE 11–7
JOSÉ LUIS CUEVAS
Sheet of Sketches, 1954–1959
Pen and blue and black ink with
brush and colored washes on pink
laid paper with red fibers, 47.9 ×
33.5 cm
*Gift of Joseph R. Shapiro. Photograph © The Art
Institute of Chicago. All Rights Reserved (1959.244)*

FIGURE 11–8
JOANNE BROCKLEY
Untitled, 1984
Pastel and watercolor, 32 × 40″
Courtesy, the artist

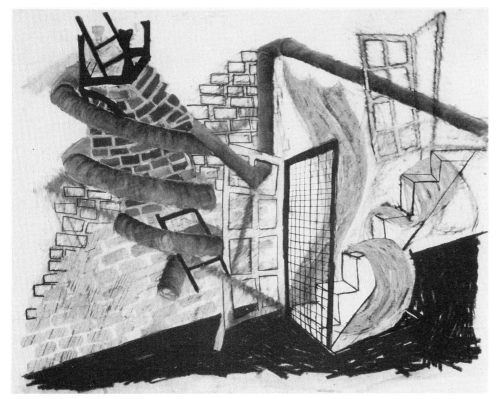

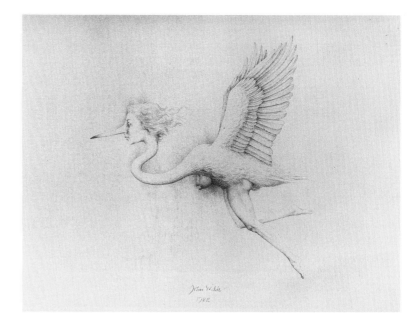

FIGURE 11–9
JOHN WILDE
Lady Bird Series #9–Emily Egret,
1982
Silverpoint on paper, 8 × 10¼"
(sight)
The Arkansas Arts Center Foundation Collections:
The Tabriz Fund (83.24.2)

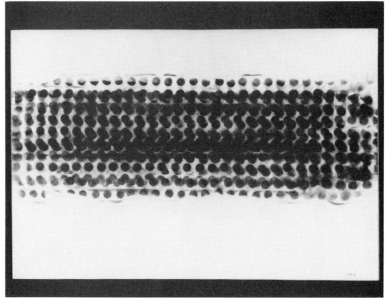

FIGURE 11–10
OTTO PIENE
Smoke Drawing, 1959
Smoke/soot on paper, 50 × 60 cm
Courtesy, the artist

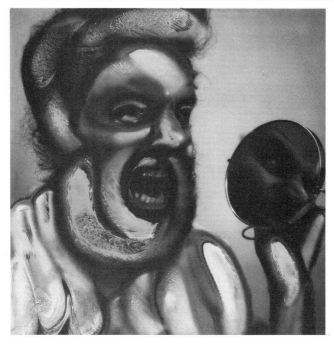

FIGURE 11–11
LUCAS SAMARAS
Photo-Transformation, 1973
SX70 Polaroid, 3 × 3"
Courtesy, Pace Wildenstein

yourself for a time with drawing-related techniques from other artistic disciplines, such as monoprinting (Fig. 11–12), which is traditionally associated with printmaking. Alternatively, try extending your drawing into actual three dimensions as in Figure 11–13, whose image has been constructed within a cardboard box.

Perhaps the best known way to spontaneously generate visualized imagery is to doodle. Doodles are usually thought of as idle scribbling that helps to pass the time or vent nervous energy. But for the artist, doodling represents a form of "automatic drawing" that can stimulate an outpouring of intuitive imagery.

Artistic approaches to the doodle vary. Doodles can incorporate a variety of lines and tones and even media changes, as in Paolozzi's *Kop* (Fig. 11–14), which includes fragments of collage. Some artists use the doodle as a point of departure, leading to imagery that is more intentionally developed, as in Figure 11–15.

For other artists, automatic drawing is the sole means by which they create their imagery. This is particularly true for artists such as Jackson Pollock, who credit the unconscious as the source for their art. Interestingly, Pollock's astonishing ability to channel his subconscious feelings onto paper is confirmed by the fact that many of his innumerable sheets of studies (Fig. 11–16) were used as a therapeutic aid for him by his psychoanalyst.

Drawing the Visualized Image

Once you have come up with an idea in your imagination, the next step is getting it down on paper. Or if you have seen an image emerge while doodling or experimenting with media, you will need to develop and refine it. This section briefly addresses some of the considerations that apply in either case to the drawing of visualized images.

Usually when drawing from the real world, we choose subjects that are

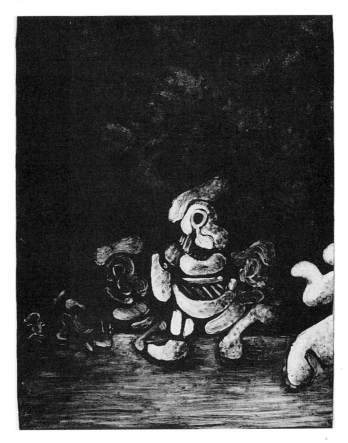

FIGURE 11–12
DeAnn Gould, Clarion University
Student drawing: monoprinted
image 19 × 15″
Courtesy, the artist

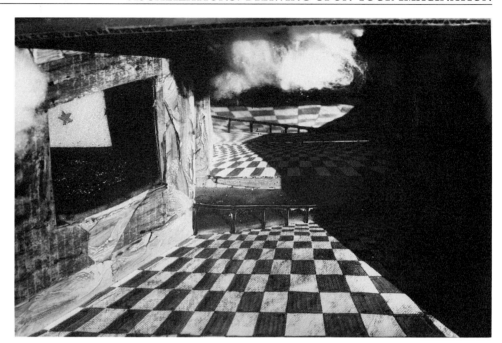

FIGURE 11–13
JULIE MALECHA, University of
Arizona
Student work: constructed drawing
in three dimensions
Courtesy, the artist

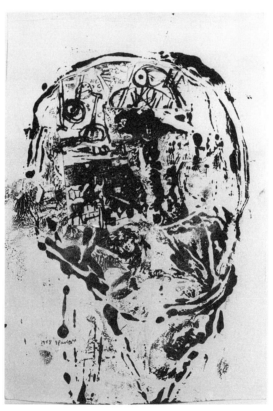

FIGURE 11–14
EDUARDO PAOLOZZI
Kop, 1950
Collage, 46 × 31 cm
*Rijksmuseum Kröller-Müller, Amsterdam, The
Netherlands*

stationary and clearly defined by actual light and shade. This allows us to measure the success of our depiction against the concrete objects and spaces before us. When drawing things in motion (such as a pacing zoo animal or people milling about in a public terminal), we are forced to retrieve and generalize information from a continually changing subject. But even in these circumstances, we still may test, to some degree, what we've made against what we see.

Drawing from images we visualize is another matter altogether. In this case, we do not have the luxury of directly comparing our effort with the source material. And in order to rough out and develop what we have imagined, we

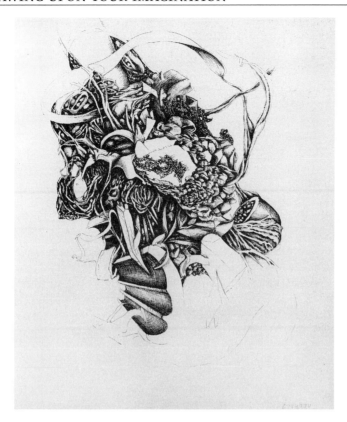

FIGURE 11–15
JONATHAN BOROFSKY
Untitled at 2,784,770, n.d.
Ink and pencil on paper, 14 × 11"
Private collection. Photo: James Dee

FIGURE 11–16
JACKSON POLLOCK
Sheet of Studies, c. 1941
Pencil and charcoal pencil on
paper, 11 × 14"
*The Museum of Modern Art, New York. Gift of
Charles B. Benenson. © 1996 Pollock-Krasner
Foundation/Artists Rights Society (ARS), New York*

must try to capture what is often a fleeting and vaguely formed mental picture,
the particulars of which may seem to disappear in translation. This is why
drawing invented forms and spaces, especially when they are complex, can be
a test for any artist. But in spite of the demands, the execution of visualized
imagery should not be beyond the capability of anyone who has a command of
fundamental drawing skills.

Drawing images from your mind depends first of all on a utilization of the basic facts of seeing as gained from drawing real things. This is because even the process of drawing the structural properties of real objects is usually organized around an internalized image or gestalt; in other words, each surface change recorded from an actual subject in a drawing is measured against what this gestalt feels like in the mind's eye.

Drawing the visualized image entails a somewhat similar operation, except for the fact that you will be plugging more directly into a generalized gestalt, without the intermediary of an observed object. This means that no matter what approach you employ (cross-contour lines, mass gesture, planar analysis, and so forth), in effect you will be "sculpting" or discovering the structural specifics of your visualized subject as you draw it. The tactile characteristics of an imagined subject can be clearly seen in Figure 11–17, in which the swell of the towering ocean wave has been suggested by loose topographical strokes of paint and chalk. In Figure 11–18, cross-contour marks give a feeling of solidity to the jumbled vaselike objects.

Thus, many of the factors you have to consider when recording your impressions of actual space and form can be used as building blocks to guide the emergence of something recalled or imagined. The most important of these factors are:

1. The vantage point from which to draw what you have envisaged.

2. The gestural essence of visualized forms, which includes their overall proportions.

3. The spatial relationships of imagined objects. For example, note how spatial clarity has been imparted to the envisioned scene in the Yarber drawing (Fig. 11–19) by using such guidelines as relative scale, foreshortening, overlapping, and linear perspective. Linear perspective is also instrumental in Figure 11–20, in which the principles of convergence and eye level invest this visionary image with the authority of actual circumstance.

FIGURE 11–17
JOHN BYAM SHAW
The Tempest, c. 1900
Watercolor, gouache, and chalk,
10¾ × 8¼"

The Museum of Modern Art, New York. Gift in honor of Myron Orlofsky. Photograph © 1995, The Museum of Modern Art, New York

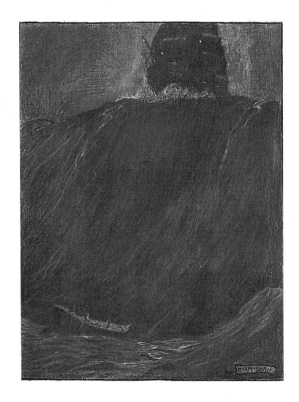

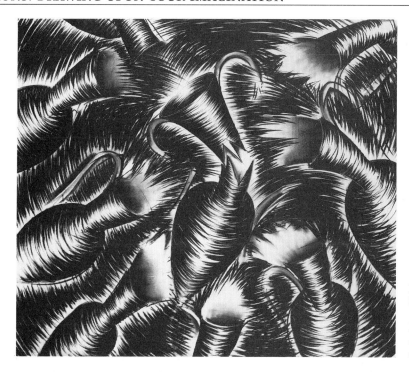

FIGURE 11–18
SUSAN CHRYSLER WHITE
Untitled 2
Dayglow, gouache, and charcoal,
48 × 42½″
Courtesy, Rutgers–Camden Collection of Art

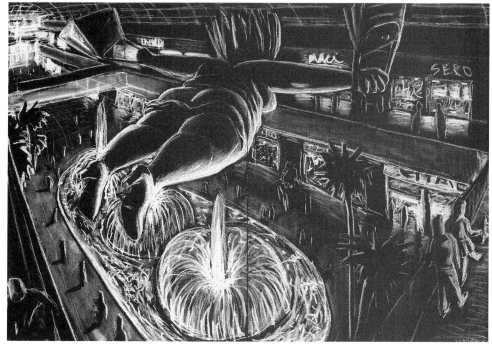

FIGURE 11–19
ROBERT YARBER
Falling Shopper, 1985
Pastel on paper, 39½ × 55½″
Courtesy, Sonnabend Gallery. Photo: Jon Abbot

4. The surface structure of imagined forms, which includes an understanding of their major planes and topography (see Figs. 11–17 and 11–18).

Another thing you will want to bear in mind when drawing a visualized image is the positioning of its form in relation to the picture plane. When drawing from life, it is good practice to select that view of your subject that best reveals its spatial character (unless flatness is a specific aim of your work). But finding the most spatially dynamic view of an imagined subject takes a more concentrated effort. Typically, beginners visualize their images in an unforeshortened view, that is, the view in which the form's profile most readily identifies the subject. But imagined forms appear more impressive and more natural if they

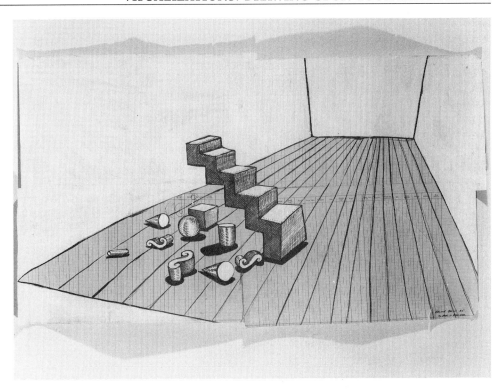

FIGURE 11–20
EDWARD ALLINGTON
The Steps or Staircase, 1985
Ink and emulsion on paper,
25½ × 45″
Courtesy, Lisson Gallery, London

engage space fully by confronting the picture plane (Fig. 11–21). If you find you are not able to overcome the difficulty of drawing your visualized subject in a foreshortened view, try fashioning a small three-dimensional model of it from clay or cardboard. Look at your model from a number of angles to find the view that is most expressive of what you wish to communicate.

So it is a good habit, when drawing from your imagination, to turn the subject around in your mind, making thumbnail studies as you go along, as in Figure 11–22, in which the artist has explored a mysterious headless figure in a variety of settings and drawing approaches. In doing this you will, of course, be depending on both your visual memory of how similar forms look from

FIGURE 11–21
HIRAM D. WILLIAMS
Challenging Man, 1958
Oil and enamel on canvas,
8′¼″ × 6′⅛″
The Museum of Modern Art, New York. Fund from the Sumner Foundation for the Arts

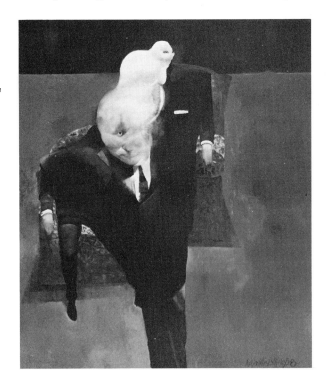

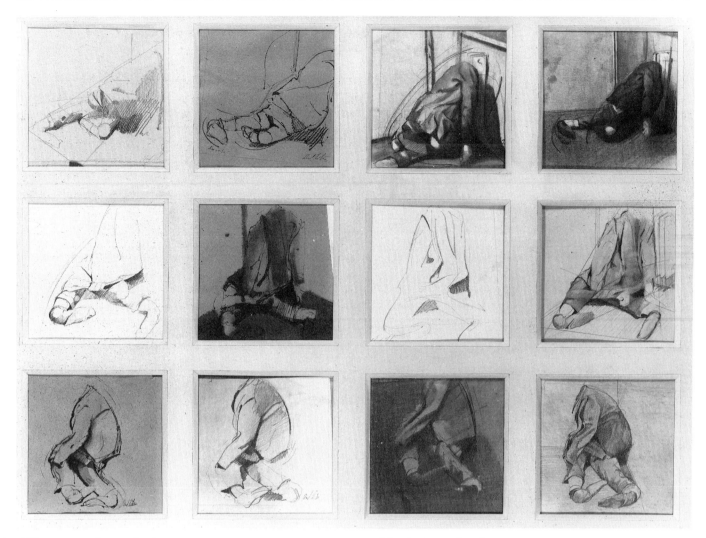

FIGURE 11–22
DANIEL QUINTERO (b. 1949)
Sketches of Pelele, 1974–1975
12 drawings on paper,
ea. 4¾ × 4¾″
Private collection. Courtesy, Marlborough Gallery

different angles and also to some extent on your powers of logic to make the conceptual connection between various aspects of the form.

Before we conclude this section, it is important to point out that the two extremes of drawing from life and drawing from your imagination can be mutually beneficial. Rigorous scrutiny of things seen through the act of drawing can help you realize envisioned images because it increases the reserve of forms that you have committed to memory. And the conceptualization required for drawing visualized images can make you more adept at rapidly grasping the essential gestural and structural qualities of the real subjects you draw.

Categories of the Visualized Image

This chapter has taken a straightforward look at the topic of visualized imagery. With our commonsense approach, we have endeavored to reassure you that the basic building blocks of representing observed form and space provide the underpinning for even the most complex of imaginary images. In making the working processes more comprehensible, however, we run the risk of implying that visualized-image drawing is formula-bound and mechanical.

Nothing could be further from the truth. On the highest level, the creative drawing act is a magical and unpredictable process that resists analysis or rigid formulas. Nowhere is this more evident than with the creation of envisioned images, which are conceived from scratch, so to speak, using the resources of

the artist's imagination. The practical insights in this chapter are meant to em-
power you in discovering your own creative resources; and it is our hope that
the reproductions of old and new master drawings throughout this book will
communicate the depth of innovation and expressive impact commonly asso-
ciated with drawings of visualized imagery.

To reinforce our theme that inspiration can be taken from studying the
visualizations of other artists, this last part of the chapter categorizes and briefly
examines a select group of twentieth-century visualized-image drawings. The
categories are arbitrary; they are used purely to lend temporary structure to the
seemingly endless array of imagined images in pictorial art. As a practicing
artist, you are encouraged to combine these categories and even to invent new
ones.

IMAGES BASED ON MEMORY

The artist's memory is perhaps the most common source for visualized images.
Some artists rely heavily on the remembrance of things past for their subject
matter. Artists who work this way often take great pains to reconstruct the
memory picture they have visualized. For example, they might do a substantial
amount of photo research to augment their powers of recall, visit sites that are
similar to the one imagined, or make studio models of the scene to retrieve
structural detail and lend their work an air of authenticity.

For the most part, however, artists do not so intentionally take advantage
of the opportunities their active memories may provide. Instead, they react
intuitively to overtones in a developing work that trigger their memory of, let
us say, the peculiar physiognomy of someone glimpsed in a bus, the striking
pattern of shapes under restaurant tables, or even an unusual pairing of colors.
The contributions of things impulsively remembered and acted on can greatly
enrich a drawing, or any work of art.

But whether you are consciously mapping out the visual coordinates of an
event that has haunted you for years or simply responding to whatever at the
moment you are provoked to recall, it is important that you trust your memory
and go wherever its unfolding narrative takes you. This is not to imply, however,
that the images you draw must be rigorously controlled by your memory. The
drawings you make will have their own momentum; what you recall should be
considered a basic script, or scenario, to get at deeper meanings. Thus, you
should feel free to manipulate the images you visualize, to insert symbols to
heighten their content, or to combine the memories of several individual events,
as can be seen in Eric Fischl's *Sundeck Hoopla* (Fig. 11–23).

TRANSFORMATIONS

In everyday life, transformation refers to a change in the outward form or ap-
pearance of a thing. There are two basic states of transformation. One is the
alteration of something as we know it—think of a densely forested tract of land
altered by a fire. Transformation may also mean a more complete and essential
change, as in the metamorphosis of a caterpillar into a butterfly.

For artists who transform reality to make an envisioned image, the same
two orders of change apply. At their best, transformed images seem to be the
result of artistic alchemy, as if the change were magically induced. And as is
the case with actual living matter, the central feature of artistic transformation
is a sense of process or movement from one phase to the next, which is either
apparent or felt.

The transformed self-portraits by Lucas Samaras (Fig. 11–11) and Charles
Littler (Fig. 11–24) are striking examples of how an altered exterior can act as
an extension of the psychological self. Both of these drawings exhibit a mastery
of form improvisation that, in view of the subject matter, can be considered to

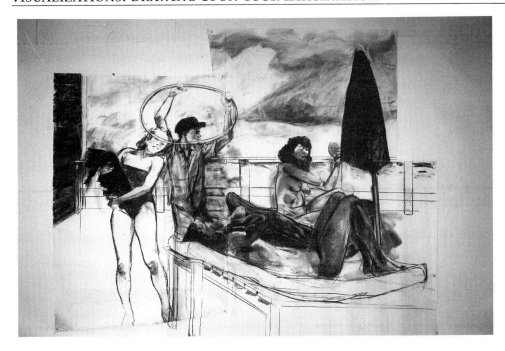

FIGURE 11–23
ERIC FISCHL
Sundeck Hoopla, 1985
Charcoal on paper, 105 × 129"
Courtesy, Mary Boone Gallery, New York
(M BG #2576)

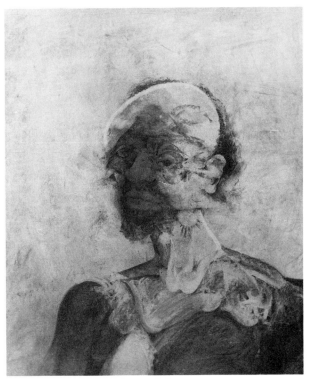

FIGURE 11–24
CHARLES LITTLER
Self Portrait, 1977–1985
Charcoal, 36 × 30"
Collection of Arnold and Marilyn Nelson

have resulted in images of grotesque abnormality. But the intent of both artists was to communicate certain interior feelings more forcefully than would be possible with an objective rendering. And as you compare them, note how different is the expression in these two works: the snarling visage of Samaras is diabolical; the Littler is marked by gentility and repose in the presence of change.

The startling imagery in Figure 11–25 depicts the metamorphosis of beggars into dogs. These mutational forms are modern parallels of the human–animal hybrids that abound in the mythologies of ancient peoples. But in spite of their fantastic bearing, these images seize and hold our attention because they seem structurally plausible and because their swift, tracerlike lines express energy and

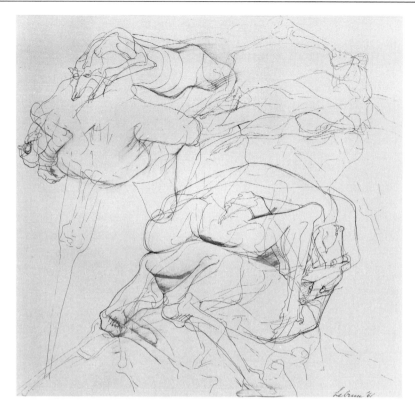

FIGURE 11–25
RICO LEBRUN
Three-Penny Novel–Beggars into Dogs
Ink on paper, 37¼ × 29⅞"
Worcester Art Museum, Worcester, Massachusetts

the passage of time. Note as well that these transfigured beings embody a timeless social theme: the fate suffered by those who are cast out by society.

Transformations of the human form can have a particularly intense emotional impact on us because our identification is so immediate and profound. And yet one of the reasons artists are a vital cultural resource is that their transformative powers often shift and refresh our perceptions of the most commonplace things in our environment. Look, for example, at the drawing by Max Ernst (Fig. 11–26). By the seemingly simple strategy of applying the texture of wood grain to a leaf, Ernst short-circuits what is often an important clue in recognizing an object—its distinctive surface quality—and makes us consciously reconsider what we normally take for granted.

INVENTIONS

The dividing line between visualized-image inventions and transformations is thin and at times impossible to pinpoint. But for our purposes, it seems necessary to differentiate between those images in which a change in the appearance of something known is the critical element and those that are generated by the ambition to graphically portray things that either cannot be seen or did not previously exist.

Visualized-image inventions are speculative adventures, inspired by a window on another world. Some illuminate visions of magical subject matter such as futuristic landscapes or miraculous plants and animals. For instance, André Masson populated his *Caribbean Landscape* (Fig. 11–27) with skeletons of as yet undiscovered vertebrates.

Other invented images are such baffling composites that they defy strict subject matter classification. For example, *Bio Chemica C* (Fig. 11–28), by Renart, synthesizes plant, animal, and human associations. Its overall form suggests a cushion plant (complete with thorns) or the fleshy pads on the underside of a dog's paws. The mass of bristles is reminiscent of a hedgehog's coat, and the center hints at parts of the human anatomy. Altogether, this organic mongrel both attracts with its erotic overtones and repulses with its unpleasant surface

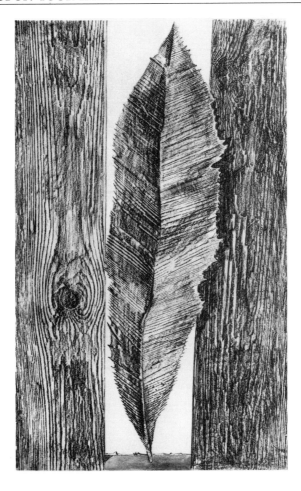

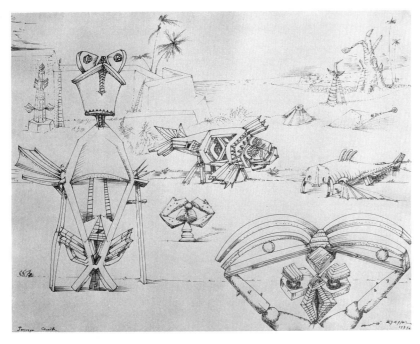

and mysterious origins; and these conflicting qualities are heightened by the actual size of the drawing, which measures approximately nine square feet.

Yet another type of invented image makes visually explicit those natural forces and dimensions that are otherwise invisible. Todd Siler's drawing (Fig. 11–29), for instance, may be understood as a metaphor for the unobservable

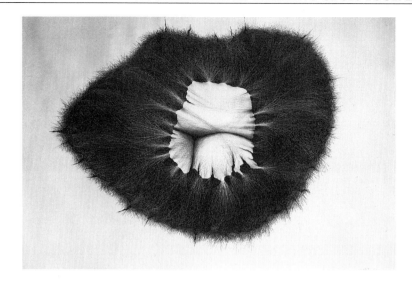

FIGURE 11–28
EMILIO J. RENART
Bio Chemica C, 1966
Brush, pen and ink, 30 × 40⅛″
The Museum of Modern Art, New York. Inter-American Fund

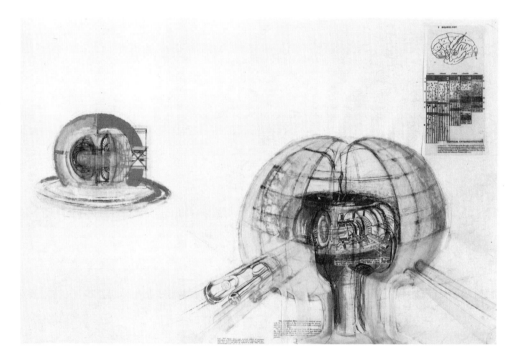

FIGURE 11–29
TODD SILER
Cerebreactor Drawing: Tokamak, 1980
Mixed media and acetate on rice
paper, 24 × 35″
Courtesy, Ronald Feldman Fine Arts. Photo: eeva inkeri

processes of the mind. It combines visual and verbal excerpts from a real neurological text with diagrams of an apparatus apparently designed to initiate a chain reaction within the cerebral cortex and release enormous amounts of energy in the form of human thought. And finally, Robert Smithson visualized a fantastic landscape (Fig. 11–30) to illustrate the effects of entropy, or the measure of disorder and randomness in the universe.

Exercise 11A *Visualized-image drawing should be practiced frequently as a complement to drawing from observed phenomena. Drawing from your imagination sharpens your ability to conceptualize and heightens your powers to express yourself pictorially.*

Drawing 1. Choose as your subject a couple of utensils of some sort. In your drawing, animate those objects while at the same time providing some kind of spatial environment for them. The example in Figure 11–31 is of particular interest for its dual spatial system. While the graters slide in and out of the format parallel to the picture plane, the eggbeaters plow every which way through a three-dimensional matrix of marks. Notice how the foreshortening of the eggbeaters activates the space and makes for an unsettling image.

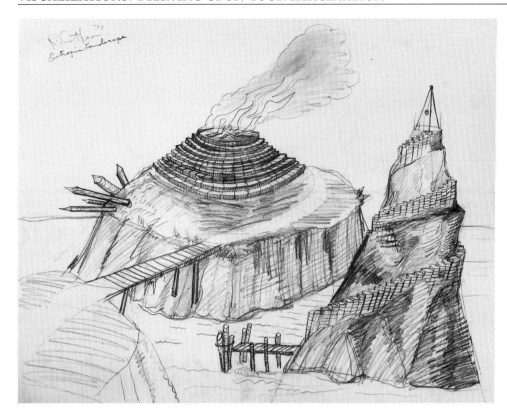

FIGURE 11–30
ROBERT SMITHSON
Entropic Landscape, 1970
Pencil on paper, 19 × 24"
Estate of Robert Smithson. Courtesy, John Weber Gallery, New York. Photo: Rabin

FIGURE 11–31
JEN PAGNINI, Arizona State University
Student drawing: egg beaters and graters in a matrix of marks
Graphite, eraser, 18 × 24"
Courtesy, the artist

Drawing 2. *Again you will be placing moving forms in some type of environment (imagine a medium such as algae-filled pond water, or misty air, or plasma). Invent a biomorphic form that you think could inhabit the environment you have provided for it. Draw that life form, making sure that its movement is directed through three-dimensional space, as in Figure 11–32.*

FIGURE 11–32
CHRISTOPHER ARNESON, University
of Wisconsin at Whitewater
Student drawing: biomorphic forms
in spatial medium
Courtesy, the artist

Exercise 11B *The projects that follow urge you to express subjective responses by transforming subject matter of your choice.*

Drawing 1. *The goal here is to transform the appearance of your subject, stopping short of a metamorphic change. To do this you can choose to improvise on its form and structure (Figs. 11–11 and 11–24), to transfer onto its surface an inappropriate texture (Figs. 11–26 and 11–33), or to recompose it using an accumulation of other objects.*

Drawing 2. *Choose an ordinary object that, by virtue of some visual characteristic, suggests another, otherwise unrelated object. In a set of drawings, clearly describe the metamorphosis of the first object into the second (Fig. 11–34).*

FIGURE 11–33
KEN RILEY, University of Arizona
Student drawing: transformation of
lobster by using altered texture
Courtesy, the artist

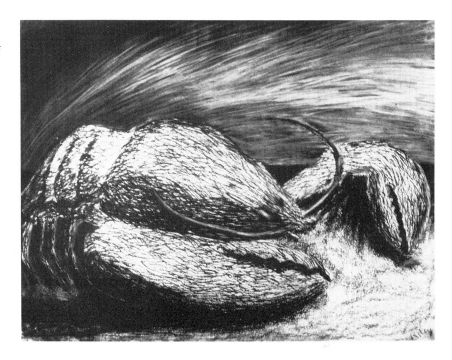

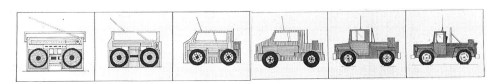

FIGURE 11–34
PAUL PITTMAN, University of
Missouri at Kansas City
Student drawing: metamorphosis of
a radio into a jeep
Courtesy, Leonard Koenig

Drawing 3. *Make an envisioned image by combining collaged material with drawn images to produce a unified work. To free yourself from old habits and expectations, you might wish to incorporate nontraditional materials, as in Figure 11–35, in which sheet rock was used as a drawing surface.*

Exercise 11C

Drawing 4. *Draw more-complex environments, with or without figures. The images for these drawings may be ones you have seen in your dreams, ones that come as a result of reflecting on a passage in a novel or a poem, or even images that pop into your head while listening to music.*

It may help to rely on drawing devices with which you are already familiar, such as linear perspective (Fig. 11–36) or cross contour (Fig. 11–37).

Exercise 11D

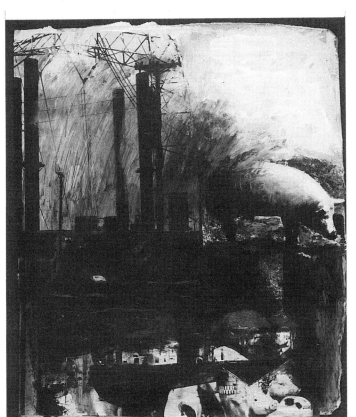

FIGURE 11–35
CHRISTINE KARKOW, University of
Montana
Student drawing: envisioned image
using collaged material on sheet
rock
15 × 20″
Courtesy, the artist

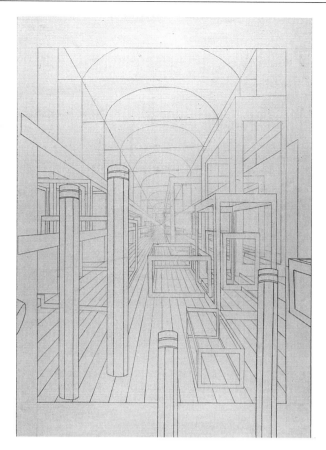

FIGURE 11–36
SHAN EILLS, Clarion College
Student drawing: imagined
architectural interior
Graphite, 24 × 18″
Courtesy, the artist

FIGURE 11–37
CHRISTOPHER ARNESON, University
of Wisconsin at Whitewater
Student drawing: envisioned image
using cross contour
Courtesy, the artist

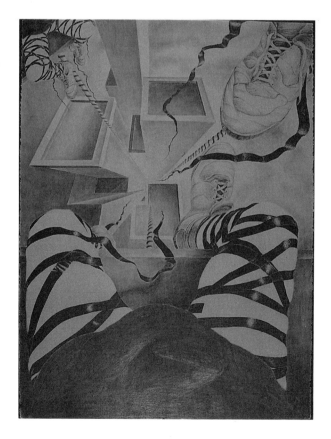

Portfolio of Student Drawings

This chapter is devoted entirely to student drawings. The drawings were selected from sixteen university art departments and art schools around the United States and represent the efforts of foundation drawing students in very large as well as very small programs from each geographic section of the country. Some of the drawings were made in response to specific assignments; others were created in the context of open or "free" projects, when students were left to their own devices. In every case, however, students put their grasp of visual fundamentals to work for expressive ends.

Each of these drawings represents a sustained effort in which the student artist grappled with challenging issues of form and content. The principal goal of this chapter is to inspire you to synthesize the space, form, and expressive information contained in previous chapters to create challenging and complete drawings of your own. With the work of some of your peers as a guide, it is our hope that you will gain a clearer and perhaps refreshed perspective on what you can aspire to, even at an early stage in your artistic career.

To structure our discussion, we have organized the drawings into five categories: self-portrait, visualized and narrative imagery, the figure, still life, and abstract and nonobjective imagery. Admittedly, our arrangement is to some extent arbitrary, since many of the drawings could be addressed under more than one category.

Self-Portrait

The self-portrait offers a ready subject for artistic exploration. An artist can use the self-portrait as a vehicle for formal concerns, as in Figure 12–1. Here the image has been divided into three parts, each handled in a distinctly different way. Despite its explicit divisions, however, the image retains legibility as a continuous figure. This is due to the lucidity with which each part is drawn and also to the choice of an essentially unforeshortened viewpoint, enabling the viewer to grasp the figurative gestalt even while being jarred by the abrupt stylistic changes. The relationships of strong visual opposites also make this drawing conceptually provocative. For example, we might interpret the contrasting images as an expression of how difficult it is to forge a whole identity

FIGURE 12–1
ROBERT H. PRANGER
Three Part Self Portrait
Colored pencil, marker ink on
paperboard, 60 × 24″
*Courtesy, the artist. Instructor: John P. Gee, Ball
State University*

in a media-driven culture that regularly seeks to redefine who we are. In league with that thought, does the emphasis on surface in this work depersonalize the figure?

In addition to objectively recording the outward appearance of our image, self-portraiture can also look inward, as if we are holding up a mirror to an aspect of our personality or a chapter out of our private history. To effect this, it is not necessary to work in an expressionist style or to distort the image (although some artists use distortion to achieve remarkably expressive self-portraits—see the Samaras and Littler self-portraits, Figs. 11–11 and 11–24). Self-portraits with subjective content can be accomplished, for example, by representing a specific facial expression or bodily gesture, by placing the self-portrait among images that connote a personally symbolic narrative, or by manipulating the composition to convey the message.

All three strategies are used to good effect in Figure 12–2. In this poignant self-portrait, a homesick art student from Russia lays bare his spiritual yearnings by portraying himself with an abstracted look and a closed posture, profiled against a train window that is the ground for projected memories of his homeland. The geometry of the composition maps out the narrative of his recollections and reveals a penchant for order that is echoed in his well-groomed appearance. Spatially, the partial image of a passenger in the foreground acts as a buffer, or steppingstone, connecting spectator space and pictorial space. Sandwiching the figure between the crunch of fellow travelers and the unresponsive, hard surfaces of the train makes the private moment of this self-portrait that much more touching.

The content of Figure 12–3 is similarly introspective. In this drawing which took fifty hours to complete, the picture plane has been treated to look like a makeshift construction of thin panels; one of the panels has been slid side-

FIGURE 12–2
DENIS NAKHTSEN
Crosstime Train to Brooklyn
4′ × 5′
Courtesy, the artist. Instructor: William Sayler, Pratt Institute

FIGURE 12–3
PAUL LILE
Conserve Your Soul, 1991
Pastel, charcoal, prisma color,
conté, graphite on paper,
42½ × 29¾″
Courtesy, the artist. Instructor: Dale Leys, Murray State University

ways, or removed entirely, to reveal the artist as a young man in front of the interior space of a closet-sized bathroom. The exterior face of the picture plane looks to be dirty, peeling, mildewed, and rusty—grim reminders of the student's physical surroundings (the drawing was done in his dorm room!). This surface is also busy with symbols of his concern for conservation, both natural and personal. For example, the light bulb and toothbrush speak to, respectively, a loss of energy (turn the lights off when leaving a room) and a waste of water (turn the faucet off when brushing). But the most compelling image related to the depletion of natural resources is the sink turned upside down with water running into a garbage can. On a personal level, the doorknob is a caution to the artist to choose wisely among lifestyle and career "doors" that may open, to prevent loss of focus and positive energy. (Formally, note the number of doorlike rectangles that repeat the picture format, beginning on the actual two-dimensional picture plane and stepping-down into the illusory mirrored reflections.)

Another view of everyday life is found in Figure 12–4, which incorporates a self-portrait into a still life. In this drawing, it is the deadpan humor that tells us a lot about the artist–subject. Initially, it is a surprise to see this massive head, seemingly toppled like a statue, plunked down front and center among the other household objects. The expression of mock resignation on the face, however, suggests a depth of personality, quickly dispelling any notion that this is a lifeless monument. The scale of the head, its sculptural modeling to achieve the illusion of great bulk, and its audacious placement, creating an obstacle we are forced to negotiate to enter more fully the pictorial space of the drawing, all contribute to the incongruity of the image and, hence, give us added insight into the droll intent of the artist. (Is this the image of someone who has fallen over from overeating and not quite passed out; or has he feigned collapse over the drudgery of domestic chores? Do you interpret the content as good-natured parody, or does the meaning of the work seem more serious to you?)

The artists in Figures 12–5 and 12–6 have represented themselves acting out symbolic gestures. The expressive intent behind Figure 12–5 is to ask the question, Where am I going in life? The motivation to ask this question in visual

FIGURE 12–4
Neal Conley
Still Life with Self-Portrait
Charcoal, conté, 19 × 24"
*Courtesy, the artist. Instructor: Robert Stolzer,
University of Wisconsin at Stevens Point*

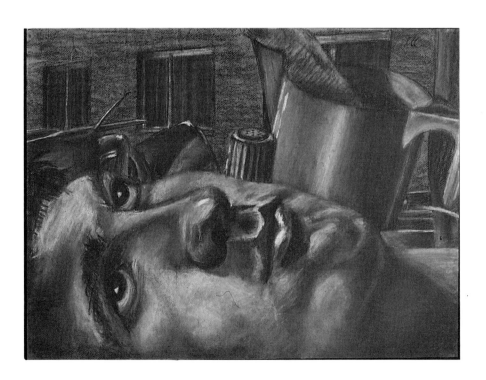

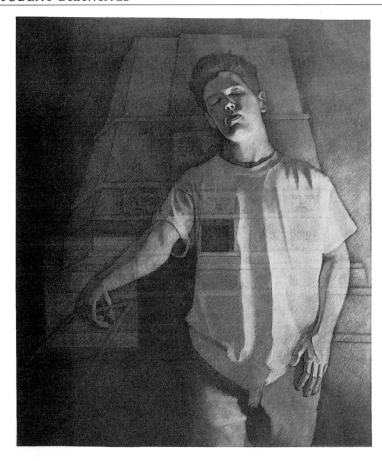

FIGURE 12–5
CHRISTOPHER RIELLY
Sleepwalker
4′ × 5′
*Courtesy, the artist. Instructor: William Sayler,
Pratt Institute*

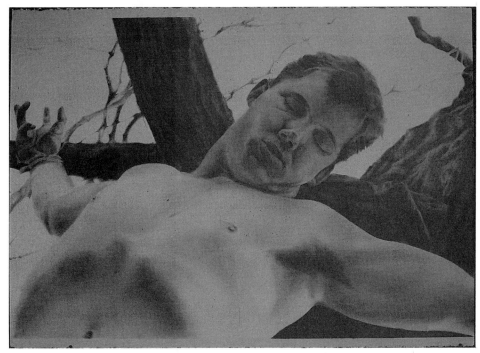

FIGURE 12–6
CHRISTOPHER ARNESON
Phototransfer Self-Portrait
Charcoal, 22 × 30″
*Courtesy, the artist. Instructor: Susan Messer,
University of Wisconsin at Whitewater*

form was the heightened self-awareness, the anxiety and confusion, often felt by art students as their artistic and psychic lives develop simultaneously. The particular image in this drawing was inspired by the sight of a blind woman being led by her guide dog through a maze of underground subway cars and tunnels. Impressed that the blind woman could ''see'' a direction in her life

better than he could in his, the artist composed this riveting image of himself as sightless and vulnerable, moving uncertainly away from a zigguratlike structure that represents his soul and his purpose, as if he were metaphorically blinded by self-doubt, false starts, and misdirected energies.

The self-portrait illustrated in Figure 12–6 was created using a phototransfer process. First, the student constructed a set that expressed something about his personality, taking into account the lighting, props, and the placement and appearance of the human form (he actually rigged himself in a tree). The set was photographed and the prints manipulated through cutting and pasting, cropping, and the addition of appropriated elements. The contrived image was then drawn to scale in a larger format through a grid transfer. The final result is a graphic tour de force that dramatically portrays the artist exorcising demons through the symbolic enactment of a personal crucifixion. Note how the horizontal axis gives the drawing an appropriately cinemascopic reach; the viewpoint hurtles us into the image, up and across the expansive thorax, after which we are swept by the strong cross-rhythms that communicate an undercurrent of violent emotional impact.

Visualized and Narrative Imagery

Visualized images are an important outlet for personal content. Like other students, you may be exhilarated by the opportunity to use what you have learned from studying objective reality to chronicle flights of your imagination or to concoct imagery that comments meaningfully on the world as you understand it.

The visualized image takes many forms, from unlocked memories and dreams to altered and invented realities.* In Figure 12–7, for example, a pencil is transformed into a lighthouse. This charming work was inspired by films that weave complex interrelationships between fantasy and reality (such as *Brazil* and *Time Bandits*). Part of its appeal is simply the freshness of the image (is this a visual pun on the graphic arts as a beacon?) and the witty way in which it "rides the fence" conceptually between a still life and a landscape. It is also visually seductive. The economic use of value, consistently organized into clear-cut shapes, enhances the drawing's content and gives the image a disarming immediacy. High contrast and warm, velvety blacks make the central figure stand out against the cooler and subtler gradations of the ground. The diminutive, flat line renderings at the bottom, captivating in their childlike bluntness, set off the voluptuousness and gigantic scale of the lighthouse–pencil.

In Figure 12–8, the riveting mystery and physical presence of the image is the direct outcome of an intense involvement with materials. We are keenly aware of the active, tactile surface of this work; its layers of collaged print media overlaid with smudges of charcoal produce an indistinct series of forms that suggest primeval flora and fauna. The threatening gestures of these forms together with the close, dark values that seem to pollute the drawing's limited space create a forbidding environment for the image of a doll-like infant to occupy. The poetic union of media and image reaches a climax in the area dominated by the doll's head. Here, the scarred texture (from charcoal applied where collage material has been peeled off) charges the surface, and its raw energy resonates with the lost, almost despairing, expression on the doll's face.

A playful attitude abounds in Figure 12–9, which is an altogether affectionate souvenir of childhood spliced together into an overall visual field. The range of childhood imagery invests this drawing with mythic overtones: the

*For a detailed discussion of visualized imagery, sources, and processes, see Chapter 11.

FIGURE 12–7
Mark Bemen Darter
1992
Instructor: Anne Hoff, University of Arizona

FIGURE 12–8
Amy O'Neill
Doll drawing
Collage, charcoal, colored pencil,
2′ × 4′
Courtesy, the artist. Instructor: William Sayler, Pratt Institute

FIGURE 12–9
JENNIFER LANGSTON
Dreams and Memories
36 × 48"
Courtesy, the artist. Instructor: Bill Lundberg, University of Texas at Austin

innocent stick figure and cartoon-drawing styles, along with depictions of common juvenile paraphernalia from kids' toys (jacks, Tinkertoys, Mr. Potato Head) to a coke bottle, tricycle, and dresser drawers, suggest a slice of the collective memory of modern youth. The variety of gestural and scribbled marks energizes this complex drawing and is in keeping with the merriment of its implied theme. Also, you cannot miss the large jack in the lower right, which, with its striking change of scale and almost three-dimensional effect (in contrast to the otherwise flat space of the image), is the single most powerful unifying element in the drawing.

Figure 12–10 is a good example of the complementary relationship that

FIGURE 12–10
ALYCE KUKINSKI
Two figures with framing text about battered women
Courtesy, the artist. Instructor: Sara Nott, University of Arizona

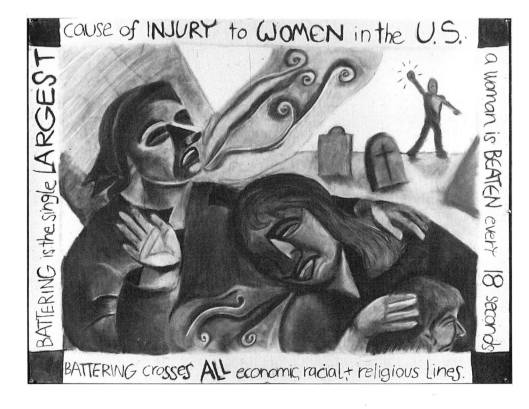

can occur between word and image. There is a strong contrast in this drawing between the expressionist style of the image and the statistical information that appears, like ticker tape, along its margins. These subjective–objective dimensions operate like alternating current, supplying visual information to provoke the viewer's emotions and written information to provoke his or her thinking. Note that the crudely drawn figures, reminiscent of roughhewn, carved folk icons, convey the urgent content of this work more persuasively than a carefully observed rendering would have.

Figures 12–11 and 12–12 continue the theme of social politics found in Figure 12–10. Figure 12–11 speaks of the artist's interest in the plight of Native Americans. The work's title is in response to an observation by Oliver Wendell Holmes, Sr., in 1855, that American Indians were a "half-filled outline of humanity," a "sketch in red crayons of a rudimental manhood."* Struggle and oppression are persuasively expressed by the visual narrative of the drawing. The forms on the left side of the image swirl and writhe with compressed, intense energy suggesting organic tissue under great tension. Pointed is the statement about forced religious conversion, as symbolized by the large diagonal cross that appears to be crushing the Native American figure represented in the lower left-hand corner.

Figure 12–12, a transformative family portrait, explores the private domain of interpersonal politics. Here the imagery expresses the hostility the artist felt toward unsavory relatives who overran the home of his adoptive parents. The grotesque, invented characters come off as either buffoons or mean-spirited humanoids; the slapstick style in which these sinewy bodies are huddled precariously atop an absurdly small vehicle makes them objects of ridicule. The beautifully drawn surfaces and well-defined abstract composition (note the way in which the steering wheel is echoed in the conglomerate of limbs just behind it) may seem to advance content that is contradictory to the harsh emotional

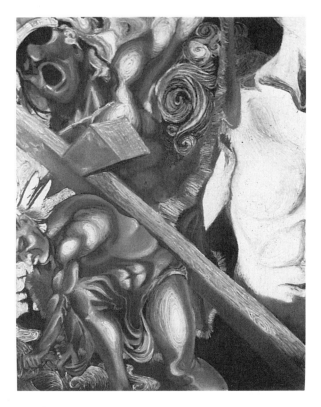

FIGURE 12–11
MICHAEL BREIDENBACH
*A Sketch in Red Crayon of a
Rudimental Manhood,* 1991
Pastel on paper, 28½ × 22½"
*Courtesy, the artist. Instructor: Dale Leys, Murray
State University*

*As quoted in Thomas F. Gossett, *Race: The History of an Idea in America* (New York: Schocken Books, 1963), p. 243.

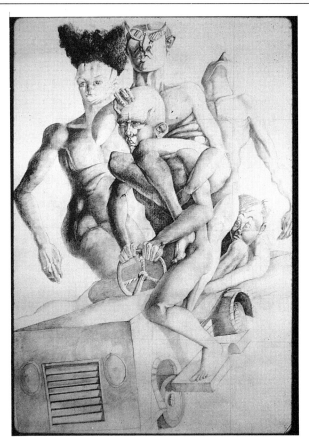

FIGURE 12–12
JAMES CONNORS
Family Tree, 1985
Charcoal and pencil
*Courtesy, the artist. Instructor: Constance McClure,
Art Academy of Cincinnati*

tone of the figures. Paradoxically, though, this quality of visual elegance serves to heighten the drawing's underlying current of fear.

The Figure

As a subject for drawing, the human figure is a rich source of information about structurally complex living forms in nature. Moreover, since the human image stirs mind/body impulses deep within us, it can also be a ground for constructing a wealth of psychological meaning. Expressive approaches to the figure range along a continuum from the more objective recording that is sensitive to outer signs of character (Fig. 12–13) to a more subjective interpretation of inner states of being (Fig. 12–17). Approaches to integrating the figure into a full-page drawing conception also vary widely: empathic responses to the figure can set the formal and emotional tone for the entire field of the drawing, or conversely, visual responses to the field may dictate the development of form-meanings in the figure. Keep in mind, however, that clear, strong, humanistic content in a drawing is a *visual* statement. Consequently, regardless of style, it is the abstract form of a drawing (the information chosen from a subject and the way it is handled and organized) that is paramount in carrying the full force of personal expression.

In Figure 12–13, a man's head is depicted as if turning away from a brilliant light source. (Light-gray gestural marks at points along the head's outer contour create the sensation of air currents still settling from the disturbance.) This is a particularly human gesture that lends the image the immediacy of everyday reality. The head is convincingly drawn—proportion, structure, and the illusion of light and shade playing over the volume of the head are all rendered adeptly. Equally important, however, is the effective manner in which the artist has *characterized* the subject by emphasizing the rugged, bony armature of the head,

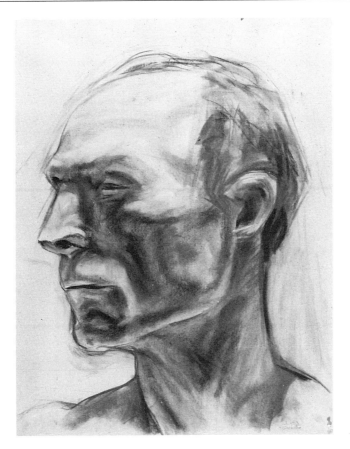

FIGURE 12–13
JOHN GONZALEZ
Head
Newsprint, 36 × 24"
*Courtesy, the artist. Instructor: Richard Thompson,
University of Texas at Austin*

its slicing jaw line, pursed lips, slitlike eyes, and large crown. Combined, these features persuade us that this is a specific person of a definite age and character type, and they invite us to speculate on the origins of this person's apparently steely disposition and stoic outlook. Our impressions of a strong personality are furthered by the scale of the head within the format and the sculptural strength with which it carves out the drawing's negative shapes.

The expressive strengths of Figure 12–13 are derived from the artist having carefully observed, and selectively emphasized, aspects of the *external* features of the model. By comparison, it is the artist's apparent identification with the *internal*, psychological condition of the figure that distinguishes the content in Figure 12–14.

Form-meaning in this drawing is achieved by representing the model pushed back from the picture plane into a corner space. This promotes a mood of self-absorption in the figure, effectively detaching the viewer from her image. A sense of security is heightened by the pyramidal shape of the figure and chair, and feelings of intimacy are evoked by the various recesses and crawl spaces throughout the image.

The artist capitalized on the cramped gesture of the pose as a symbol for emotional containment by cropping the head as though the ceiling were pressing down on it. (Note how the darkened face, topped by a light forehead that connects with an arching movement across the top margin of the drawing, keeps your eye from running off the page.) The diffuse light, expressed by soft gradations of tone and delicately burnished planes (note the use of the eraser to create white or dark hatchings on most of the surfaces), underscores the drowsy, sluggish air of the drawing.

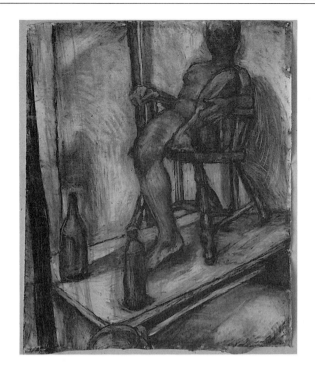

FIGURE 12–14
Sandy Lipsman
Seated Woman
Charcoal on paper, 5′ × 6′
Courtesy, the artist. Instructor: Graham Nickson,
The New York Studio School of Drawing, Painting,
and Sculpture

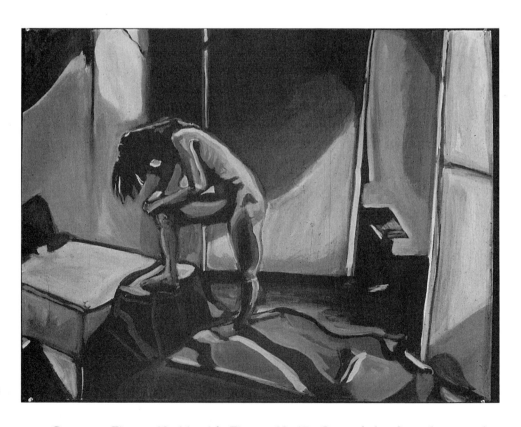

FIGURE 12–15
Karen Kurt
Figure in Interior, 1984
Acrylic on paper, 18 × 24″
Courtesy, the artist. Instructor: Jim Sajovic, Kansas
City Art Institute

Compare Figure 12–14 with Figure 12–15. One of the first clues to the difference between the two drawings is the relationship of the figure to its surroundings. In Figure 12–14, the two bottles are charged with a talismanlike significance because of their association with the figure. If you take the figure out of this drawing, the emotional power of the entire work disappears. The human figure is again the psychological climax in Figure 12–15, but since the artist's mood and vision pervade this drawing as a whole, remove the figure and the emotional personality of the drawing remains relatively intact.

In reference to the compositional form of Figure 12–15, note first that the perspectival organization of the space is based on an elongated triangle (the major axis of which runs diagonally from the lower right-hand corner to the middle of the left-hand margin), and second, how the figure has been scaled and stepped into that space. The figure also acts as a hub for the curvilinear shapes of light and shadow that radiate out into the interior space of the image. It is the treatment of these lights and darks that gives this drawing its tense psychological edge. The Edvard Munch–like anxiety in the drawing is created by the dissonance of the value changes arranged into an unrelieved pattern that threatens to engulf the figure. Perhaps most macabre are the series of silhouetted white, gray, and black shapes circling the elbow of the figure, which, taken together, construct an image that is eerily reminiscent of a jack-o'-lantern.

Figures 12–16 and 12–17 serve up particularly strong differences in content. In Figure 12–16, the figures do not possess the subjective weight found in the three previous drawings. Instead, the artist, like a good novelist or film director, has set the scene so that we feel the *anticipation* of human contact. Interestingly, the furniture in the foreground harbors more figurative connotations than the figures themselves. Both the table and chair exude a particular vintage and character born of human use, and their slightly divergent angles animate them. Together they create a strong sense of place. (Look at the genre touches supplied by the artist, such as the bottles sitting on a shelf, their shine dulled through years of use.)

The diagonal axes of the table and chair also establish a gently rocking rhythm that guides our eye as if we were tacking into the illusory space of the drawing. Treated more as common objects, the figures have meaning on several formal levels. Clearly, they function as specific points in the space and as part of a network of incidents that construct a design motif on the surface. As tonal opposites, they act as gauges for the light, shade, and atmosphere in the drawing (the darker of the two dissolves somewhat in the heavy shadows and dusty air).

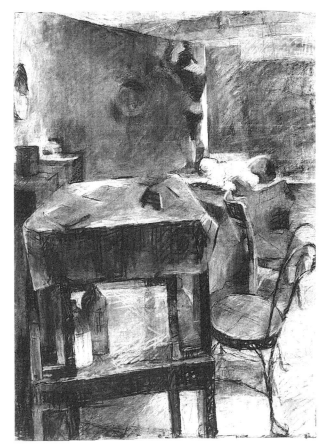

FIGURE 12–16
MILA LIBMAN
Figure with Table
Charcoal on paper, 51 × 72"

Courtesy, the artist. Instructor: Graham Nickson, The New York Studio School of Drawing, Painting, and Sculpture

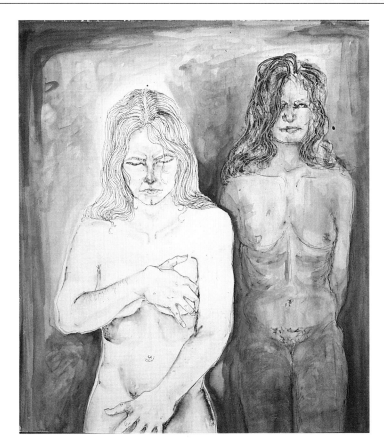

FIGURE 12–17
KATHERINE STINCHCOMB
Untitled, 1993
Watercolor, ink, pastel on paper,
27 × 23″
*Courtesy, the artist. Instructor: Dale Leys, Murray
State University*

Principally, however, the figures represent the most decisive (and truest) horizontal and vertical of the image, and their formation as a right angle is both a signpost and a structural pivot for the drawing's underlying geometry.

In Figure 12–16, human presence is subordinated to the time-honored theme of the artist's studio, which may be considered more a subgenre of the interior than of figurative work. In Figure 12–17, the reverse is true. Here the two figures constitute the total image and are so close to the picture plane and so spatially confined as to implicate the viewer both emotionally and intellectually. Moreover, they appear to be self-consciously engrossed in an utterly private, psychodramatic ritual that is uncomfortable to watch.

Both figures have an allegorical presence, expressed through body language and daring formal contrasts. With a sullen look on her face and hands covering her nakedness, the white figure is meant to symbolize shame and insecurity caused by feelings of unworthiness. We may associate the whiteness of this figure with disembodiment, and therefore with an emphasis on spiritual turmoil. However, this relative absence of value is in such stark tonal opposition to the ground that the figure is pushed painfully forward as a corporeal entity, exposing it, as it were, to the harsh light of scrutiny.

The emotional awkwardness and uncertainty of this figure is accentuated by its indeterminate spatial position. Angled slightly off the parallel of the picture plane, and looking flat and cut-out, especially along the outer contour of the body, the white figure gives the impression of occupying a space that exists ambiguously between the surface of the drawing and spectator space. In contrast, the figure in the background represents a self-confident inner state of being that the white figure longs to cultivate. Depicted parallel to the picture plane and firmly within a shadowed pocket of the drawing's pictorial space, the formal attitude of this figure is in keeping with its emotional tenor.

Still Life

The still-life artist is perhaps the prime alchemist in the visual arts. Since the still life traditionally makes use of inanimate objects as its subject matter, turning lifeless props into striking imagery poses a distinct challenge.

Artists who take up the challenge often find that a rewarding paradox awaits them: the very fact that still-life objects are usually clichéd and taken for granted makes them an ideal subject for artistic manipulation. (Interiors and landscapes offer a similar freedom except that, in most instances, still-life objects are more handy to draw.) So once you get over the hurdle of realizing that the excitement of drawing is not found in *what* you draw but in *how* you draw it, you may find that the relative ordinariness of still life gives you enormous flexibility to transform appearances, improvise compositionally, and breathe meaningful content into your work.

In Figure 12–18, still-life subject matter serves as a vehicle for the artist to explore the drawing process itself as a basis for personal expression. Here, line is the dominant element. Registering a rich dynamic of touch, the tracery of gestures accompanied by a variety of marks and smudges establish the drawing's expressive identity. Note, for example, that shifts in line weight, focus, and value in this drawing can be equated with different visual energies. For example, many of the charcoal lines and marks used to depict the surfaces have been slowed and thickened by blurring them with an eraser, and more-nervous gestures are seen in the erased flicks that break free of the glutinous atmosphere.

Surface structure in this work is based loosely on a grid, which plots the coordinates of a limited space. This geometric framework creates a tension between the still-life objects that appear to be receding diagonally into space and the flattened intersections of that space along which the objects have been deployed. Correspondingly, note how the front and back edges of the tabletop have been asserted. The front edge recedes only briefly before the whole plane lifts toward the picture surface in the manner of a Cézanne still life. (Note as well the strong diagonal that goes up more than it goes back.)

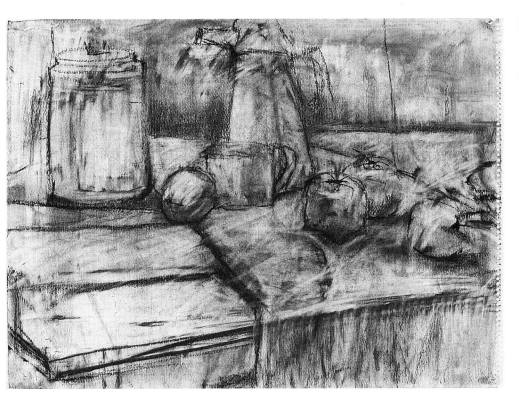

FIGURE 12–18
ANDREAS EFSTATHIOU
Still Life
Charcoal on paper, 24 × 18"
Courtesy, the artist. Instructor: Charles Cajori, The New York Studio School of Drawing, Painting, and Sculpture

The still-life objects have a sense of volume by virtue of chiaroscuro modeling, but because their contours stress edge over roundness, these forms have little weight. Moreover, due to the fact that the erased and tonal passages of the drawing constitute a separate spatial system superimposed over the localized boundaries of individual forms, the still-life objects have been drained of physical substance. (Note how the pieces of fruit on the right are nearly dissolved by the violent slashes of the eraser.)

The converse is true in Figure 12–19, in which the still-life objects have been depicted to express a forceful material presence. This diptych is based on two views of a "sculpture" constructed from objects and trash found in garbage dumpsters and on the ground. By cropping the images, the artist has made the forms appear monumental, increasing our sense of their mass and tactility.

Heightening the authority of this drawing is the daring manner in which the artist has exploited the diptych format. By coupling images with opposing visual characteristics, the artist created an immediacy of impact but ran the risk of having the composition split in two. Summarizing the imagistic differences, left to right, of the work, we find that the left side is made of close, middle-range tonalities that induce feelings of calm; the high contrast on the right builds tension. The temperature on the left is cool, reminiscent of a shadowed interior space; the right side emits heat, appearing to be in an exterior, sunlit space. The left side is a patterned field drawing; on the right, the velvety black form has an explicit figurative bearing.

Given the exaggerated contrasts in the drawing as a whole, note the formal discoveries the artist made to unify the images. Most conspicuous is the X in the middle, composed of a curve of rope bridging the two halves of the drawing, which is itself crisscrossed by two spatially staggered white shapes that move on a diagonal from upper right to lower left. The spatial action of this figure X effectively camouflages the physical edge of the separate sheets and splices the pictorial illusion of the two images. Also contributing to unity in this drawing are the directional motive of the rope as it weaves throughout the images and the repetition of textures, including the horsetail shapes with their coarse, fibrous surfaces.

If Figure 12–19 convincingly *depicts* sensations of materiality, Figure 12–20 uses the *actual physicality* of its media as a metaphor for material things in the world. Indeed, the spontaneous power of this drawing in large part rests on the sensual, almost palpable application of its media, organized into a startling economy of image.

FIGURE 12–19
RANDALL HAMM
Dumpster Dive Diptych
Charcoal, 24 × 36"
Courtesy, the artist. Instructor: Allyson Comstock, Auburn University

FIGURE 12–20
CARLA GALUPPO
Lamp Still Life
Charcoal, 22 × 30″
*Courtesy, the artist. Instructor: Jane Burgunder,
Middle Tennessee State University*

This drawing may seem deceptively simple, and yet, after its initial impact has subsided, subtler visual tensions can be discerned. For example, the interplay between positive and negative areas is a key design factor because it integrates figure and ground into a totality of image that is scaled completely to the drawing's format. Furthermore, the weight and forward-moving pressure of the ground create the impression of having sandwiched the still-life objects against the picture plane, decisively flattening them like flowers pressed between the pages of a book. (Note the way the lower portion of the neck of the lamp looks as though it has been scored and then splayed against the drawing's surface.)

The objects themselves are quasi abstract, yet personally, even eccentrically, conceived. Minimal definition and rough texture give these skeletal forms a crude, commanding presence; a more "beautiful" rendering would not have held parity against the aggressive ground. And given the stark simplicity of the image, the design feature that borders on the poetic is the delightful rhyming of the lampshade and the flowerpot.

In Figure 12–21, we see full-blown the ability of still life to mimic other genres of subject matter. This large-scale, collaborative, time-based (five-day) drawing carries figurative and landscape connotations.*

Here the unusually elongated format first attracts attention and also invites different spatial interpretations. On the one hand, if we understand the picture plane to be a transparent window opening onto a space, it is inevitable that the image would be seen as a limited slice of a much larger landscape space continuum. On the other hand, we can read the picture plane itself as a still-life object, as if we were seeing one side of a container, like a produce crate, that is filled nearly to capacity.

Despite the landscape implications of the image, the vertical axis of the format recalls the upright condition of a human being. The artists acknowledged and capitalized on this association by depicting a length of pipe leading to a faucet that dominates the image much as a figure would. In this way, the figurative connotation inherent in the format itself has been expanded through the choice and treatment of subject matter, with the result that meaning in the work as a whole has been more fully integrated and deepened.

*For a related discussion, see that of Figure 12–7.

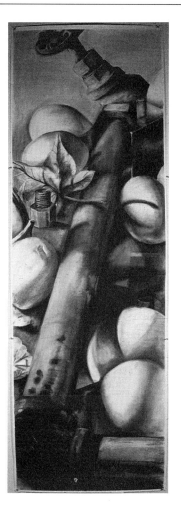

FIGURE 12–21
CHRISTOPHER LUCAS and
CHRISTOPHER ROSS
Vertical Still-Life, 1992
Charcoal, 3' × 12'
*Courtesy, the artist. Instructor: Anne Lindberg,
Kansas City Art Institute*

Expanding on the figurative implications of the pipe, note how the point of view shifts when you look from one end of it to the other. At the bottom of the drawing, the pipe is seen from a bird's-eye view; at the top it is seen from a less extreme viewpoint. This tactic causes the pipe to appear to be rising from a prostrate position, apparently endowing this inanimate object with the capability of gesture.

Considered in the context of the provocative forms that surround it, the image of the pipe alludes to an open-ended content, as if it were pointing to several, perhaps related, meanings at once. For instance, the opposition of the organic, egg-shaped forms and the inorganic pipe may speak of male–female duality or, correspondingly, the regenerative powers of nature (the pipe as a conduit for life-restoring fluids?). From another, but similar, standpoint, does the elevation of the faucet end of the pipe, with the round forms seemingly attendant, suggest the theme of ascension in a religious narrative?

The still lifes in Figures 12–22 and 12–23 mix keen observation with distinct conceptual characteristics. For the "minutiae" project reproduced in Figure 12–22, the student was given an envelope that contained a heterogeneous group of small objects and a page of guidelines, which included the directive to "make a still life by spreading out the items in the envelope on any surface that you please." In an inspired move, the student chose to incorporate the torn envelope and sheet of instructions into the still life, using them as the ground for the miscellany of tiny objects. By making a drawing that explicitly refers back to the set of ideas that generated it, the artist closed the conceptual loop of the drawing and in so doing poised himself as a strategist playing a mind game with the viewer.

In Figure 12–23, multiple realities have been melded together to create an

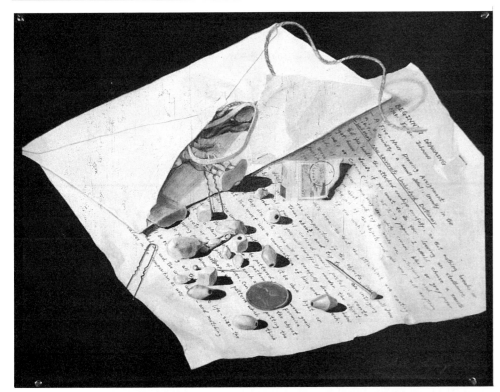

FIGURE 12–22
CHI-HSING LAI
Minutiae Project, 1991
*Courtesy, the artist. Instructor: Mary Frisbee
Johnson, Indiana State University*

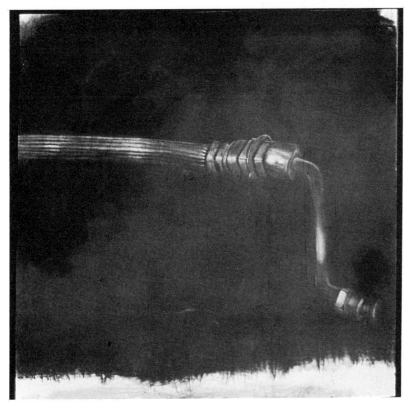

FIGURE 12–23
CHERYL LONG
Machine Part, 1988
Charcoal, 40 × 40″
*Courtesy, the artist. Instructor: Stephen Fleming,
Kansas City Art Institute*

enchanting image while at the same time exposing the artificiality of its visual representation. Put another way, this drawing can be enjoyed as a meticulous rendering of a piece of hardware set majestically against a relatively nondescript ground in the manner of salon portraiture. It can also be interpreted, however, as a particularly pointed expression of a current philosophical concept that a drawing, like any visually encoded sign, is a simulacrum, or imitation, that is distanced from the substance of reality.

The conceptual backbone of the drawing is the set of layered spatial ambiguities. Observe, for example, that the dark ground stops short of filling the format along the lower edge and upper corners. This creates the impression that the entire charcoal field could be peeled from the surface like a skin, thereby underscoring that, despite the convincing illusion of space, the drawing is flat. Furthermore, the two-toned ground suggests a mirrored surface, like a calm body of water reflecting a landscape image (the blurred and feathered common contour between the two value shapes hints at foliage and atmospheric perspective). Consistent with that impression, the piece of hardware could be read as if it were underwater. But with its fugitive appearance and the glints of light along its surface, this mysterious implement seems to refer to yet another spatial dimension.

The alienation of the constituent parts of this image recalls the effect of a photographic double exposure: things from different places having been brought into one visual moment, frustrating attempts to unify the experience. In that regard, the content of this still-life drawing may be said to parallel the so-called postmodern condition that prevails in Western society today, which is characterized more by feelings of disjunction than continuity.

Abstract and Nonobjective Imagery

Working from subject matter, artists may choose to veer from a highly descriptive type of representation to take advantage of the latent abstract qualities of forms and spaces in their drawings.* Keep in mind that an *abstract* style of art still contains recognizable subject matter, regardless of how many steps the image may be removed from a naturalistic portrayal. A few of the ways in which artists achieve abstraction include:

1. juxtaposing repeated views of a subject, eventually combining aspects of them into new forms

2. distorting, fragmenting, or reconfiguring familiar things

3. improvising on the visual properties of a subject to create variations on a theme

4. simplifying and flattening imagery, sometimes also using graphically rich passages of pattern and texture

5. displacing objects from their normal contexts

6. cropping an image so severely that the identity of one or more of the objects is concealed

7. uninhibitedly exploring media to recast the visual character of a subject.

For artists who wish to work *purely* with the visual elements, however, the manipulation of subject matter resemblances, regardless of how far removed from objective appearances, is still too restrictive. These artists will elect to work *nonobjectively* so that they can freely create a pictorial reality that bears no likeness to the visible world. (This is true, of course, only in terms of physical appearances. The forms and spaces constructed by nonobjective artists always invite metaphorical interpretation because no artist can truly get outside nature.)

Artists work abstractly or nonobjectively not only because they desire the

*For more discussion on abstract and nonobjective styles, refer to ''What Is Abstraction Anyway?'' in Chapter 9.

liberty to invent new material realms; they are also attracted by the content potential of these styles. Although both genres are misunderstood and thought by the general public to be meaningless, abstract and nonobjective styles can stimulate artists to express levels of content, from psychic states and metaphysical concepts to poetic and mystical correspondences that, in their immateriality, could not be communicated as effectively, if at all, in more traditional terms.

An example of the process of abstraction can be seen in Figure 12–24, in which the biomorphic inventions resulted from the artist overlapping and synthesizing images of a moving figure. From a formal standpoint, the drawing may at first appear to be a confusion of light and dark shapes, but after a short viewing time the image orders itself into a large ellipse of figurative forms.

It is on this basic elliptical structure that the more complicated spatial issues of the drawing are improvised: the equivocal figure–ground shift between the positive and negative zones of the image, and the darkening of some of the figurative shapes so that they look like afterimages or shadows lying across the positive forms. Both strategies make it difficult to sort out the figure from the field with certainty, which ultimately has the effect of compacting the totality of form in this drawing into a congealed and limited space.

The dramatic visual qualities of this work can elicit strong content associations. Different speeds of motion are communicated through line and repetition of mass. Graceful, attenuated strokes of charcoal, in tandem with smears of tone, express fleet and erratic movements. In contrast, the succession of spotlit, figurative forms is more deliberately paced. Their trudging movement gives them an air of mystery, as if they were a procession of intimidating presences caught in a primeval ritual. The foreboding mood is augmented by the overall impression in the drawing of contorted flesh and by what appear to be dismembered body parts (the clenched hand at the lower right is reminiscent of the figurative distortion in Picasso's *Guernica*).

The pair of abstract images in Figure 12–25 is based on a two-part positive–negative reversal project. The image at the bottom is a blue-line positive of the original drawing, which was executed in pen and ink on acetate. In the blueprint image at the top, the value scheme has been transposed. We discuss here the upper image, since it represents the final resolution of the artist's abstract conception.

The artist used the formal design features of a grid in conjunction

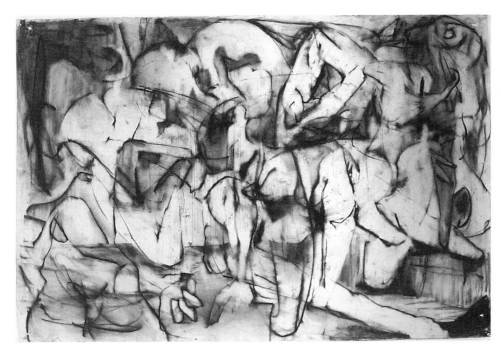

FIGURE 12–24
TIM GIBLIN
Machine Moving Figure
Charcoal on paper, 42 × 63"
*Courtesy, the artist. Instructor: Matthew Radford,
The New York Studio School of Drawing, Painting
and Sculpture*

FIGURE 12–25
NAMIKO KANAMARU
Blueprint Reversal Image, 1991
Courtesy, the artist. Instructor: Mary Frisbee Johnson, Indiana State University

with the blueprint process to good advantage. With an emphasis on precise craft and a flat, optically lush spatial field, this drawing betrays as its source the world of graphic design. (The large central shape, composed of interconnected squares and rectangles and bordered by a pattern of darkish rectangles, resembles a florid, art deco–influenced gift box, ready to be folded.) The images themselves are like codes that must be deciphered, with the two silhouetted Oriental figures acting as thematic keys. Moreover, the assortment of imagery and styles, from the cartooned figures to stylized floral patterns, ideograms, schematic clouds, and even a comparatively naturalistic depiction of bamboo shoots, recalls the mass-culture subjects and eclectic re-representations of Postmodern art.

Compartmentalized design and monochromatic color join forces in Figure 12–25 to assemble dissimilar subject matter elements into a compositional whole. Figures 12–26 and 12–27 are unified conceptually and pictorially through improvisations on a single subject.

The source for the abstract drawing in Figure 12–26 is a bird. Using a fragment of a feather to center the image, the artist responded to the tactile and visual characteristics of her subject by constructing multiple layers of marks and rhythmic complexity. Mark systems in the lower half of the drawing, for example, convey a sense of the lightweight and delicate yet strong property of feathers; and the short, darting rhythms used here can be associated with the aerodynamics of a bird's plumage. These qualities are complemented by the openness of the hatching in this area, which enables the marks to "breathe," suggesting the intermingling of light and atmosphere during flight.

Meaning in this drawing is also generated by the allusiveness of the image. Provoking free associations, the forms in this drawing metamorphose in the mind, from a solitary feather multiplied and woven into a nest to acres of trees or a mountainous topography. Taken as a totality, the artist expanded the drawing's expressive values by inferring, from the microcosm of its subject, visual analogies to a larger natural order. For that reason, this work clearly demonstrates

FIGURE 12–26
MYRTA WOLD
from the *Bird* series
Graphite, conté, eraser, charcoal on
paper, 18 × 24"
*Courtesy, the artist. Instructor: David James,
University of Montana*

FIGURE 12–27
KIM HOLLAND
Motif Variations
Graphite, charcoal, conté, 18 × 24"
*Courtesy, the artist. Instructor: Janice Pittsley,
Arizona State University*

how an abstract image can make metaphorical content leaps in a manner unavailable to more representational modes of art.

Figure 12–27 is a nonobjective drawing with variations based on a motif. The recurrent geometric forms are carefully arranged to control the visual narrative of the work. The border on the left, stenciled repeatedly with the word *art*, appears to be pressed against the picture plane. By restating the vertical framing edge, this border anchors the surface depiction to the format and leads our eye, like a stairway step, into the drawing. Three bricklike shapes, also placed on a strict vertical, continue the path across the surface. The regulated movement, from left to right, is violently disrupted by the two overlapped squares that, tilted on different diagonal axes, torque the drawing's grid-based geometry and set its design energies in motion.

Spatially, the overlapped squares reverse the drawing's left-to-right two-dimensional course; as they arc back to the left, they also create the three-dimensional illusion of lifting up and out toward spectator space, as if they have spun free of the gravitational force of the drawing's ground. In that regard, notice how the darkened, haloed emphases inside each of the bricks enables these forms to act as visually stabilizing counterweights to the unpredictable tensions unleashed by the rotating squares.

The imagery of this drawing connotes a range of potential meanings even though it has no reference point in nature. For example, this drawing may be seen to carry allusions to architecture (dank, underground structures, like basements), to sidewalks (with graffiti and grating), or to cartography (as if the stamped-out shapes represent a road map of landmarks and destinations).

Figure 12–28 is a collaborative drawing based on a nonobjective painting by American artist Willem de Kooning.* The assignment was to improvise a personal statement using an analysis of the construction of a masterwork as the point of departure.

In this drawing, the artists have uncovered the structural framework of the de Kooning painting, translating its scope into a majestic architectural setting that rivals the cavernous building spaces depicted in Piranesi drawings.** What

FIGURE 12–28
COLLABORATION DRAWING
Study after de Kooning
Charcoal and acrylic wash
Courtesy, Don Kimes. Instructor: Don Kimes, American University

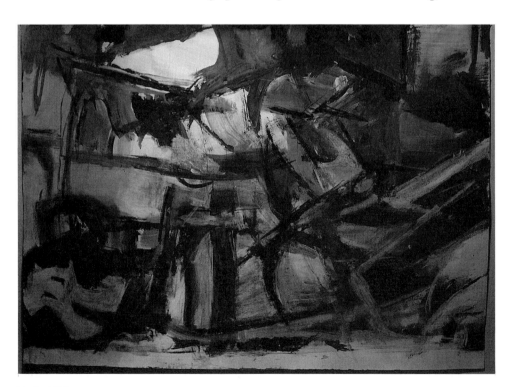

Attic, 1949.
**Piranesi drawings are reproduced in Figures 1–37 and 4–7.

immediately attracts our attention is the formal continuity between the sweeping curvature of the space of this drawing, broadly rendered in the hectic, gestural, "action-painting" style associated with de Kooning, and the manner in which the scaffolding of that space interlocks to compose the two-dimensional surface of the work. The drawing's large-scale and restless movements are reminiscent of the work of the seventeenth-century Flemish, Baroque artist, Peter Paul Rubens, sometimes cited as an influence on de Kooning. Extending the Baroque analogy is the dramatic lighting in this work, generated by the plane of light in the upper left-hand quadrant. This brilliant shape particularizes the image and implies a reference to nature by expressing a time of day, even a time of year. Functioning like an overhead window, this opening seems to allow a shaft of vernal, afternoon sunlight to stream in, bathing forms in its path with a warm glow.

The diptych in Figure 12–29, also a collaborative effort, resulted from a foundations program exchange between the art departments of two state universities. The assignment had four basic steps:

1. Student artists were to create nonobjective symbols that reflect aspects of their individual self-concepts, for example, physical self-image, personality traits, psychological, or emotional characteristics.

2. After developing a symbol, each artist was to join in partnership with another member of the class for the duration of the project.

3. Each team was then to pick one drawing from among the completed images sent by the class at the other university. The selected drawing was to provide the spatial context for both artist's symbols. (More specifically, both members of the team were asked to pinpoint and enlarge a *different* spatial location within the selected drawing and to develop studies incorporating their respective symbols into that illusionistic setting.)

4. The final studies by both partners would then be combined and compositionally orchestrated to form a unified diptych.

In the example we have chosen, the personal symbol in the left half of the drawing is the large, fleshy mass that appears to have been hoisted above deck

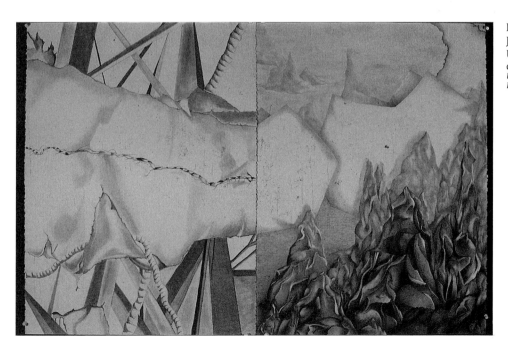

FIGURE 12–29
JOANNA GROH and LAURA REULAND
Untitled collaborative drawing

Courtesy, the artists. Instructor: Susan Messer, University of Wisconsin at Whitewater, Foundation Exchange Project

on a sailing vessel. Meant as a detail of a stingraylike shape, this symbol was closely associated by the artist with her experiences as a lifeguard. Involved in a number of life-saving incidents, the artist created this form to express a heightened awareness of her spine, its articulated and streamlined design, its supportive strength and flexibility, as the body is self-propelled through water. (Note the hairline crack in the form, revealing the vertebrae and nerve center of this creature.) The variety of what look like industrial beams behind the dominant form is a visual metaphor for the support, or "spinal reinforcement," she in turn, received from others.

In contrast to the soft, wrinkled exterior of the form on the left, the personal symbol of teeth in the right half of the drawing possesses hard, smooth surfaces. Translated into quasi-geometric volumes, this series of molars carries important content about the artist's self-concept at the time, since it makes poignant reference to her self-consciousness over wearing orthodontal braces.

Aside from the linear continuity of the symbolic forms (and the way in which they span the entire, combined picture plane to divide the surface into thirds, horizontally), what ties these drawings into a singular image is primarily the use of the triangle as a main motif. Fascinating, however, is the way in which the parts of this drawing do not settle into an easy harmony, since our eyes have to constantly scan the surface to find the strategies that glue it together. In this way, the identities and power of the individual meanings have not been compromised by the achievement of compositional unity.

Portfolio
of Contemporary
Drawings

Contemporary art can best be typified by its relentless search for new forms of expression. To be sure, traditional drawing practices continue to flourish in the midst of the unpredictability of today's art. But the sheer diversity of styles and media in art today, bred by the mixed-media consciousness, has made it virtually impossible to come up with a blanket definition of what constitutes contemporary drawing.

Our purpose in this chapter is to suggest how recent innovations in the visual arts have been reflected in the art and techniques of drawing. To help you grasp some of the current streams in drawing, we have grouped our selection of drawings by subject matter, form, and content concerns. A brief look at the implications of the terms *Modernism* and *Postmodernism* may help to set the stage for further discussion.

Modernism is not a style per se but rather an attitude informed by a distinct awareness of being modern. For practitioners in the arts, this awareness translates into the determination to be avant-garde and to produce work that is original, experimental, and formally innovative. The Modernist artist's claim to be "on the cutting edge" of artistic expression isolates the artist not only from the mainstream of tradition but also from the general public, who simply cannot keep up with the pace of change. Modernist artists tend to express faith in the authenticity of the art object, which they offer up as a model of a reality not ordinarily discernible outside the art experience.

Postmodern art undermines many of the assumptions of the avant-garde. The unity of experience proposed by the Modernist art object is argued by the Postmodernists to be yet another fiction in a world already impacted by too many harmful fictions. The viewer is not encouraged to enter into the Postmodernist picture or empathize with the Postmodernist sculpture, but rather to correctly identify those objects as constructs to be "read" and analyzed. Postmodern art tends to deal with systems, most frequently linguistic, social, or political systems.

The Modernist art object generally appears self-sufficient. Its very completeness encourages empathy, contemplation, and admiration. The authenticity of its expression is created in part by its status as an original creation on the part of the artist. The form of a Postmodern art object, on the other hand, is

more open-ended, challenging the viewer to enter into a dialog with the work. The Postmodern artwork does not proclaim its uniqueness, nor does it designate its creator as an author of originality.

We hope this discussion will help you to distinguish whether the various works in this chapter address primarily Modernist or Postmodernist concerns. When looking at any one of these works, making that initial judgment may put you in a better position to explore its form and content.

Mixed Media and Installation

Traditionally, two-dimensional art invites the viewer to contemplate imagery in an imaginary pictorial space. A conventional format, one that is small and rectangular, is admirably suited to this end. Its intimate scale entices the viewer to relinquish everyday reality to enter an invented world in miniature. The long-accepted convention of the rectangular format aids in this transition from the real world into a pictorial one. The clear and abstract boundary of the picture's frame separates the experience of pictorial contemplation from everyday life; the viewer, as it were, looks through the rectangular shape as through a window or door into another realm of experience.

This tradition of framing the aesthetic experience continues in much of today's pictorial art, as can be seen by scanning the numerous contemporary drawings included in previous chapters of this book. But many other artists have deviated from this tradition. Employing unusual media and expanded formats, their goal has been to maximize the material existence of the art object and to minimize the viewer's escape from real time and actual space.

Liliana Porter frequently uses images from pop culture in her mixed-media work. In Figure 13–1, the outline of a famous mouse gestures to us in a familiar way, welcoming us not into his magic kingdom but "into his head," which is littered with scraps of cultural refuse. Spending time among these scraps, we might be tempted to construct a narrative, but that narrative would be quite different from the sentimental stories told in Disney films. Here we find images signifying prosperity (houses and a yacht), emblems of order (pyramids, cubes, watches, and the moon), items employed in the high-art tradition (the paintbrush and paint daubs), and images of vanity and death (the clock, snail shells, dominoes, and the horse and rider). As we pick through all this visual flotsam, we realize that Mickey, although generally accepted as a larger-than-life popular icon, may in fact be interpreted as just another archaeological remnant of our consumer culture.

Fariba Hajamadi (Fig. 13–2) plays with our identification of the picture plane as a door or window into space by using a trompe l'oeil technique to illusionistically transform a birch panel into a pair of French doors. Note that the picture space depicted in the six lights (windows), while not contiguous, does correspond generally to such visual benchmarks as ground plane, horizon, and treetops. Consequently, we do not get the impression of looking through the windows of the door at a consistent landscape beyond. Instead, we are keenly aware of separate images that encourage us to remember standing by a door or window during inclement weather, thinking of ourselves located in some favorite spot outside.

The 1980s and 1990s have seen an increase in various types of installation art. Some of the issues that motivate installation art pertain to the artist's relationships to patrons, to the gallery and museum system, and to larger economic institutions. This form of art has its roots in the 1960s and 1970s, when radical artists sought to subvert their position as producers of marketable art by making works that could not be easily collected, such as earthworks, performances, and epemeral installations. Frequently seen as an expansion of sculptural practice, installation art can sometimes be extended to the more intimate realm of drawing.

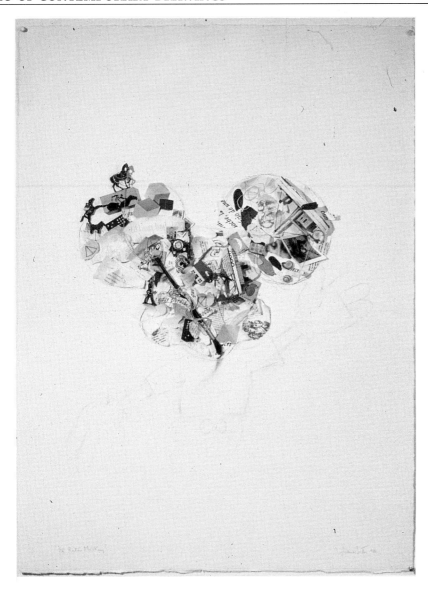

FIGURE 13–1
LILIANA PORTER
Mickey Mouse IV, A.K.A. *El Raton Mickey*, 1992
Mixed media collage on paper, 42 × 30″
Courtesy, Steinbaum Krauss Gallery, New York City

Nicole Eisenman makes large, multifigured compositions drawn in ink directly onto gallery walls. Her works make lavish use of imagery from high art and popular culture and frequently recast classical subject matter from a feminist, or more specifically, lesbian, point of view. Figure 13–3 is the center portion of a very large mural flanked on the one side by the wholesale slaughter of hapless men by female equestrians (a reversal of the Greek victory over the Amazons) and on the other side by a town fair featuring a lesbian kissing booth (a reversal of what you might find in early-twentieth-century American scene painting). The role reversal shown in these flanking murals calls into question the permissive attitude our culture has toward depictions of violence against women and how it turns their bodies into commodities. In the center panel (Figure 13–3), entitled "Family Values," we see an idealized nuclear family, obviously down on its luck, gathered stoically around a trash-can fire.

Note how Eisenman uses the illusory architectural framework to tie the mural into the actual wall surface. But in this case, the architecture, a pastiche of classical Renaissance and Baroque motifs combined with twentieth-century functional structures, refers metaphorically to a host of cultural institutions and "infrastructure." The architecture (symbolic of the socioeconomic order) is breaking up over our heads, while at the bottom, seated in front of a Classical predella, the well-known Monopoly game symbol has been reduced to the status of a hobo figure dolefully roasting his frankfurter over a campfire.

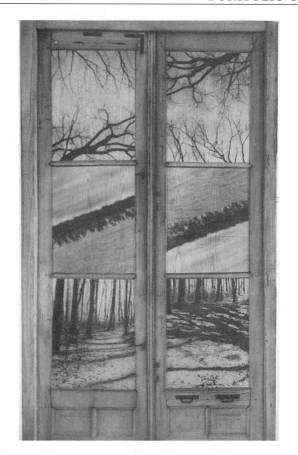

FIGURE 13–2
FARIBA HAJAMADI
Mountains Like Tilted Skies, 1990
Oil and emulsion on birch panel, 75½ × 46″
Courtesy, Rhona Hoffman Gallery, Chicago

FIGURE 13–3
NICOLE EISENMAN
Family Values:, fire, 1993
Ink on wall. Center mural,
15′ × 25′
Courtesy, Shoshana Wayne Gallery, Santa Monica

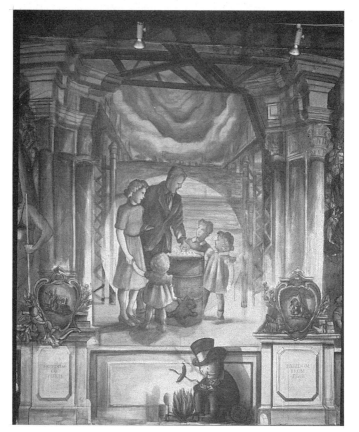

Brian Sikes is another artist whose work refers to the architectural context in which he presents his wall drawings. Like many muralists since the early Renaissance, Sikes is aware of the pitfalls of introducing linear perspective into a mural, namely, that too much of an illusion of deep space will destroy the visual solidity of the wall itself. But Sikes, like Eisenman, uses structural motifs to dismantle the architectural setting in which he works. In Figure 13–4, he has chosen a quatrefoil, or four-leaf-clover shape, as the starting point for his perspectival invention. As an architectural element, the quatrefoil, favored by Gothic builders as a wall opening, would be located on a vertical plane. In this drawing, the artist has turned the quatrefoil on its side to produce something like a tabletop. The result is a peculiar image that resembles a useless piece of furniture. Notice, too, that the total isolation of this perspectival projection within a field of white has a curious effect. By depicting this exceedingly spatial image without a spatial context of some sort, the solidity of the actual wall plane is not compromised. The flat integrity of the wall is lost only within the confines of the image, which can be read as an abrupt and gaping hole.

Unlike the works by Eisenman and Sikes, Sue Williams's installation *The Sweet and Pungent Smell of Success* (Fig. 13–5) is not tied formally to the architecture in which it is presented. Like many other installation artists, however, she appears to regard the wall as an oversized wraparound screen on which to project a series of mixed-media images. It could also be that Williams regards the room as a metaphor for the human mind.

In this work, which combines paintings along with drawings and text applied directly to the walls, a connection is made between eating disorders, domestic violence against women, and socially imposed forms of female oppression. Here the head from the colossus (oversized statue) of Constantine the Great oversees a sordid scene in which a woman, accustomed to receiving abuse

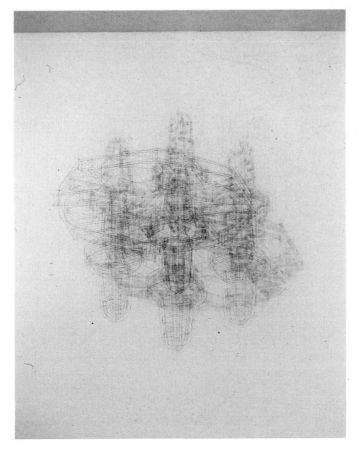

FIGURE 13–4
BRIAN SIKES
Quatrefoil Rotation (92–7), 1992
Graphite, acrylic and latex on wall,
98 × 98" (approximate)
Courtesy of the artist and Zola/Lieberman Gallery Inc., Chicago

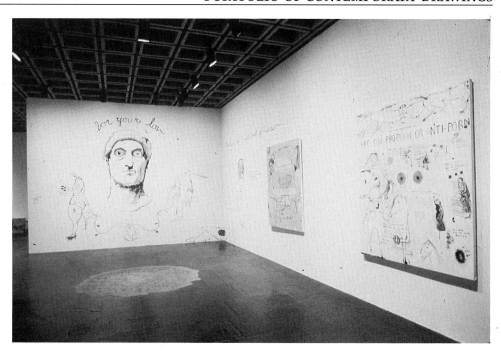

FIGURE 13–5
SUE WILLIAMS
The Sweet and Pungent Smell of Success, 1993
Installation at Whitney Museum, 1993
Courtesy, 303 Gallery, New York

from a male member of the household, apparently makes an offering of a plate of sweet-smelling homemade fudge. But, as it turns out, the proffered morsels are not for the emperor–god, the male abuser, but instead are for her own consumption, adding empty calories to her diet and fat to her already burgeoning thighs. On the floor close by, a pool of plastic vomit reinforces the notion of binging and purging, a cycle of self-abuse by which the victim mimics the maltreatment inflicted on her by others.

The style of this work is purposely raw: a more "beautiful" depiction of this subject would distract from the work's content. Nonetheless, we are alternately attracted by the casual, cartoonlike depictions and repulsed by the hard-hitting theme of the artwork. And in the midst of this tug of war, all our senses are engaged: the vomit, though plastic, threatens to offend our nose and dirty our shoes; the written words alternately whisper and shout; and depictions of the protagonists' flesh gape and balloon out, causing the empathetic viewer physical discomfort. By stimulating such an intense visceral reaction in us, Williams stakes a claim not only on our minds but also on our bodies.

Technologically Produced Art

The art world, like our culture as a whole, has for a long time had a love/hate relationship with technology. The general sentiment is that technology separates us from direct contact with nature, or the verifiable truths of physical reality. Since traditionally the visual arts re-create the physical world by accentuating tactile experience, most artists have been reluctant to give up the sheer sensuality of conventional art media (e.g., drawing, painting, sculpture) for the more abstract properties of electronic media. However, a growing number of artists now regard technology as a new and exciting tool by which to accomplish their artistic ends. Not coincidentally, various electronic media have also become increasingly adapted to artistic purposes. Current computer technology, for example, is so user-friendly that an artist can utilize software to draw or paint without having to undergo extensive technical training.

FIGURE 13–6
MIKE HOLCOMB
Miss So and So, 1992
Computer color laser print, 8 × 10"
Courtesy, the artist

Mike Holcomb used a computer to shape and arrange areas of simulated texture in Figure 13–6. The image we see here is similar to works produced by the Cubists at the beginning of the twentieth century, but unlike those artists, Holcomb is not limited to the patterns or textures that he can find, or painstakingly create by hand. Instead, he is able to quickly invent and refine his textural ideas at the computer keyboard, changing the color, density, value and so forth, with the touch of a key. The fictitious personality he creates here is informed by textures and patterns reminiscent of things in both the natural and industrial landscape.

While Holcomb uses the computer to produce images over which he has complete control, Angela Bulloch (Fig. 13–7) uses her low-tech drawing machines to entangle the viewer in a witty reversal of the roles of artist and audience. Normally we enter a gallery with the expectation that the artist is the one who has created something for us to experience. But encountering the exhibition pictured here, we find instead a machine that will slowly inscribe lines according to the directions we give it with a foot pedal. To take in what the artist has to offer, *we* must become engaged with this reluctant machine that enables us to draw while at the same time frustrating our desires to do so freely. In place of the spontaneity we associate with drawing, we suffer the dead weight of an unnecessary robotic arm; and in place of the intimacy of the drawing process, the machine entangles us in a public spectacle. And where, we wonder, is the artist whose work we came to see?

Figure 13–8 was created by an accomplished painter and printmaker, Andrew Polk, who is intrigued by the computer medium for its own sake, particularly the way in which it demands decisions based on predicted outcomes and then all the same yields surprising results! In this work, for instance, the challenge was to achieve imagistic harmony between a strong checkerboard pattern and the figurative elements. Initially, all of the figures were drawn by hand and then scanned into the computer, where they were later arranged and duplicated. To integrate the figures into the patterned field, however, Polk had to create a

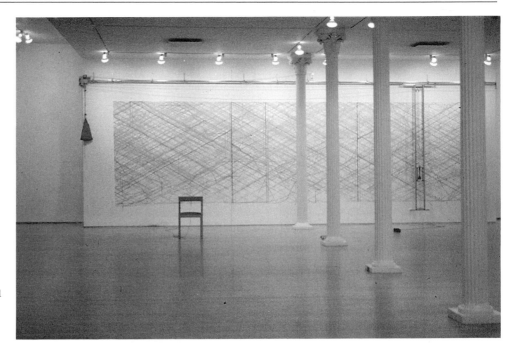

FIGURE 13–7
ANGELA BULLOCH
Pushmepullme Drawing Machine, 1991
Installation view at the Drawing
Center, New York
Courtesy, 1301, Santa Monica

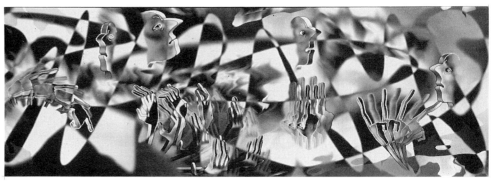

FIGURE 13–8
ANDREW POLK
I Have Something to Say (Version I),
1993
Computer graphic, size is variable
Courtesy, the artist

give-and-take relationship within the checkerboard system; in places the pattern was allowed to determine pictorial order, while in other areas the system was compromised in order to accommodate the imagery.

Intended originally as a design for a billboard located near a school for the deaf and the blind, Polk's work draws attention to a segment of our population that has a hard time making itself heard. The fictitious spokesperson for that population appears to us here four times. His fervid eyes and mute, open mouth suggest that he urgently needs to communicate what's on his mind, while at the same time he gesticulates wildly. In fact, his hands are spelling out in American Sign Language the words *I have something to say.*

Laser copiers scan an image, breaking it up into small pixels that can be copied with little degradation of the image. The work by David Humphrey (Fig. 13–9) appears, on account of the moiré pattern of pixels, to be a copy of an already-scanned image. This pattern, which is created when one pattern is superimposed on another, can be seen particularly well on the foreground objects of middle value, such as the chair in the lower right-hand corner. But once you identify the pattern there, you can easily pick it up on the side walls, the distant wall, and even on the far chairs. Since this technologically produced pattern is absolutely flat, it serves to reinforce the picture plane, directly contradicting the logic of linear and atmospheric perspective also depicted in this drawing.

Emphasis on the picture plane serves the content of this work. We become aware of the drawing's surface as a screen through which the image is filtered and get the uneasy feeling that we might be voyeurs into this space. The position of voyeur is ultimately one of alienation, and alienation best describes our general

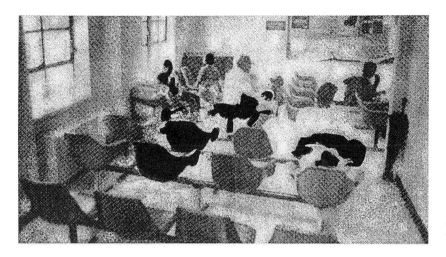

FIGURE 13–9
DAVID HUMPHREY
Waiting Room, 1991
Unique laser drawing on paper,
5½ × 9¾″ (image)
Courtesy, McKee Gallery, New York

state of mind when we sit among strangers in anonymous waiting rooms, preparing ourselves for the verdict on our legal, financial, or health status. The powerlessness we feel in such situations, where luck or bureaucracy rule, is reflected in this drawing by the random pattern of occupied and unoccupied chairs and the arbitrary assignment of tone to those chairs.

Social and Political Themes

Dissatisfaction with social or political conditions, a recurrent theme in Western art since the late eighteenth century, is a particularly motivating force in art today. Much of this work is intended to protest specific injustices, and a growing portion of politically based art urges the viewer to get involved. Still other artists are able to use the production of the art itself as an agent of actual social, political, or environmental change.

Figure 13–10 can be characterized as protest art. It takes as its subject the maquiladora industries located on the Mexican side of the U.S.–Mexican border. These industries are touted as a great economic boon to the poor, but in fact,

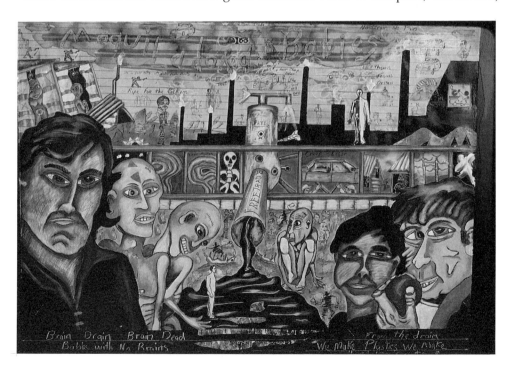

FIGURE 13–10
BRUCE THAYER
Maquiladora Babies, 1993
Mixed media on paper, 52 × 42″
Courtesy, Zaks Gallery, Chicago

the maquiladora shantytowns are notorious throughout the Southwest for their general squalor, and most especially for their lack of sanitation and appalling industrial pollution. Of course, the most vulnerable victims of these living conditions are small children and infants.

This drawing lays out some of the complexities of the border economy: impoverished Mexican nationals for whom terribly underpaid jobs are better than no jobs; serious health risks and environmental pollution; and the politics of free trade bolstered by American demand for cheaper goods, a demand that conflicts with American labor's desire to keep manufacturing jobs at home.

The style of this work, like that of much political protest art, is harsh, in recognition most likely of the equally harsh realities that are the drawing's subject. There is an aggressiveness in the caricatured figures and in the messages and slogans that appear like graffiti throughout the drawing. But note that puns and other quirky details do much to leaven the tone of the work. Artists of political protest frequently employ humor to draw viewers into a work that intentionally avoids an aesthetically pleasing appearance.

The work of Sue Coe, a British artist equally successful in the worlds of commercial art (she designs album covers) and the New York gallery scene, also falls under the category of protest art. The drawing we see in Figure 13–11 is topical. Its subject is the senatorial review of Clarence Thomas's nomination to the Supreme Court. This review included dramatic testimony by Anita Hill that Thomas, her former boss, had subjected her to on-the-job sexual harassment.

FIGURE 13–11
SUE COE
Thank You America (Anita Hill), 1991
Graphite and gouache on white
Strathmore Bristol board, 40 × 30"

Copyright © Sue Coe. Courtesy, Galerie St. Etienne, New York

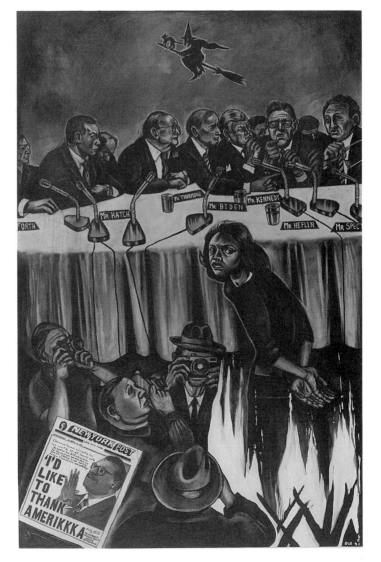

More precisely, though, this work draws a parallel between the vilification of Anita Hill during the Thomas hearings and an old-fashioned witch hunt.

In Coe's drawing, an all-white, all-male committee of United States senators sits at the table debating the issue. Unlike many political artists, Coe represents these flawed judges as intelligent men; their faces register thought, concern, and an understanding of the complexities of the case. Meanwhile, Anita Hill, who is burning at the stake, turns her suffering glance toward the viewer, ignoring the gaggle of parasitical reporters who click away with their cameras.

Although the subject of Coe's work is not unlike what you might find in a political cartoon, her visual treatment of the subject invests the theme with a deeper resonance. The bold use of tone, total occupation of the picture plane, and generally plastic use of form and space impart a visual weight to the depiction that is unlike what one would find in more swiftly realized newspaper cartoons.

Art as political protest or social commentary is one route for an artist to pursue. Art as *actual* political action is another, and this form of activist art frequently demands the collaboration of the artist with the artwork's intended audience. Following the rallying cry Art Saves Lives! artists in the 1980s began working with young people from disadvantaged neighborhoods to produce murals that would not only replace gang graffiti but also, as beautiful or inspirational focal points, be a source of pride and identification for blighted neighborhoods.

Much of this art is of such a public nature that it is far removed from the more intimate realm of drawing. One exception is the work of Tim Rollins, a New York–based artist who, for years, has been collaborating with Puerto Rican youth in a collective called "Kids of Survival" (KOS). The work on paper in Figure 13–12 is one from a series of drawings on book pages. Although Rollins and KOS are professional artists fully engaged in a for-profit business, Rollins's intention is to use art as a hook by which to draw students into pursuing a well-rounded education. Rollins has discovered that getting the young artists

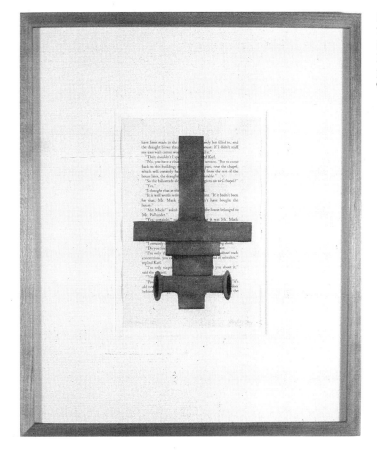

FIGURE 13–12
TIM ROLLINS and KOS
Study for Amerika XIII, 1991
Pencil and watercolor on bookpage
page #77, 7⅞ × 5⅛"
Courtesy, Rhona Hoffman Gallery

to draw directly on book pages is one way of encouraging them to examine not only the content but also the historical context of a piece of writing.

In this case, the image of a machine part isolated against a page from Kafka's *Amerika* can be seen as emblematic of a machine-age utopia that attracted so many immigrants to this country, including the parents of many of these young artists. That machine-age ideal is still reflected in the great skyscrapers of Manhattan, but the manufacturing jobs associated with that utopia are for the most part gone. The machines themselves, like the skyscrapers, are taking their place in history. Indeed, there is a curiously archaeological look to the machine part in this drawing; by contemporary standards it looks clunky, but its sleek, lathed surfaces are reminiscent of the art deco elegance that was once considered so modern and so progressive.

The collaborative team, Helen Mayer Harrison and Newton Harrison, engage in what they call "conversations" about various ecopolitical issues realized through media as diverse as poetry, photographs, maps, drawings, and performance. For years, these artists have been dealing specifically with the urgent subject of global warming caused by factors such as the burning of fossil fuels and the massive destruction of the world's rainforests.

Figure 13–13 is a proposal for a project, *Tibet Is the High Ground*, that was conceived in response to the Dalai Lama's vision of the Tibetan high plateau as a World Peace Park. For the Harrisons, the Dalai Lama's idea of the Peace Park as an embodiment of Buddhist moral high ground becomes also the literal high ground to which all land-loving forms of life may have to retreat when the oceans, swelling from the melting polar ice caps, reshape the global land masses and submerge much of the world's densely populated lowlands.

By envisioning Tibet as a world peace park or as a sanctuary for all non-aquatic life, the Harrisons seek to correct the current political and ecological reality. Rather than directly addressing the more widely publicized genocidal campaign waged by the Chinese against the Tibetan people, this work concentrates instead on the ecological disaster that has taken place there since the Chinese invasion. The Harrisons point out that Eastern Tibet, which a few decades ago was virgin rainforest, is today virtually a desert as a result of the clearcutting of the forest for lumber by the Chinese. This devastation has not only resulted in erosion of once-arable soil but has also had an effect on all of Tibet's downstream neighbors (the mountains of Tibet are the source of seven major Asian rivers). Already attributable to the clearing of Tibetan forests are the floods in Bangladesh and changes in monsoon patterns. There is even speculation that the "chimney effect" taking place over this vast new desert has so disrupted wind patterns that it may be responsible for the droughts in California and inland Oregon.

FIGURE 13–13
HELEN MAYER HARRISON and
NEWTON HARRISON

Tibet Is the High Ground
Paper, ink, colored pencil, graphite. Detail
36 × 84″
Courtesy, the artists

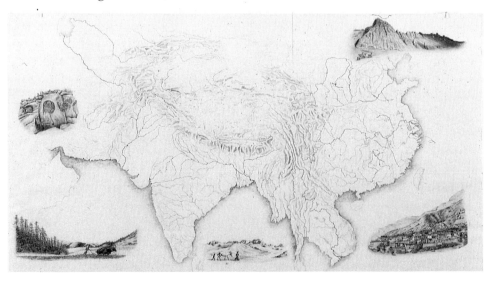

Tibet Is the High Ground is a three-part long range project: the first part will depict Tibet before and after Chinese occupation; the second will give a panoramic, "overflight" view of Tibet; and the third will result in a large-scale, three-dimensional model of Tibet. The first of these projects will publicize the destruction now being carried out, and the other two will demonstrate the actual scale of this destruction, which has so far resulted in the creation of about one million square miles of desert. The intention of this project is to draw the attention of world leaders to the situation in Tibet with a view to restoring Tibet's forests and farmlands.

Feminist Perspectives

In the wake of the feminist movement of the late 1960s and early 1970s, a special focus on the position of women artists developed. At that time, it was exceedingly difficult for a woman artist to be taken seriously within the male-dominated art world. Today the economic handicap for women artists, though less severe than it once was, continues to impact women's ability to dedicate themselves to their art. (The Guerrilla Girls, a New York–based art-as-political-action group, points out that in the population as a whole, women earn 66 percent of what men do, but women artists have an average income of only 33 percent of their male counterparts.)

The feminist art movement not only addressed income inequities, it also questioned the gender-based imagery and posturing of much Modernist art. It was frequently remarked that Abstract Expressionism, and even Pop Art, tended to reinforce male domination in its form (macho when not downright phallic) and subject matter (tragic/heroic when abstract, presupposing the male gaze when figurative). Feminist artists sought to correct this situation by using the female experience as subject matter, or by employing formal means that drew on the traditions of the useful and the decorative arts, idioms that generally have been ignored or trivialized because of their association with "women's work." Holding to the notion that the "personal is political," women artists encouraged each other to produce art that was personal or that flaunted its decorative qualities in the face of the prevailing male opinion that decoration is flimsy and nonessential. Today, with the position of women artists beginning to improve, the range of subject matter and forms is more varied.

Intelligent members of any disenfranchised group will naturally take a hard look at themselves to determine how much of their personal predicament is caused by "the system" and how much is a result of one's own compromising of goals and desires. When Susan Hauptman looks at herself (Fig. 13–14), she sees the face of an uningratiating, hard-bitten realist. This precise rendition of the unsmiling face with its level gaze and drawn lips seems to suggest a woman who is clear-sighted, experienced in human relations, and able to insist that she will take no guff from anyone. But her sense of humor is evident in the absolutely absurd placement of the tiny ponytail at the top of her head.

The female experience in the Speiss-Ferris (Fig. 13–15) is couched in more mythical terms. This is an image of the woman looked on by society as the "other." She is trapped in objecthood (she looks like a chair) and is associated closely with nature (as opposed to male rationality), procreation (as opposed to male creation), and death (as indicated by various vanitas symbols). Like the Hauptman self-portrait, this image is of someone who keenly observes her situation in life. In this case, however, the figure is too ladylike to object to the image others impose on her.

Judie Bamber (Fig. 13–16) not only refuses to be shaped by others, she throws us a sublime bit of nonsense herself. Everyone is probably sick of all the self-help books that purport to instruct us on how to take control of our lives.

FIGURE 13–14
SUSAN HAUPTMAN
Self Portrait, 1993
Pastel and charcoal on paper,
12 × 19″
Courtesy, Tatistcheff Gallery, New York City

FIGURE 13–15
ELEANOR SPIESS-FERRIS
The Acquisition, 1993
Conté drawing, 47 × 65″
Courtesy, Zaks Gallery, Chicago

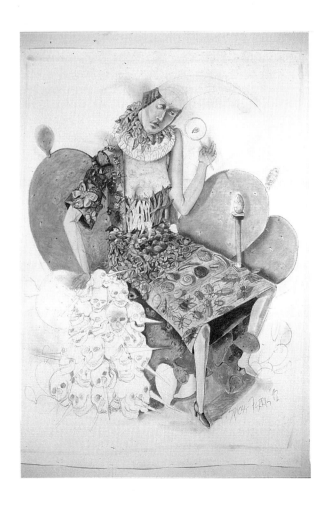

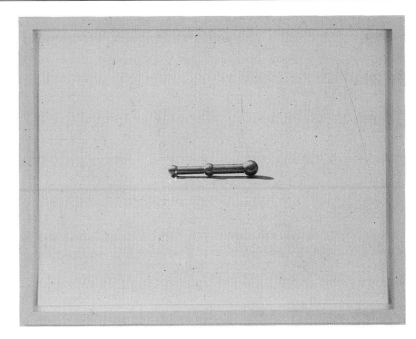

FIGURE 13–16
JUDIE BAMBER
I Don't Know My Own Strength
(Vaginal Barbell), 1991
Graphite on paper, 30 × 24"
Courtesy, Richard Telles Fine Art, Los Angeles

Exhorting us to know our own strength, these books are unable to explain what that means for a woman who has to protect herself from all kinds of hurt, including severe bodily harm. An absurd solution, but one with a kernel of truth in it, might be a vaginal barbell! Although this device might have current use in one of our society's subcultures, for the majority it is just an intriguing idea. It is hard for us to imagine what this thing would look like or how it would be used. Bamber's hilarious proposal for this object as a means of self-improvement, though preposterously impractical, does point out the desirability for such a device.

Karen Yasinsky's cavorting women in Figure 13–17 give the impression of having found strength, however temporary. This work is from a series of drawings portraying women gathered in impromptu support groups. They appear to be wounded or somehow rendered incomplete (witness the recurrence of vestigial limbs and lack of sexual parts), but they have orifices aplenty on their faces—large mouths with noticeable teeth and tongues, flaring nostrils, and multiple eyes. These women are very different from the passive chair-bound woman of the Speiss-Ferris drawing. They are in full possession of all their faculties and capable of unrestrained movement regardless of their disabilities. The content of Yasinsky's drawing proposes that female culture has a significant advantage over male society because of the ability of women, even those who are total strangers, to establish immediate sympathy and rapport with each other.

Ethnic Identities

Until the 1970's or 1980's, minority artists living in the West who succeeded in the art world usually did so *despite* their cultural origins. In fact, an artist from a minority racial or ethnic group used to be regarded as having a severe handicap, because "high art" was considered difficult to master for those unfamiliar with the established Western tradition. Consequently, minority artists, if they wished to get ahead in the art world, tended to work in a manner similar to their white

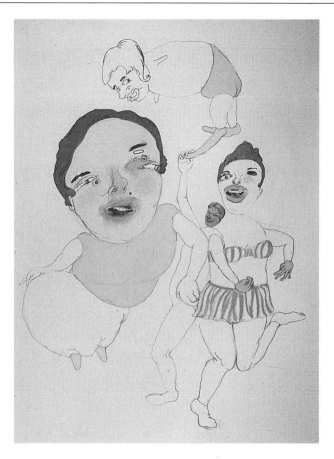

FIGURE 13–17
KAREN YASINSKY
Flirting Evenly, 1993
Charcoal, pastel and collage on
paper, 30 × 32"
Courtesy, the artist

contemporaries. By contrast, minority artists today are far more likely to use their own cultural experiences as the source for both the subject matter and the formal qualities of their work.

Robert Colescott began his professional career among the School of California figurative painters that concentrated on color as an expression of light and space. In midcareer Colescott's work began to address the conflicts he experienced as an African-American artist painting with great success in what was essentially a European-derived style. Without abandoning all that he loved about color and its formal implications, he began to repaint well-known masterpieces of European art in blackface. These paintings had a comical pop character, as did his other work from roughly the same period, which made fun of racial stereotypes and caricatures in the entertainment and advertising industries.

Colescott's mature work replaces stereotype with myth, which is much more deeply seated in the collective consciousness. The African-American female protagonist we see in Figure 13–18 lacks all the specifics of caricature, but she seems most definitely larger than life. The title suggests that she has left home to find a better-paying job, only to be faced with enormous temptations. Casting one eye upward she sees members of her family, sources of her own pride and self-respect, who issue her a belated warning about strange white men.

This drawing seems to sum up very well the power relationship between the white male looking for his own lost body in the black surrogate, and the "other" symbolized by an African-American female who is in some respects privileged to have retained her body and her family roots but who lacks the ability to command recognition as a total person from those who desire her most.

The drawing by Victor Estrada (Fig. 13–19) can be seen as a kind of Chicano

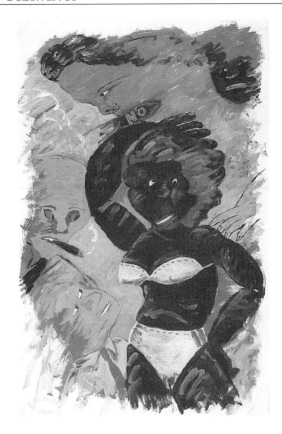

FIGURE 13–18
ROBERT COLESCOTT
Atlantic City, 1991
Acrylic on paper, 40½ × 26″
Courtesy, the artist

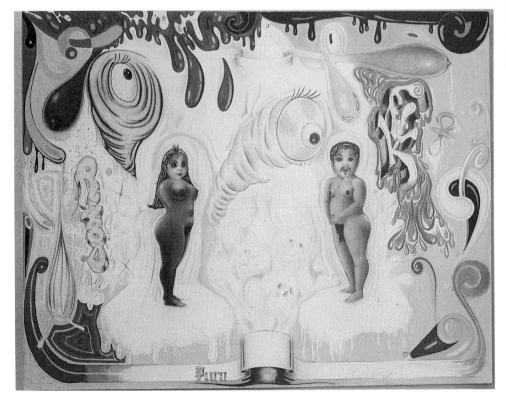

FIGURE 13–19
VICTOR ESTRADA
Untitled, 1993
Pencil, 17¼ × 14″
Courtesy, Shoshana Wayne Gallery, Santa Monica

altarpiece featuring Adam and Eve as Kewpie dolls. The couple's sweetness recalls the little figurines placed atop wedding cakes, and indeed, sickly sweetness and fertility are the dominant themes of this image. The gooey, pop-style swirl that frames the "newlyweds" includes what appears to be molten chocolate, blood, semen, and eyes on springs as well as at the ends of elongated breasts. We seem to be in an Eden in which body parts and fluids mingle with reminders of the biological destiny of regeneration (symbolized by the pacifier) and death (symbolized by the pile of sugar skulls used in the Mexican celebration of the Day of the Dead).

The artist has publicly alluded to his interest in the "interface" between the private spiritual mind and popular culture. This notion, foreign as it is to the dominantly Protestant/Puritan American concept of the spiritual, is consonant with an Iberian-American Baroque sensibility that accommodates the sensual in religious art because of the belief that everything in the world perceived through the senses is in actuality an emblem of Divine Truth. The extension of popular culture to the realm of the spiritual, which is in fact typical of Chicano art and folk art, is currently affecting the culture of much of the southwestern United States but most especially that of southern California, the home of this artist.

The drawing by Enrique Chagoya (Fig. 13–20) also uses popular imagery but in a political context. This work comments on the English-only ruling adopted by some states with a high immigrant population, a ruling that prohibits the use of languages other than English in the conduct of government business. The pop element here is the giant hand that with a deft movement of thumb and forefinger is about to flick a child out of the way, as one might a crumb or insect.

FIGURE 13–20
ENRIQUE CHAGOYA
When Paradise Arrived, 1989
Charcoal and pastel on paper,
80 × 80″
Courtesy, the artist

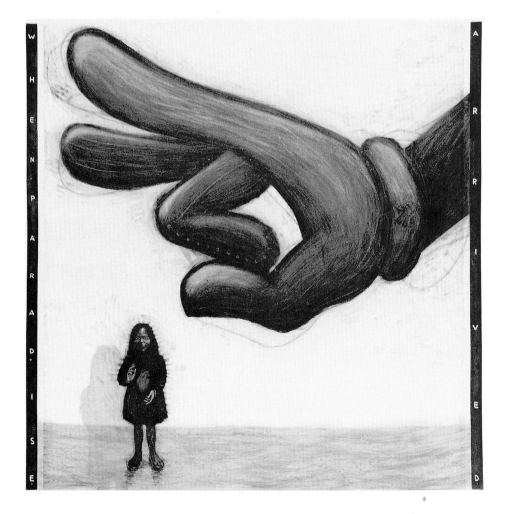

Notice that the style in which the child is drawn is more naturalistic than the cartoonish depiction of the hand. The implication perhaps is that the law that would separate this child from her cultural heritage is "Mickey Mouse," or without any legal or humanistic merit.

Arnaldo Roche Rabell (Puerto Rican–born) and Michiko Itatani (Japanese–born) both live in Chicago and work in a style not unlike the Neo-Expressionism that surfaced in Europe and America in the early 1980s. Some of the hallmarks of this style include a hero who is in some way frustrated or rendered mute and who appears to represent Everyman (a metaphor for the universal human condition), larger-than-life or mythical bodies acting in ways that are not easily comprehensible, references to national identity, and a loose or vigorous application of media.

A search for personal and ethnic identity is central to the work of Roche Rabell, but his use of the Neo-Expressionist mode implies that this quest is a more universal human condition. In this drawing (Fig. 13–21), he uses a traditional "Spanish palette" of black, white, and numerous grays along with red and yellow accents. The image is also reminiscent of one of the most famous Spanish paintings, the melancholy *Blue Guitar* of Picasso. But while Picasso's frail guitarist arouses our sentimental pity, he also plays music to us. The figure created by Roche Rabell calls for empathy of a grosser sort. This figure neither entertains us nor ingratiates himself to us through mournful song; instead, he offers us a view of his ungainly shoulders as he peers through his legs at his guitar. His gesture is monumentally ambiguous. Is he intending to pick up his guitar from this unlikely position, is he merely contemplating the guitar, or is he about to sit on it?

The image raises further questions about the identity of the Spanish/Hispanic artist symbolized by the musician. Picasso's musician, a naive artist who may live in utter poverty and not know how to read or write, can still comfort humanity through his music. Roche Rabell's figure seems to recognize that myth as a ripoff. The poverty depicted here is not the kind one can escape from in song, as we may infer from the inability of the artist in this image to pick up

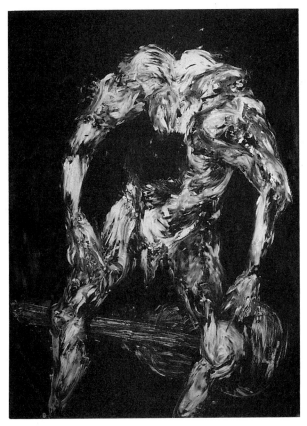

FIGURE 13–21
ARNALDO ROCHE RABELL
I Surrender, 1988
Ink on paper, 60 × 44"
Courtesy, Struve Gallery, Chicago

the guitar and embrace his art. The guitar, which because of its shape is a frequent metaphor for the female body, brings into play the more universal theme of disappointed love.

The leaping, arm-swinging figures in Michiko Itatani's drawing (Fig. 13–22) derive from diverse sources. Their generally frenetic energy, expressed most eloquently in the convulsed feet, reflect the tradition of vulgar subject matter in the historical woodcuts of the artist's native Japan. On the other hand, the pronounced musculature and heroic bulk of these figures are clearly reminiscent of the High Renaissance or Baroque styles in Italy.

Unlike Japanese and Italian figure compositions, these figures are not acting within a recognizable narrative context; the energy we see here is not directed to any explainable ends, and the protagonists have no antagonists. Usually we are not convinced by great shows of emotion unless we can relate somehow to the object of that emotion. What we are seeing here may be histrionics, but it may also be that the gestures, the contortions, and the output of energy are themselves the subject of the work. Although the veils of slanting parallel lines cutting through the otherwise featureless landscape suggest that destiny, or some societal force, is at work, we are less concerned with the force that drives them than we are with the physical presence of the figures themselves and with the visceral, reflex sensations they stimulate within us of our own bodies in the heat of activity.

Realism and Reality

During certain historical periods, realism has provided an important means for artists to more fully comprehend the various forces at work in their environments. More recently, artists have turned to realism not only to better understand the world around them but also to comment on it from a particular ideological point of view. In this regard, it is important to distinguish between the terms *realism* and *naturalism*. By *realism,* we mean the depiction of things as they actually are without the intervention of ideal conceptions. A related term, *naturalism* refers to a close observation of natural appearances. Realism goes beyond naturalism in that its truth pertains to all the complexities of a given situation, not just to those things visible to the eye.

Bill Vuksanovich combines naturalism with realism in his drawing of a railway by a brickyard (Fig. 13–23). We are immediately struck by the fidelity to natural appearances (naturalism) in this depiction, and our first reaction may be to gasp that it looks as "real" as a photograph. But the picture's actual realism has to do with the gritty and untidy complexity of the subject. We see that the pollution caused by industry has marred what might once have been a lush landscape. Trees and wildflowers still exist here, but so do ugly buildings, ship-

FIGURE 13–22
MICHIKO ITATANI
Untitled, Q–11, 1991
Mixed media on paper, 22 × 48"
Courtesy, Printworks Gallery, Chicago, IL

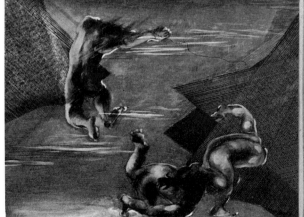

FIGURE 13–23
BILL VUKSANOVICH
Rails along the Brickyard, 1990
Graphite on paper, 30 × 42"
Courtesy, Struve Gallery, Chicago

ping containers, and filthy railway tracks. The sun glares through the overcast sky to illuminate steam or smoke emitting from one of the many smokestacks or vents. We ordinarily go to landscapes, actual or depicted, to escape our cares and to be revitalized by nature. But Vuksanovich, in nearly relentless realism, offers us a landscape that is all too reminiscent of the painfully blemished one we wished to leave behind.

Like many artists working from photographic sources, Diane Kepford questions the relationship of mass-media imagery to actual reality. Figure 13–24 is one of a series of drawings she has done from well-known photographs of famous personalities. In these larger-than-life blow-ups she crops out the contours of the heads, thus in effect drawing us close to the person's face. In this portrait of Picasso we see the ferociously intelligent eyes; the brow furrowed in concentration; the large, masculine nose; and the tightly drawn lips. We would like to think that physiognomy and expression tell us something about the person behind the face, but size and lack of context here make us aware that this image is an empty icon of glamour; it adds little to what we already know about Picasso as a person and even less about Picasso as an artist.

Vija Celmins (Fig. 13–25) uses photographic source material to explore connections between vision and knowledge. Science is dependent on knowledge verifiable by the senses, and even when theoretical science explores things that cannot be seen, it does so through visual models.

In this image of Saturn, the eight slightly different views of that ringed planet suggest our viewpoint might be from a spacecraft. Note that none of the poetic possibilities have been lost by virtue of our privileged position in relation to the subject. The planet glows as brightly as ever against the velvety deep, and the fact that the image has been repeated eight times suggests traditional symbolic association of this planet with the number eight. The medieval identification of the number eight with regeneration or resurrection also accords with the myth of Saturn, or Father Time, who first ate and then regurgitated his own children and who also, according to the Romans, ruled over the Earth during its peaceful and happy Golden Age.

Mark Tansey is best known for his complex, multifigured compositions painted in monochrome, which often have the look, at first glance, of academic history paintings or ceremonial photographs of momentous events.

FIGURE 13–24
DIANE KEPFORD
Picasso, 1987
Colored pencil, pastel on paper,
48 × 40"
Courtesy, Littlejohn/Sternau Gallery, New York

FIGURE 13–25
VIJA CELMINS
Drawing Saturn, 1983
Graphite on paper, 14 × 11"
Courtesy, McKee Gallery, New York

Tansey's manipulated photocopy drawings have less an air of gravity than his paintings. In fact, the artist likens them to the scherzi or capricci of Tiepolo, Goya, and Ernst. The malleability of photocopy drawing, in his words, gets away from the "burden of absolute or monumental assertion." The drawing we see in Figure 13–26 is the result of a multistep process that starts with a thumbnail sketch of the idea followed by an assembling of collaged materials including pictures from magazines, books, newspapers, and the artist's own drawings or photographs. The photocopy made from the collaged material is then modified by the subtractive process of erasing into the toner.

The artist is intrigued with the alternation of work done by hand with photographic technology and describes this mix as a "dialectical dance." In fact, the manipulation of the photograph by hand or by computer is now becoming so commonplace in both the art world and in the world of commercial graphics and animation that our perception of the photograph as an indisputable record of truth is changing. Photography is now malleable like other art media and is rapidly losing the aura of authenticity it once had.

This particular drawing presents a witty commentary on the polemics of the picture frame. In Tansey's scenario we see two figures located, it seems, at a municipal dump, who are caught in the act of throwing a picture frame off the edge of a precipice. Tellingly, the light source located behind these pedants of Modernism casts their shadow, and that of the frame, on the adjacent mound of rubbish.

In this retelling of Plato's analogy of the cave of unknowing is the suggestion that the artist might dispense with the discrete site of representation (symbolized by the picture frame) but that doing so results in an even more shadowy, or vague, setting for art to inhabit. That Plato's cave has been transformed into a

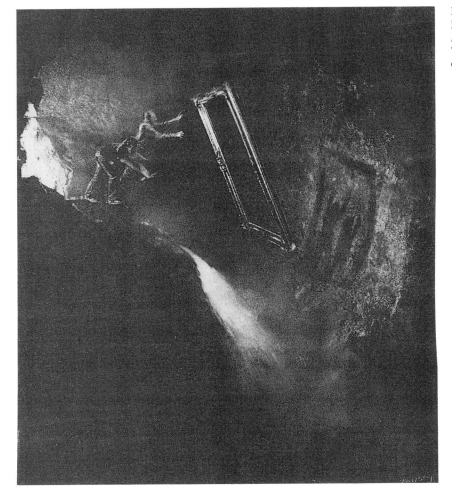

FIGURE 13–26
MARK TANSEY
Literalists Discarding the Frame, 1992
Toner on paper. Image 8 × 7"
Courtesy, Curt Marcus Gallery, New York

landfill is particularly ironic since Tansey consistently makes pointed references to the "landscape of the mind," a landscape in this case filled with intellectual garbage.

Narrative Art

Narrative in visual art, as in literature or film, allows the viewer to observe how characters relate to each other or behave in the face of a series of events. While narrative art can be very explicit, artworks with a less identifiable storyline can also be considered narrative if they at least encourage us to make up our own story. The drawings by G. D. Massad (Fig. 13–27) and Sam Messer (Fig. 13–28) are examples of art with an inferred narrative. In the Massad, we see a twig with leaves and two slender sections of denuded grapevine spotlighted against three velvety black shadows. The title, *Torches for the Night*, calls to mind returning home on a crisp fall evening and seeing the last leaves of autumn lit by street-lamps or by the momentary flash of car headlights. The details of curled, frail surfaces, veins, and tendrils are rendered beautifully and realistically. Despite their dried up state, these pieces of vegetation appear to be emblems of life. Note, too, how these forms are laid out like specimens on a page, the flatness of which is emphasized by the hints of written words.

The Messer drawing has a more recognizable story line. Here we see a scrawny, blindfolded, bare-breasted diva singing away with a full complement of stage gestures. Since she cannot look down, she may not be aware that her peg leg is firmly planted in a pile of skulls. We are left to interpret whether what is going on here refers to the condition of this particular person, the condition of humankind in general, or perhaps some more symbolic representation about the relationship between love, death, and art. Note that although the image has immediate impact, it takes some looking to actually see some of the key passages. The hill of skulls, for instance, is not easy to make out. Messer, it seems, wants us to make contact with this lady first, and then once we have met her, so to speak, we begin to realize the seriousness of her predicament. This tactic of slowing down our absorption of the story is consonant with the double exposure of the stage gesture and gives us the impression of a particular dream that at

FIGURE 13–27
G. D. Massad
Torches for the Night, 1990
Pastel and pencil on paper,
22 × 33"
Courtesy, Tatistcheff Gallery, New York City

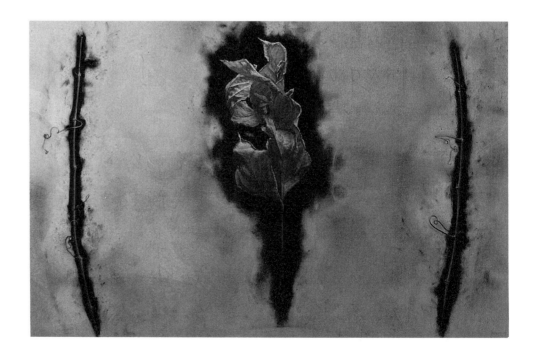

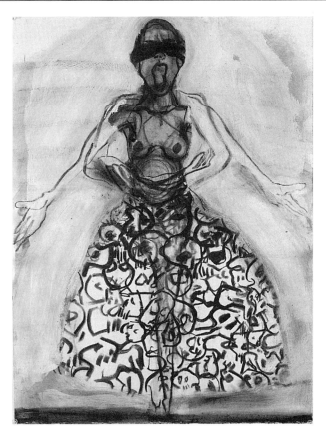

FIGURE 13–28
SAM MESSER
Untitled, 1991
Mixed media on paper, 30 × 22"
Courtesy, David Beitzel Gallery, New York

once seems to be unfolding in time yet has memorable moments that produce long-lasting images.

The Jennifer Bartlett drawing (Fig. 13–29) was intended as a study for one of a series of twenty-four paintings representing the hours of the day. Viewed as a whole, the series gives the impression of an artist who works almost all the time, sleeps little, and takes barely a moment's leisure. The theme of workaholism is less evident in this drawing (which was not actually used for the final painting titled *11 a.m.*), but all the same it communicates the idea of a person

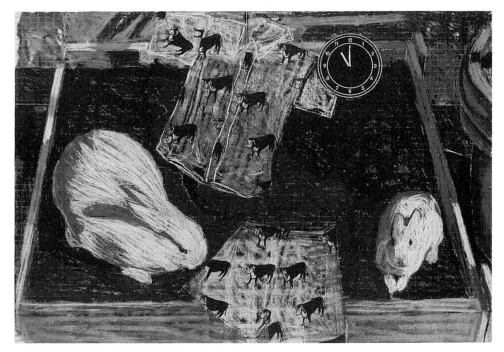

FIGURE 13–29
JENNIFER BARTLETT
11 A.M. Bull Shirt, 1992–1993
Pastel on paper, 42 × 60"
Courtesy, Richard Gray Gallery, Chicago

who is in a panic about not having the time to do all that she is supposed to do.

At eleven o'clock, our invisible protagonist realized it is time to feed the rabbits and iron her clothes. So here we see, in a loamy container that resembles more a raised planting bed than a rabbit hutch, two white rabbits drawn in beautiful raking light, crouching as rabbits characteristically do. The ground for the entire drawing is gridded, and attached to the nonspatial grid is a clock and a matched shorts set with a bull motif. The naturalistic drawing of the rabbits and their container contrasts strongly with the assertive, picture-plane flatness of the grid, clock face, and clothing.

In this wonderland, the white rabbits are more real than anything else is. The informal backyard setting, a place where we can privately get away with being untidy if that is our nature, is also more beautiful and more enduring than such flimsy constructs as the grid, the clock, and this season's leisure fashions. Especially wry is the juxtaposition of the rabbits and the shorts (take note of the title of the drawing and the hardly coincidental emergence of one of the bulls from the crotch of the shorts).

Peter Drake's haunting dream images are peopled by silent figures who glide, often on skates, through phosphorescent landscapes or architectural settings. In this work (Fig. 13–30), we see silhouetted against an extravaganza of artificially lighted clouds, the form, both comforting and menacing, of a Gothic church. We do not know whether the figures, holding their arms out for balance, are skating toward the edifice for refuge or whether they are being drawn toward it involuntarily. There is a sense that fate rather than human volition may be at work here.

Drake's image captures well the zeitgeist, or "spirit of the times," as it pertains to the last decade of the twentieth century. The mysterious action of the trio of skaters and the phosphorescent light recalls a contemporary multimedia spectacle, such as what one might experience at a rock concert or in night scenes in action and science fiction films. Despite the relative quietude of this

FIGURE 13–30
PETER DRAKE
Study for Acolyte, 1992
Acrylic and oil on paper, 19¼ × 23"
Courtesy, Curt Marcus Gallery, New York

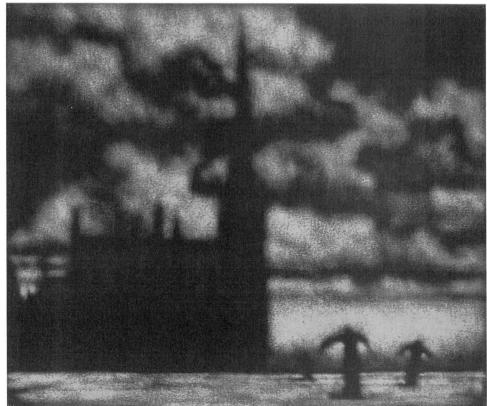

image, we feel anxiety about the present and future human condition, a function perhaps of millennial fear as the year 2000 approaches. Interestingly, this beautiful image of doom is full of anachronism. While the high-powered artificial lighting suggests advanced technology, the futuristic look is contradicted by the architectural style of the church and the generalized medieval costumes of the slender figures.

The Continuing Abstract Tradition

Up to this point, most of the work we have been looking at in this chapter has been thematically based and therefore not primarily concerned with an advancement or expansion of the formal tradition. But many artists working today believe that formal means are the major carriers of content in the visual arts. For these artists, structural logic, degrees of tactility, and implications of movement or stasis all refer to conditions of our own actual existence; thus, it is through the metaphoric powers of the formal properties of an artwork that the artist magnifies our consciousness of being a presence in the world.

Actually, formalist art can be highly representational, abstract, or completely nonobjective. We are more likely, however, to focus on the formal aspects of a work if the subject matter is abstracted or not evident at all. Content in the works of art we are about to look at must be inferred from the works' form.

The abstract drawing with strong figural associations in Figure 13–31 is by William Tucker, a sculptor and an author of several books on the nature of sculpture. It is hardly surprising that sculptors should be among the most fervid in their advocacy of form-meaning over literary content because sculpture, no matter its ostensible subject, is always first of all about the pure fact of being. The sculptural presence Tucker speaks of so eloquently in his writings is not just the presence of a fictive other, it is also our own presence; sculpture makes

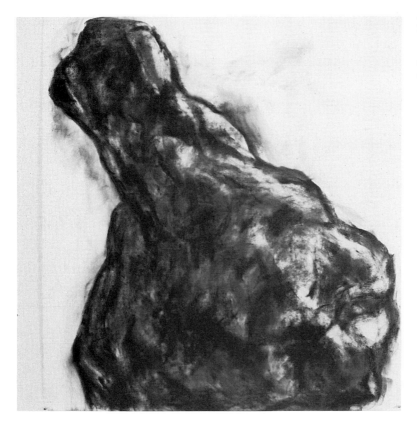

FIGURE 13–31
WILLIAM TUCKER
Untitled, 1991
Charcoal on paper, 47 × 42"
Courtesy, McKee Gallery, New York

of our bodies, which we all too often regard as obdurate objects, something subjective. The value of sculpture, or at least the very best sculpture, is that it mends the rift between body and mind and allows us to see afresh our relationship to the rest of physical existence.

In this drawing, presumably an idea for a sculpture, we witness a virtually inchoate mass struggling to attain the outward form intended for it. We sense the existence of a pattern or a will to structure hidden within this emerging presence, but how that form will develop cannot yet be seen, and its eventual shape may bear no more resemblance to what we see here than an embryo of undetermined species bears to the later well-developed fetus or a butterfly to its chrysalis. Figurative presence in this work manifests itself in the logic and determination of its growth rather than in the final resolution of the image.

Jake Berthot holds to the Modernist stance that the act of painting entails investigation, belief, and transcendence. Interestingly, he does not identify himself as an abstract painter; it is the representational artists, he says, those who make abstractions of real things, who are the true abstract artists. He considers himself a perceptual realist who believes first of all in the certainty of his medium.

The geometric web in Berthot's drawing (Fig. 13–32) may first appear to be a structurally closed system, but prolonged observation reveals it to be resplendent with choice, especially in relation to the nature and directions of the lines and in the treatment of space. The linear elements here have an uneasy, unfixed relationship to one another and to the picture plane. Places where lines of even thickness enclose areas, such as in the flat, saillike shape in the upper right, conflict with the light diagonals that merge into atmospheric depth. Meanwhile, more-insistent diagonals slash relentlessly from upper left to lower right, all but canceling the static peace of the shapes located on the picture plane and the tender regression of the modulated lines. It is as if we were being lured by the eternal and the beautiful only to be jerked back into reality by these bold gestures that smack strongly of the present tense.

For years, Elizabeth Murray has been working with the challenge of adapt-

FIGURE 13–32
JAKE BERTHOT
Untitled #3, 1992
Ink and gesso on paper, 22 × 21"
Courtesy, McKee Gallery, New York

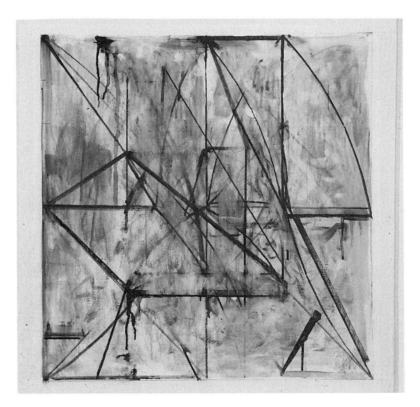

ing abstracted imagery to shaped formats. Many of the artists who choose to work within nonrectangular formats do so out of the desire to be free from the automatic identification of the picture plane as a framed door or window onto space. For these artists, the intention usually is to get viewers to recognize the objecthood or materiality of their support, to look *at* the picture's surface rather than *through* the picture plane.

Murray's eccentrically shaped supports and work-worn surfaces do assert their physical presence, as can be seen in Figure 13–33, which resembles a stretched and beaten animal hide. For Murray, however, there is always a balance of tension between image and surface. Notice how in this work the image tries to free itself from the surface and gets as far as casting a set of inconsistent shadows on the ground. But the surface of that ground is also insistent and struggles to reclaim the image, especially around the edges, where the boundaries of the format nearly coincide with the writhing pipette forms.

Murray's approach in this drawing is boldly eclectic, a characteristic closely associated with Postmodernism. Ingeniously integrated are quotations that run the gamut of art history: from the flowerlike form at the right side that recalls similar imagery on the eleventh-century bronze doors of the church of St. Michael's of Hildesheim to the mechanistic brides of Duchamp, the sculpture of Julio Gonzales, and the bandaged forms of the contemporary painter Philip Guston. Her conception, however, is in large part Modernist since she retains belief in the truth of a work of art, as well as the rootedness of all art, in nature. These tenets of faith can be seen reflected in the general closure of form in her work and in the curiously animated characters that suggest organic life in spite of their machinelike forms.

Peter Halley emerged in the early 1980s as an art theorist and as one of the young New Abstract or "Neo-Geo" painters.* Among his major areas of investigation, both as theorist and artist, is geometry and the use to which it is put in our culture. He has noted that over the past two centuries, our culture

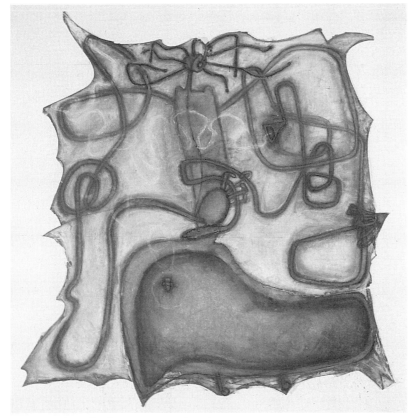

FIGURE 13–33
Elizabeth Murray
Untitled, Spring 1992
Pastel and glue on paper,
60¾ × 62"
Private collection. Photo courtesy of Paula Cooper Gallery, New York

Neo-Geo refers to a renewed emphasis on geometry in art.

has become increasingly obsessed with geometry and has chosen more and more to live within geometric systems.

Geometry, as the formal underpinning and even as the subject matter of art, is certainly not new in the twentieth century, but Halley's employment of this geometry can be differentiated from earlier uses. A host of Modernist movements, from Russian Suprematism and De Stijl earlier in the century to Abstract Expressionism at mid century, saw the potential for mysticism in geometry. For artists in these movements, geometry offered in modern form everything that Nature had once embodied, namely, formal logic and the potential for patterned growth, beauty, purity, and the intimation of eternal truths. These artists were not so much substituting geometry for nature as they were naturalizing geometry.

In the 1960s, Minimalism broke from this mystical/naturalist approach to geometry by leaching from geometric form any of the iconic content previously associated with it. Halley takes note that neither the Modernists nor the Minimalists represented geometry the way it is actually used in our cultural environment, namely, as an efficient organizational system and, more ominously, as a means of control.

In the early 1980s, Halley began his paintings of prison cells and conduits as a means of examining geometry's social role. The drawing in Figure 13–34 is a late example of this conception. In this work, the square represents a cell and the linear elements symbolize underground conduits of some sort.

These conduits could stand for the foundation that supports a particular social system, for example, utilities that regulate light and temperature in a prison. What is particularly odd, and maybe even a little frightening, is the termination on both ends of each conduit. These conduits do not actually enter the perimeter of the square: that is, they offer no entrance to, or escape from, the cell. The other ends of the conduits are arbitrarily lopped off, either by the ground line on which the cell sits or by the geometry of the squared format. In this work, we have all the appearances of order and regulation without the assurance of organic function or purpose.

Philip Taaffe, another artist often referred to in the early 1980's as a New Abstract painter, employs the strategy of appropriation in his work. Most recently, he has appropriated the Pattern and Decoration style initiated by the women's movement, and like the early practitioners of "P and D" he assembles motifs from various cultures.

FIGURE 13–34
PETER HALLEY
Untitled, 1992
Acrylic, day glo acrylic and pencil on graph paper, 18 × 22¼"
Courtesy, Gagosian Gallery, New York

Historically, pattern is used on three-dimensional objects (even textiles are three-dimensional). Formally, pattern serves to give variety to an object without seeking to break the unity of its surface. For this reason, pattern works best when it is flat, for any three-dimensional illusion would compromise the surface tension of an object on which it is applied. But an allover pattern, which is very useful in the decorative arts, does not translate naturally into good painting, or at least anything recognized as good painting by Western standards. Even painting that emphasizes surface derives much of its power from manipulating our expectation of finding spatial illusion somewhere within it.

In our culture, spatial illusion and subjectivity are closely linked. A depiction that deals with the ordering of things in a spatial continuum serves to remind us of our own psychic space. In cultures still close to their agrarian origins, the kind of order the mind is concerned with is more temporal, because the most important consideration for survival is knowing the correct time of year to plant crops. In these cultures, pattern figures strongly in the arts, for pattern is what allows one to perceive temporal order.

Notice that both the spatial and the temporal exist in the Taaffe image in Figure 13–35. The decorative motifs are appropriated from numerous agrarian cultures and include Gothic moldings from Europe and paisleys from India. There is a hint of eternity here perhaps because pattern represents the eternal inherent within constant change. But Taaffe breaks the pattern, separating out the little motifs that are each an icon of timelessness, and arranging them in a way that suggests matter in flux. Gone is the repeated, predictable pattern that in its original cultural context would be either allover or symmetrically arranged. The asymmetrical arrangement of motifs here bespeaks a subjectivity that is clearly spatial. So the kind of delight derived from the temporal experience of seeing variety within pattern (which suggests enduring order) has been substituted by the more materialist Western pleasure derived from the illusion of an inky substance within a spatial field.

It is interesting that Taaffe and Halley, who both gained early success as painters working directly out of Postmodern theory, should gravitate back toward naturalizing their images according to the tradition of Western art. The more mature styles of both artists seem subjective, heroic, and perhaps even spiritual, in a way more consonant with the Romantic inclinations of Modernist art.

FIGURE 13–35
PHILIP TAAFFE
Untitled, 1993
Mixed media on Fabriano paper,
27½ × 39¼"
Courtesy, Gagosian Gallery, New York

Art with Spiritual Concerns

Natural piety, a phrase coined by William Wordsworth to describe the feeling of love and awe we experience when confronted with nature's power and beauty, is perhaps the most universal of all spiritual experiences. During the Romantic period, an admiration for nature gained practically cult status, especially in the Protestant countries of northern Europe and America, where the pantheistic view that God exists in all of nature allowed pious Christians to take sensual pleasure in nature's beauty and abundance.

An updated instance of art as the observance of natural piety can be found in the Donald Sultan drawing (Fig. 13–36). Were it not for its title, we would not know that the dark forms in Sultan's drawing represent morning glories; the very dense black used in place of the light blue we associate with the morning glory denies the fragility of that trumpet-shaped bloom. But like many true Romantics, Sultan offers us an interpretation based less on outward appearances than on a transmogrified impression. These almost formless images of darkness, each pierced at the center by a perfectly round circle of light, assert the kind of presence we associate with mysterious life forms. We are drawn to, and mesmerized by, the circles of light as the darkness advances upon us.

Sultan is a mixed-media artist who makes large paintings on supports fashioned from linoleum tiles, asphalt, and plaster. But even when working in charcoal, as ordinary a drawing material as one could ask for, Sultan lets the connotations of the medium add to the meaning of the image. Note how the tiny light located at the center of each black flower actually recalls the smoldering of a live charcoal fire. These dark flowers burn into our memory and again suggest the words of Wordsworth, who speaks of the experience of sublime terror recalled in moments of tranquility.

A compassionate approach to the human spirit informs the work of many "body artists" including installation artist and sculptor Kiki Smith. At the core of Smith's work is the concern that we no longer seem to relate to our bodies.

FIGURE 13–36
DONALD SULTAN
Morning Glories June 20, 1991, 1991
Charcoal on paper, 30 × 22"
Courtesy, Knoedler & Company, New York

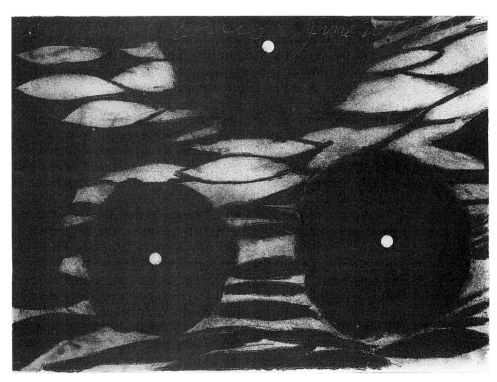

Although most certainly a feminist, Smith does not seem to be speaking of something applicable only to women; the problem as she expresses it in her work is universal. As a corrective measure in view of the intense forces of depersonalization in our culture, she suggests that we become more familiar with our various bodily functions. To this end, the artist has embarked on a long series of works investigating the various systems of human anatomy, including the cardiovascular system, the lymphatic system, the nervous system, and the male and female reproductive systems (Fig. 13–37).

The image in this drawing, symmetrically splayed and isolated on a shimmering silvery ground, has the appearance of an altar cloth or ecclesiastical banner. Although undoubtedly human, these testicular forms are expressed in terms so general that they might also refer to the male reproductive system of other animals, or even to the stamens of a flower. We may also see in this image a homunculus, or little man, frowning under the burden of long, ungainly antennae.

In the history of medicine, the homunculus represents the pattern for the development of the future man, planted in the receptive womb. In regard to the science of human behavior, the homunculus is an image of consciousness, one that is depicted as a little man lodged in our brain who tells us what to do. Although we have known for decades that consciousness is no more than a series of electrochemical reactions, as a culture we still cling to the image of the homunculus, which helps perpetuate the Cartesian division of body and mind. The wisdom of this division is now being questioned by many thinkers, foremost amongst them artists like Smith.

The drawing by Thaddeus Strode (Fig. 13–38) is especially declarative of its spiritual content. The title indicates that this image is one from a series of drawings that, taken as a whole, alter the forms in William Blake's illustrated *Book of Job* from the eighteenth century. The title also has strong overtones of juvenile pop culture, and, indeed, other drawings from the series contain collaged comic-book material.

Some of the elements in this drawing relate to the trials of Job as told in the Old Testament and as interpreted by Blake according to his antimaterialist, spiritual program. The central image here, the tree, appears in the more peaceful scenes in Blake's version presumably as a symbol of natural shelter and comfort.

FIGURE 13–37
KIKI SMITH
Uro Gental Male, 1990
Ink on Japanese paper, 30 × 22"
Courtesy, Shoshana Wayne Gallery, Santa Monica

FIGURE 13–38
THADDEUS STRODE
Book of Job, Mutated after William Blake (Counting the Fingers Until the Soul Splits #5), 1991
Mixed media on paper, 17 × 14″ each
Courtesy, 1301, Santa Monica

In this re-creation, the sad-eyed face behind the tree could be the face of the complaining Job, although it bears a striking resemblance to the physiognomy of that endearing space alien E.T.

The tree is composed of splotches of thrown ink, and a similar technique has been used to achieve the ten descending mantras that line up like the successive images in a time-lapse photo of a moon rising. Anyone who has tried this drawing technique knows that getting the ink to fall where it is wanted takes a great deal of concentration. This kind of focused attention on a repeated movement, in this case the flick of a brush, carries meditative connotations. Lest there be any doubt, the act of repetition is introduced again at the bottom of the page, where an ink-stained fingertip leaves prints of fading value as it stamps its way across the page, recalling the multiplication of votive candles one finds burning before a statue of a saint in a Catholic church. Note too the implication of pain in this drawing, a theme running throughout the Book of Job, but that in the context of the Buddhist and Hindu mantras seems reminiscent of the trials by fire performed by Indian fakirs.

Joseph Nechvatal does not shy away from employing the most sophisticated of current technologies to allude to the universal and the spiritual. He has written about the superabundance of imagery transmitted to us through the media, and typically his work crackles with countless broken lines and image fragments reminiscent of nothing so much as poorly received electronic signals.

Nechvatal's process usually begins with found imagery that he refines and manipulates through a series of redrawings, rephotography and video, until the "drawing" itself resembles a screen on which electrical impulses have been recorded. This drawing is then digitized by a computer that in turn instructs a robot how to lay down the paint.

The image we see in Figure 13–39 is one from a series produced during the artist's stint as the Louis Pasteur artist-in-residence at the Ledoux Institute in Arbois, France. In this work, as in others from the same series, a computer

FIGURE 13–39
JOSEPH NECHVATAL
Vital Attacque II
Computer robotic assisted acrylic
on canvas, 2 × 3 meters
Courtesy, the artist

virus, devised by the institute's technicians, was introduced into the program. The traces of this virus can be detected in the scattered middle-tone pattern that drifts across the otherwise symmetrical image, appearing basically as "visual noise." The idea for incorporating the virus in the work comes from the acknowledgement of the fact that the Pasteur Institute was the first to identify and isolate the AIDS virus.

Viewed as a victim of a viral attack, the strongly evocative, quasi-figurative image at the center of this work is Everyman, as indeed its very generalized features would lead us to believe.* The figure also bears a remarkable similarity to the colossal stone images of Shiva conceived in the gloom of a Hindu rock-cut temple. The overall image in this drawing impresses us with its aura of mystery as we try to comprehend the relationship between the intangible, dispersed field of light and the contrasting solidity of the haunting figurative mass.

*See page 297 for a definition of the term "Everyman" in the context of the Neo-Expressionist style of art.

Glossary of Media

Papers

The following are definitions of terms commonly used to distinguish the qualities of one paper from another; see also the accompanying table, which indexes popular drawing papers according to relative cost and physical properties.

Acid Free Papers without acid content. Either 100 percent rag papers, or papers that have been chemically treated to obtain a neutral pH. Acid free papers are permanent, that is, they will not yellow or become brittle.

Block Solid pack of papers, prestretched and glued on all four sides. Suitable for direct application of wet media.

Cold Press Refers to the texture of certain 100 percent rag papers. Cold press papers have a medium rough texture as a result of being pressed with cold weights during processing. (See also *Hot Press* and *Rough*.)

Hot Press Refers to the texture of certain 100 percent rag papers. Hot press papers have a smooth texture as a result of being pressed with hot weights during processing. (See also *Cold Press* and *Rough*.)

Ply Refers to the number of layers which constitute a sheet of paper or paper board. For example, two-ply papers are made of two layers bonded together.

Rag Papers made from cotton rag or a combination of cotton rag and linen. Rag papers are acid free and permanent. (See also *Wood Pulp*.)

Rough A designation indicating the paper has a good "tooth." In reference to 100 percent rag papers, "rough" means that the paper has not been pressed and as a result has a naturally bumpy surface. (See also *Cold Press* and *Hot Press*.)

Sizing A dilute glue that is either mixed with the wood or rag pulp during the paper-making process, or applied externally to a finished sheet of paper. Sizing inhibits the "bleeding" or spreading of wet media on paper.

Tooth Textural character of a paper due to its fibrous surface. A "good tooth" is desirable for drawings made with abrasive media, such as charcoal or conté crayon.

TABLE OF PAPERS

Paper	Price	Fiber/Color	Weight	Surface Qualities	Recommended Media	Other Characteristics
Bond	moderate	usually wood pulp, although better quality has mixture of rag and wood pulp, or even 100% rag; generally white	light to medium weight—in neighborhood of 50 pounds	lighter weights usually have smooth finish; heavy weights generally have more tooth; erases well	all-purpose; recommended especially for dry media and pen and ink	semipermanent, available in separate sheets and a wide range of pads and bound sketchbooks
Bristol Board	moderate	wood pulp, partial rag or 100% rag; usually very white	heavy—sometimes several ply	available in plate (smooth) finish, or kid (vellum) finish; semiabsorbent hard surface, erases very well	pencil, crayon, pastel, watercolor; especially recommended for ink	can stand some wetting without buckling; better qualities are especially permanent; sold loose or in pads
Charcoal Paper	moderate	some rag content, better qualities 100% rag; wide range of color	medium	good tooth on both surfaces; one surface usually has imprinted "woven" texture and the other surface is like vellum; erases well	charcoal, pastel, or conté crayon	sold in single sheets or in pads
Etching Papers	expensive	usually 100% rag, white or off-white; unsized	heavy	very absorbent; soft surface; does not erase well	dry, soft media—pastel, charcoal, crayon, soft pencil, or powdered graphite	sold in single sheets, generally in large to very large sizes
Illustration Board	moderate to expensive	two ply; consists of watercolor or drawing paper bonded to cardboard; better qualities use 100% rag paper mounted with acid free binder	heavy	varies according to paper used	all-purpose; especially good for watercolor and ink	can stand some wetting without buckling; better qualities have great permanency
Newsprint	inexpensive	wood pulp; high acid content; grayish white or yellow white	light	available in smooth or "rough"—even the rough grade does not have much tooth; soft media erases fairly easily	vine charcoal, compressed charcoal, soft pencil, conté crayon	very impermanent, yellows quickly; fragile, usually available in large pads
Oatmeal	inexpensive	rough wood pulp; oatmeal color	medium	very rough; soft, fragile surface	soft media—pastel, charcoal, crayon	not permanent
Rice Paper	expensive	rice fiber; usually white	very light	very soft and absorbent surface; will not erase easily	sumi ink and water color; also collage	
Sketch Paper	moderate	neutral pH wood pulp; off-white	medium-light	medium tooth, surface sized; withstands repeated erasure	pencil, charcoal, pen and ink	
Tag Board	inexpensive	wood pulp; yellowish tan	medium-heavy	slick; erases well	ink, soft pencil, oil pastel	available in single sheets, large size
Watercolor Paper	moderate to very expensive	usually partial rag to 100% rag; usually very white	medium-heavy to very heavy	hot pressed, cold pressed, and rough; absorbent	designed for watercolor; but hot pressed may be used for pen and ink and hard pencil, and cold pressed is good for all pencils	the heaviest papers will not buckle when wet; lighter weights must be "stretched" before use with wet media; this is done by soaking papers for a few minutes and then using gummed paper tape to fasten edges to a wooden board

Weight Refers to the thickness and density of a paper. Typically, the weight of a paper in a ream (500 sheets) determines its price per sheet.

Wood Pulp The chief ingredient of inexpensive papers. Papers made entirely of wood pulp are highly impermanent, unless they have been treated to neutralize their acid content. (See also *Rag.*)

Dry Media

CHARCOAL (FIG. G–1)

Among the most popular of drawing media, charcoal is made by baking wooden sticks until essentially only pure carbon is left. Capable of producing countless effects from thin lines to husky tones, charcoal comes in two forms, vine and compressed.

FIGURE G-1
Counter clockwise: (1) Vine charcoal, (2) Vine charcoal, (3) Vine charcoal, (4) Compressed charcoal, (5) Stump, (6) Stump, (7) Stump, (8) Charcoal pencil, (9) Charcoal pencil, (10) Carbon pencil, (11) Sandpaper pad, (12) Large rubberband, (13) Art bin, (14) Chamois, (15) Clips, and (16) Workable fixative

Vine Charcoal is easily erased so it is excellent for the early stages of a drawing when a succession of rapid changes are necessary. But its fragility may also frustrate unwary students who accidentally smear and lighten their drawings. It comes in different diameters, from jumbo (⅝″) to fine (⅜″), and in varying hardnesses.

Compressed Charcoal is manufactured from powdered charcoal mixed with a binder. Capable of a broader range of tones and more intense blacks than vine charcoal it is also more permanent and harder to erase. It may be purchased in soft blocks and also in round sticks or pencils of varying hardnesses.

Charcoal Accessories include a chamois, which is a thin piece of leather used to lighten, blend, or erase deposits of charcoal; a tortillon, or rolled paper stump, which is also used for blending; a sandpaper pad for sharpening charcoal to a fine point; and fixative (see also *Fixatives* in the Glossary of Media, pp. 320–21).

CHALKS (FIG. G–2)

Chalks are manufactured from precipitated chalk, pigments, and generally non-fatty binders (such as gum tragacanth or methyl cellulose). The most popular forms of chalk used by the artist are conté crayon, soft pastels, hard pastels, and lecturer's chalk.

FIGURE G-2
Left to right: (1) Conté crayon
(white), (2) Conté crayon (black),
(3) Litho crayon, (4) Soft pastel, (5)
Hard pastel, (6) Carbon pencil, (7)
Conté pencil, and (8) Lecturer's
chalk

Conté Crayon contains, in addition to the usual chalk, pigments and binders, small amounts of ball clay, soap, and beeswax. It is semihard with a slightly waxy texture, making it difficult to erase. It comes in both pencils and square sticks (which can be sharpened by using fine sandpaper), and it may be purchased in three hardnesses. Pressed with its edge flush against the paper, stick conté achieves thick marks; when sharpened or rotated to a corner or edge, it produces thin and incisive marks. Traditionally available only in black, white, assorted grays, brown (or bistre), and earth reds (sanguine, light medium, and dark), conté crayon has recently been introduced in a wide range of blendable colors.

Soft Pastels are made with a high grade of precipitated chalk, nonfatty binder, and pigment or dyes. The buttery texture of this medium is due to the very slight amount of binder used in its manufacture. Soft pastels come in a full spectrum of colors with a range of tones under each hue. The better qualities possess a good degree of lightfastness because they are made with true pigments, and their hue is generally designated by the name of the pigment (such as raw umber, viridian, etc.). It should be noted that some pigments, such as the cadmium reds and yellows, are toxic, so breathing in their dust should be avoided. The less expensive pastels utilize dyes instead of pigments and are not guaranteed lightfast, but they are probably less toxic. Pastel drawings must be handled and stored with care as their surfaces will always be fragile. The surface of a pastel drawing may be somewhat stabilized by a light application of fixative, but a heavy application of fixative will dull its color. (See also *Fixatives* in the Glossary of Media, pp. 320–21.)

Hard pastels, in contrast to soft pastels, contain a greater percentage of binder, including some fatty agents. They are not as prone to scatter pastel dust as the softer variety, but they are also more difficult to erase. (See also ''Pastel Pencils'' under *Colored Pencils* in the Glossary of Media, p. 319.)

Lecturer's Chalk is very soft and nonfatty. It comes in large blocks and in a broad range of colors. Lecturer's chalk is excellent for gesture drawing and for rapidly applying broad areas of tone.

GRAPHITE MEDIA (FIG. G–3)

Graphite is soft, crystallized carbon, which is available in an assortment of hardnesses, from 9H (the hardest) through the intermediate degrees of H, F, and HB, to the soft pencils from 1B to 8B (the softest). Graphite is easily manipulated by smearing, smudging and erasing. But, particularly in the softer range, overworked areas can take on an unappealing shine and mottled appearance. Graphite comes in the following forms:

FIGURE G-3
Left to right: (1) Carpenter's pencil, (2) Drawing pencil, grade B, (3) Ebony pencil, (4) Drafting pencil, (5) Woodless pencil, (6) Leadholder, (7) Blackie drawing pencil, and (8) Graphite stick

Graphite Pencils, sometimes referred to as "lead" pencils, actually contain a mixture of clay and ground graphite. An "ebony" pencil is somewhat greasier than regular drawing pencils and is capable of deep blacks and lustrous tones. A "carpenter's" pencil, or "broad sketching" pencil, is excellent for layout and blocking in the large masses of a subject.

Graphite Sticks have the same ingredients as graphite pencils, but without the wooden casings. Graphite sticks apply broader single stroke marks but are usually available only in HB, 2B, 4B, and 6B. Several years ago, a lacquer-coated "woodless pencil" was introduced which may be sharpened to a point and which keeps the hands from getting dirty.

Graphite Leads come in a wider range of hardnesses than do graphite sticks and are used in mechanical lead holders.

Powdered Graphite may be made by crushing leads or sticks, or may be purchased in tubes from a hardware store (it is used as a lubricant). Rubbed onto a smooth surfaced board or paper with a cloth, tissue, or soft brush, powdered graphite can produce evenly blended, atmospheric values.

CRAYONS (FIG. G–4)

Crayons are either wax or oil based. Wax crayons are the kind manufactured for children; they are made with paraffin and stearic acid and are not color permanent. Colored pencils, which contain a wax binder are, technically speaking, crayons. Oil crayons include lithographic crayons, China markers, and oil pastels.

FIGURE G-4
Left to right: (1) Colored pencil, (2) Pastel pencil, (3) China marker, (4) Litho crayon, (5) Colored pencil, water soluble, and (6) Oil pastel

Colored Pencils are available in a wide variety of brilliant and blendable colors. Made with a wax binder, they provide little resistance when drawing, but they are also not easy to erase. And due to the hardness of the binder, the value range of many brands is much more limited than graphite drawing pencils. Two alternatives are "pastel pencils," which produce a wider range of values than conventional colored pencils, and "watercolor pencils," which can be dipped in water or moistened with a brush to produce washes.

Lithographic Crayons are made for the lithographic printing process, but they have become popular with artists as a drawing medium. Made only in black, they come in pencil and stick forms, and in six degrees of hardness, from #00, which is the softest and contains the most fatty acid (grease), to #5, which is the hardest and most similar to graphite in its grease content. Litho crayons are soft and pliable and make rich velvety blacks, but they are virtually impossible to erase. However, they may be scraped and flecked on heavier papers, and they can be made into a wash when brushed with turpentine or mineral spirits. Note: Never use solvents without proper ventilation.

China Markers have an oily texture and an ease of manipulation similar to litho crayons, and they may be obtained in a broad range of colors.

Oil Pastels are oil paint in a stick form. Soft in texture, they may be applied thickly or thinned with solvents and brushed into a wash; generally they dry overnight. They also may be scraped with a razor or smudged and smeared with a soft cloth or finger (in this case it is advisable to wear a plastic glove). Oil pastels are available in a full spectrum of colors, including iridescent hues. Note: Never use solvents without proper ventilation.

COLORED MARKERS

By colored markers we refer to the wide variety of so-called "felt-tip" pens now on the market. Manufactured in fine, bullet-shaped, and chisel tips, they come in a broad assortment of colors which are bright, flat, and sometimes impermanent. Colored markers may be hazardous if they contain a solvent such as xylene or toulene as a vehicle for the colorant. More recently introduced, however, are acrylic and opaque paint markers, which allegedly are nontoxic and colorfast.

Ballpoint Pens may be considered a form of colored markers. Although long favored by artists because they are inexpensive, fluid, uniform of line and possess an aura of "Pop" culture, many ballpoint pen inks are unfortunately also highly impermanent.

ERASERS (FIG. G–5)

As corrective devices, erasers should be used in moderation, lest they become a kind of "crutch." More appropriately, erasers should be viewed as drawing tools by virtue of their ability to initiate and alter surface textures, as well as to blend, lighten, smear, and even create hatched or tracery-like white lines through deposits of charcoal, conté, and graphite. Selected erasers for the artist include:

FIGURE G-5
Top to bottom: (1) RubKleen pencil eraser, (2) Pink Pearl pencil eraser, (3) Combination plastic eraser, (4) Fiberglass ink eraser, (5) Kneaded eraser, and (6) Artgum eraser

Kneaded Erasers are soft and therefore less likely to tear thin papers such as newsprint. They are easily formed into a point to pick out accents from dry media; and when this eraser becomes dirty, kneading it will produce a clean surface. When using media which does not erase easily, such as colored pencil or conté crayon, you may use the kneaded eraser to lift off the top layer of the deposit prior to using a harder eraser to finish the job.

Artgum Erasers are good all-purpose erasers. Crumbly and nonabrasive, they are particularly effective for manipulating charcoal and graphite.

Pink Erasers in a block form are serviceable for all dry media. More abrasive than kneaded, artgum, or vinyl erasers, they are also more effective on heavy deposits of charcoal, conté, and graphite. Not recommended for soft papers.

Vinyl or Plastic Erasers occupy an intermediate position between artgum and pink erasers, in both their ability to deal with dense deposits of dry media, and in their abrasive qualities.

Fiberglass Ink Erasers are very abrasive and should be used on hard papers only.

FIXATIVES

Fixatives traditionally consist of a very dilute solution of shellac or cellulose lacquer; they are now being replaced by the more chemically stable acrylic lacquers. Fixative is used to protect the delicate surface of charcoal or pastel drawings by minimizing the accidental dusting-off of the media. Fixative is applied by spraying in one or more *light* even coats, and it should be allowed to dry between applications.

Workable Fixative will help to stabilize the deposits on your paper, minimizing unintentional obliteration of your image and allowing you to build up deeper tones.

Nonworkable Fixative is formulated for use on a finished work. Some artists use fixative to cut down on the sheen of graphite drawings.

Caution: Solvents in fixatives are harmful to your health as are the airborne particles of the fixative itself. Always use fixative in a well-ventilated area and in accordance with the manufacturer's directions.

Wet Media

INK

Ink is a drawing medium with a venerable tradition both in our culture and in oriental cultures. It may be used in a variety of pens or diluted with water to produce graded washes that are applied with a brush. The ink most commonly used by artists is a liquid ink called "india ink," which comes in a variety of colors under two basic categories: waterproof and nonwaterproof. Ink in a solid form, called "sumi ink," has been steadily gaining in popularity.

Waterproof Inks contain shellac and borax so that the dried film will withstand subsequent wetting without dissolving. This is an advantage when you wish to layer washes in order to build areas of tone or when you wish to add washes to a line drawing.

Nonwaterproof Inks are more suited to fine line work and wet-on-wet techniques, since the dried film will not stand up to further wetting. This may work to your advantage if you wish to make changes in your drawing. When using line in combination with washes, it is advisable to begin with your washes and add line only after the washes are dry or near dry.

Sumi Ink, an especially high grade of ink manufactured in Japan, comes in a solid block or stick. Traditionally it is rubbed with water on an ink stone until the desired intensity is produced. Both ink and stone are usually available in art supply stores or oriental specialty shops.

Opaque Inks, intended for use by calligraphers and designers, are less frequently used in a drawing context because they cannot be successfully diluted to produce graded washes. For variety's sake you may wish to try using an opaque white ink in combination with a darker ink or tinted paper.

PENS (FIG. G–6)

There are a large variety of pens on the market. Some are designed especially for freehand drawing; others, designed for lettering or drafting, may nonetheless be used by the fine artist.

Reed or Bamboo Pens do not hold much ink and become blunt quickly if they are oversharpened. They are, therefore, best suited for bold, short marks and do not lend themselves to flowing line.

Steel Pens come in a wide range of shapes and sizes and are used with a pen holder. The flexible "crowquill" will give a very fine line and is excellent for small scale cross-hatch drawing. It should, however, be used on a smooth, hard paper because of its tendency to catch on the fibers of a soft or rough paper. The "bowl-pointed" pen yields a somewhat heavier, smooth flowing line. "Calligraphy" pens produce a line of the most varied width. They come in a variety

FIGURE G-6
Top row left to right: (1)
Waterproof ink suitable for
technical pens, (2) India ink
suitable for fountain pens, (3) Sumi
ink and ink stone, and (4) Sepia ink
for fountain pens
Bottom row left to right: (1)
Technical pen, (2) Fountain pen
with drawing nib, (3) Nylon tipped
marker, (4) Steel pen, fine nib, (5)
Steel pen, hawkquill, (6) Steel pen,
calligraphy, (7) Steel pen, crow
quill, and (8) Bamboo pen

of styles and sizes, some of which are well suited to drawing. Because calligraphy pens use a greater amount of ink than the genuine drawing pens, they often have a small reservoir built into the nib to minimize the frequency with which you must dip them.

Fountain Drawing Pens are usually designed to accept interchangeable nibs of varying widths. They are very convenient, especially for field use. *Caution:* Only inks formulated for use in these pens should be used, and ink should not be allowed to dry in the pen.

Technical Pens are designed to give a line of uniform width and are used principally for drafting, as their stylus-type nib is compatible with the use of a straight-edge. They will accept interchangeable nibs which come in a variety of widths. Unlike other pens, the line of a technical pen is free-flowing in any direction, and for nondrafting purposes its use may be extended to stipling and cross-hatching. The nib mechanism is delicate so care must be used in cleaning it. *Caution:* Only inks formulated for use in technical pens should be used. In order to function properly these pens need to be disassembled and cleaned often, and ink should never be allowed to dry in them.

PAINTS

The use of painting media in a drawing context will help accustom you to thinking of your drawing surface in terms of broad areas and will discourage you from limiting your mark-making to linear elements. Although color is increasingly being used in contemporary drawing, you may wish to limit your palette severely at first so that you can concentrate more fully upon the tonal structure of your drawing. A tube each of black and white paint is generally thought sufficient for the student in a beginning or intermediate level drawing class. Alternatively, you may try using white in combination with one warm color, such as burnt sienna, and one cool color, such as prussian blue.

Acrylic Paints are made with pigments or permanent dyes bound with an acrylic (a kind of vinyl) polymer emulsion. Acrylics are soluble in water when wet but dry quickly to a tough waterproof film. These properties, which allow you to apply successive layers of paint in a short amount of time, will also make the

blending of colors upon the working surface very difficult. You may use the paints directly on paper or board, or if you prefer, you may first prime your paper or board with acrylic gesso.

Gouache (or Opaque Watercolor) is an opaque water-based paint with a gum arabic binder. Intended primarily for use by designers, these paints are tinted generally with dyes rather than with true pigments and should not be considered permanent. Colors can be mixed on the palette but will not blend well once they are laid on the support. Gouache is a good medium to use in combination with other media since its opacity will allow you to cover unwanted marks; and when dry, its matte, slightly chalky surface is very receptive to media such as graphite, charcoal and pastel. Drawings made with a limited range of light and dark colors on tinted papers are particularly handsome.

Oil Paint is generally a highly permanent medium comprised of pigments bound with linseed oil. Oil paint colors blend superbly both on the palette and upon the support, and the colors dry true without darkening or turning chalky. If these paints are used directly on paper, the oil will spread through the paper fibers causing an oily halo around the color and weakening the paint film. For this reason, some artists prefer to coat their paper with acrylic gesso prior to painting with oils.

Watercolor is a transparent water-based paint with a gum arabic binder. Watercolor is especially appreciated for its capacity to recreate the effects of outdoor light and the vagaries of weather. It is generally applied in layers of dilute washes and somtimes wet on wet. When left to dry in separate patches, the areas of color tend to form crisp outlines and thus achieve the dappled effect of sunlight and shade. Although a translucent white (called Chinese White) is available, purists frown upon its use, advocating instead leaving untouched the ground of the paper where the highest values are desired.

BRUSHES (FIG. G–7)

In choosing a brush from the seemingly endless variety available, you should consider the bristle in relation to the media you intend to use. In regard to size, a good rule of thumb is to select the largest size possible for any given task. This will cut down on your work time and will impart to each brushstroke a greater immediacy.

Artists' brushes come in three major styles: "flats," which have broad, straightedged tips; "brights," which are a little less flat with more rounded edges; and "rounds," which come to a fine point when more flexible hairs are used.

Proper care of your brushes will guarantee them a longer life, so clean them thoroughly after use, never leave them standing for more than a moment in water or solvent, and store them so that their bristles are not bent.

Housepainting Brushes, with either natural or synthetic bristles, are commonly available in sizes ranging from ½-inch to 7 inches or larger. Artists use them primarily for applying gesso, but they may be used also for painting in large gestural strokes.

Bristle Brushes are made from bleached hog's bristles. The individual bristles are fairly stiff and slightly forked at the tips. These properties prevent the brush from coming to a fine point but allow it to carry a good load of paint. They are traditionally favored for oil painting but may also be used for acrylics. The flat style is generally considered the most versatile. The round style lends itself well to drybrush technique and to the blending of dry media, such as pastel.

FIGURE G-7
Left to right: (1) Sable, round, (2) Sumi, (3) Nylon, flat, (4) Nylon, round, (5) Bristle, flat, (6) Bristle, round, and (7) House-painting brush

Sable Brushes are made from a mink-like animal. The individual hairs are tapered and in the best quality brushes are carefully arranged so that the wetted brush comes gradually to a fine point. The flexibility, resiliency, and fine pointing properties of this brush make it a favorite for use with watercolor or detailed passages in oil paint. Sable brushes range in price from expensive to extremely expensive, but if properly looked after they will last for years. Use with acrylics, however, will diminish the life of a sable brush.

Synthetic Brushes generally have nylon bristles and may imitate the properties of either hog's bristle or sable hair. Less expensive than bristle or sable, these brushes clean easily and are, therefore, often used with acrylics.

Japanese Brushes come in a variety of styles suitable to water-based media. The round goat's hair brush set in a bamboo handle is available in medium to large sizes, and it possesses a moderate pointing capabilty. It is excellent for ink and ink washes. Far less expensive, though not nearly so versatile as a sable, these brushes may also be used for watercolor. "Hake" brushes, made with soft white sheep's hair, are wide and flat. More sensitive than the housepainting brush, they are best used for laying down watercolor washes.

Other Brushes include camel's hair or squirrel's hair. These range in price from inexpensive to moderately expensive depending upon the quality of the hair and the care put into their manufacture. Although they lack the spring and fine pointing qualities of a sable brush, they will hold a fair amount of water and therefore may be used for aqueous media. They are too soft to be used with oil paints.

Glossary of Terms

Abstraction The process of selecting and organizing the visual elements to make a unified work of art. Also a twentieth-century style of art in which the particulars of subject matter are generalized in the interests of formal (compositional) invention.

Achromatic Denotes the absence of hue and refers to the neutrals of black, white, and gray. (See also *Chromatic* and *Neutrals*.)

Actual Grays Uniform value achieved by the continuous deposit of drawing media, such as blended charcoal or ink wash. (See also *Optical Grays*.)

Ambiguous Space A visual phenomenon occurring when the spatial relationships between positive and negative shapes are perceptually unstable or uncertain. (See also *Figure-Ground Shift, Interspace,* and *Positive-Negative Reversal*.)

Analogous Color Scheme A color arrangement based on several hues that are adjacent or near one another on the color wheel. (See also *Analogous Colors* and *Color Scheme*.)

Analogous Colors Colors that are adjacent, or near one another, on the color wheel and therefore have strong hue similarity. One set of analogous colors is yellow, yellow-green, green, and blue-green. (See also *Analogous Color Scheme* and *Color Scheme*.)

Angling The process of transferring perceived angles in the environment to a drawing surface.

Approximate Symmetry A form of visual balance which divides an image into similar halves but which avoids the potentially static quality of mirror-like opposites associated with symmetrical balance. (See also *Asymmetrical Balance* and *Symmetrical Balance*.)

Artistic Block The interruption of an artist's natural creative output. Often accompanied by feelings of severe frustration and loss of confidence.

Artistic Rut The feeling that you are doing the same thing over and over and not getting anywhere.

Asymmetrical Balance Achieving visual equilibrium in a drawing by adjusting

325

such qualities as the scale and spatial orientation of opposing parts. (See also *Approximate Symmetry* and *Symmetrical Balance*.)

Atmospheric Perspective A means for achieving the illusion of three-dimensional space in a pictorial work of art. Sometimes called aerial perspective, it is based on the fact that as objects recede into the distance their clarity of definition and surface contrast diminish appreciably.

Background The most distant zone of space in a three-dimensional illusion. (See also *Foreground* and *Middleground*.)

Basetone The darkest tone on a form, located on that part of the surface which is turned away from the rays of light. (See also *Chiaroscuro*.)

Blind Contour Line drawings produced without looking at the paper. Such drawings are done to heighten the feeling for space and form and to improve eye-hand coordination.

Brilliance The vividness of a color.

Cast Shadow The shadow thrown by a form onto an adjacent or nearby surface in a direction away from the light source. (See also *Chiaroscuro*.)

Chiaroscuro In the pictorial arts, chiaroscuro refers to the gradual transition of values used to create the illusion of light and shadow on a three-dimensional form. The gradations of light may be separated into five separate zones: highlight, quarter-tone, halftone, basetone, reflected light, and cast shadow.

Chroma See *Intensity*.

Chromatic Refers to color or the property of hue. (See also *Achromatic* and *Hue*.)

Chromatic Gray Gray created by adding hue to a neutral or by mixing complements to achieve a neutralized color. (See also *Neutral*.)

Color Climate Sensations of moisture or dryness associated with the color temperature of a hue.

Color Scheme An association of selected colors that establishes a color harmony and acts as a unifying factor in a work of art. (See also *Analogous*, *Complementary*, *Discordant*, *Monochromatic*, and *Triadic* color schemes.)

Complementary Color Scheme A color arrangement based on hues that are directly opposite one another on the color wheel. (See also *Color Scheme* and *Complementary Colors*.)

Complementary Colors Colors that are directly opposite one another on the color wheel and represent the strongest hue contrast, such as red and green, blue and orange, and yellow and purple. (See also *Complementary Color Scheme*.)

Complex Local Color The natural range of hues of some objects that, under normal light, create the overall impression of a dominant local color. (See also *Local Color*.)

Cone of Vision A conical volume that constitutes the three-dimensional field of vision. Its apex is located at eye level; its base lies within the imagined picture plane (See also *Picture Plane*.)

Constellation The grouping of points in a three-dimensional space to form a flat configuration or image.

Content The meanings inferred from the subject matter and form of a work of art.

Contour Line A line of varying thickness—and often tone and speed—used to

suggest the three-dimensional qualities of an object. Contour line may be applied along, as well as within, the outer edges of a depicted form.

Convergence In the system of linear perspective, parallel lines in nature appear to converge (come together) as they recede.

Cool Colors Psychologically associated, for example, with streams, lakes, and foliage in the shade. Cool colors such as green, blue-green, blue, and blue-purple appear to recede in a relationship with warmer colors. (See also *Warm Colors*.)

Cropping Using a format to mask out parts of an image's subject-matter.

Cross-Contour Lines Contour lines that appear to go around a depicted object's surface, thereby indicating the turn of its form.

Cross-Hatching The intersecting of hatched or massed lines to produce optical gray tones. (See also *Hatched Lines* and *Optical Grays*.)

Diagrammatic Marks Those marks and lines artists use to analyze and express the relative position and scale of forms in space.

Diminution In linear perspective, the phenomenon of more distant objects appearing smaller.

Discordant Color Scheme A color arrangement based on hues that compete or conflict, resulting in a relationship of disharmony. (See also *Color Scheme*.)

Envisioned Images Depictions that are based wholly or in part on the artist's imagination or recall.

Eye-Level The height at which your eyes are located in relation to the ground plane. Things seen by looking up are above eye-level (or seen from a "worm's eye" view); things seen by looking down are below eye-level (or seen from a "bird's eye" view).

Figure The representation of a recognizable object or nonrepresentational shape (such as a tree, a letter of the alphabet, or a human figure), which may be readily distinguished from its visual context in a drawing.

Figure-Ground Shift A type of ambiguous space which combines aspects of interspace and positive-negative reversals. It is characterized by "active" or somewhat volumetric negative areas and by the perception that virtually all the shapes are slipping, or shifting, in and out of positive (figure) and negative (ground) identities. (See also *Ambiguous Space*, *Interspace*, and *Positive-Negative Reversals*.)

Figure-Ground Stacking A sequential overlapping of forms in a drawing, making the terms figure and ground relative designations.

Fixed Viewpoint Depicting an image in a way that is consistent with its appearance from one physical position.

Force lines Lines used to reveal the structure of a form by indicating the counterbalancing of one mass against another.

Foreground The closest zone of space in a three-dimensional illusion. (See also *Background* and *Middleground*.)

Foreshortening In foreshortening, the longest dimension of an object is positioned at an angle to the picture plane.

Form The shape, structure, and volume of actual objects in our environment, or the depiction of three-dimensional objects in a work of art. Form also refers to a drawing's total visual structure or composition.

Formal Refers to an emphasis on the organizational form, or composition, of a work of art.

Format The overall shape and size of the drawing surface.

Form-Meaning That aspect of content which is derived from an artwork's form, that is, the character of its lines, shapes, colors, etc., and the nature of their organizational relationships overall.

Form Summary Simplifying the form description of a complex or articulated object, usually for purposes of analysis or to render a subject's three-dimensional character more boldly.

Gestalt A total mental picture, or conception, of a form.

Gesture Drawing A spontaneous representation of the dominant physical and expressive attitudes of an object or space.

Grisaille The arrangement of an image into varied steps of gray values.

Ground The actual flat surface of a drawing, synonymous with a drawing's opaque picture plane. In a three-dimensional illusion, ground also refers to the area behind an object (or figure).

Ground Plane A horizontal plane parallel to the eye-level's plane. In nature this plane may correspond, for instance, to flat terrain, a floor, or a table top.

Halftone After the highlight and quarter-tone, the next brightest area of illumination on a form. The halftone is located on that part of the surface which is parallel to the rays of light. (See also *Chiaroscuro.*)

Hatched Line Massed strokes that are parallel or roughly parallel to each other. Used to produce optical gray tones. (See also *Cross-Hatching* and *Optical Grays.*)

Highlight The brightest area of illumination on a form, which appears on that part of the surface most perpendicular to the light source. (See also *Chiaroscuro.*)

History Painting A picture which is usually painted in a grand or academic manner and which represents themes from history, literature, or even the Bible.

Horizon Line The line formed by the *apparent* intersection of the plane established by the eye-level with the ground plane. Often described as synonymous with eye-level.

Hue The name of a color such as red, orange, blue-green, etc. The term "chromatic" is sometimes used to refer to the property of hue. (See also *Chromatic.*)

Installation Art A form of mixed media, multidisciplinary art that interfaces with the architectural space or environment in which it is shown.

Intensity The saturation, or purity, of a color. Colors as they usually come from the tube are at maximum intensity. (Sometimes also referred to as *Chroma.*)

Interspace Sometimes considered synonymous with negative space. In many works of modern art, however, it is more accurately described as a type of ambiguous space, in which negative shapes have been given, to a certain degree, the illusion of mass and volume. (See also *Ambiguous Space.*)

Intuition Direct mental insight gained without a process of rational thought.

Layout The placement of an image within a two-dimensional format.

Light-Window Usually refers to one of several light sources in a multipaned window or door.

Linear Perspective The representation of things on a flat surface as they are arranged in space and as they are seen from a single point of view.

Local Color The actual color of an object, free of variable or unnatural lighting conditions. (See also *Complex Local Color.*)

Local Value The inherent tonality of an object's surface, regardless of incidental lighting effects or surface texture.

Luminosity Refers to the appearance of light glowing from inside an area of color.

Mass The weight or density of an object.

Mass Gesture A complex of gestural marks used to express the density and weight of a form.

Measuring A proportioning technique using a pencil to gauge the relative sizes of the longest and shortest dimensions of an object.

Middleground The intermediate zone of space in a three-dimensional illusion. (See also *Background* and *Foreground.*)

Moire A pattern like that of watered silk, which results from laying one pattern on top of another (such as the stripes of a zebra seen through the bars of a cage).

Monochromatic Consisting of one color. (See also *Polychromatic.*)

Monochromatic Color Scheme A color arrangement consisting of value and intensity variations of one hue. (See also *Color Scheme.*)

Monocular Vision Vision which uses only one eye, and therefore only one cone of vision, to perceive an object.

Motif The repetition of a visual element, such as a line, shape, or unit of texture, to help unify a work of art.

Negative Shape The pictorial, flat counterpart of negative space in the real world.

Neutrals Refers to black, white, and gray. (See also *Achromatic* and *Chromatic Gray.*)

Non-Objective A style of art in which the imagery is solely the product of the artist's imagination and, therefore, without reference to things in the real world.

One-Point Perspective In one-point perspective, a rectangular volume is centered on the line of vision, thus causing all receding (horizontal) parallel lines to appear to converge, or meet, at one point on the horizon line.

Optical Color Refers to the eye's tendency to mix small strokes of color that are placed side by side or overlapped.

Optical Grays The eye's involuntary blending of hatched or cross-hatched lines to produce the sensation of a tone. (See also *Actual Grays* and *Cross-Hatching.*)

Outline Usually a mechanical-looking line of uniform thickness, tone, and speed which serves as a boundary between a form and its environment.

Overall Image The sum total of all the shapes, positive and negative, in a drawing.

Overlapping An effective way to represent and organize space in a pictorial work of art. Overlapping occurs when one object obscures from view part of a second object.

Perceived Color The observed modification in the local color of an object which is caused by changes in lighting or by the influence of reflected colors from surrounding objects.

Pictorial Refers to a picture, not only its actual two-dimensional space but also its potential for three-dimensional illusion.

Picture Plane The actual flat surface, or opaque plane, on which a drawing is produced. It also refers to the imaginary, transparent "window on nature" that represents the format of a drawing mentally superimposed over real-world subject matter.

Planar Analysis A structural description of a form in which its complex curves are generalized into major planar zones.

Polychromatic Consisting of many colors. (See also *Monochromatic*.)

Positive-Negative Reversal A visual phenomenon occurring when shapes in a drawing alternate between positive and negative identities. (See also *Ambiguous Space*.)

Positive Shape The pictorial, flat counterparts of forms in the real world.

Predella The base of a large altarpiece, frequently painted with scenes that elaborate on the content of the main panel(s).

Primary Colors The three fundamental colors—red, yellow, and blue—that cannot be produced by mixing other hues or colors. When mixed in pairs or combined in admixtures containing all three, the primaries are the source for all the other hues on the color wheel. (See also *Secondary Colors*.)

Principles of Design The means by which artists organize and integrate the visual elements into a unified arrangement, including unity and variety, contrast, emphasis, balance, movement, repetition, rhythm, and economy.

Proportion The relative size of part to part and part to whole within an object or composition.

Push-Pull Spatial tension created by color interaction.

Quarter-Tone After the highlight, the next brightest area of illumination on a form. (See also *Chiaroscuro*.)

Reflected Light The relatively weak light which bounces off a nearby surface onto the shadowed side of a form. (See also *Chiaroscuro*.)

Relative Position A means by which to represent and judge the spatial position of an object in a three-dimensional illusion. Generally, the higher something has been depicted on a surface, the farther away it will appear.

Relative Scale A means by which to represent and judge the spatial position of an object in a three-dimensional illusion. Generally, things that are larger in scale seem closer; when there is a relative decrease in the scale of forms (especially if we know them to be of similar size) we judge them to be receding into the distance.

Rock-Cut Refers to structures excavated from a living rock face, such as some of the temples and tombs of ancient Egypt, India, and the Holy Lands.

Secondary Colors The three hues—orange, purple, and green—that are each the result of mixing two primaries.

Shade A color darkened by adding black.

Shape A flat area with a particular outer edge, or boundary. In drawing, shape may refer to the overall area of the format or to the subdivided areas within the format.

Shape Aspect The shape of something seen from any one vantage point.

Shape Summary Recording the major areas of a three-dimensional form in terms of flat shape, usually for purposes of analysis.

Simultaneous Color Contrast The enhancement of contrast between two different colors that are placed together.

Space In the environment, space may be defined as area, volume, or distance. In drawing, space may be experienced as either a three-dimensional illusion or as the actual two-dimensional area upon which a drawing is produced. (See also *Picture Plane.*)

Spatial Configuration The flat shape or image produced by connecting various points in a spatial field.

Spatial Gesture The gestural movement implied by a perceived linkage of objects distributed in space.

Station Point In the system of linear perspective, the fixed position you occupy in relation to your subject (often abbreviated to SP).

Stereoscopic Vision Normal perception using two eyes. In stereoscopic vision two slightly different views of an object—i.e., two separate cones of vision—are combined to produce a single image.

Subject Matter Those things which are represented in a work of art, such as a landscape, portrait, or imaginary event.

Subject Meaning That aspect of content which is derived from subject matter in a work of art.

Subjective Color Refers to arbitrary color choices. Such arbitrary color choices can be used to convey emotional or imaginative responses to a subject and to compose more intuitively or expressively.

Symmetrical Balance Symmetrical balance is achieved by dividing an image into virtually mirrorlike halves. (See also *Approximate Symmetry* and *Asymmetrical Balance.*)

Synesthesia In synesthesia, a subjective sensation accompanies an actual sensory experience—for example, you hear a sound in response to seeing a color.

Tactile Perceptions gained directly from or through memories of the sense of touch.

Tertiary Colors Colors made by mixing a primary and a secondary color. Mixing red with orange, for example, produces the tertiary red-orange.

Three-Dimensional Space The actual space of our environment, or the representation of it in the form of a pictorial illusion.

Three-Point Perspective The kind of linear perspective used to draw a very large, or very close, object. In three-point perspective, the object is positioned at an angle to the picture plane and is seen from an extreme eye-level point of view, with the result that both the horizontal *and* the vertical parallel lines appear to converge, or meet, respectively at three separate vanishing points.

Tint A color lightened by adding white.

Tonal Key The coordination of a group of values in a drawing for purposes of organization and to establish a pervasive mood. Tonal keys may be high, middle, or low.

Topographical Marks Any marks or lines used to analyze and indicate the surface terrain of a depicted object. Cross-contour lines and hatched lines used to describe the inflections of planes are both topographical marks.

Triadic Color Scheme A color arrangement based on three hues that are equidistant from one another on the color wheel. (See also *Color Scheme*.)

Triangulation Angling between a set of three points on the picture plane to accurately proportion the overall image of your drawing.

Two-Dimensional Space The flat, actual surface area of a drawing, which is the product of the length times the width of your paper or drawing support. Synonymous with the opaque picture plane and flat ground of a drawing.

Two-Point Perspective In two-point perspective, a rectangular volume is positioned off-center—i.e., it is not centered on the line of vision—thus causing the receding (horizontal) parallel lines of each face to appear to meet at two separate points on the horizon line.

Value Black, white, and the gradations of gray tones between them, or the lightness or darkness of a color when compared with a gray scale.

Value Shapes The major areas of light and shade on a subject organized into shapes, each of which is assigned a particular tone that is coordinated with the values of other shapes in the drawing.

Vanishing Point In linear perspective, the point on the horizon line at which receding parallel lines appear to converge, or meet.

Viewfinder A homemade device that functions as a rectangular "window" on your subject. It is a useful aid for proportioning and layout.

Visual Elements The means by which artists make visible their ideas and responses to the world, including line, value (or tone), shape, texture, and color.

Visual Weight The potential of any element or area of a drawing to attract the eye.

Volume The overall size of an object, and by extension the quantity of three-dimensional space it occupies.

Warm Colors Psychologically associated, for example, with sunlight or fire. Warm colors such as red, red-orange, yellow, and yellow-orange appear to advance in a relationship with cooler colors. (See also *Cool Colors*.)

Working Drawings The studies artists make in preparation for a final work of art.

Index